	The ABC Television Network presents
FRIDAY AUGUST **29** 1975 Show Time 8:00 P.M. Doors Close 7:30 P.M.	starring **RON HOWARD, HENRY WINKLER** **& Also TOM BOSLEY** Co-Starring MARION ROSS, ANSON WILLIAMS DONNY MOST & ERIN MORAN *Paramount Television Studios* *Melrose & Gower*
	Children under 16 will not be admitted

50 YEARS OF HAPPY DAYS

A VISUAL HISTORY OF AN AMERICAN TELEVISION CLASSIC

BRIAN LEVANT & FRED FOX JR.

Foreword by
HENRY WINKLER

INSIGHT
EDITIONS

SAN RAFAEL · LOS ANGELES · LONDON

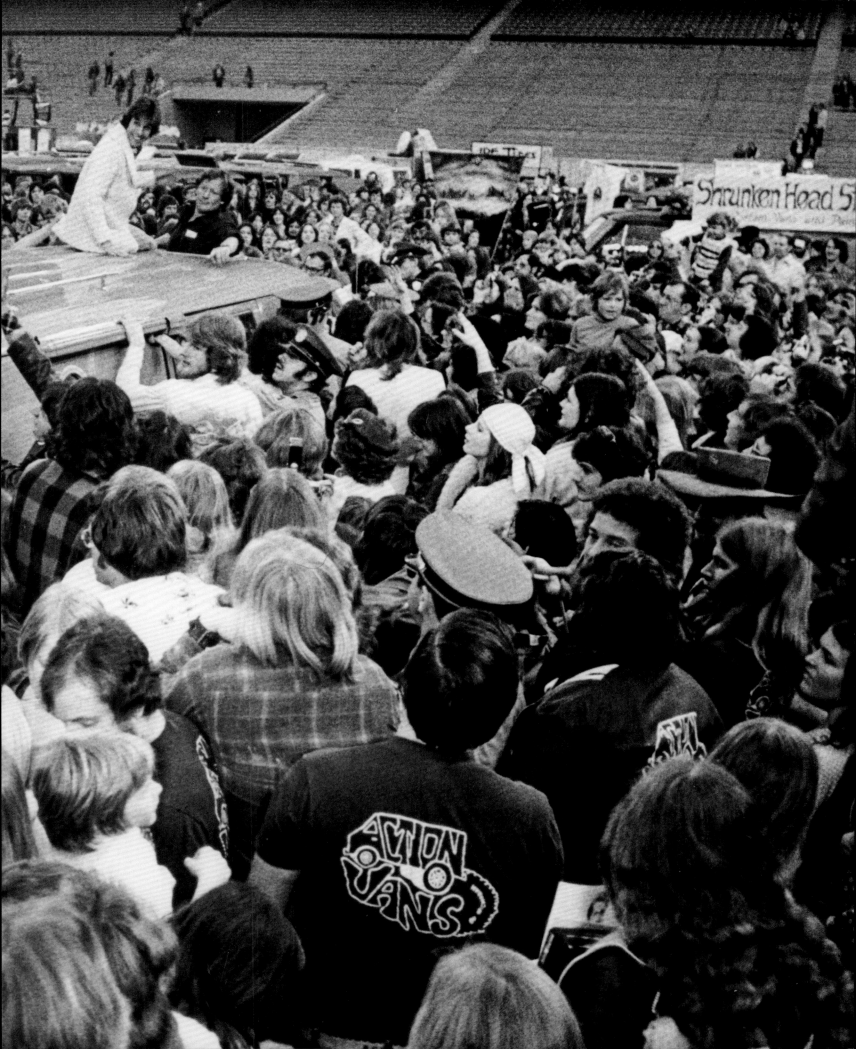

We dedicate this book to the creator of *Happy Days*, Garry Marshall, a man whose empire was built from laughter.

Arnold's Drive-In

Foreword BY HENRY WINKLER

"*50 YEARS OF HAPPY DAYS* IS OUR TELEVISION SERIES' CURTAIN CALL . . . AN INSIGHTFUL, FIRST-HAND ACCOUNT OF THE ENTIRETY OF *HAPPY DAYS*' HISTORY AND THOSE WHO BROUGHT IT TO LIFE" 9

Introduction

THE CUNNINGHAMS GRACIOUSLY WELCOMED SUPER BOWL-SIZED AUDIENCES INTO THEIR HOME FOR ELEVEN SEASONS AND 255 EPISODES 11

50 Years of Happy Days

THE AUTHORS, LONGTIME WRITERS AND PRODUCERS OF THE SERIES, CHRONICLE THE PROGRAM'S ENTIRE HISTORY, IN FRONT OF AND BEHIND THE CAMERA 15

Before Happy Days

FOR *HAPPY DAYS* CAST AND FOUNDERS, THE JOURNEY TO MILWAUKEE TRAVELED MANY UNLIKELY ROUTES BEFORE FINDING A HOME ... 25

New Family in Town

IN 1971, *HAPPY DAYS*' ORIGINAL PILOT SHOWED TREMENDOUS PROMISE . . . BUT DIDN'T SELL AND GATHERED DUST FOR ALMOST THREE YEARS............................... 35

Season One

GIVEN A SECOND CHANCE, A NEW TITLE, AND MAJOR CAST ADDITIONS, *HAPPY DAYS* SOARS IN ITS MAIDEN SEASON! 43

Season Two

HAPPY DAYS RATINGS CRASH OVERNIGHT AND A DESPERATE, LAST-DITCH EFFORT TO SAVE THE SERIES MOVES THE FONZ TO CENTER STAGE 63

Season Three

AAAY, HAPPY DAYS EXPLODES IN POPULARITY AS AMERICA CATCHES FONZIE-FEVER. RICHIE AND FONZIE DOUBLE-DATE WITH A PAIR OF BOTTLE CAPPERS NAMED *LAVERNE & SHIRLEY* 79

Spin-offs: Part One

HAPPY DAYS BIRTHED A RECORD NUMBER OF SERIES. THE FIRST WAS *LAVERNE & SHIRLEY* . . . WHICH DEBUTED AS ABC'S BIGGEST PREMIERE EVER AND KEPT CLIMBING 89

Season Four

HAPPY DAYS REIGNS AS TELEVISION'S NUMBER ONE SHOW, BUT FOR THE SHOW'S STAR, RON HOWARD, IT'S A MIXED BLESSING 101

Season Five

FONZIE JUMPED A SHARK . . . BUT DID THE SERIES? SPOILER ALERT: THEY MADE ANOTHER 164 EPISODES........................ 113

Spin-offs: Part Two

ROBIN WILLIAMS'S UN-EARTHLY TALENTS SENT *MORK & MINDY* INTO THE STRATOSPHERE............................ 135

Season Six

CHANGES BEHIND THE SCENES LED TO THE LEAST HAPPY OF *HAPPY DAYS*.................145

Season Seven

IN WHAT WOULD BE RON HOWARD AND DON MOST'S FINAL SEASON, *HAPPY DAYS* REBOUNDED FROM A ROUGH START TO CLIMB BACK TO THE TOP OF THE PARAMOUNT MOUNTAIN..............159

Season Eight

WITHOUT ITS LEAD ACTOR, *HAPPY DAYS* IS FORCED TO REVAMP AGAIN, ADDING NEW CHARACTERS AND SENDING FONZIE BACK TO JEFFERSON HIGH....................169

Barnstorming

BY ANY METRIC, THE *HAPPY DAYS* CAST AND CREW WERE A GREAT TEAM . . . ESPECIALLY ON THE BASEBALL DIAMOND, AS THE TRAVELING SQUAD DOMINATED OPPONENTS ACROSS THREE CONTINENTS...........181

Season Nine

MORE THAN EVER, THE SPOTLIGHT SHONE ON CHACHI AND JOANIE'S ROMANCE . . . AND IF IT SEEMED AUTHENTIC, IT WAS BECAUSE AT THE TIME, THE PAIR WERE A COUPLE................195

Spin-offs: Part Three

NOT ALL OF *HAPPY DAYS*' PRIMETIME SPIN-OFFS WERE SUCCESSFUL, BUT THEY RULED SATURDAY MORNINGS.......205

Season Ten

THE FONZ GIVES MONOGAMY A WHIRL WHEN HE FALLS HEAD-OVER-HEELS FOR A BEAUTIFUL, CULUTURED, SINGLE-MOM, ASHLEY PFISTER, AND AN OLD ENEMY PLOTS REVENGE ON THE FONZ................213

Camp Marshall Mount

EXECUTIVE PRODUCER GARRY MARSHALL, CLAD IN SHORTS, WHISTLE AROUND HIS NECK, WELCOMED THE STAFFS OF HIS MULTIPLE SERIES EACH SEASON, STRESSING "LIFE IS MORE IMPORTANT THAN SHOW BUSINESS"......................225

Season Eleven

HAPPY DAYS' FINAL SEASON FEATURED A GALA 250TH EPISODE HOMECOMING, GUEST STARRING RON HOWARD AND DON MOST PLUS AN HOURLONG FINALE, FULL OF SURPRISES................231

After Happy Days

FOR MOST, A LONG-RUNNING HIT SERIES WOULD BE THE PINNACLE OF THEIR CAREERS . . . NOT SO FOR THE HANDS THAT SHAPED *HAPPY DAYS*, WHO CONTINUED TO EXCEL, AND OFTEN DOMINATE, IN TELEVISION, FILMS, THEATER, MUSIC, AND PUBLISHING.................243

MILWAUKEE · WISCONSIN · EST. 1949

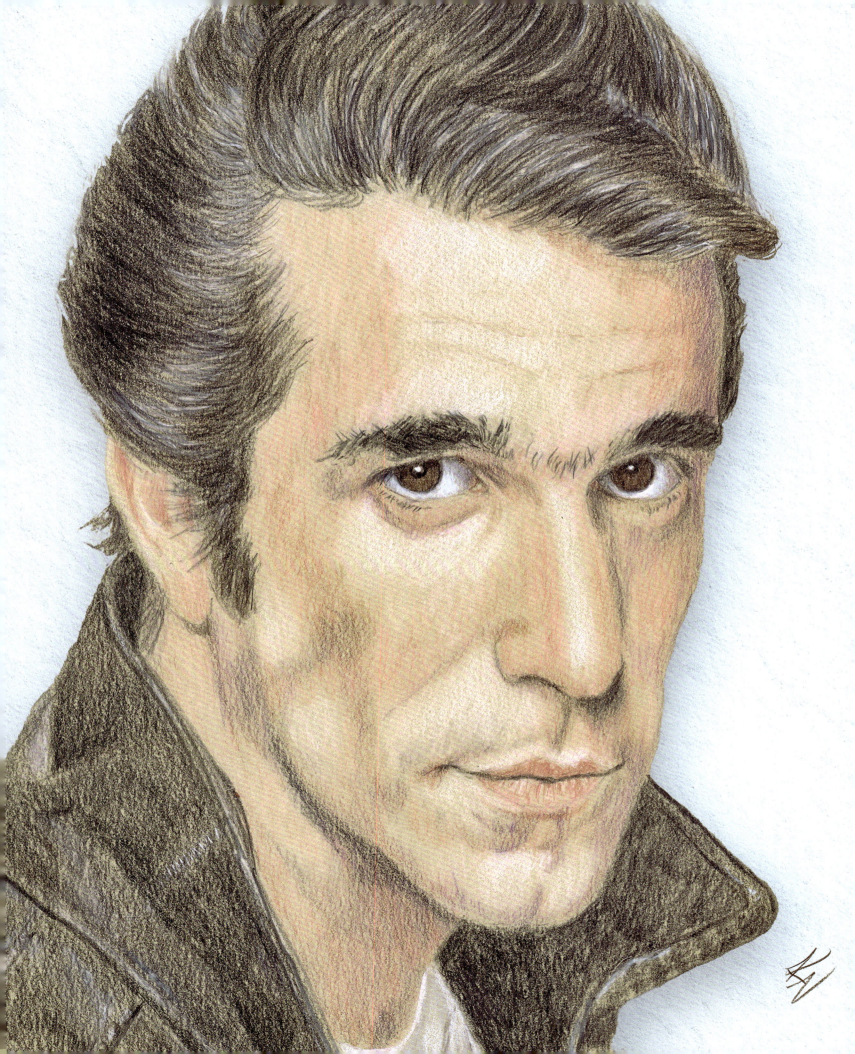

FOREWORD

by Henry Winkler

One of my favorite parts of working onstage is the curtain call: the moment when the show is over, when the audience meets the performers as themselves, rather than their characters, and where the theatergoers and actors share their appreciation for one another. *50 Years of Happy Days* is our television series' curtain call.

So, please join me in applauding an incredibly talented, kind, decent, and creative group who cherished working together for more than a decade, dearly loved one another, and still do. Make no mistake, producing one show a week for 255 episodes was a lot of hard work, but as the saying goes, it's never "work" when you love what you do.

This book is a chronicle of our journey throughout the making of *Happy Days*. Luckily, you have very experienced guides in authors Brian Levant and Fred Fox Jr., two of the show's longest-serving writer-producers. They offer an insightful, firsthand account of the entirety of *Happy Days* history and those who brought to life what you saw on the screen. Season by season, they provide an honest assessment of *Happy Days*' singles, home runs . . . and strikeouts. Reading *50 Years of Happy Days* revived wonderful memories for me, many long forgotten. Our surviving colleagues have all shared their reminiscences along with candid and personal reflections. I know you'll enjoy hearing from Don, Anson, Marion, Scott, Ted, Cathy, Lynda, Linda, and, of course, Ron as much as I have.

A half century ago, "screen sharing" meant having the entire family sit together to watch our show. I am honored to be part of this incredible group of people, for whom working on TV's top series was just the beginning of their extraordinary adventures. *Happy Days* creator Garry Marshall, and our director Jerry Paris, set a tone and standard which propelled us to the pinnacle of success. They taught us how to carry those lessons in our futures with grace, professionalism, and gratitude. None of us ever took this meteoric rise for granted and never will.

Portraying Arthur Fonzarelli was a gift that keeps on giving and has provided the foundation that I've built the rest of my life on. To say I've been very lucky is an understatement. For eleven seasons, every time I stepped onto Stage 19, it was a joyous experience and I hope you'll feel the same way during your "visit" to our mythical Milwaukee.

OPPOSITE: A colored pencil drawing of Henry Winkler as The Fonz by artist Kent Villeneuve.

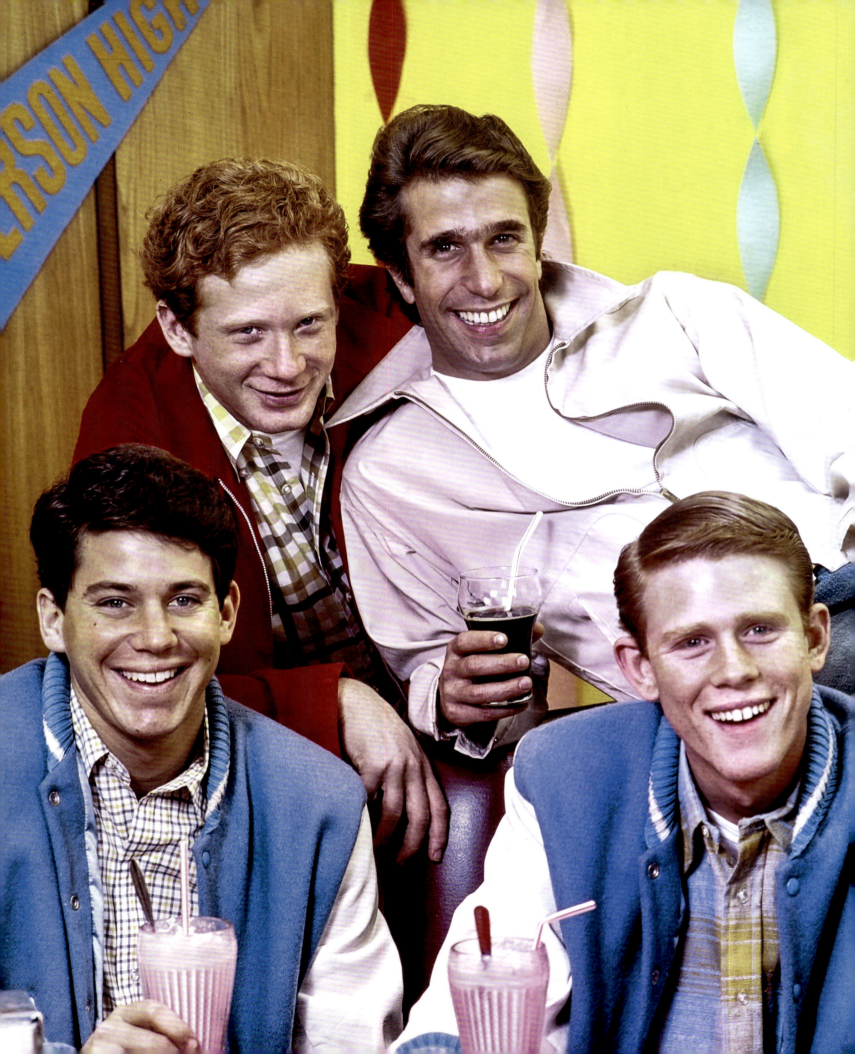

INTRODUCTION

by Brian Levant & Fred Fox Jr.

By any standard, *Happy Days* was one of the most successful television series of all time. In its late-1970s peak, *Happy Days* drew over thirty million viewers weekly in America and became a global sensation. So why didn't anyone ever write a book about the show and the people in front of and behind the camera? To celebrate *Happy Days'* fiftieth anniversary, we decided it was time to chronicle the surprising and occasionally rocky path of the show's long, triumphant journey.

Most books about popular television shows tend to be written by academics or fans. We are definitely not academics, but we *are* huge fans of the show—who also had the pleasure of writing on and producing over a combined three hundred episodes. We consider the people we worked beside for eight years not as colleagues, teammates, or even just friends—to us they are family.

> **FEW SERIES HAVE CREATED BONDS THAT HAVE RUN AS DEEP AND ENDURED AS LONG AS THOSE WHOSE ROOTS DATE BACK TO A FAILED 1971 PILOT.**

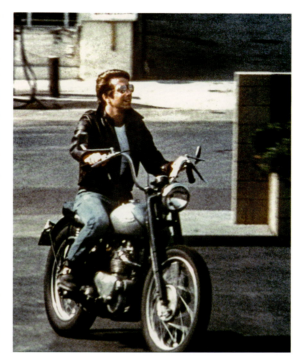

OPPOSITE: Clockwise from top left: Most, Winkler, Howard, and Williams photographed during the filming of *Happy Days* first episode, 1973.

LEFT: Despite lessons, Winkler rarely looked comfortable riding a motorcycle. According to producer Bill Bickley, Henry was "scared shitless" of motorcycles.

Few series have created bonds that have run as deep and endured as long as those whose roots date back to a failed 1971 pilot. From *Happy Days'* lean first seasons through its glory days in the late 1970s, the cast and crew weathered every storm by standing together. The unique leadership of creator and executive producer Garry Marshall, along with the show's stars Ron Howard and Henry Winkler, fostered a welcoming environment, emphasizing the "ensemble" concept and an admirable work ethic that spread throughout the company. The depth of these relationships has only grown since the final curtain came down on the series in 1984.

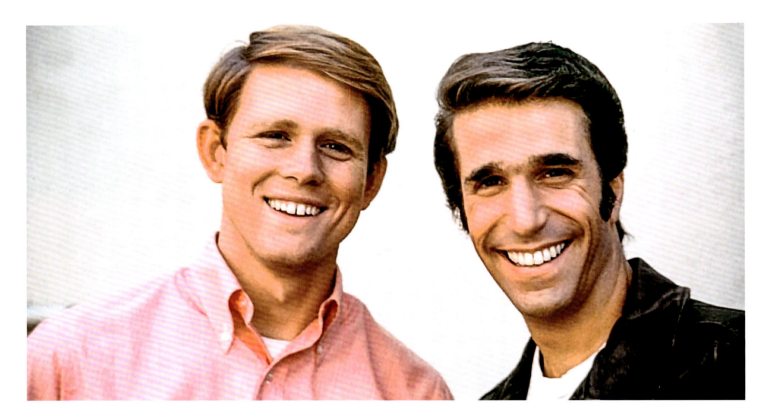

ABOVE:
Ron Howard and Henry Winkler formed an immediate bond that has lasted for over half a century.

OPPOSITE:
A set of 44 wax pack trading cards released by Topps in 1976.

We felt that with the show passing the half-century mark, it presented the perfect opportunity to paint a "family portrait," offering an insider's perspective and commentary in chronicling the program's entire history, in front of and behind the camera, as well as on and off Paramount's Stage 19. Throughout these pages, we detail the creative dynamics, delve into the program's long-known (and unknown) history, and explore the characters who played the characters.

Alongside the highlights and miscues, we'll share hundreds of memorable images from iconic episodes, as well as presenting historic items from the massive collection of licensed products, wardrobe, and props of Dr. Giuseppe Ganelli. A radiologist from Codogno, Italy, Ganelli is the founder of the Happy Days International Fans Club. He was recently certified by Guinness World Records as owning the largest collection of *Happy Days* memorabilia on Earth, and for decades has been warmly welcomed as a member of the *Happy Days* family.

It's been fun to revisit all of *Happy Days*' 255 episodes and rediscover the work we created when we were both very young. This book also provided an opportunity to sit down and reminisce with all our friends and colleagues and discover how *Happy Days* influenced their lives and how time has affected their views of the experience.

50 Years of Happy Days reflects our dedication to, and shared affection for, the series and those who brought it to life. So, ditch your homework, put a little dab of Brylcreem in your crew cut, apply some flavored lipstick, put on your saddle shoes, hop in your hot rod, put the pedal to the metal, and get ready to rock!

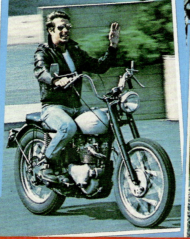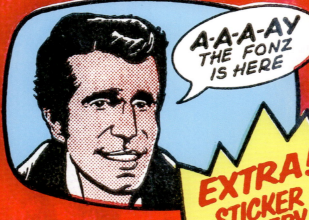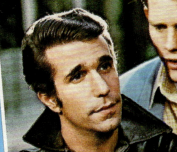

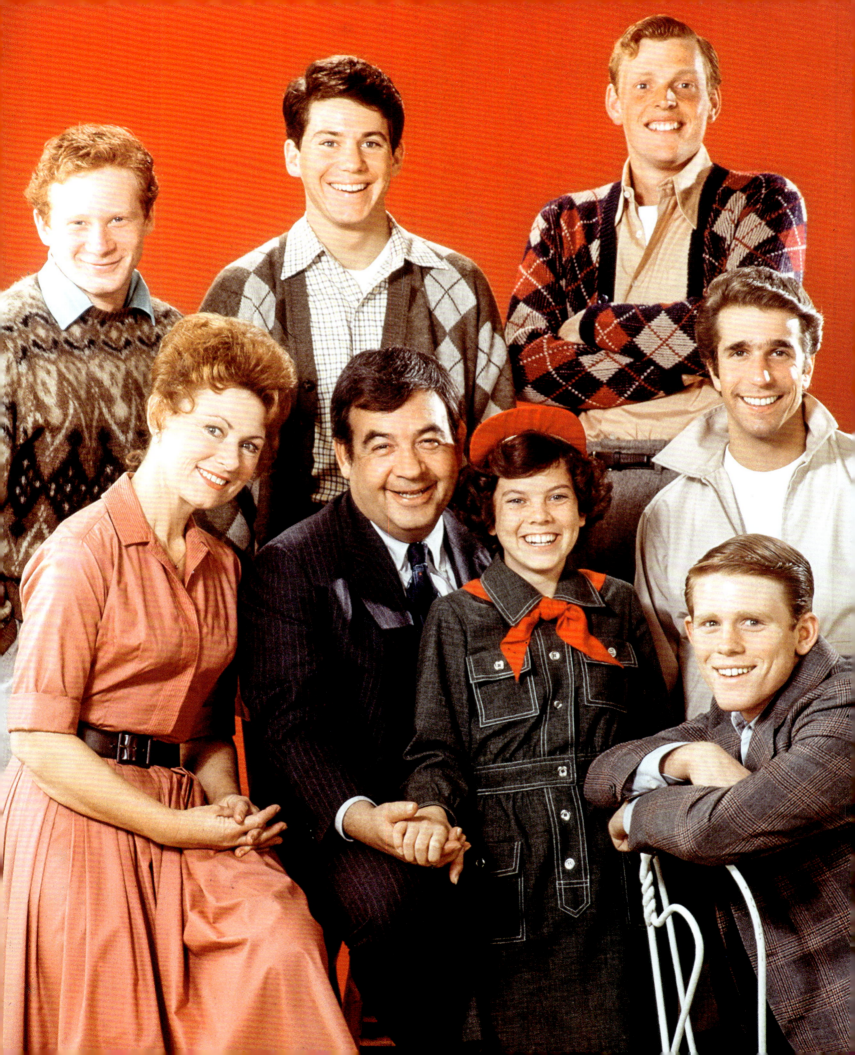

50 YEARS OF HAPPY DAYS

In January of 1974, while the nation reeled from the divisive war in Vietnam, 11 percent inflation, a gas shortage, and President Nixon refusing to comply with a congressional subpoena on Watergate, a new show debuted that offered an idealized version of a simpler time: America during the 1950s.

> *"Sunday, Monday, Happy Days*
> *Thursday, Friday*
> *Happy Days*
> *Saturday, what a day*
> *Rockin' all week for you!"*

Happy Days debuted January 15th that year and provided a respite from the nation's ills in the form of drive-ins, sock hops, cruisin', poodle skirts, ducktails, hot rods, 45s, *American Bandstand*, double standards, and rebels without a cause.

The television show's concept, created by legendary writer, producer, and director Garry Marshall, was to counter Norman Lear's successful social issue–driven series such as *All in the Family*, *Maude*, and *The Jeffersons*, which dealt with formerly taboo primetime issues like race relations, menopause, and abortion. *Happy Days*' pilot episode, which chronicled the dating travails of high school sophomore Richie Cunningham—the middle child of a middle-class, mid-American family—gave no indication that it would soon rocket to the top of the ratings. And certainly not that Henry Winkler's portrayal of Milwaukee's motorcycle-riding oracle Arthur Fonzarelli—better known as "The Fonz"—would propel *Happy Days* to become a once-in-a-decade international phenomenon.

Every Tuesday night at 8 p.m. (7 p.m. Central Time), the Cunninghams graciously welcomed Super Bowl–sized audiences into their home for eleven seasons and 255 episodes. And they are still available across the entertainment

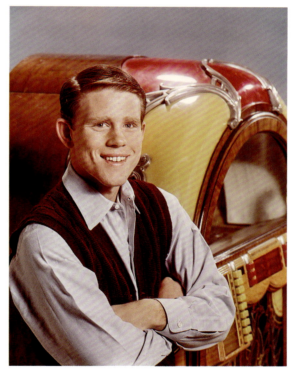

OPPOSITE: The original cast of *Happy Days* including Gavan O'Herlihy as Richie's older brother Chuck, the second of three actors to portray the hapless character, who was written out of the series in Season Two.

LEFT: Ron Howard poses as part of a session for a *TV Guide* cover in 1974.

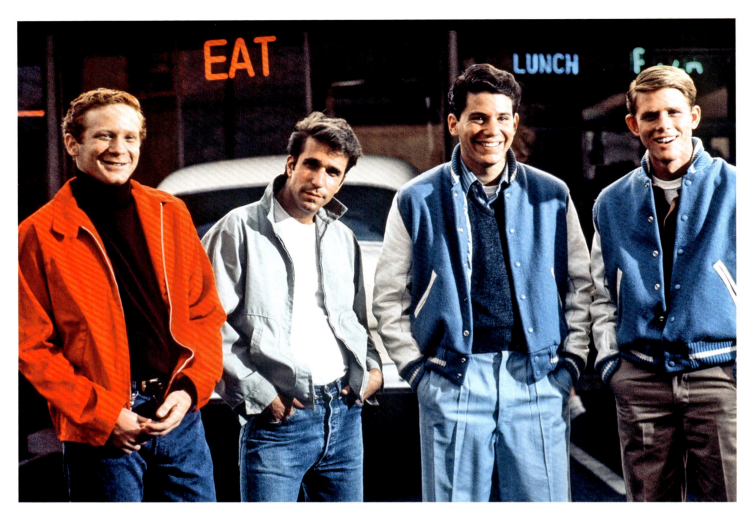

ABOVE:
From left: Don Most, Henry Winkler (before Fonzie was allowed to wear a leather jacket), Anson Williams, and Ron Howard at Arnold's Drive-In, 1974.

OPPOSITE:
The 1976 Mego Corporation line of *Happy Days* figures are now prized collectibles selling for hundreds of dollars apiece.

spectrum, worldwide. The show birthed an incredible eight spin-off series, including *Laverne & Shirley* (1976–1983) and *Mork & Mindy* (1978–1982) which unleashed Robin Williams's unearthly talents to the world. Both series were launched with crossover appearances by Henry Winkler, and, incredibly, both series debuted as television's top-rated program. Today, six decades later, *Happy Days* is still beloved by ardent fans around the world and occupies a prominent place on pop culture's top shelf.

Happy Days' original, 1971 pilot was titled *New Family in Town*. It starred Ron Howard (Richie Cunningham), Marion Ross (Marion Cunningham), and Anson Williams (Warren "Potsie" Weber), though not Erin Moran or Tom Bosley. Joanie Cunningham was played by Susan Neher, and the role of hardware store owner Howard Cunningham was played by Harold Gould. The story centered on the impact of the Cunninghams becoming the first family in their neighborhood to purchase the latest status symbol in postwar America: a television set. Like 75 percent of network pilots, it wasn't picked up to go to series. To recoup their investment in the pilot, Paramount retitled the piece "Love and the Happy Days" and shuffled it into a segment of their hour-long anthology series *Love, American Style* (1969–1972).

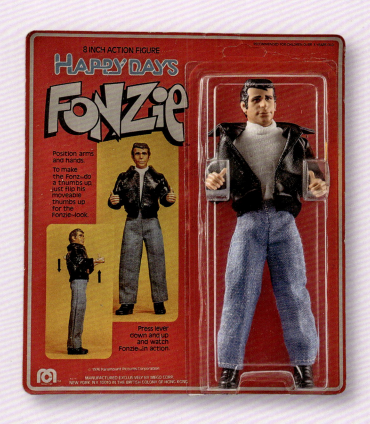
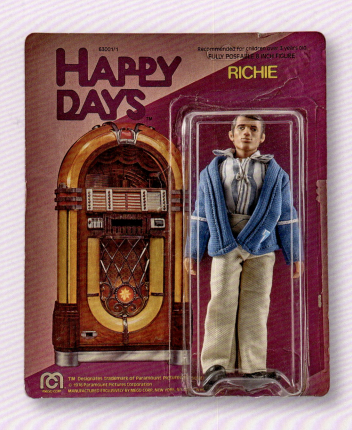

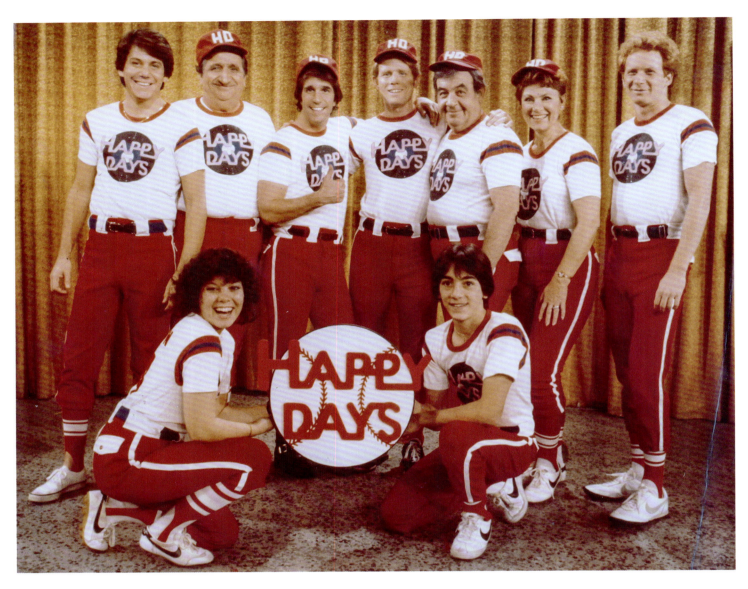

ABOVE:
The cast of *Happy Days* traveling softball team gathered for a team picture in 1978.

OPPOSITE:
The Fonzie watch, produced by Gifts Unlimited, came with a 15-day home trial.

PAGE 20:
The Cunninghams were all smiles in the Season Two photo session, but the show came ever so close to being canceled.

PAGE 21:
This shot represents the first time Fonzie was allowed to wear a leather jacket in a promotional photo session.

Two years later, "Ronny" Howard would star in George Lucas's monster hit *American Graffiti*, which encouraged ABC to exhume *New Family in Town*. A new first episode was shot, and because Harold Gould was appearing in a play in England, the producers turned to Tony Award–winner Tom Bosley to play the family patriarch. Freckle-faced thirteen-year-old Erin Moran came aboard as Joanie. Two more series regulars were added to the script by Marshall, his then brother-in-law Rob Reiner, and his writing partner Phil Mishkin. The first was "Donny" Most as funster Ralph Malph. And, in an effort to emulate *American Graffiti*'s Paul Le Mat's charismatic street-racing character, they introduced a charismatic leather-jacketed, motorcycle-riding leader of the pack: Arthur Herbert Fonzarelli, better known as The Fonz.

The role of Fonzie was based on a childhood friend of Marshall's from Yonkers, New York, the person he called the "coolest . . . and only person I knew who had a motorcycle." The role had been written for a physically imposing, streetwise Italian brawler. However,

the performer who knocked out every one of his competitors was a five-foot-six Jewish actor from New York's Upper West Side armed with a master's degree from the Yale School of Drama: Henry Winkler.

Garry Marshall labeled Fonzie the "hood with the heart of gold." Though the character was relegated to the background of the first two seasons, when the second season's ratings plummeted, in a desperate attempt to avoid cancellation, Marshall and the studio threw a Hail Mary. They completely revamped the show to take advantage of Fonzie's steadily growing popularity. They banked on Fonzie's "cool" to save the series, and for the season finale, they put the character front and center, then flipped the production from a single-camera, movie-style program to one filmed with multiple cameras in front of a live studio audience. The move to the multi-camera format unleashed a fireball of comedic energy onstage and tremendous potential. The experiment succeeded, and *Happy Days* was renewed for another season.

The fall season of 1975 saw *Happy Days* open with a string of episodes brimming with the show's newfound zeal. In Episode 42, "Fearless Fonzarelli Part I," where Fonzie attempts an Evel Knievel–esque motorcycle stunt on national television, The Fonz not only cleared fourteen garbage cans, but the show also made a huge jump in the Nielsen ratings. *Happy Days*' success, soon coupled with *Laverne & Shirley* and *Charlie's Angels*, helped make ABC the highest-rated network for the first time in its thirty-three-year history, and would forever change the lives of everyone involved with the show.

Henry Winkler, whose credit didn't even appear in the first season's main title, began to receive over fifty thousand fan letters a week. The Fonz's face was plastered on magazines around the world as well as on more than 2,000 licensed products: lunchboxes, T-shirts, trading cards, action figures, coffee mugs, paper dolls, pin-back buttons, vehicles, playsets, books, AM radios, and Halloween costumes. Even a "cool" Fonzie watch with a denim band appeared on store shelves worldwide.

As the years rolled on, the show became an institution, with tens of millions of families gathered weekly in front of their TV sets to share the laughter and

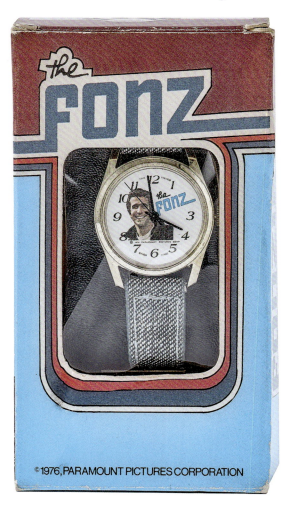

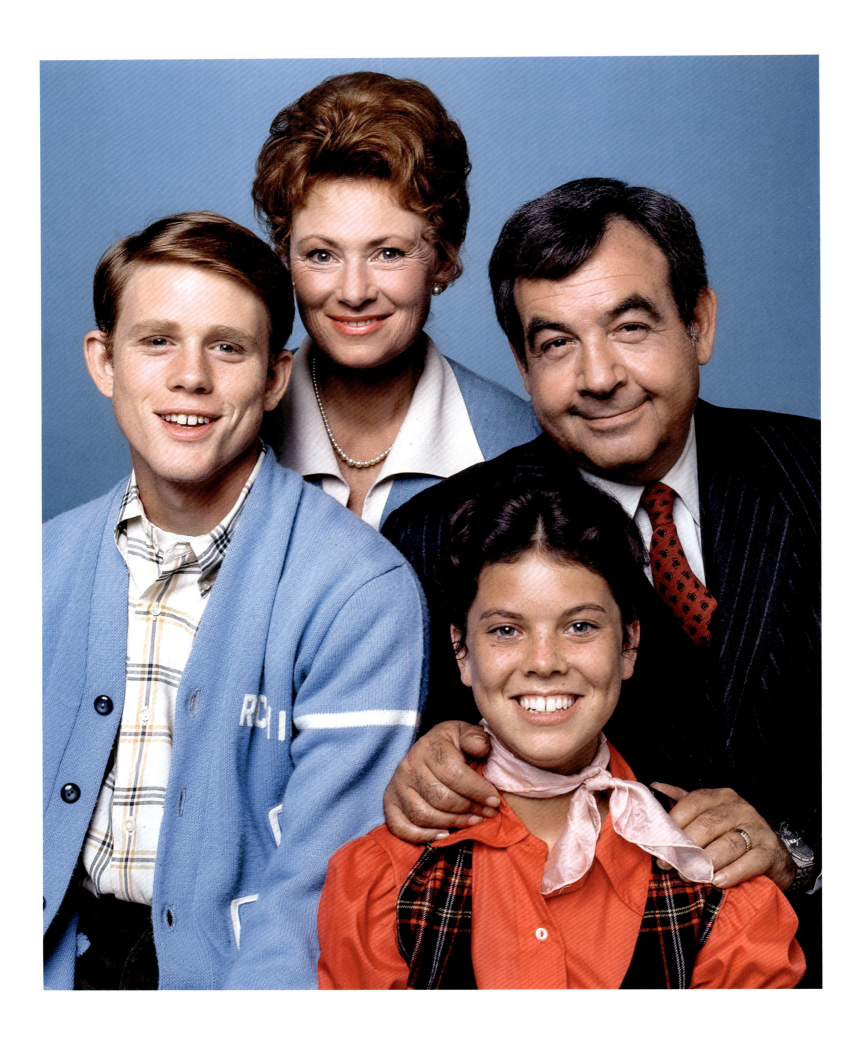

warmth that every episode generated. While the show may be best remembered for Fonzie's demolition derbies, bull riding, sword fighting, or "jumping the shark," Marshall felt a responsibility to explore more substantial issues, too. Over the years, the show shone a light on those living with disabilities and conditions like epilepsy and diabetes. Several episodes dealt with racism, including a first-season episode in which Howard Cunningham confronts a neighbor who objects to the family hosting a wedding for Howard's Black Army buddy. And in a controversial Season Nine story, Arnold's Drive-In owner Al Delvecchio and The Fonz become involved with the Civil Rights Movement.

Series creator Garry Marshall's warm, upbeat presence fostered an environment that felt more like a family get-together than a workplace. Along with the show's director and fellow *Dick Van Dyke Show* alumnus, Jerry Paris, they set a tone for the entire company that valued collaboration and support—a "team" concept that extended beyond the stage to the baseball diamond. The cast and crew's barnstorming softball team lost only a handful of games over the course of ten years. With the entire cast suiting up, the team played dozens of games as an opening act for major league teams, headlining major charity events and two grueling USO tours spanning West Germany's Zonengrenze (Zonal Border) to the China Sea.

For many, working on a legendary TV series becomes the pinnacle of one's career. But that's hardly been the case for those who have worked on *Happy Days*. Many of the hands who shaped the show

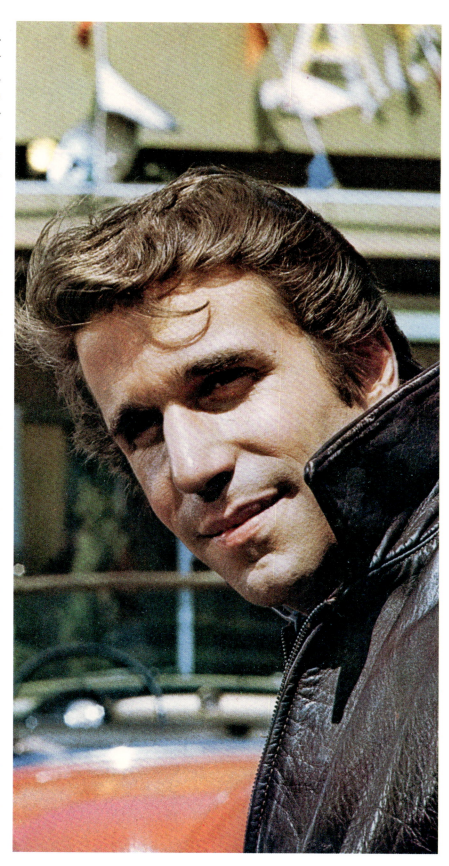

ABOVE:
The company celebrated the completion of their 100th episode "Requiem for a Malph." (L-R) Molinaro, executive producer Eddie Milkis, Winkler, producer Bob Brunner, Howard, Ross, executive producer Tom Miller, executive producer Garry Marshall, Most, producer Jerry Paris, Baio, Moran, and dialogue coach Bobby Hoffman.

OPPOSITE (TOP):
TV Guide bade farewell to the entire *Happy Days* gang in 1984.

OPPOSITE (BOTTOM):
Ron Howard holding Oscars for Best Picture and Best Director for *A Beautiful Mind* in 2001 and Henry Winkler winning the Emmy for Outstanding Supporting Actor for *Barry* in 2018.

over the years continue to be prominent figures in the entertainment industry. Ron Howard, who left the show after its seventh season to pursue his childhood dream of becoming a director, has gone on to helm over forty narrative features, documentaries, and a wide range of broadcast projects. In 2002, Howard won the Academy Award for Best Director for his exceptional work on the previous year's *A Beautiful Mind*. Along with his longtime Imagine Entertainment partner, Brian Grazer, Howard has produced more than 200 films and television series.

Garry Marshall, who at one time was responsible for four of the five top-rated TV shows, moved on to directing films including *Beaches* (1988), *Pretty Woman* (1990), and *The Princess Diaries* (2001). Marshall was also a talented actor, bringing his Bronx accent to projects as varied as Albert Brooks's *Lost in America* (1985) and Disney's *Chicken Little* (2005). Henry Winkler has amassed nearly forty major

> ### *HAPPY DAYS* "WAS FAR MORE THAN A GIG . . . IT WAS A COMING-OF-AGE EXPERIENCE . . . A LIFE EXPERIENCE, AND A REMARKABLE ONE."
>
> **—RON HOWARD**

acting and producing award nominations and won nineteen, including the 2018 Emmy for Outstanding Supporting Actor in a Comedy Series for his work on HBO's *Barry*, forty-two years after his first nomination for *Happy Days*.

Happy Days alumni would create and/or helm an incredible number of successful series such as *Family Matters*, *The Larry Sanders Show*, *Step by Step*, *Moesha*, *The Love Boat*, *The Proud Family*, *Perfect Strangers*, *Webster*, *Superstore*, *Malcolm in the Middle*, *The Cosby Show*, *Married . . . with Children*, *Diff'rent Strokes*, *Arrested Development*, and *Hannah Montana*. Former *Happy Days* talent also provided the producers, writers, and directors for dozens of blockbuster feature films, including *A League of Their Own* (1992), *Silver Streak* (1976), *The War of the Roses* (1989), *Foul Play* (1978), *The Princess Bride* (1987), *Splash* (1984), *Revenge of the Nerds* (1984), *Overboard* (1987), *Father of the Bride* (1991), *Beethoven* (1992), *Barbershop 2* (2004), *City Slickers* (1991), *The Flintstones* (1994), and *Parenthood* (1989).

For those who contributed to it, *Happy Days* was a clinic in achieving and sustaining success. But it taught other lessons as well. Recently, Ron Howard put the show in perspective, saying *Happy Days* "was far more than a gig . . . it was a coming-of-age experience . . . a life experience, and a remarkable one. Man, has it endured. It's fantastic and kind of incredible."

Looking around the world today, events are as frightening as they were when the show debuted. In 1974, it was an antidote to a time of crisis and today . . . it's obvious that we need *Happy Days* more than ever.

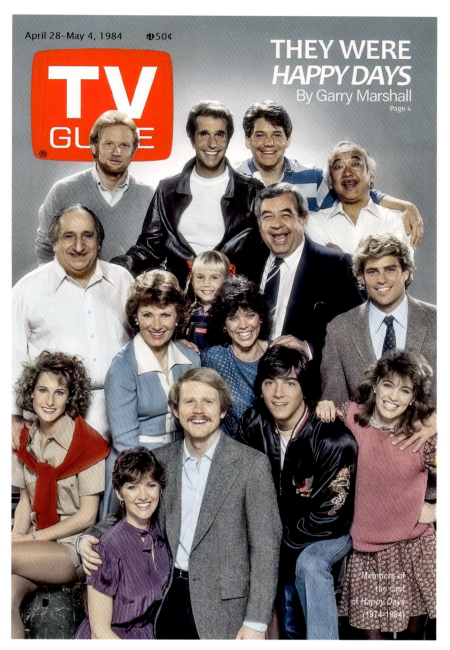

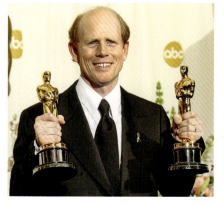

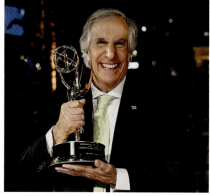

BEFORE HAPPY DAYS

Our story begins as we introduce the key players, and throughout this chapter, we will follow the paths that led them to joining the show for which they would come to be known.

Before most of her castmates were born, the eternally joyful **Marion Ross** (Marion Cunningham) was already a regular on an early television series, as the Day family's Irish housekeeper on the adaptation of Broadway's longest-running play, *Life with Father* (1953–1955). Ross grew up in Albert Lea, Minnesota, until her family moved to San Diego, where she caught the acting bug. Ross would make her screen debut in 1953's *Forever Female*, starring Ginger Rogers and William Holden. After that, she was cast in a succession of small roles in films throughout the decade—opposite

> **[ROSS] WAS CAST IN A SUCCESSION OF SMALL ROLES . . . OPPOSITE THE LIKES OF HUMPHREY BOGART, CLARK GABLE, TONY CURTIS, CARY GRANT, AND THE LONE RANGER.**

CO-STARRING MARION ROSS

AND STARRING TOM BOSLEY AS HOWARD CUNNINGHAM

the likes of Humphrey Bogart, Clark Gable, Tony Curtis, Cary Grant, and the Lone Ranger.

During the 1960s, Ross continued her acting career while navigating a troubled marriage and raising two children, Jim and Ellen. She and her husband divorced in 1968, which prompted her to make a more concentrated effort toward her career. Only three years later, she would land her role on the original Happy Days pilot and would charm the world when the show finally hit the air two years later.

Ross's future TV husband, **Tom Bosley** (Howard Cunningham), rose to prominence as the title character in the musical Fiorello!, based on the 1930s reign of New York Mayor Fiorello La Guardia. The show was written and directed by Broadway legend George Abbott, and Bosley won the Tony Award for Best Performance by a Featured Actor in a Musical. The show also received the Tony Award as Best Musical, as well as the Pulitzer Prize for Drama in 1960.

Chicago-born and -bred, and a lifelong Cubs fan, Bosley served in the Navy during World War II, then attended DePaul University. While a student at DePaul, he made his stage debut in the Canterbury Players' production of Our Town. Before

> **BOSLEY WON THE TONY AWARD FOR BEST PERFORMANCE BY A FEATURED ACTOR IN A MUSICAL.**

HENRY WINKLER

succumbing to a pressure campaign to sign on with *Happy Days*, Bosley, an everyman blessed with a pleasant, distinctive voice, made guest appearances on nearly a hundred television series and stood out in films such as *The World of Henry Orient* with Peter Sellers and *The Secret War of Harry Frigg*—which reunited Bosley with a buddy from his early New York acting days, Paul Newman.

In the summer of 1960, a red-haired, freckled, and already a seasoned professional, six-year-old **Ron Howard** (Richie Cunningham) would begin an incredible eight-year reign atop the television ratings heap as Opie Taylor, the son of a widowed Southern small-town sheriff on *The Andy Griffith Show*. During the show's run, he would also co-star in feature films, including *The Music Man* and *The Courtship of Eddie's Father*. After *The Andy Griffith Show* ended, Howard spent a season and a half as Henry Fonda's son on *The Smith Family*, and made dozens of guest appearances on everything from *Gunsmoke* to *M*A*S*H*.

When he was growing up in Burbank, California, Howard's boyhood dream was to become a film director. At the age of ten, Howard began making Super 8mm films, and by the time he finished high school, one of his short films, *Deed of Daring-Do* (1969), had won a Kodak-sponsored national competition. Howard took a giant step toward his goal when he was accepted at the University of Southern California's prestigious film school, where he continued to attend classes until *Happy Days* was picked up for its second season.

> **HAVING SEEN HIS BROADWAY DEBUT, *42 SECONDS FROM BROADWAY*, CLOSE THE NIGHT IT OPENED, WINKLER HATCHED A NEW PLAN . . . HE GAVE HIMSELF ONE MONTH TO ESTABLISH A CAREER IN HOLLYWOOD.**

After graduating from Emerson College in 1967, **Henry Winkler** (Arthur Fonzarelli, aka The Fonz) was accepted into the Yale University master's program in theater. Winkler had always been serious about his craft. He was a founding member of the New Haven Free Theater and appeared in the acclaimed New York Public Theater's Shakespeare Festival. Winkler made his film debut, ironically, as a 1950s ducktailed hood alongside Sylvester Stallone in the 1974 film *The Lords of Flatbush*.

Having seen his Broadway debut, *42 Seconds from Broadway*, close the night it opened, Winkler hatched a new plan. Using the "thousand dollars I made doing a commercial," in late October of 1973, Winkler headed to Los Angeles. He gave himself one month to establish a career in Hollywood. But within only ten days, Winkler was put to work by future Oscar winner and godfather of *The Simpsons*, James L. Brooks—he gave Winkler six lines on his Emmy-winning *The Mary Tyler Moore Show*. Winkler impressed MTM Productions so much that they handed him small roles on *Rhoda*, *The Bob Newhart Show*, and the pilot episode of *Friends and Lovers*. Soon after, he auditioned for and was cast on *Happy Days*—incredibly, just ahead of his thirty-day deadline.

> **AFTER GRADUATING, [WILLIAMS] DECIDED THAT HE WANTED TO BREAK INTO THE ENTERTAINMENT INDUSTRY. HIS FAMILY LITERALLY RESPONDED WITH, "GOODBYE. COME BACK WHEN YOU'RE SANE."**

Don Most (Ralph Malph) grew up in Brooklyn's Flatbush section and appeared in over forty television commercials, including a McDonald's spot with Morgan Freeman. While enrolled at Lehigh University in Pennsylvania, Most took a summer session at UCLA and tested the Hollywood waters, auditioning for parts. He felt so confident about his acting prospects that he left Lehigh and moved to Los Angeles to pursue acting full-time. Like Henry Winkler, Most landed his first TV role on a James L. Brooks show, appearing in the final episode of *Room 222* in 1974. Then, after a months-long acting drought, Most says he came close to taking what he called "a real job," before landing his *Happy Days* audition . . . for the part of Potsie Weber. Spoiler alert: He didn't get the part.

Anson Williams (Warren "Potsie" Weber), like Ron Howard, grew up in Burbank, California. In high school, he was a 149-pound football scrub. Williams appeared in some high school productions, and, after graduating, he decided that he wanted to break into the entertainment industry. His family literally responded with, "Goodbye. Come back when you're sane."

Williams scraped by, sharing apartments and driving a clunker while prowling open-mic talent nights around

Before Happy Days

a Hollywood theater, Williams landed the audition for the role of Potsie Weber—the role that would change his life.

The bubbly **Erin Moran** (Joanie Cunningham) was born in 1960 and grew up in a family of six children in North Hollywood, California. She made her onscreen debut at five years old and became a series regular on the final season of the Africa-set series *Daktari*, created by *Flipper* executive producer Ivan Tors. Moran also appeared in the Garry Marshall and Jerry Belson penned film *How Sweet It Is!*, directed by Jerry Paris and starring Debbie Reynolds and James Garner, as well as series ranging from *Gunsmoke* to *The Courtship of Eddie's Father*—all before being cast as Joanie Cunningham in 1974.

Scott Baio (Charles "Chachi" Arcola) was born in 1960, in Brooklyn, where he was a Little League All-Star. At thirteen, Baio was cast as the title character (opposite a young Jodie Foster) in Director Alan Parker's kid gangster movie send-up, *Bugsy Malone*—even after tossing his script and storming out of his audition (he was tired of long rides into Manhattan for auditions and not being able to be with his friends). The film was in competition for the 1976 Palme d'Or at the Cannes Film Festival and would garner twelve Golden Globe, BAFTA, and Academy Award nominations. Paramount screened *Bugsy Malone* for all their in-house producers. There, most of the interest was directed toward Johnny Cassisi, the boy who played Fat Sam Staccetto. However, Garry Marshall saw the potential appeal of the handsome, easygoing Baio with female viewers, so the entire Baio family moved from New York to "Milwaukee."

town, before stumbling onto and nailing a local audition for a summer stock company in Wichita, Kansas. There, Williams learned the ropes, and upon returning to Los Angeles, he soon landed "boyfriend" parts on shows like *Marcus Welby, M.D.* and a Steven Spielberg–directed episode of *Owen Marshall, Counselor at Law*. And then, while working as an understudy in

> **MORITA HAD BEEN STRICKEN WITH TUBERCULOSIS AND RECOVERED, ONLY FOR HIM AND HIS FAMILY TO BE SENT TO AN INTERNMENT CAMP FOR JAPANESE-AMERICANS IN ARIZONA FOR THE DURATION OF WORLD WAR II.**

As a child in California, **Noriyuki "Pat" Morita** (Arnold Takahashi) had been stricken with tuberculosis and recovered, only for him and his family to be sent to an internment camp for Japanese-Americans in Arizona for the duration of World War II. After the war, Morita worked at the DMV and in the aerospace industry. While working at his family's Sacramento restaurant, Morita turned entertaining customers into a career in stand-up comedy. Known as the "Hip Nip," Morita played small comedy clubs in Northern California before Lenny Bruce's mother, Sally Marr, booked him into some of Los Angeles's top comedy clubs. Morita toured for years with acts including the singers Vic Damone and Connie Stevens, as well as his friend and mentor, comedian Redd Foxx. Morita also guest starred multiple times on Foxx's hit show, *Sanford and Son*.

Umberto Francesco Molinaro (Al Delvecchio), who went by "Al," was raised in Kenosha, Wisconsin. Al Molinaro was as sweet a person as you'll ever meet. Al knew he was no matinee idol, but he didn't allow his prominent hawklike nose or his hound-dog expression to stop him from hopping a bus in 1940 to seek his fortune in Hollywood. For decades, acting gigs were few and far between, so to survive, he started a collection agency and later became successful as a real estate speculator. In a late-'60s improv class, Molinaro met Penny Marshall, whose brother, Garry, attended one of their performances. The producer was impressed enough to cast Molinaro as Murray the Cop in his 1970 TV adaptation of *The Odd Couple*. Molinaro would play Murray in seventy-three episodes. Molinaro slipped into Pat Morita's apron as the new owner of Arnold's Drive-In in *Happy Days*' fifth season.

Creator and executive producer **Garry Marshall**, born Garry Masciarelli in 1934, was by the mid-1950s hustling jokes to comics and columnists. He received a

fiery initiation into television when, in 1960, he joined the writing staff of *The Tonight Show* under the heel of host Jack Paar, after which he headed west and teamed up with Jerry Belson. The pair landed a succession of jobs on series including *The Lucy Show* and *Make Room for Daddy*, for producers Danny Thomas and Sheldon Leonard, which led to their becoming story editors on the producers' legendary *Dick Van Dyke Show*.

In 1966, Marshall and Belson sold their first series, *Hey, Landlord*. Unfortunately, it was a flop. Marshall then suffered several more failed efforts, until Marshall and Belson struck pay dirt with their 1970 TV version of Neil Simon's play *The Odd Couple*, which ran for five seasons and earned its stars, Jack Klugman and Tony Randall, multiple Emmy Awards for their performances as mismatched roommates. The writers' partnership ended when Belson, who preferred comedy with a harder edge than Marshall, declined to participate in *Happy Days*.

Director **Jerry Paris**, the chef who brought *Happy Days* to a boil for 237 of the series' 255 episodes, was born in

San Francisco and trained at the Actors Studio while a student at New York University. He would find early success acting in films such as *The Wild One* (1953) and *The Caine Mutiny* (1954). He appeared opposite Ernest Borgnine in 1955's *Marty*, which won four Academy Awards, including Best Picture, and the Palme d'Or in Cannes. Paris then joined Eliot Ness in battling the Chicago mob on *The Untouchables* for two seasons. Paris found a forum to display his comedy chops when he was cast as dentist Dr. Jerry Helper on *The Dick Van Dyke Show* (1961–1966).

For two years, Paris begged creator and executive producer Carl Reiner to let him direct an episode. Finally, Reiner relented. Paris would go on to direct eighty-four episodes of the show and win the 1964 Emmy Award for Outstanding Directorial Achievement in Comedy. After the Van Dyke show, Paris continued to collaborate with Garry Marshall and Jerry Belson on *Hey, Landlord*, *Sheriff Who*, *Evil Roy Slade*, and *The Odd Couple*, and he directed the pair's first two features, *How Sweet It Is!* (1968) and *The Grasshopper* (1970). Other directing credits include the pilot for *The Partridge Family* and the 1968 Jerry Lewis film *Don't Raise the Bridge, Lower the River*.

Happy Days was set in Milwaukee because it was where executive producer **Thomas L. Miller** grew up. In fact, Arnold's was a stand-in for Miller's high school hangout, The Milky Way Drive-In. After graduating from the University of Wisconsin in 1961, he headed to Los Angeles to break into the entertainment industry. Luckily, Miller found an incredible mentor in the legendary director Billy Wilder. Miller served as dialogue coach on four Wilder films, including *Some Like It Hot* (1959). In 2001, the film was named the top comedy of all time by the American Film Institute.

Miller then became a junior executive at 20th Century Fox Television, before taking over as head of television development for Paramount. He was such a champion of *New Family in Town* that Garry Marshall promised him that if it sold, Miller would be his partner. In the two years before *Happy Days* became a reality, Miller formed a producing partnership with **Edward "Eddie" Milkis**.

Eddie Milkis was born in Los Angeles and began his career in ABC's film shipping department and soon rose to become an assistant editor on Alfred Hitchcock's *North by Northwest* (1959) and MGM's *The Time Machine* (1960). With Milkis's background in visual effects, in 1966 Gene Roddenberry beamed Milkis aboard the Starship Enterprise as the original *Star Trek*'s associate producer. And when the Enterprise was dry-docked in 1969, Milkis was named postproduction supervisor for the entire studio. Milkis then joined forces with Tom Miller, and the pair produced a string of movies for television, including *The Devil's Daughter* (1973), with Shelley Winters, written by Colin Higgins, who would go on to write the pair's first two theatrical features, *Silver Streak* (1976) and *Foul Play* (1978).

Like almost every television series, when its various ingredients are first mixed together, one never knows if the combination will be inert, harmonious, or just explode. In the case of *Happy Days*, the formula produced the rarest of results: lightning in a bottle.

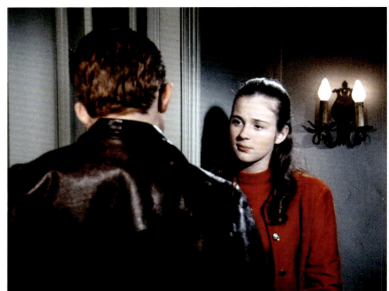

NEW FAMILY IN TOWN

Happy Days was born in the middle of a snowstorm in Newark, New Jersey, in 1971. Their flight to L.A. delayed, ABC wunderkind programmer Michael Eisner and Paramount development executive Tom Miller began talking about television shows that were no longer on the air, sharing fond memories of *Father Knows Best*, *Leave It to Beaver*, and *Mama*. *Mama* was the television adaptation of the 1948 George Stevens film *I Remember Mama*, starring Irene Dunne as the sunny matriarch of a large Norwegian family in 1930s San Francisco, as seen through the eyes of her teenage daughter. Miller thought the concept could be updated to the era he grew up in: the 1950s.

Upon his return to Los Angeles, Miller's first call was to writer-producer Garry

Marshall. Beyond being executive producer of the turbulent series *The Odd Couple*, he was about to launch *The Little People* (later known as *The Brian Keith Show*). It was a gentle series about a father-daughter team of pediatricians in Hawaii, featuring Shelley Fabares (*The Donna Reed Show*). Armed with the knowledge that the impetus came from the network's head of programming, Marshall jumped on board. The project was given the working title *New Family In Town*.

However, there was one hurdle. Marshall would later recall, "They wanted characters named Lars and Nels . . . I didn't know how to write for guys named Lars and Nels." But Marshall loved the idea of setting a show in the era in which he, too, had come of age. So Marshall steered the concept to a middle-class family living in Middle America in the middle of the twentieth century.

Marshall's script centered on the family of Marion and Howard Cunningham, the

> **"THEY WANTED CHARACTERS NAMED LARS AND NELS . . . I DIDN'T KNOW HOW TO WRITE FOR GUYS NAMED LARS AND NELS."**
>
> —*GARRY MARSHALL*

OPPOSITE: Richie Cunningham fails terribly in his attempt to score a goodnight kiss with date Arlene Nestrock (Tannis G. Montgomery).

LEFT: The Production Draft of *Happy Days* original 1971 pilot episode.

RIGHT: After the original pilot failed to sell, it was aired as a segment on Paramount's long-running anthology series, *Love, American Style*.

OPPOSITE: The original Cunningham family: Harold Gould as Howard, Ron Howard as Richie, Marion Ross as Marion, and Susan Neher as Joanie pay close attention to the operating instructions for their first television set, from technician Billy Sands (*The Phil Silvers Show*).

owners of a hardware store and parents of hormone-driven high school sophomore Richie, college basketball star Chuck, and their little sister, Joanie. The story followed Richie's vain pursuit of a "stacked" girl, Arlene Nestrock, using as bait the fact that the Cunninghams were the first family on their block to have a TV set. Richie learns a lesson, as he would for many years to come, about the nature of the opposite sex. Marshall's pilot script was among the best work of his career. The writing was beautifully constructed, with multiple storylines dovetailing as Richie sacrifices his best friend for a shot with his dream girl—who, Richie eventually finds out, already has a steady boyfriend and is just using him for his television. In the end, as in the classic sitcoms that Eisner and Miller had recalled, the brokenhearted son is comforted by his knowing father.

ABC loved the script and rushed *New Family In Town* into production. Veteran director Gary Nelson, who'd worked with both Marshall and Ron Howard, was brought on to helm the pilot. Mildred Gusse, who supervised all casting for Paramount TV, was tasked with finding the Cunninghams. The producers began their search by targeting seventeen-year-old Ronny Howard.

At the time, Ron Howard's most recent role was as the middle child of screen legend Henry Fonda on *The Smith Family*. The ABC show, about the family of a police detective, had just been canceled, and it was not a positive experience for Howard. In fact, it made him doubt his desire to continue acting. Howard recalled, "So as depressing as it was to work on a mediocre, going-nowhere show—I came out of *The Smith Family* super charged to chase my dream, and become a film director." His co-star Fonda encouraged him to "go for it!" and gifted Howard several books on great

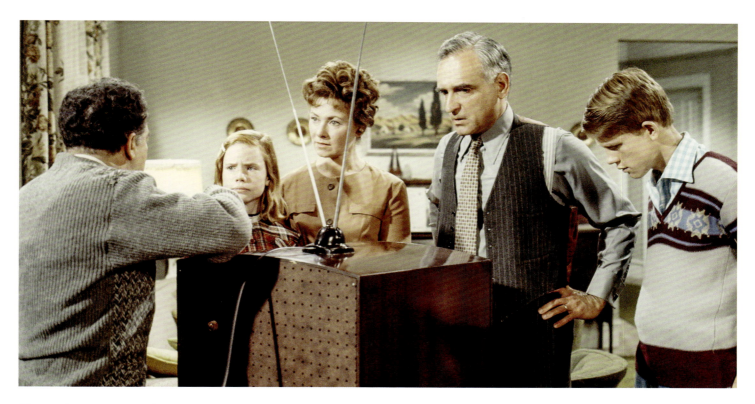

filmmakers. Howard proceeded to apply to the highly respected film school of the University of Southern California.

But when Howard received an offer for the pilot, he liked the idea of "being the bona fide lead of a television show. I hoped to hold down the center like Andy [Griffith] did on his show." Howard had an ulterior motive as well. At the time, the war in Vietnam was raging, and in 1969 a draft lottery was instituted. The Selective Service had ended student deferments the year before, and Howard turned eighteen, the age of draft eligibility, on March 1, 1971. He was saddled with a low draft number, forty-one, low enough to essentially guarantee that he would be drafted. Howard says, "I didn't know what to do, but knew I didn't want to go into the military, I didn't want to go to Canada, I was already in love with Cheryl, and I wanted to go to USC . . . So I actually thought, 'Huh, this is a good script and a good part,' and I had a feeling that ABC and [Paramount's parent company] Gulf and Western would find a way to keep me out, put me in the reserves or something." And so Howard signed on to the pilot, which sported a new title: COOL.

In 1969, Marion Ross was determined to reestablish her acting career, and caught a lucky break when she was cast as Joan Myers, a passenger on a perilous flight in the star-studded 1970 hit film *Airport*. During the entire shoot, her seatmate was Sandra Gould, best known as Gladys Kravitz on *Bewitched*. The two became fast friends. At a dinner party at Gould's house the following year, Ross found herself sitting next to casting director Mildred Gusse. Over dessert, Gusse mentioned she had "a role you may be perfect for"—and indeed Ross was.

Rounding out the Cunninghams were Susan Neher as Joanie and Ric Carrott,

LEFT: Richie loses his best friend Potsie when he chooses Arlene Nestrock for the Cunningham's viewing party.

the first of three actors to play the thankless role of Chuck Cunningham. For Howard Cunningham, former Cornell University alumnus and drama teacher, Harold Gould landed the role.

But one very important role wouldn't be cast until the very last second. At twenty-two years old, with his boyish looks and megawatt smile, Anson Williams still could easily pass for a high school student. The search for Potsie Weber had gone on for weeks with the producers passing on several seasoned performers, among them a young Richard Dreyfuss, before word trickled down to Williams. He set off to his audition in his "really crappy" car in a torrential downpour.

Miles from his destination, the car's water pump failed. Williams was certain he'd blown the opportunity but decided not to throw in the towel. The rain-drenched Williams arrived four hours late. When he finally arrived, Mildred Gusse called out, "He's lucky we haven't cast a Potsie yet." With a cigarette dangling from her lip, Gusse read with Williams. She then told him to stay put. From the next room, Williams heard Gusse holler, "I don't care if you're busy, get down here, he's perfect." Soon, "This tired, wet man, Garry Marshall, shuffled in." Williams again read with Gusse. Marshall was quiet for a moment, then asked a surprising question: "Do you play softball?" "Yeah, I play." "Are you good?" "Yeah, I'm pretty damn good." With that, Williams was sent to another room where, twenty minutes later, in walked Ron Howard, who was on the lot for a wardrobe fitting. Howard said, "Oh, hey, we're supposed to read together."

"Reading with Ron," Williams recalls, "he was so cool and confident, he made me comfortable." The pair rehearsed, and soon Williams was surprised to see a parade of "suits" arrive. ABC and Paramount executives had been summoned to approve Williams as Warren "Potsie" Weber . . . but at the end of the audition, all Williams received was a "Thanks for coming in."

Williams was disappointed and felt he'd wasted his time, until he arrived at his apartment to find the phone ringing, and his agent gave him the news that he'd gotten the part and was to report to the studio at 6 a.m. the following morning which turned out to be the first day of shooting.

Production began in mid-April of 1971. By all accounts the filming was relaxed, and Ron Howard immediately bonded with Anson Williams and Marion Ross. In fact, Ross was the first person with whom Howard proudly shared his letter of acceptance from USC's film school.

The pilot episode's opening sequence seemed more like it was set in the 1940s than the '50s, with a Glenn Miller–esque score, dissolving through black-and-white images of Harry Truman and Rita Hayworth, before landing on an Ike/Nixon campaign button. Richie Cunningham then exchanges his scuffed gym shoes for a pair of penny loafers, while offering gentle voiceover narration.

"It's pretty hard to be sixteen and growing up. Maybe it was easier when my parents were young, but now it's the 1950s . . . and the world is really getting complicated."

The pilot's storyline featured the Cunninghams' plans for a gala viewing

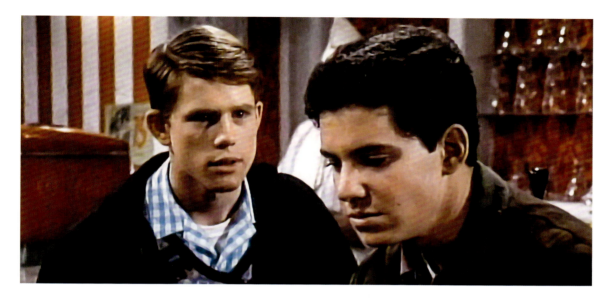

party to celebrate being the first on their block to acquire a television set. Richie and Joanie are allowed to invite one guest each. Richie creates a riff with his best friend, Potsie, when he chooses to invite his crush, a girl named Arlene Nestrock, rather than his pal. The Cunninghams' living room is jam-packed for the big night, the guests including Robert DoQui and Jackie Coogan, post–*The Addams Family*. The entire affair quickly unraveled as reception on the new TV's tiny screen remained horrible no matter how Mr. Cunningham desperately tried to manipulate the "rabbit ears."

> **FROM THE NEXT ROOM, WILLIAMS HEARD [CASTING DIRECTOR, MILDRED] GUSSE HOLLER, "I DON'T CARE IF YOU'RE BUSY, GET DOWN HERE, HE'S PERFECT."**

However, the show's centerpiece was Richie doing everything in his power to secure a good-night kiss at Arlene's door, only to be foiled by her mother, then accidentally and repeatedly ringing the doorbell and, finally, leaning against and falling through the unlocked door. Richie's dreams are truly shattered when Arlene's boyfriend picks her up for their "late date."

After this heartbreak, Richie agonizes over having pushed aside his best buddy for a girl, but Potsie forgives him, stating, "When it comes to chicks, all's fair . . . and I woulda done the same thing." Richie and his dad, Howard, share a moment while playing "sock" basketball as Howard recounts his surprising history of being dumped. Howard adds, "Richard, you got hurt tonight, but *hurt* can teach you a lesson." "To not get hurt?" asks Richie. "No, it teaches you that you can live with hurt." The pilot ends with Richie and Howard standing, hands over their hearts, while Kate Smith sings "God Bless America" as the TV station signs off . . . until 7 o'clock the next evening.

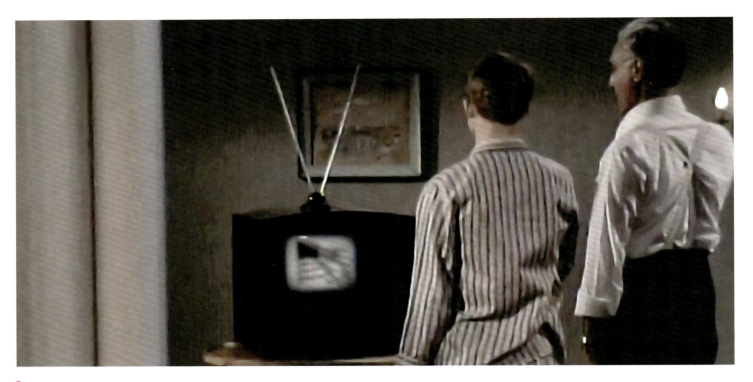

ABOVE: Hands over hearts, Richie and his father listen to Kate Smith singing "America the Beautiful" before the TV station signs off for the night.

OPPOSITE: A screen-worn Jefferson high-letter sweater.

COOL was truly a throwback. It was nostalgic, sweet, and filled with genial humor, never looking for a knockout punch. The performances were low-key and solid, particularly Ron Howard's. After years of watching his TV fathers, Andy Griffith and Henry Fonda, carry the story from scene to scene, it seemed second nature to him. Anson Williams exuded confidence, and originally Potsie's character was far more worldly than he would be in later years, when Fonzie became more and more Richie's guiding light. On the other hand, Marion Ross's cheerful and sweet character emerged fully formed on day one and remained that way for over four thousand more.

Test audiences weren't floored by the title, *COOL*, and it was Tom Miller who came up with its replacement, *The Happy Days*. Despite its many charms, ABC passed on the show. Ron Howard wasn't completely disappointed, saying, "I didn't really care. It was a good script, a good show, and Garry was great—but I was going to USC . . . then I got *American Graffiti*." To recoup its losses, Paramount played off the pilot as a twenty-minute segment on its anthology series *Love, American Style*. The military draft lottery that weighed so heavily on Ron Howard officially ended in 1973, and Howard never even had to take a physical. *The Happy Day*s continued to gather dust—until *American Graffiti* became the most profitable film of 1973.

> **TEST AUDIENCES WEREN'T FLOORED BY THE TITLE, *COOL*, AND IT WAS TOM MILLER WHO CAME UP WITH ITS REPLACEMENT, *THE HAPPY DAYS*.**

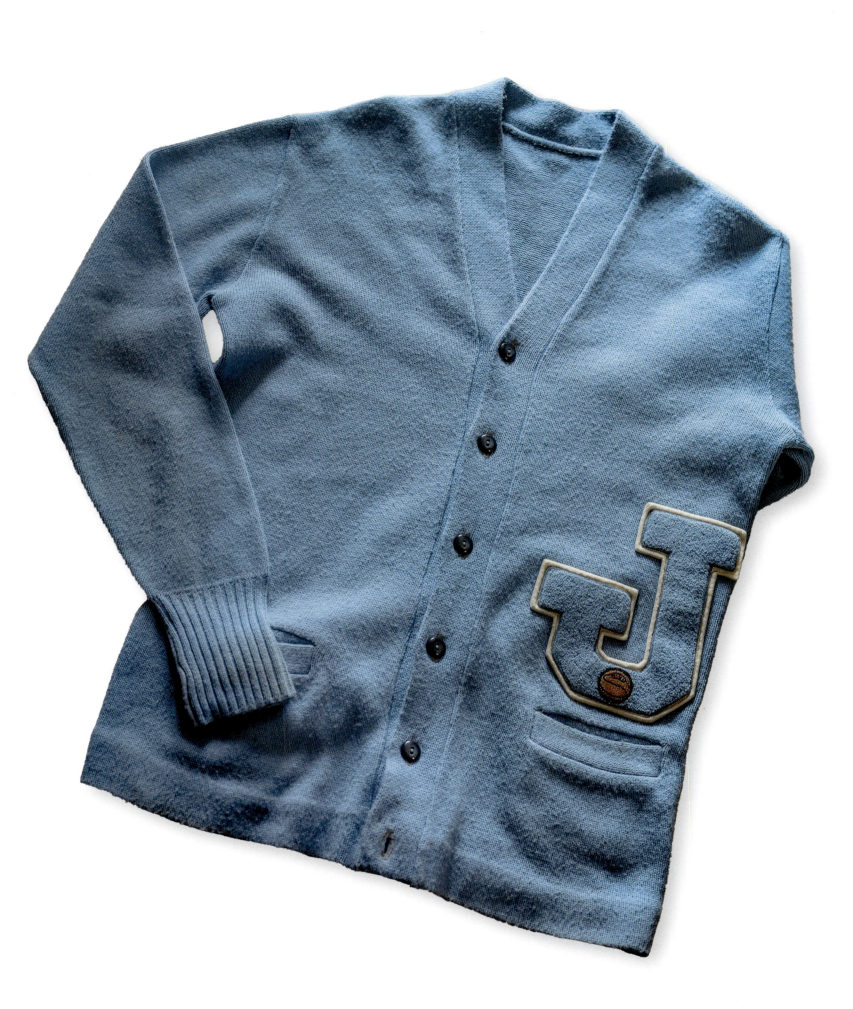

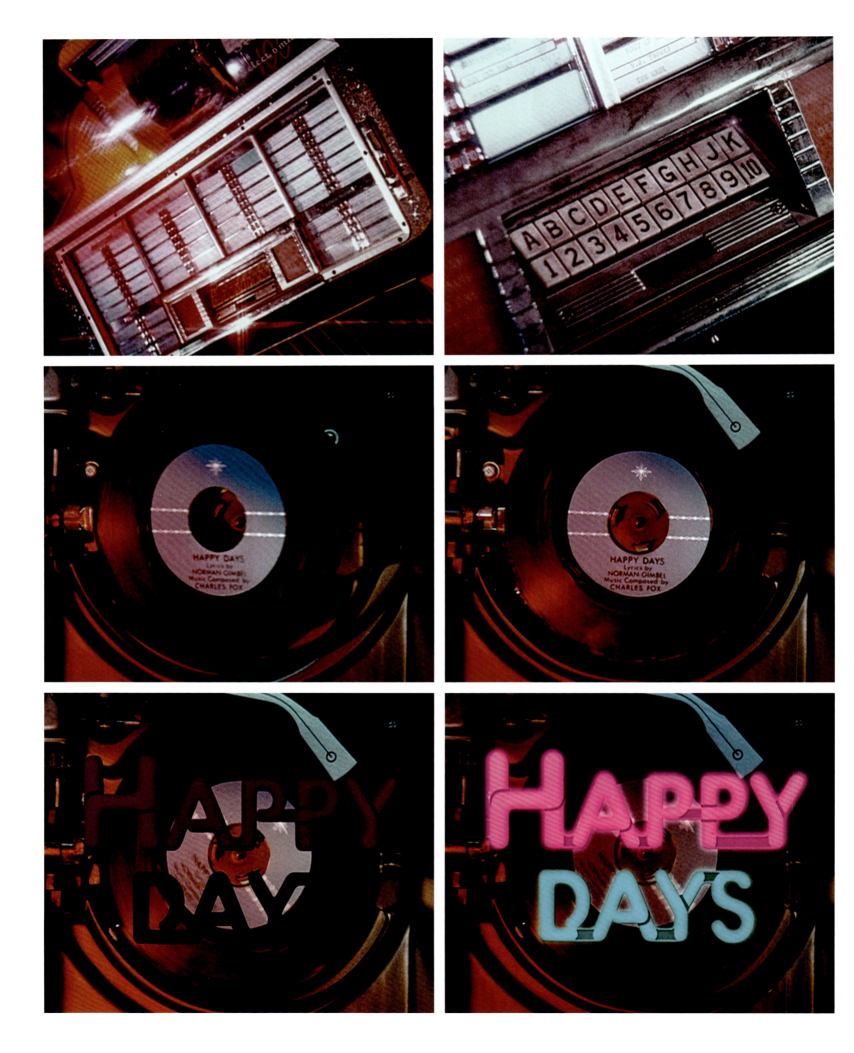

SEASON ONE

It's hard to believe that every studio initially passed on financing *American Graffiti*. Despite the film's low budget and the stature of its producer, Francis Ford Coppola, who mere months earlier won the Oscar for Best Picture for *The Godfather*, studios were reluctant to trust its young director and co-screenwriter, George Lucas. Finally, Universal's Ned Tanen picked up the project, figuring that the sales of a '50s-era soundtrack album for the studio-owned Universal Records (that he'd founded) would cover any losses.

When *American Graffiti* finally received its green light, casting director Fred Roos knew exactly where to begin when casting the lead role of college-bound Steve Bolander. Roos had cut his teeth casting *The Andy Griffith Show*, which had starred Ron Howard. And, at the time, Roos was partnered with Garry Marshall in the talent agency Compass Management. So, Roos screened the original *Happy Days* pilot for George Lucas. And though Lucas was impressed with Howard, the actor had to endure six auditions over several months before he won the part. Howard then spent his final summer before film school in Petaluma, California, shooting all-nighters and "learning more about USC, talking to George Lucas and shadowing him through the entire shoot."

The film, which cost less than a million dollars, grossed $140 million. *American Graffiti*'s two-disc soundtrack album went double platinum. The movie's massive success reverberated throughout the industry—especially in network offices, where executives scrambled to find a retro, youth-driven project. According to Ron Howard, when the news of the search reached Garry Marshall, he called ABC and reminded them that "you already

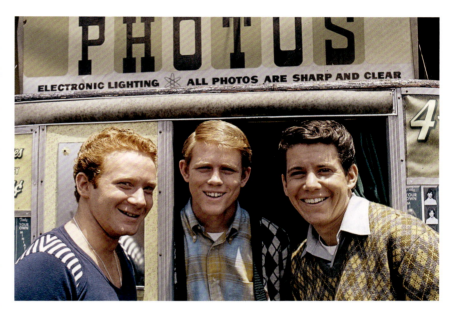

ABOVE: Don Most wistfully looks back on the first season. "Shooting at night at the drive-in, sooo much fun."

OPPOSITE: For 11 seasons, the jukebox spun the show's theme song.

> **[MARSHALL] CALLED ABC AND REMINDED THEM THAT "YOU ALREADY MADE THAT SHOW, WITH THE KID WHO'S IN THE MOVIE!"**
>
> —RON HOWARD

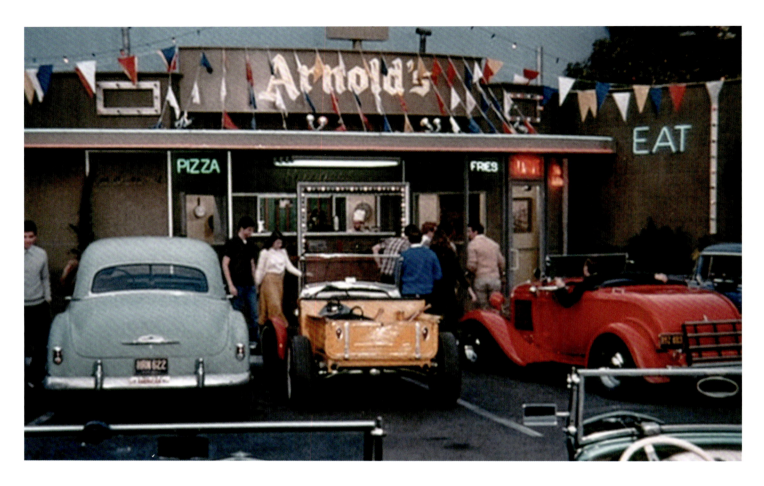

made that show, with the kid who's in the movie!" ABC ordered a new pilot script.

With two series on the air, Marshall split writing duties with his then brother-in-law, Rob Reiner, and partner Phil Mishkin. At the time, Reiner was starring on TV's top show, All in the Family, and had sold his first series, the short-lived The Super. Their script, like the original and virtually every other story in the initial run, centered on Richie and his pals trying to win dates with "chicks." ABC, desperate to capitalize on the American Graffiti phenomenon, rushed the pilot into production, and a problem surfaced immediately. Garry Marshall wanted Ron Howard and Anson Williams to reprise their roles, but the network felt that the pair were simply too old to play high school sophomores.

Ron Howard remembers that "they insisted on me auditioning again . . . and it really pissed me off. I didn't say anything, that's the rules and it's OK." Williams was equally surprised, but said, "OK, whatever." Howard and Williams were reunited at a wardrobe fitting the day before their screen test. Learning that they'd be

> "WE STARTED HEARING THE BUZZ THAT RON HOWARD'S TESTING. WE WERE INTIMIDATED."
>
> —DON MOST

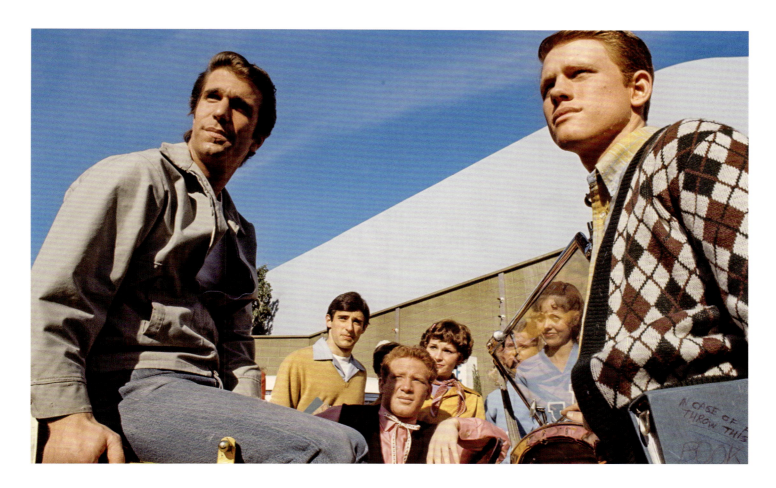

auditioning together, Howard proposed that they rehearse together, because they wouldn't be given a lot of time for their screen test. According to Williams, Howard said, " 'I suggest we find where the scene will be shot and we work it out, and then tomorrow, we'll make it look like it's all original, like we made it up on the spot. Like we're really creative.' So we rehearsed, and the next morning we show up—and we didn't realize there would be all these other people trying out."

Don Most also tested for the role of Potsie that day and recalls his excitement when showing up for his screen test: driving on the lot, sitting in the hair and makeup chairs, and being wardrobed in cuffed jeans and a letterman's jacket. "I was psyched until I turn the corner . . . and there's ten other guys in letterman's jackets. Most got wind that they had some serious competition. "We started hearing the buzz that Ron Howard's testing. We were intimidated." Among those vying for the part of Richie were Barry Miller (*Saturday Night Fever*) and a young up-and-comer with dreamy blue eyes, Robby Benson (*One on One*).

Garry Marshall personally directed the screen tests. The material was an updated version of a scene Howard and Williams had performed in the original pilot. They went first. Howard recalls, "Garry gave us like three hours for our scene, and the rest of them, Robby Benson and all, were shuffled in and out." When they finished shooting, the pair confidently walked past their competitors. According to

OPPOSITE: Arnold's Drive-In was constructed on Paramount's backlot and its atmosphere was steeped in period fashion, music, and cool cars.

ABOVE: The biggest battles between the producers and the studio were over Fonzie's hair and wearing a leather jacket.

PAGES 46–47: Fifty years after meeting at *Happy Days*' first script reading, Henry Winkler says of his castmates, "They are my friends, they are my family."

Season One 45

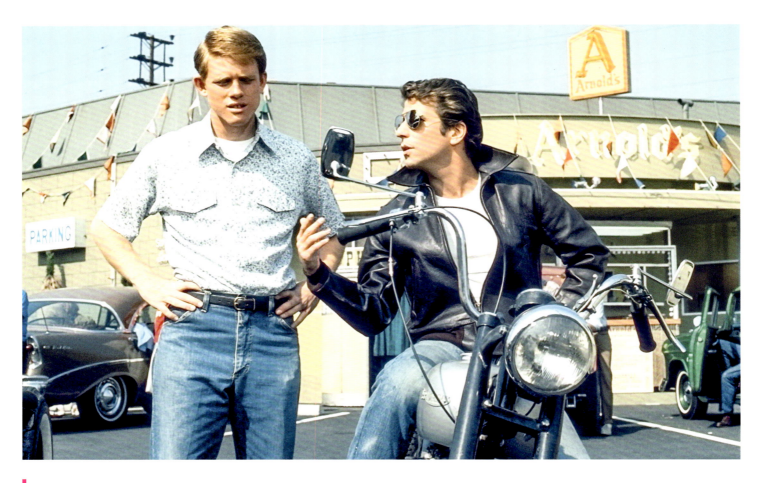

ABOVE: The conflict with ABC about Fonzi's leather jacket was finally resolved as long as he was astride his motorcycle.

OPPOSITE: The cast became aware of the growing wave of "Fonzie-mania" when the four boys went out on a publicity tour following the first season and encountered thousands of screaming fans.

Howard, "Garry gave us every chance to win it." As the day dragged on, Most grew discouraged. "So, by the time they finally got to me, I was feeling so deflated, like I had no chance in hell. I lost all the angst and tension . . . and maybe it worked for me." It certainly did, as ABC's Michael Eisner took a shining to Don Most and suggested they make him part of the ensemble—and the wisecracking Ralph Malph was born.

ABC wanted to inject the same element of danger that Paul Le Mat's drag racing character brought to *American Graffiti* and asked for a motorcycle gang to be part of the show. Always conscious of budget, Marshall whittled the notion down to a single character. The new script introduced a six-foot-two Italian terror, Arthur Fonzarelli, better known as The Fonz . . . but in auditions, the actor who took the producer's breath away was far less imposing. Henry Winkler brought authority and a restrained sense of menace to the role despite his small stature. But, in the words of executive producer Tom Miller, "He made you feel that he was six

> "THIS GUY'S LIKE A PACINO, A DUSTIN HOFFMAN . . . HE JUST TOOK OVER THE ROOM."
>
> —TOM MILLER

feet tall." Winkler's audition remains fresh in his mind. He walked into the room, surveyed his competition, including Micky Dolenz, star of television's answer to the Beatles, *The Monkees*. Winkler thought, "All these people are on TV . . . and *me*."

When his turn came, Winkler entered the room to find Mildred Gusse, the three executive producers, and "a million other people." In that moment, Winkler surprised himself and everyone else. "I don't know where I got the nerve, but I changed my voice." Winkler dropped his velvety, Ivy League voice, and replaced it with a deeper one, a voice marinated in asphalt and tinged with authority. With this new persona emerging, Winkler bantered with the "suits." "Hey, Pasquale, siddown . . . you behind the desk, you're a-dorable. Hey, whattaya lookin' at?" When Winkler finally finished the scene, he tossed the script in the air and sauntered out the door.

Tom Miller would later tell Ron Howard that their casting choice for Fonzie was far from stereotypical: "This guy's like a Pacino, a Dustin Hoffman . . . He just took over the room." With a few days left in the one-month deadline Winkler gave himself to establish a career in Hollywood, he landed the role that would change his life, and so many others.

ABC agreed to stick with Howard and Williams. The network also concurred that Marion Ross should continue as the series' mom and wanted Harold Gould to reprise the part of Howard Cunningham. However, Gould was unavailable, acting in a play in the U.K. Gould was saved from being an answer to a trivia question when, later that year, he grew a mustache and began a four-year run as Rhoda

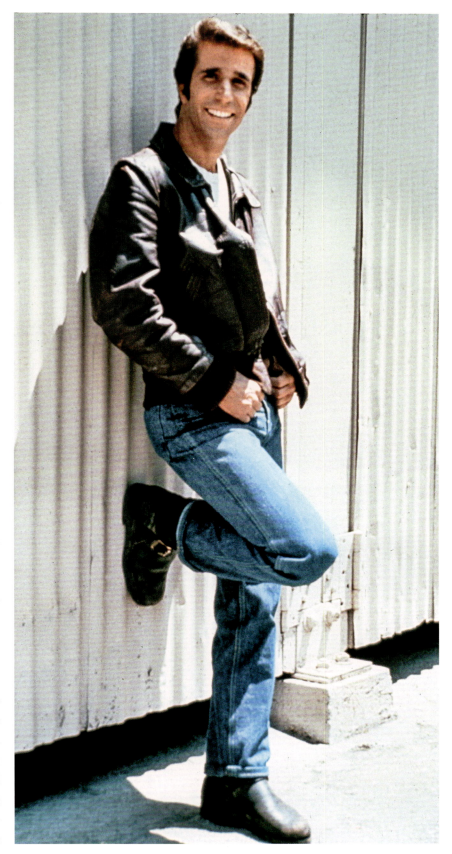

ABOVE: It took a while for Marion Ross and Tom Bosley to be as compatible offstage as on.

OPPOSITE: A full set of Palmer Hobbies' *Happy Days* model car kits.

Morgenstern's father on the hit *Mary Tyler Moore Show* spin-off *Rhoda*. Bright-eyed Erin Moran was cast as Richie's tattletale baby sister, Joanie, but the family still had a seat to fill at the head of the table.

Tony Award–winner Tom Bosley had originally wanted to be a sports announcer but began acting during college in his native Chicago. He moved between the stage and television, making guest shots as villains or blackmail victims, with a season performing sketches on *The Dean Martin Show* before landing his first comedy series, *The Sandy Duncan Show*. When that show, which was also produced by Paramount Television, was canceled after thirteen episodes, Mildred Gusse approached Bosley about *Happy Days*. After such a major disappointment, the actor was reluctant to just jump aboard the first thing that came along. But after meeting with Garry Marshall, and rereading the script, Bosley was touched by the father-son relationship and agreed to sign on.

The new pilot was shot in early October 1973 under the direction of Mel Ferber. Ferber had helmed eleven episodes of *The Odd Couple* and, like Gary Nelson, was a calm, veteran presence. That dynamic would change dramatically after the show was picked up and Marshall's longtime collaborator, Director Jerry Paris, hit the stage. Paris,

an emotionally volatile ball of comedic energy, would go on to direct all but four of Season One's episodes.

Titled "All the Way," the pilot was shot on the Paramount lot and on location at Arthur's Restaurant, a genuine '50s drive-in in Burbank. The towering, famous, rotating giant neon "A" was mounted on the roof of the circular building. When the series sold, the name of the diner was changed to Arnold's and the drive-in and a facsimile of the sign were erected on the backlot.

The entire first season was colorful, fun, and a nostalgic treat. The cars, the clothes, the hairdos—everything felt authentic. Pulsating with classic rock 'n' roll and a crowded dance floor, the show radiated a youthful energy.

Anson Williams and Don Most became as good of friends as their characters on the show were, and the two remain very close, even today. Ron Howard and Henry Winkler developed "an instant chemistry." Howard has remarked that, in those days, the show was "far from fully formed," but Winkler seemed to have his role down pat from the start. His Fonzie didn't speak a word for the first twenty-five pages of the script, but still managed to exude a foreboding presence. According to Howard, "You could feel it in the reading. I'm not kidding. I'm not saying that after the fact—you could feel it right away. He was so fun to act with from the beginning. Henry was an artist who was not only inventive but viewed the world from a very creative place."

Don Most, hoping to soak up as much knowledge as possible, spent as much time as he could on set. Early on, he witnessed a contentious debate between

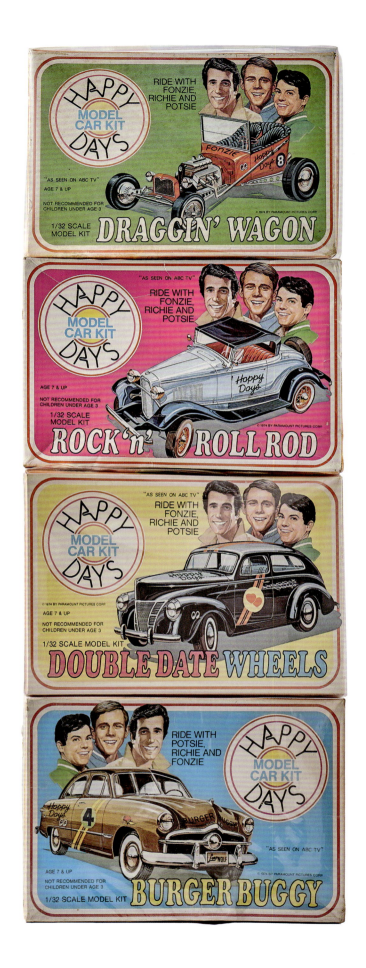

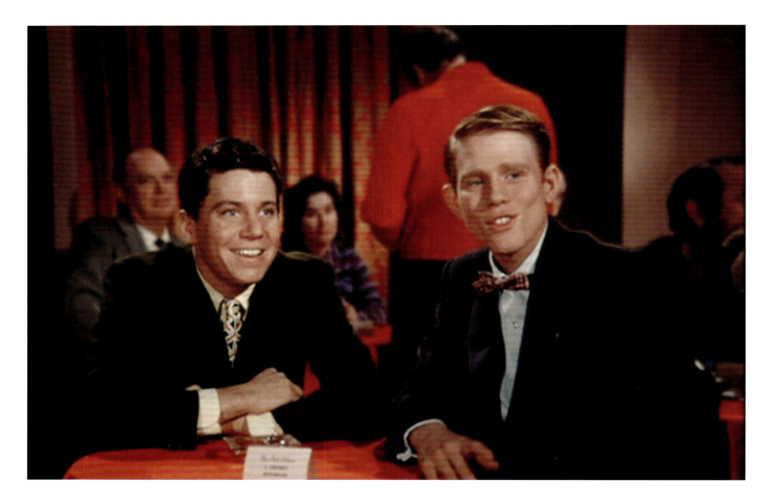

ABOVE:
In Episode 9, "The Skin Game" Fonzie gets Richie and Potsie fake IDs to attend their first burlesque performance only to find Howard Cunningham is also in the audience.

OPPOSITE:
Episode 1, "All the Way," Winkler's spontaneous choice to not comb his hair instantly defined the character.

Winkler and Director Mel Ferber, one that would prove to be impactful. The script called for Fonzie to look in the mirror and comb his hair. Most recalls, "Henry said, 'I can't do that.' Mel said, 'What?' And Henry said, 'It's a cliché. Every character like this has always done that.' Ferber said they had a scene to shoot and what were they supposed to do? Winkler responded, 'I don't know, let's see what happens.'" When the cameras began to roll, The Fonz takes out his comb, looks in the mirror—sees only perfection and basks in it for a moment, smiles in approval, then exits. The move helped to instantly define Fonzie's character, and a version of this action would be repeated in the main title for eleven seasons.

The second pilot wrapped production, was rushed through postproduction, and was previewed for a test audience just three weeks later. *Happy Days*' main title sequence was a compilation of gags and moments from the show, and because the Charles Fox and Norman Gimbel–penned theme song hadn't been recorded yet, they substituted Bill Haley & His Comets' pounding 1954 hit "Rock Around the Clock." Each preview audience member held a dial that they would turn to express their likes and dislikes.

By the time Haley hit "9 o'clock rock," the dials spiked and remained high throughout. *The Happy Days* was back! Though, like The Batman and The Facebook, it soon lost the "The" in its title.

Garry Marshall's next move was to get Paramount to pay for five additional scripts so they'd be prepared if they were to go to air. To supervise the writing, Marshall turned to twenty-six-year-old William S. Bickley. The Texas-born Bickley's first job in Hollywood was reading scripts for Tom Miller. He had also written two episodes for Marshall's *The Odd Couple*, and another for Belson and Marshall's TV adaptation of playwright Neil Simon's *Barefoot in the Park*. The only problem was that Bickley was still under contract to Columbia Pictures, producing *The Partridge Family*. Bickley was told, "We'll take care of it," and was soon burning the midnight oil behind Paramount's iconic gates. But Bickley had reservations. "I'd never run a show. Why did they put me in charge of the show? It was because nobody thought it was going to work." Garry Marshall's wife, Barbara, concurs, "I think Garry was so involved with *Odd Couple* he didn't think about *Happy Days* because he didn't think it was going anywhere."

Assisting Bickley was Bob Brunner. Brunner and Marshall had first met as copyboys at the *New York Daily News*. Brunner had gone on to work as a publicist, his clients included Louis Armstrong and Tony Bennett. He also sold jokes to columnists like Walter Winchell, before Marshall brought him out to Los Angeles to work on *The Odd Couple*. Brunner and Marshall developed Fonzie together. Brunner drew inspiration from a guy in his old neighborhood named Fonzarelli, who had dropped out of high school years before, but still hung with the underclassmen. Brunner would become *Happy Days*' story consultant alongside

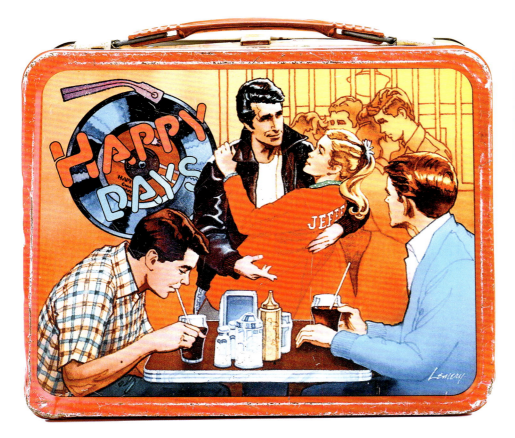

ABOVE: Only the coolest kids had the *Happy Days* lunchbox from King Seeley, illustrated by noted commercial illustrator Gene Lemery.

OPPOSITE: All during the first season, Ron Howard continued taking classes at the University of Southern California's school of cinema.

future *Cosby Show* co-creator Michael Leeson. Bickley and Brunner wrote or supervised five new scripts . . . and the ink was barely dry on them when the show was picked up. The cast was notified the day after Thanksgiving, and *Happy Days* was rushed into production on December 3, 1973.

The series almost literally stumbled out of the gate. On the first morning of production, producer Bill Bickley arrived early and headed to the set. The company began shooting an episode he and Bob Brunner wrote, titled "Richie's Cup Runneth Over." In the episode, Richie and Potsie attend their first bachelor party and play their first drinking game. The rules state that the losers down shot glasses of beer. Naturally, an inebriated Richie is driven home by the girl who popped out of the groom's cake at the party. When he returns home, his dad asks if there was alcohol involved in the festivities, and the tipsy Richie responds, "That's silly, all we had was some beer . . . in teeny-weeny glasses." Mr. C asks, "How many teeny-weeny glasses did you have?" Richie says he lost count at 72.

Bickley arrived on the set where they were filming their very first scene—the drinking game. Bickley watched take after take . . . and then became concerned. He took Director Jerry Paris aside and asked, "What are they drinking?" Paris answered, "Beer." "Real beer?" "Yes." "Jerry, it's 8 o'clock in the morning. Haven't you noticed that they look a little glassy-eyed?" The prop master was quickly sent off to get some Neer Beer.

From there, Season One's production barreled through sixteen episodes.

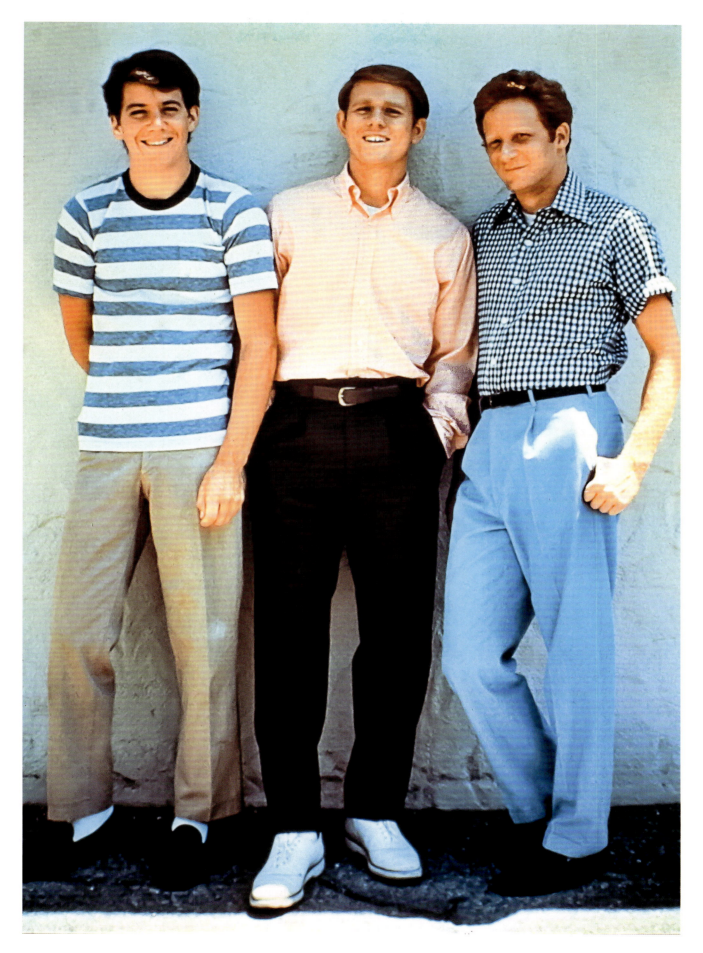

Season One 55

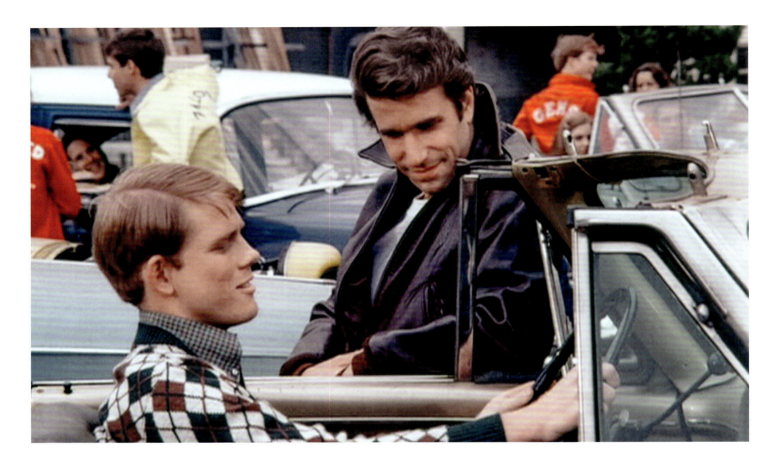

Except for two days off for Christmas, filming continued for eighty days straight. Money was always tight. Last-minute script revisions were constantly slipped under doors. The show's assistant director, responsible for all scheduling, died suddenly the night before the first day of shooting. Production became a constant scramble and, at one point, the company was forced to shoot two episodes over a five-day period. Still, the first-season episodes are glossy, funny, and warm.

Like *American Graffiti*, the series' jukebox was filled with period music thanks to contracts with artists like Fats Domino, Bobby Darin, Johnnie Ray, and Elvis Presley. Today, Don Most wistfully looks back on the first season: "Shooting at night at the drive-in, sooo much fun." During the first season, Garry Marshall was not a regular presence, but Tom Miller was. According to Ron Howard, Miller was "all over the pilot and very much there during production. He was very excited about what this series could be, he

> **"FIGHTING TO GET THE LEATHER JACKET ON FONZIE . . . I THINK [GARRY] FINALLY REALIZED THAT THIS FAMILY SHOW WAS WHERE IT WAS GOING TO BE AT."**
>
> —BARBARA MARSHALL

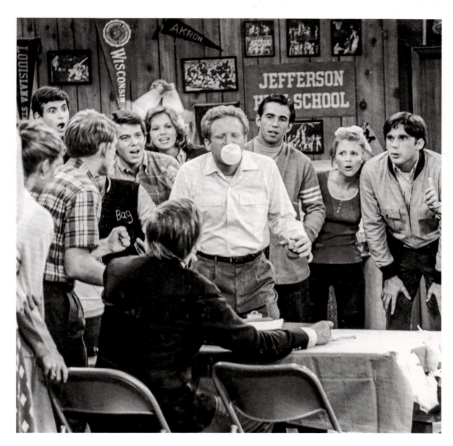

advocated for warmth and wanted it to be funny and safe." Despite the frenetic pace of shooting with each episode, the ensemble grew in confidence, and grew closer—with one surprising exception.

Tom Bosley and Marion Ross weren't nearly as harmonious a couple as they seemed onstage. Speaking candidly, Ross confides that at first, she and Bosley had "no chemistry at all," and he was "very difficult to work with" and always "a little bit rude and didn't want me to touch him." After working together for a while, though, Ross says, "eventually we became family."

Behind the scenes, the only other major conflicts were the battles with the network over Fonzie's hair and leather jacket. In the early episodes, Fonzie was clad in a T-shirt and beige windbreaker because ABC, which had first requested a motorcycle gang, completely flip-flopped and demanded that Fonzie lose the leather and the ducktail. When Marshall returned from production of *The Brian Keith Show* in Hawaii, he was not happy to see Fonzie in the windbreaker. The producer and network went back and forth for weeks before Marshall got the network to concede that leather jackets are worn by motorcycle riders for protection. According to Barbara Marshall, "I think fighting to get the leather jacket on Fonzie got Garry to be more interested in working on the show. I think he finally realized that this family show was where it was going to be at."

As a compromise, Fonzie was allowed to wear the jacket only when atop his bike, even if this meant bringing it into Arnold's.

OPPOSITE: "AAAAY," *Happy Days* concluded its first season as a top 20 show and the highest rated new series on television.

ABOVE: Though he failed to win the part of Potsie Weber, Don Most impressed the ABC brass, who requested they create a part for him.

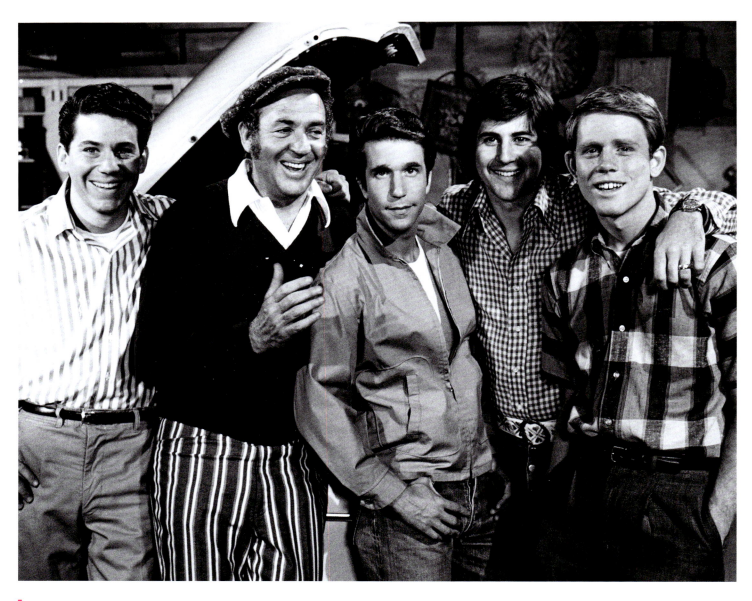

ABOVE:
On the set of Episode 3 "The Lemon" (L–R): Williams, Director Jerry Paris, Winkler, Producer William S. Bickley, Howard.

OPPOSITE:
In Episode 6, "The Deadly Dares," Richie and Potsie's fraternity initiation takes an awkward turn when Fonzie turns his charms on a "wallflower."

However, though The Fonz was often astride his bike, he was rarely seen actually riding his Harley. Despite numerous lessons, Winkler always looked unsteady in the saddle. As Bill Bickley explains, "Henry was just scared shitless of motorcycles."

Many hard-core fans of the show think the first season was the best, among them Tom Bosley and future cast member Scott Baio, who says, "My favorite episodes of Happy Days were [from] the very first year, the single-camera shows. I found the show so innocent, so damn charming, so beautiful." Highlights from the first season include "Fonzie Drops In," where The Fonz returns to Jefferson High and expects Richie to do his homework and cheat for him. In "Breaking Up Is Hard to Do," Richie has the most awkward prom date of all time—Arlene Holder, the girl he just broke up with. Baio cracks up describing his favorite first-season episode, "The Deadly Dares." "Fonzie asks Richie to dance while dressed as a girl to join a fraternity. He's blowing in her ear . . . it just doesn't get any better than that."

Season One 59

ABOVE: In their first group photoshoot the young cast exhibits their confidence and camaraderie.

OPPOSITE: The set photographer recorded the moment Howard inspected an advance copy of *Happy Days*' first cover story.

At 8:00 p.m. on Tuesday, January 15, 1974, ABC's *Happy Days* debuted opposite CBS's *Maude* and NBC's new Jack Webb series, *Chase*. *Happy Days* opened to a decent 7.5 rating and mixed reviews. The *New York Times* said, "The trouble with nostalgia was its dishonesty. And within the context of a situation comedy, it's more dishonest than usual." On the other hand, the *Philadelphia Inquirer*'s Lee Winfrey wrote, "I tuned in prepared to hate a show with characters named Potsie and Fonzie, but it didn't turn out that way." Audiences seemed to side with Winfrey and, as the season wore on, more and more viewers climbed on the bandwagon. *Happy Days* concluded its maiden voyage in impressive style, finishing as the 16th-most-watched show on the air, with more weekly viewers than even *The Carol Burnett Show* or *Monday Night Football*. The network picked *Happy Days* up for twenty-two more episodes, and everything looked very promising . . . until the next season began.

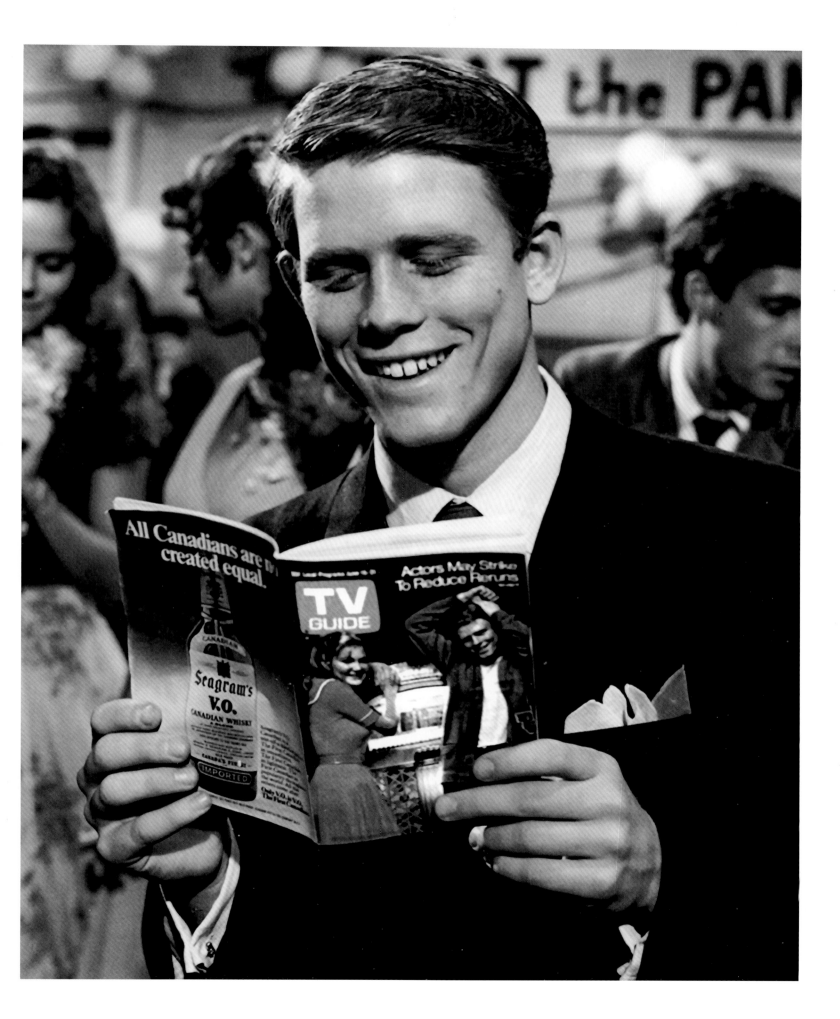

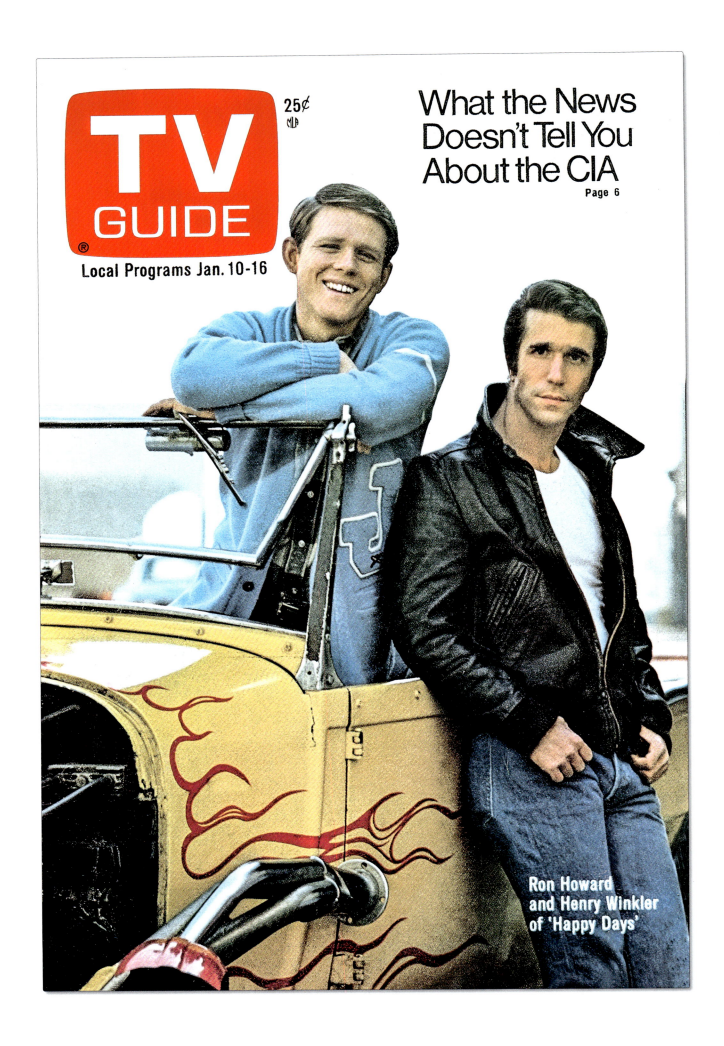

SEASON TWO

Late in the first season, producer Bill Bickley gathered the cast together, complimented them on becoming a hit, and said that it was time to buckle down and start becoming comfortable with one another because they would be together for a long time. Bickley couldn't have anticipated Jimmie Walker's sudden ascendance to stardom as "J.J." Evans on *Good Times*, *Happy Days*' time-slot rival. Nor could he have foreseen the negative impact it would have on the Cunningham clan.

In 1974 and 1975, viewers were forced to choose. They could tune in to *Happy Days* and find the Cunninghams navigating Ralph's Halloween party and the high school choral group's trip to Chicago. Or they could flip the dial to CBS's *Good Times*, where the Evans family struggled with, as Ja'net DuBois sang in their theme

OPPOSITE: Though Henry Winkler wasn't even listed in the Season One opening credits, by the second season, he was sharing the cover of *TV Guide* with his co-star, Ron Howard.

LEFT: In "Richie's Flip Side" Richie gets his own radio show, but almost loses his friends.

song, "keepin' your head above water" in a Chicago housing project. The two series virtually exchanged positions in the ratings as *Happy Days* went from sixteenth place to forty-eighth. Riding his popular catchphrase "Dy-no-mite," Jimmy Walker's rise to stardom forced *Happy Days* to take a desperate late-season measure to stave off cancellation.

But before that, the viewers who flocked to CBS missed a lot of fun. Most of the action centered on the lengths Richie would go to impress women. He incurs his father's wrath when he starts campaigning for Adlai Stevenson in the 1956 presidential election to win the affection of an attractive volunteer. When Richie, Ralph, and Potsie go "cruising for chicks," he ends up putting himself behind the wheel in a drag race. But he does get to

> **RIDING HIS POPULAR CATCHPHRASE "DY-NO-MITE," JIMMY WALKER'S RISE TO STARDOM FORCED HAPPY DAYS TO TAKE A DESPERATE LATE-SEASON MEASURE TO STAVE OFF CANCELLATION.**

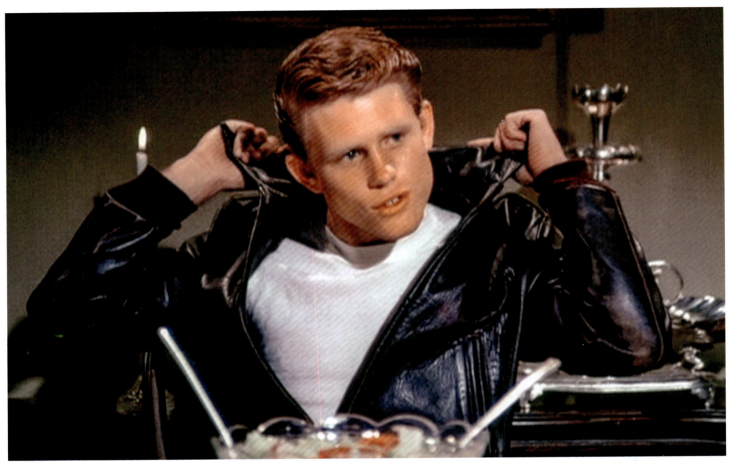

ABOVE: Incredibly, Richie lost a Howdy Doody lookalike contest...but with Fonzie's help, portrayed a convincing hood to discourage a former girlfriend.

OPPOSITE: One of the cast's early favorites, "Three on a Porch," the boys impersonate Tunisian businessmen to wow their college-age neighbors...and Fonzie's "powers" extend over the animal kingdom.

PAGES 66–67: *Happy Days* would give Tom Bosley and Marion Ross a level of success and security that they had never previously enjoyed.

"first base" with a twenty-eight-year-old divorcee, a Hollywood starlet (Cheryl Ladd), and even Fonzie's girlfriend, who Richie was "watching" for him. In real life, Ron Howard had found true love and married his high school sweetheart, Cheryl Alley, on June 7, 1975.

In Season Two, Richie's integrity shines in episodes where he refuses to accept the answers to the upcoming questions on a TV quiz show and decides not to sell a photo of *The Howdy Doody Show*'s clown, Clarabell, without his makeup.

Meanwhile, on the home front, actor Gavan O'Herlihy was replaced by Randolph Roberts in the thankless role of Richie's goofy, basketball-playing older brother, Chuck Cunningham. Though the season opened with an episode where Richie moves into Chuck's apartment, the character was seen only one other time in the entire series. Chuck was eventually written out as Fonzie assumed the role of Richie's "big brother." However, The Fonz wasn't always a guiding light. He sells his buddy Red a hot car, blackmails the boys into allowing him to join their combo on bongos, and encourages Richie to end a relationship by looking and acting like a hood when he's invited to dinner at Arlene Nestrock's (returning from the original pilot). This ploy backfires when Arlene reveals she digs the leader-of-the-pack type.

One of the cast's favorite early episodes was "Three on a Porch," in which Richie, Ralph, and Potsie believe they've rented a cabin at Lake Whitefish for the

64 50 Years of Happy Days

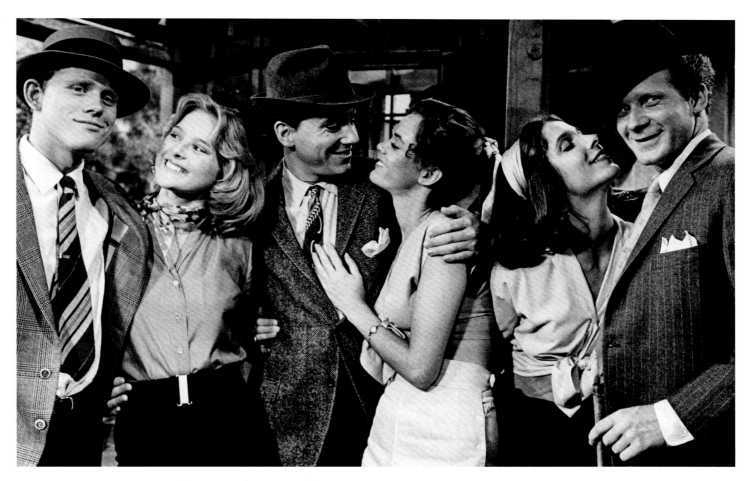

Easter holiday. Instead, the guys discover they've rented only the cabin's porch, while the inside of the cabin has been rented to three beautiful college girls. The high schoolers realize they have zero chance with their co-tenants, leading the boys to pose as wealthy Tunisian businessmen. Howard, Most, and Williams still chuckle when they recall the scene where the boys serenade their neighbors with a "Tunisian" version of "Rock Around the Clock." Ron Howard was quick to credit Don Most for the scene's success.

The "Three on a Porch" episode's "tag" (the short scene between the final commercial and the end credits) finds Fonzie, who has joined the boys, bedding down for the night outdoors. Unable to fall asleep amid the constant din of owls, frogs, raccoons, and squirrels, The Fonz sits up and orders nature to "cool it." This is followed by immediate silence. The character's "abilities," like tapping the jukebox to make it play, kicking a coke machine so a bottle tumbles out, and killing the lights in a room by tapping the wall, kept expanding well beyond the point of incredulity. Says producer Bill Bickley, "It started when Fonzie, being the best mechanic in the world, simply knew where to hit a car's stuck hood to pop it open. So, if he can do that with a Coke machine, what can you do that's bigger than that? It sort of went off the rails. And, at some point, it left the planet."

Season Two also offered a deeper look into Fonzie's psyche than the character would have liked. Throughout the

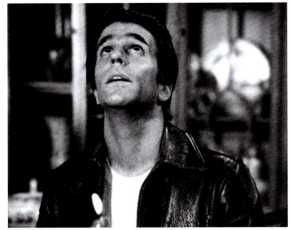

ABOVE (L):
"Guess Who's Coming to Christmas" Is a fan favorite. Fonzie does everything from fixing the Christmas tree lights to reading aloud "The Night Before Christmas" in his memorable first visit to the Cunningham's house.

ABOVE (R):
The Fonz asks to say grace, then looks skyward, gathers his thoughts and says only, "Thanks."

OPPOSITE (L-TOP):
To raise money for their baseball team, Richie & Co. put on a performance of *Hamlet*, with The Fonz as Danish Prince.

OPPOSITE (L-BOTTOM):
Ralph Malph throws a Halloween party in a haunted house. Notable for being the only episode in the series that Garry Marshall directed.

OPPOSITE (R):
Richie wins a date with a starlet played by future Charlie's Angel Cheryl Ladd.

PAGE 70:
You too can hang out at Arnold's with *Happy Days* playsets from Colorforms and Toy Factory. Note how Fonzie and Richie's faces were taken from the image on the *TV Guide* cover on page 62.

PAGE 71:
In "Not With My Sister You Don't," Richie discover's that Joanie's first date is with Fonzie's mini-me nephew, "Spike."

series, Fonzie's "cool" provided a protective shell in which to hide his closet full of fears and anxieties. Producer Bill Bickley feels that "Fonzie was a tragic hero . . . a lonely hero whose facade hid the little boy inside." This theme was fully explored in one of the most beloved episodes in the series' entire history, "Guess Who's Coming to Christmas."

When Richie invites Fonzie to join the Cunninghams for Christmas dinner, The Fonz declines, offering an unconvincing excuse that he is going to Waukesha to visit family. Later, when Richie goes to give Fonzie his Christmas present, a three-in-one wrench, he spots Fonzie eating ravioli out of a can, sitting next to his sad, scrawny Christmas tree. Richie tricks Fonzie into making his second visit to the Cunninghams' home. Fonzie is welcomed into the family's activities and delights in participating in their traditions. In this episode, a bridge that will be traveled often between The Fonz and the Cunninghams is built. Like many viewers, Fonzie finds the Cunninghams to be the family he wishes he had.

Tom Bosley was an iconic TV dad when *Happy Days* was on the air. And in some ways, his role extended offscreen as

> **"FONZIE WAS A TRAGIC HERO . . . A LONELY HERO WHOSE FACADE HID THE LITTLE BOY INSIDE."**
> —PRODUCER, BILL BICKLEY

well. He could be counted on for advice and to set an example of professionalism for the young cast, including Scott Baio. "I always found Tom to be so *easy* when he worked. He seemed like he was never afraid, he was never nervous . . . I would get so nervous. He'd be backstage with his manicured nails and his brown cigarette . . . He'd walk onstage like he was drinking a glass of water. I thought, 'Well, damnit, this guy is smooth.' " Ted McGinley, who would later play Marion's nephew Roger Phillips, enthuses, "Tom Bosley was never going to be late . . . He was always on time, and that was a great lesson. He said, 'That's how we do it in the theater, you're always a half-hour early.' Those kinds of lessons, so many lessons. It was the greatest training ground a guy

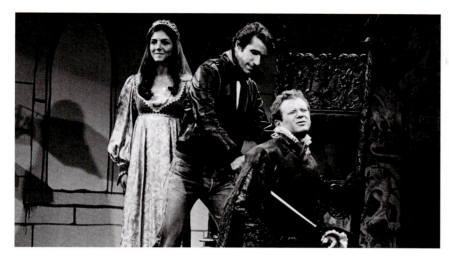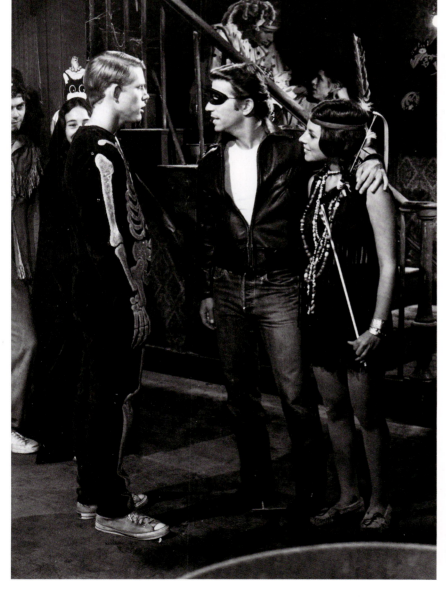

Season Two 69

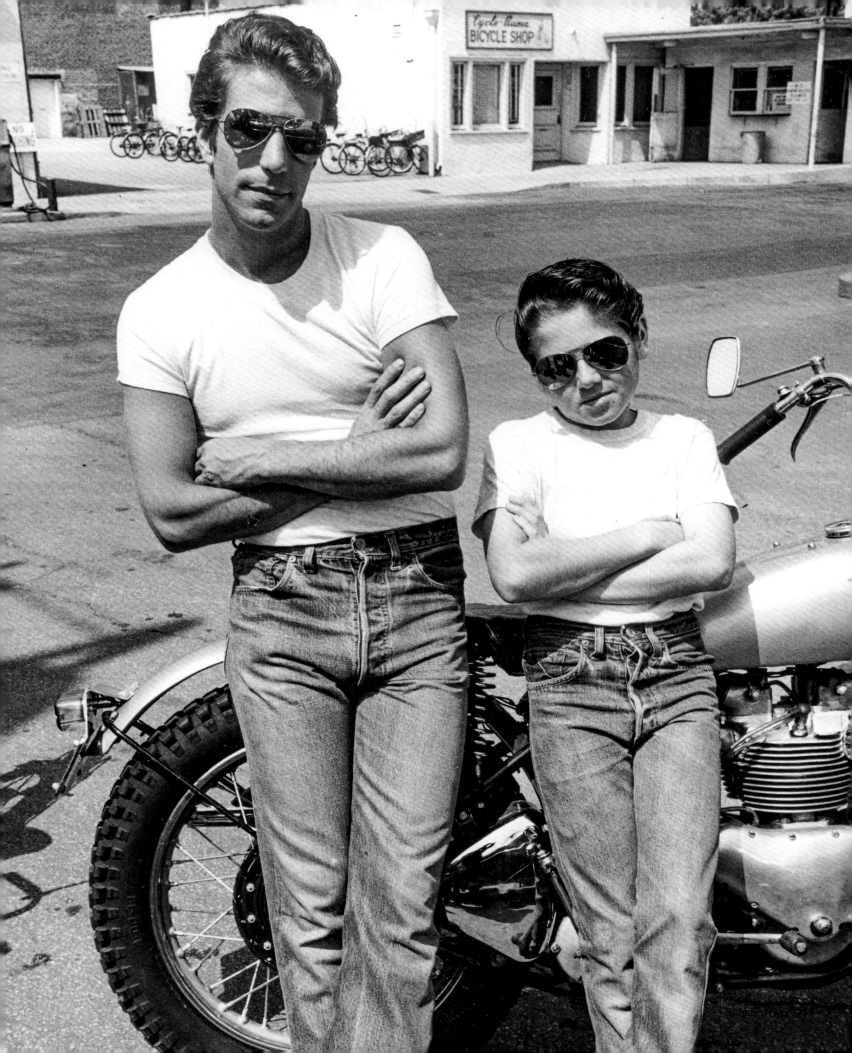

 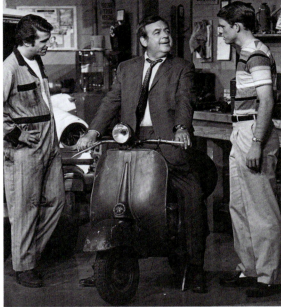

ABOVE (L): Fonzie blackmails the guys into letting him join the band for a country club gig—on bongos, of course.

ABOVE (R): Tom Bosley proved to be a father figure to the young cast.

OPPOSITE: Parker Brothers, the makers of "Monopoly", issued "Fonzie's real cool" Happy Days board game in 1976.

like me could have stepped into." To Ron Howard, Bosley was "always the voice of experience. Telling us to go ahead and get life insurance, even though we were young . . . and 'Here's the way a mortgage works,' guiding us, mentoring us as young men, building for the future."

Despite its overall quality, Happy Days was fading in the ratings and the ax was looming. Fred Silverman, the architect of CBS's powerhouse lineup, had moved over to ABC and declared that if the show was to survive, it would need to take advantage of Fonzie's growing popularity and move the character to the center of the action. At the same time, Marshall and Belson's The Odd Couple, in its fifth season, was running out of gas. Afraid of losing both series, in a last-ditch effort to save Happy Days, Marshall pulled a page from his own playbook. The Odd Couple started in the fall of 1970 as a single-camera, movie-style production, but secured a second season only by filming the show in front of a live studio audience. The move cut costs, returned the series to its theatrical roots, and paid dividends for the show's performers and survival. So, Marshall prescribed the same type of surgery to save Happy Days.

Other than Bob Brunner, no Happy Days writers had experience on shows filmed before a live audience, so Marshall enlisted two young Odd Couple scribes: Mark Rothman and Lowell Ganz. The pair had taken an unlikely path to Hollywood. After leaving City College in New York, they wrote a sample script for an Odd Couple episode—which was handed to series co-star Jack Klugman by a limo driver . . . who just happened to be Rothman's father. Klugman was impressed and gave the script to Belson and Marshall, who, incredibly, hired them as staff writers. They were brash and opinionated, and the twenty-seven-year-old Ganz was a rapid-fire dynamo, even though his mother in New York was still buying his clothes. During the week of production, Marshall asked Ganz to sit in on the reading and rewrites. In these sessions, Ganz impressed everyone with

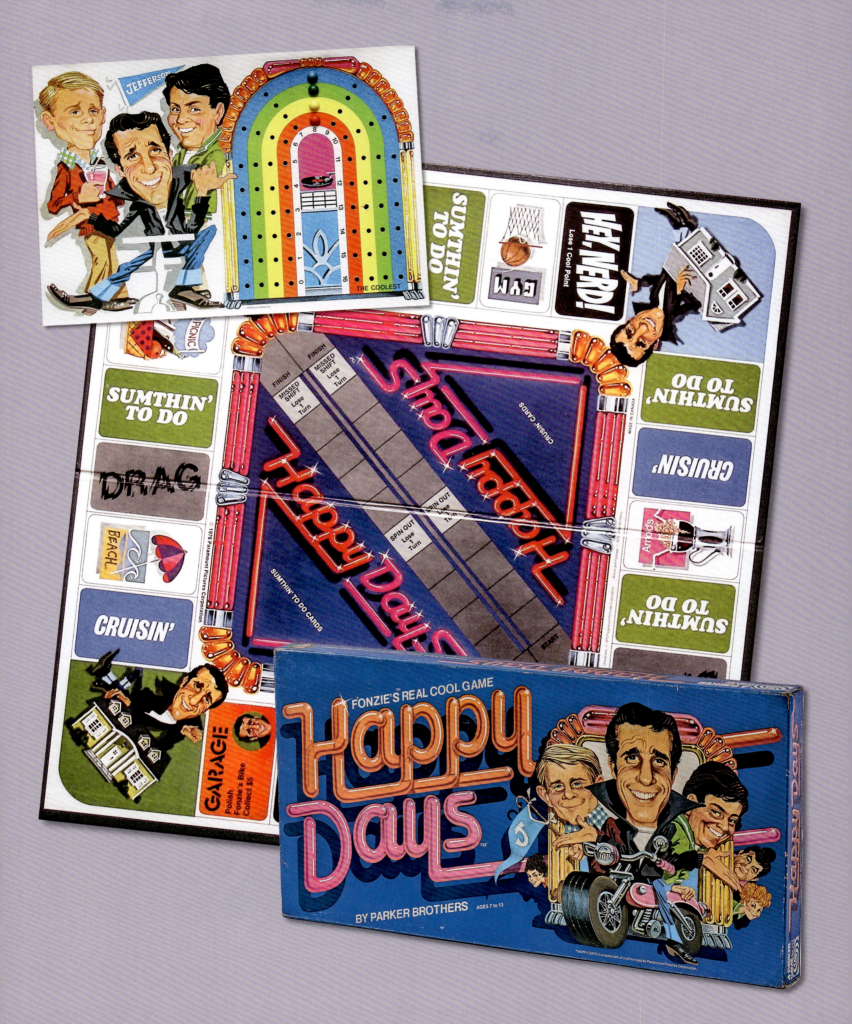

RIGHT: Play a stack-o-wax on your very own Fonzie portable record player!

OPPOSITE: In "Fonzie's Getting Married" The Fonz discovers that his fiancée isn't a librarian as she claimed...but worked under the name "The Lone Stripper." Having Fonzie's heart broken turned out to be good medicine for the series as the show was picked-up for a third season.

his energy and wit. Today, Ganz admits, "I was loud, very active, very enthusiastic... and I had the best time I ever had working. It was very gratifying."

For the final episode of Season Two, to demonstrate the revised format, Marshall handed a storyline to Rothman and Ganz where Fonzie announces he is getting married, only to have his hopes dashed, when he discovers his fiancée has lied to him when Richie and his dad inform Fonzie that Maureen is a stripper.

In "Fonzie's Getting Married," Fonzie is thrilled to have fallen for Maureen, "the woman of my dreams," a "li-berryin" who passes his five-point qualification test. "Number 4, no mustache... Number 5, must be untried." To which Ralph Malph explains to a puzzled Richie and Potsie, "That means she's never been to court." When the Cunninghams have the couple over for dinner, Maureen's distinctive laugh (think of a donkey gargling) spurs Howard to remember seeing Maureen perform her Western-themed act at a rowdy hardware convention in Chicago. Howard tasks Richie with breaking the bad news to Fonzie, who stubbornly refuses to believe Richie—until he witnesses her act and unmasks "The Lone Stripper" as his bride-to-be. Afterward, Fonzie is hurt that Maureen lied to him about who she was. Maureen tells Fonzie she wants to be a different person but can't, and chooses her career over him. For the first time, The Fonz has had his heart broken. He deals with his pain as you would expect, hiding it with the veneer of bravado that Howard and Richie easily see through.

The response to the three-camera gambit was surprisingly positive. Ron Howard calls it "a fantastic experience

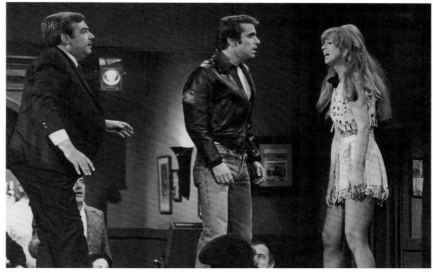

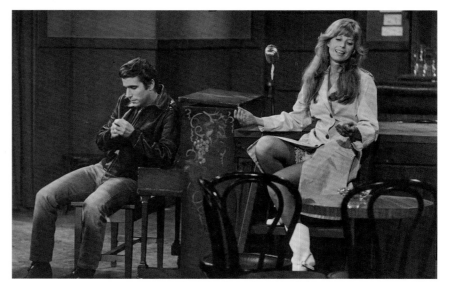

RIGHT: Jerry Paris had ridden in Marlon Brando's motorcycle gang in *The Wild One* (1953) and understood the roots of Winkler's performance, and the pair complemented one another's talents for 11 seasons.

R-TOP: The director and performer confer during a Friday night shoot.

R-CENTER: The pair wrap a scene from Season Nine's "Home Movies Part II."

R-BOTTOM: At Dodger Stadium for the softball team's second major league appearance.

OPPOSITE: Viewmaster gave Season Two's "The Not Making of a President" the 3D treatment. In the episode, Richie turns Democrat to get a date with an Adlai Stevenson campaign volunteer.

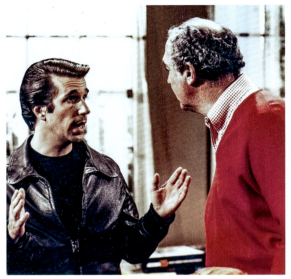

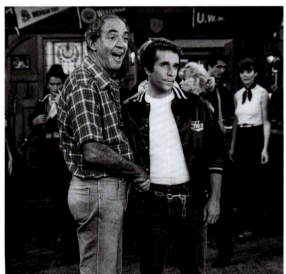

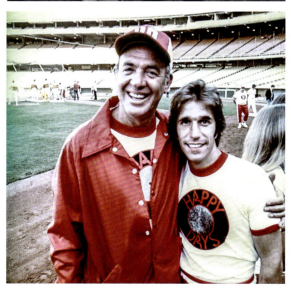

for me creatively. I learned so much about comedy timing and how to trigger a laugh." But Howard also admits that "it was terrifying for me." Winkler, Bosley, Ross, Williams, and Most were experienced stage actors. However, Ron Howard's entire career in front of a live audience consisted of a few state fair appearances with Andy Griffith and Don Knotts years before. Howard recalls that before going out to face the studio audience for the first time, he nearly vomited. Anson Williams adds that right before showtime, no one could find him. "He was standing all alone, he was very, very nervous . . . In fact, Ron was scared to death." Fortunately for Howard, he was being guided by an expert hand, Director Jerry Paris.

Paris had begun his career as an actor and segued to working behind the camera on *The Dick Van Dyke Show*. The Emmy Award–winning Paris brought life to the material and knew how to milk every drop of funny from a scene. As Anson Williams puts it, "Jerry allowed us the opportunity to contribute to what our characters became." Paris was particularly adept at enhancing Winkler's performances. The director had studied with Lee Strasberg at the Actors Studio in New York and had ridden alongside Marlon Brando in the early-1950s biker flick *The Wild One*, so he understood the concept of the antihero. He recognized that Winkler had created a comedic version of Method acting technique. Summing up the dynamics Henry Winkler and Jerry Paris brought to the relationship, Don Most says, "I think it was a great marriage . . . a *great* marriage." Paris lit a flame under the cast, and everyone tried to calm Howard's

nerves before facing a live audience, but ultimately it was unnecessary. "It was a breeze for him," Winkler recalls. "Like a duck to water. I never saw anything like it in my life, it was like he was born to do this."

Happy Days' first audience got a real treat. The performances all around were fast-paced and sharp. It was funny, too. When The Fonz and his fiancée join the Cunninghams for dinner, Fonzie's unexpected table etiquette puts Howard and Richie to shame. The Fonz's bachelor party is a disaster, especially when the stag film Ralph acquired turns out to be his cousin's trip to Yellowstone. The episode also displays a tender side, as Howard and Richie comfort the brokenhearted Fonzie.

At the curtain call, the audience rewarded the cast's exceptional performances with an extended standing ovation. Ron Howard would later call the experience "exhilarating." The new format would precipitate many changes, including a change of showrunners. Bill Bickley felt that in transitioning to an audience show, "They threw this gentle series under the bus . . . But Lowell was the ideal guy for the job." Bickley proved to be right. Ganz expresses what a joyous experience the program was for him, saying, "*Happy Days* wasn't just a show I worked on . . . *Happy Days* was the show I worked on when my dreams came true."

"Fonzie's Getting Married" proved beyond a doubt to ABC that the episode was successful in creating a new template for the series to follow and ordered thirteen more episodes. Soon, *Happy Days* would explode in popularity and become television's top series.

 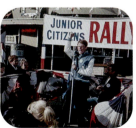

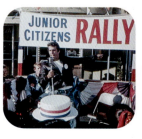

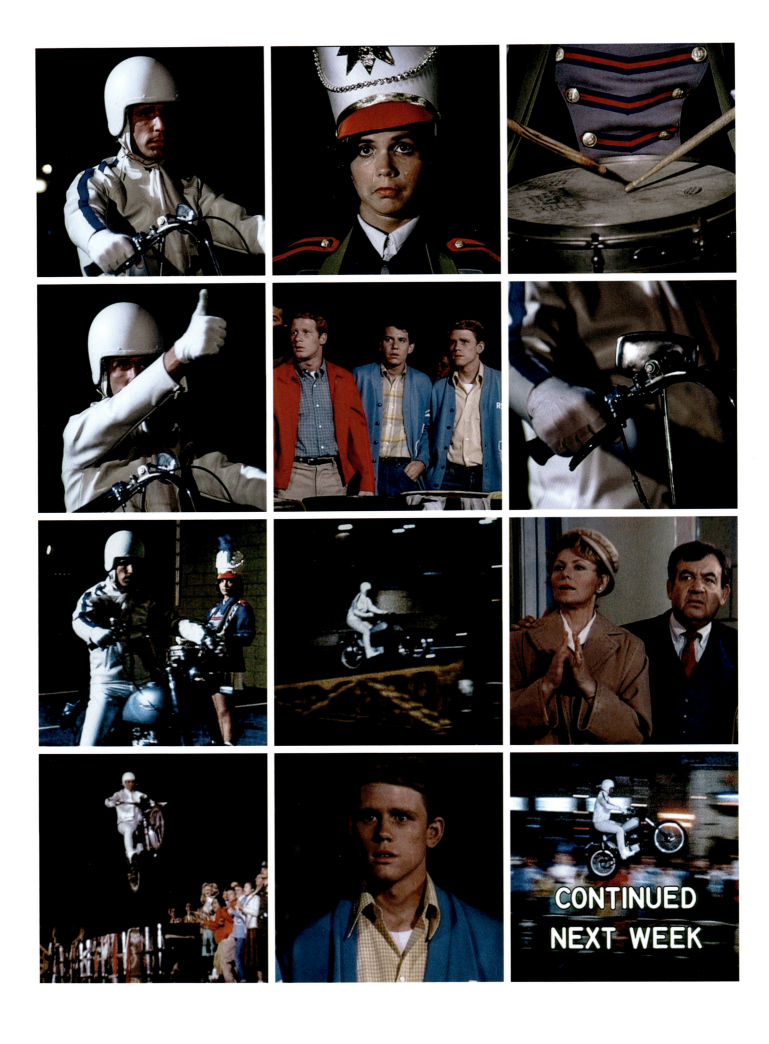

SEASON THREE

Happy Days blew into its third season with a whirlwind of energy. Morphing from a single-camera shoot to a three-camera/audience format unleashed the actors' personalities, and moving Fonzie to the center of the series brought a whole new level of excitement to the show. Within months, Fonzie-mania exploded not just in America but worldwide, storming the living rooms of Europe, Japan, and Australia. Fonzie's face soon appeared on every magazine on the newsstand. Kids sported Fonzie T-shirts, Halloween costumes, and lunchboxes. It was the kind of fame usually reserved for rock stars, premier athletes, and world leaders. Across America, Tuesday nights on ABC became appointment TV for the entire family.

Over the summer, Lowell Ganz and Mark Rothman had taken over from Bill

Bickley as showrunners, though all three would continue to come and go throughout the series' run. In May, *The Odd Couple* had been canceled after 114 episodes, allowing Garry Marshall to pour all his energy into *Happy Days*. Marshall supervised the scripts, ran the writers room, and demonstrated an impressive range of skills. Ganz, who in essence was the producer's protégé, praises his mentor. "Garry had the ability to not just look for the next line or joke or even the next story beat . . . he saw the whole picture. He was also a politician, a charmer . . . He was secure in his own skin, he knew who he was, and was a very comfortable person." Ganz goes on to commend Marshall's keen eye for finding and developing talent: "Garry created so many lives for people—not just careers, but lives."

> **MOVING FONZIE TO THE CENTER OF THE SERIES BROUGHT A WHOLE NEW LEVEL OF EXCITEMENT TO THE SHOW. WITHIN MONTHS, FONZIE-MANIA EXPLODED NOT JUST IN AMERICA BUT WORLDWIDE.**

OPPOSITE: Fearless Fonzarelli attempts to break the world record, by clearing fourteen garbage cans on national television. The show soared, but The Fonz ended up in the hospital.

LEFT: The Fonz kept a poster of his idol, James Dean in his closet, here, he laments to it, "No one understands me but you."

PAGES 80–81: Don Most and Anson Williams in the early years of the series.

RIGHT: Season Three opened with Fonzie becoming the Cunninghams tenant when he rents the apartment above the Cunningham garage, a move highlighted in this addition to the show's main title.

OPPOSITE (L): In "Motorcycle," the Cunningham's trick Fonzie into volunteering to help Joanie perform a magic trick...to prevent him from attacking Ralph when they inform him, Ralph accidentally ran over Fonz's Harley.

OPPOSITE (R-TOP): John and Julian Lennon paid a first season visit to the set...twenty years later, while filming a music video for his first album, Julian Lennon popped his head into Henry Winkler's office and asked "Remember me?"

OPPOSITE (R-BOTTOM): Acting as his own attorney, Fonzie badgers the witness, Richie, who reluctantly testifies against his father in "Two Angry Men."

PAGE 84 (L-TOP/MIDDLE): Fonzie fails as an ice cream vendor, but scores selling encyclopedias, in "Fonzie the Salesman."

PAGE 84 (L-BOTTOM): "Fonzie the Superstar" featured the character's interpretation of "Heartbreak Hotel" with Laverne & Shirley singing back-up.

PAGE 84 (R-TOP): The Fonz played peacemaker between rival gangs in "Fonzie the Flatfoot."

PAGE 84 (R-BOTTOM): As Arnold's best man, The Fonz dons a ceremonial kimono for "Arnold's Wedding."

For Ron Howard, the show's newfound success was a double-edged sword. "In the one-camera days I really, really understood *Happy Days*. It was very similar in tone to *The Andy Griffith Show*. The jokes weren't big. Henry got his laughs from being super cool and Don Knotts got his from being goofy and overreacting. When we went to three-camera and Lowell and Mark came on, the tone really shifted, and sometimes I thought *Happy Days* was just kinda broad and zany. It wasn't exactly my taste, but I liked it. *The Andy Griffith Show* episodes always rang true... and so did *Happy Days* that first season and a half. This was now 'heightened,' and it was something else, but I wasn't entirely comfortable with it... But it was sooo much fun getting those laughs!"

Howard adds, "It was so great to learn about the algebra of a joke, which I never really thought about or understood before. And it was remarkable to me to watch the script evolve over the course of the week and get sharper and funnier, and I began to really appreciate that."

The cast enjoyed interacting with their growing fan base, but their all-time favorite was of a visit by one of their biggest early admirers—young Julian Lennon, along with his father, John. The ex-Beatle and his son spent the day on the Arnold's set, took pictures, and signed autographs, an experience Anson describes as "surreal."

While the cast was thrilled for Henry's success, there were times when, according to Marion Ross, "Not Henry, but the character of Fonzie sucked the air out of everything associated with the show." Winkler, with few exceptions, handled his unlikely instant stardom well. He was always gracious in public and paid special attention to his youngest fans. Winkler sometimes bristled when people called him by his character's name and would remind them that his name was Henry, not Fonzie. Long-serving writer and former associate producer Michael Warren recalls a time the Make-A-Wish Foundation arranged for a seriously ill young boy to meet his hero. Warren noticed at dinner,

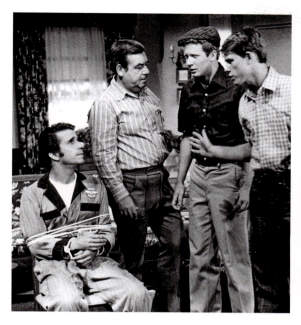
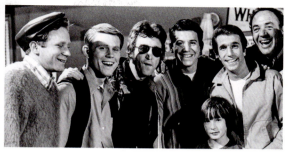

before the evening show, that Winkler was, uncharacteristically, in full wardrobe, makeup, and ducktail. Warren realized that Henry understood what it meant to the boy to meet Fonzie . . . not the man who played him. Warren observed Winkler's kindness and encouragement as the actor, in character, devoted a half-hour to the boy and his family. Linda Purl, who later played Ashley Pfister, also remembers the moment and adds that the foundation had provided only a single ticket for a parent, but Winkler paid for the entire family's airfare, accommodations, and trips to theme parks.

On Stage 19, despite Fonzie's breakout popularity, the chemistry and relationships on the set remained balanced and harmonious. Ron Howard was always the captain of the cast's ship. He quietly set an example of conduct for the entire company that precluded outbursts on set and ego trips. Howard denies being conscious of the role, but admits that he would sometimes assume the leadership position. Recalling a time when Winkler had expressed his displeasure with that week's script, Howard says he took his castmate aside and told him, "I don't think punching the script is a good idea. The writers are trying, Henry, they're trying . . . It's one thing to have notes, but don't punch the script."

Today, Winkler labels himself "a character actor," and in Fonzie he found a way to emulate the angst-filled characters created by his screen idol, James Dean. When thirteen-year-old Henry Winkler saw Dean's brooding performance in *Rebel Without a Cause*, it inspired him to become an actor. He brought that same sense of lurking danger to Fonzie, however the character wasn't a threat, he was a protector. Fonzie wore an impenetrable shield that covered a surprising number of hidden insecurities and fears.

Like an Old West gunslinger, Fonzie lived by a code that both burnished his tough-guy image and served to isolate and prevent him from doing things that made him feel "uncool." The third season was built around exploring those chinks

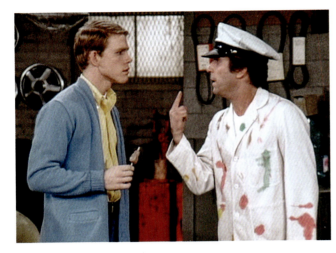
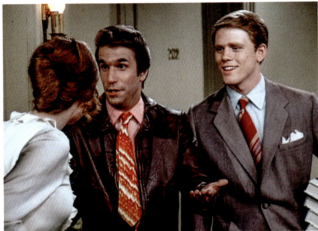

in Fonzie's armor, continually yanking The Fonz out of his comfort zone and integrating him into the Cunningham family, which helped to reveal more of the person hiding beneath his leather jacket.

On September 9, 1975, according to Lowell Ganz, the sanding of The Fonz's rough edges began in Episode 40, "Fonzie Moves In." Threatened by competition from a new Hardware City franchise, Howard Cunningham wants to bring in extra money and decides to rent the apartment over the garage. They quickly find a tenant, Fonzie's Grandma Nussbaum, played by Lillian Bronson. In episodes thereafter, she was played by *Seinfeld*'s Frances Bay. Then Fonzie decides the apartment would be perfect for him. The Fonz's frequent overnight guests and revving big-block engines quickly cause friction with Mr. C and throw the family's life into chaos. But in the end, the Cunninghams ask Fonzie to stay because they consider him part of the family. In doing so, the producers literally gave him a seat at the dinner table.

During the next twenty-three episodes, Fonzie would face challenges large and small. In "A Sight for Sore Eyes," he triumphs over the stigma of wearing glasses (though The Fonz would never be seen in them again). In "Fearless Fonzarelli," he dons a white jumpsuit and crash helmet to attempt an Evel Knievel–type stunt by jumping his motorcycle over fourteen trash cans on national TV. Part I, with Fonzie's stunt double speeding toward the launch ramp and, as he takes off, flying through the air . . . the frame froze, and millions of fans were disappointed to learn that the episode would be "CONTINUED NEXT WEEK."

When Fonzie crash-landed the following Tuesday, *Happy Days* had taken a huge leap in the ratings. The stunt would rank among *Entertainment Weekly*'s 100 Greatest Moments in Television.

It seemed Fonzie put a dent in his steely facade every time he stepped out of his leather jacket. Fonzie wears a tux when he teams up with Mrs. C for a ballroom dance competition. The Fonz dons a policeman's uniform when he is deputized to head off a rumble; a suit, tie, and fedora as a door-to-door salesman; and an Elvis-like spangled jumpsuit when he accomplishes something Fonzie believed he was incapable of: singing. Though, to be more accurate, Fonzie's performance is more of a spoken word/shouting interpretation of Elvis's "Heartbreak Hotel."

"At times," says Lowell Ganz, "I always felt Mark and I wrote Fonzie a little differently than he came to be written for the rest of the run of the show. It's understandable that he started to be written differently." Ganz observes that in Season Three, "Fonzie could be a 'dick' and unaware of how polite society operated. There was a bull in a China shop aspect to him that certainly got sanded down eventually." These traits are evident when he encourages Richie and the guys to stage a fake beauty contest to meet girls. When Richie is threatened by local hoods, Fonzie shares his secrets to intimidating an opponent—without letting Richie know that it only works *after* you've pummeled a few guys.

But Fonzie could also be generous. When Richie is in a dating slump, Fonzie opens his little black book (in actuality, a three-inch-thick binder) and arranges

a double date with two Shotz Brewery bottle cappers, Laverne DeFazio (played by Garry Marshall's little sister, Penny) and Shirley Feeney (Ron Howard's *American Graffiti* co-star Cindy Williams).

After meeting at Arnold's, Fonzie and Richie bring Laverne and Shirley to the Cunninghams', passing it off as Richie's house while the rest of the family is visiting Aunt Bessie. Almost immediately, Fonzie takes Laverne upstairs, leaving the frightened, inexperienced Richie to fend off his date's advances by offering Shirley a snack. Richie goes into the kitchen while Shirley recounts an argument with Laverne—and just as she's demonstrating the punch that ended their spat, Richie walks right into it, sending him flying, along with the chips and pretzels. Shirley apologizes with a long kiss, just as the family walks through the front door.

Lowell Ganz still raves about the episode: "It was a great, great show. It was Jerry [Paris] at his best. It was perfect for him, the kind of show he could really sink his teeth into. He infused the entire episode with the kind of energy you didn't see on TV at the time."

No one on the show, especially not Penny Marshall or Cindy Williams, had any idea what this "one shot" would lead to—except Garry Marshall. Though Richie's date with the bottle capper was unsuccessful, Garry Marshall knew he'd hit a grand slam. One hundred and seven days after "A Date with Fonzie" aired, *Laverne & Shirley* debuted as ABC's highest-rated premiere ever.

PAGE 85: The iconic pinball machine from Arnold's.

OPPOSITE: Laverne DeFazio and her roomate Shirley enter Arnold's for "A Date with Fonzie."

ABOVE: Richie's date with bottle capper Shirley Feeney ends in disaster.

Season Three 87

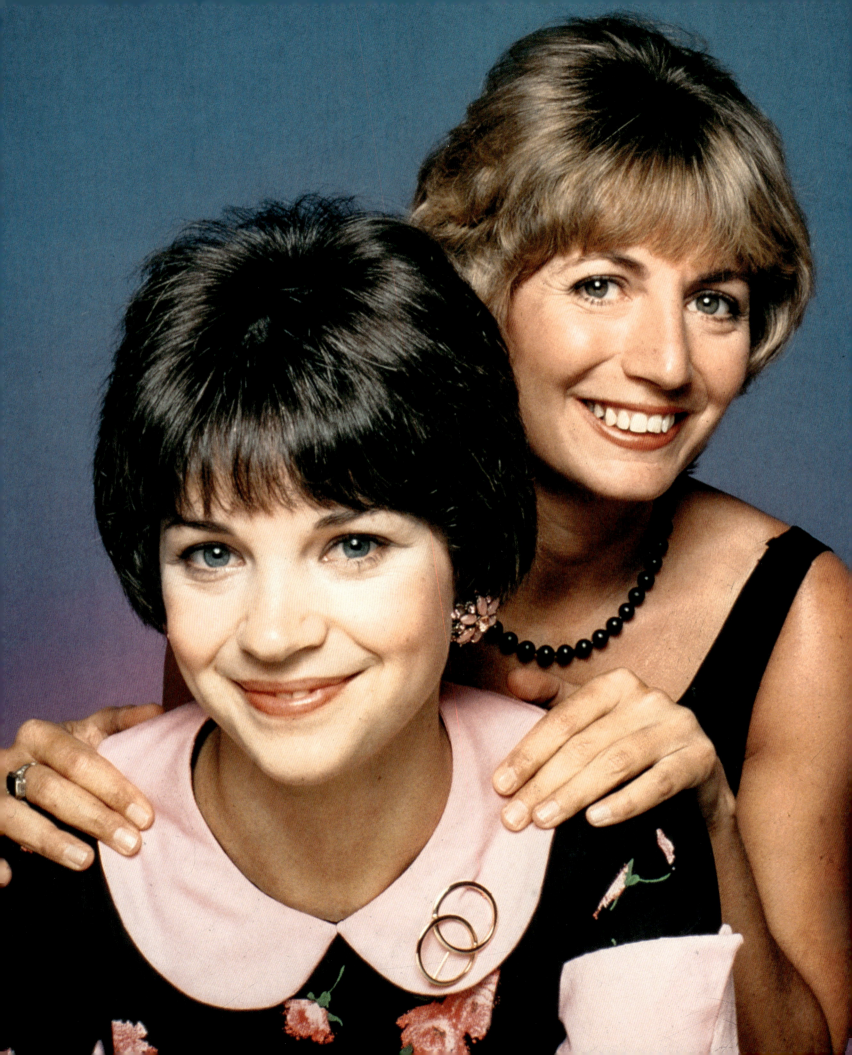

SPIN-OFFS
PART ONE
LAVERNE & SHIRLEY

Perhaps the greatest testament to the popularity of a television series is in the number of spin-off titles it generates. *Law & Order*, *Star Trek*, and *NCIS* are the proud papas of dozens of hour-long series. In the half-hour category, *The Mary Tyler Moore Show* spunoff three characters: *Rhoda*, *Phyllis*, and *Lou Grant*. *M*A*S*H* gave fans *Trapper John, M.D.* and *AfterMASH*. Longtime ratings champ *All in the Family* doled out spin-offs like Halloween candy, with seven in all, including *The Jeffersons* and *Maude*.

Canceled after a five-season run, *The Brady Bunch* returned in everything from a glitzy variety show to an hourlong drama. But the undefeated champion of spin-offs remains *Happy Days*. While many spin-offs have been successful, and a few have run longer than their forebears, none could compete with the impact *Happy Days*' spawn had on television and the culture while generating previously unimagined revenue from merchandising and syndication sales.

The first of *Happy Days*' record eight spin-offs was, of course, *Laverne & Shirley*. "A Date with Fonzie" proved to be one of *Happy Days*' most impactful episodes. The

studio audience went wild for the raucous humor and physicality of Laverne DeFazio and Shirley Feeney. Garry Marshall immediately pushed Paramount and ABC to commit to shooting a short pilot "presentation." Several weeks later, the *Happy Days* studio audience was asked to stay over for "a special treat." Mark Rothman and Lowell Ganz wrote a long scene in which Laverne and Shirley return home after their date with Fonzie and Richie.

OPPOSITE:
Cindy Williams and Penny Marshall pose for a *TV Guide* cover in 1976.

LEFT:
Clockwise from top left: Michael McKean (Lenny Kosnowski), David L. Lander (Andrew "Squiggy" Squiggman), Eddie Mekka (Carmine Ragusa), Bill Foster (Frank DeFazio), Penny Marshall (Laverne DeFazio), Cindy Williams (Shirley Feeney), Betty Garrett (Edna Babish DeFazio).

RIGHT:
The series' first episode painted Laverne as a realist and Shirley as a dreamer; but both help each other overcome life's challenges.

OPPOSITE:
The entire cast had a blast in Season 3's "Shirley's Operation" preparing to perform *Alice in Wonderland* for a youth group… before Shirley's appendix upends their plans.

> ## "PENNY AND CINDY WERE TERRIFIC; IT WAS REALLY GOOD . . . AND THEN CINDY DIDN'T WANT TO DO THE SERIES."
> —CO-CREATOR, LOWELL GANZ

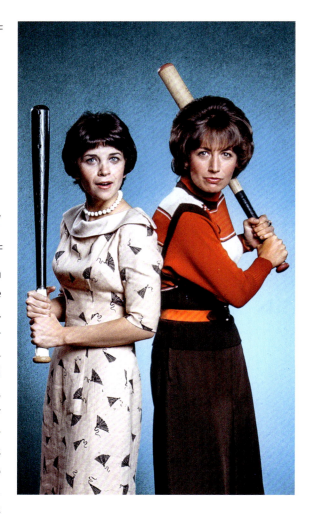

With Stage 19's Cunningham kitchen set filling in for the girls' apartment, the bottle cappers recapped their evening. The conversation helped define the differences between the two characters. Laverne paints herself as a hardened realist who accepts her station in life, and Shirley is forever a dreamer, eternally optimistic that she'll escape her blue-collar roots. But their lifelong bond helps them overcome their differences and help each other through life's rough patches. ABC responded as enthusiastically as the studio audience and ordered thirteen episodes to begin airing in January 1976. Lowell Ganz remembers the shoot vividly. "Penny and Cindy were terrific; it was really good . . . and then Cindy didn't want to do the series."

In 1973 and 1974, Cindy Williams had back-to-back successes. Though she had scant experience, she was cast opposite Ron Howard in *American Graffiti*, which grossed over a billion in twenty-first–century dollars, and then was the female lead alongside Gene Hackman in *The Conversation*, directed by *American Graffiti*'s producer, Francis Ford Coppola. But then . . . nothing. Discouraged and needing money, Williams decided to seek work as a writer. Her manager (and *Graffiti* casting director), Fred Roos, encouraged Williams to meet with fellow client Penny Marshall.

They hit it off and formed a writing partnership—which blew apart on the eve of earning their first assignment, when Marshall lost interest and never responded to Williams's pleas to complete their script. Shortly thereafter, *Laverne & Shirley* began. The incident created a mistrust between the pair which made their work together as much a rivalry as a partnership. Throughout the show's run, its two stars were hypercompetitive. Williams often felt there was no one in her corner, given that Penny

Marshall's brother, sister, and father were all producers on the show.

To counter Williams's hesitancy to do the series, Paramount kept sweetening the pot, finally more than doubling its initial offer. Begged to sign the deal by her representatives, friends, and family, Cindy Williams reluctantly signed on.

In the series, Laverne and Shirley continued working as bottle cappers, with Anheuser-Busch's San Fernando Valley plant filling in for Shotz Brewery. The duo socialized at the Pizza Bowl, where Laverne's father, Frank DeFazio (Phil Foster), ran the restaurant. Shirley was given an on-and-off boyfriend, boxer-singer Carmine "The Big Ragu" Ragusa, played by Tony-nominated actor Eddie Mekka. The scene-stealing duo of Lenny and Squiggy, Laverne and Shirley's goofy, lovable upstairs neighbors, were not part of the original plan. At a star-studded holiday party at Penny Marshall and Rob Reiner's house, Marshall urged David L. Lander and Michael McKean, members of the improv group The Credibility Gap, to perform a routine as characters Lenny and Anthony. They were hilarious, and producer Garry Marshall plotted to add them to the show. Ganz notes, "Garry, always smart, felt that if he said to ABC, 'These are going to be their neighbors,' the network wouldn't 'get' them . . . So, he brought them in as writers—but it was

Spin-offs: Laverne & Shirley

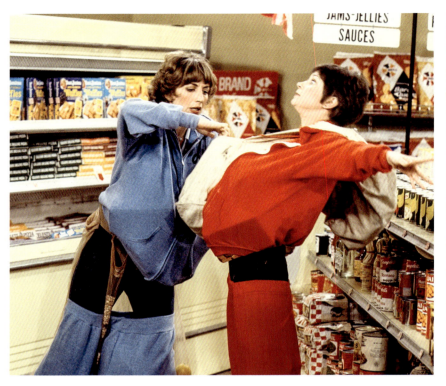 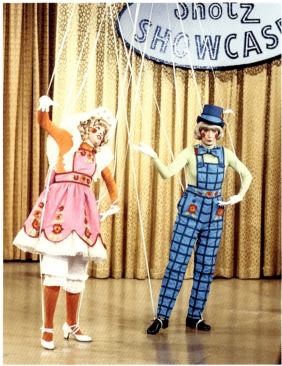

ABOVE (L): In Season Four's "Supermarket Sweep" episode, Laverne won a 3-minute shopping spree.

ABOVE (R): The annual Shotz talent contest always provided the women with an opportunity to display a range of talents.

OPPOSITE: In the second season, the episode "Oh Hear the Angels' Voices" was originally titled "Christmas at the Boobie Hatch."

subterfuge." Lander and McKean's characters were renamed Lenny and Squiggy, so they'd have the same initials as their neighbors. The duo were hired as "day players" the first week to skirt network scrutiny . . . and were hired again the next two weeks—until the pair had been successfully woven into the fabric of the show. The pair were so hilarious that Marshall and company considered spinning the pair off into their own series. A pilot episode for "Lenny and Squiggy in the Army" was shot, but cooler heads prevailed and they stayed with the series through its entire run.

Once Cindy Williams finally agreed to sign on for *Laverne & Shirley*, preproduction went into high gear. With *Happy Days* still in production, Garry Marshall, Mark Rothman, and Lowell Ganz scrambled to prepare the first batch of scripts. Meanwhile, on Paramount's Stage 20 Laverne and Shirley's basement apartment, the Shotz Brewery's break room, and the Pizza Bowl were under construction. With Garry Marshall directing, rehearsals for the first episode began the day after Christmas. It was shot right after New Year's, and on January 27, 1976, America first saw Laverne and Shirley skip along the sidewalk, arm in arm, chanting a childhood ditty: "Schlemiel, schlimazel,

> **"IF BUSTER KEATON DID HALF THE SHIT THOSE GIRLS DID, THEY WOULD BE SHOWING THEM AT THE MUSEUM OF MODERN ART."**
>
> —LOWELL GANZ

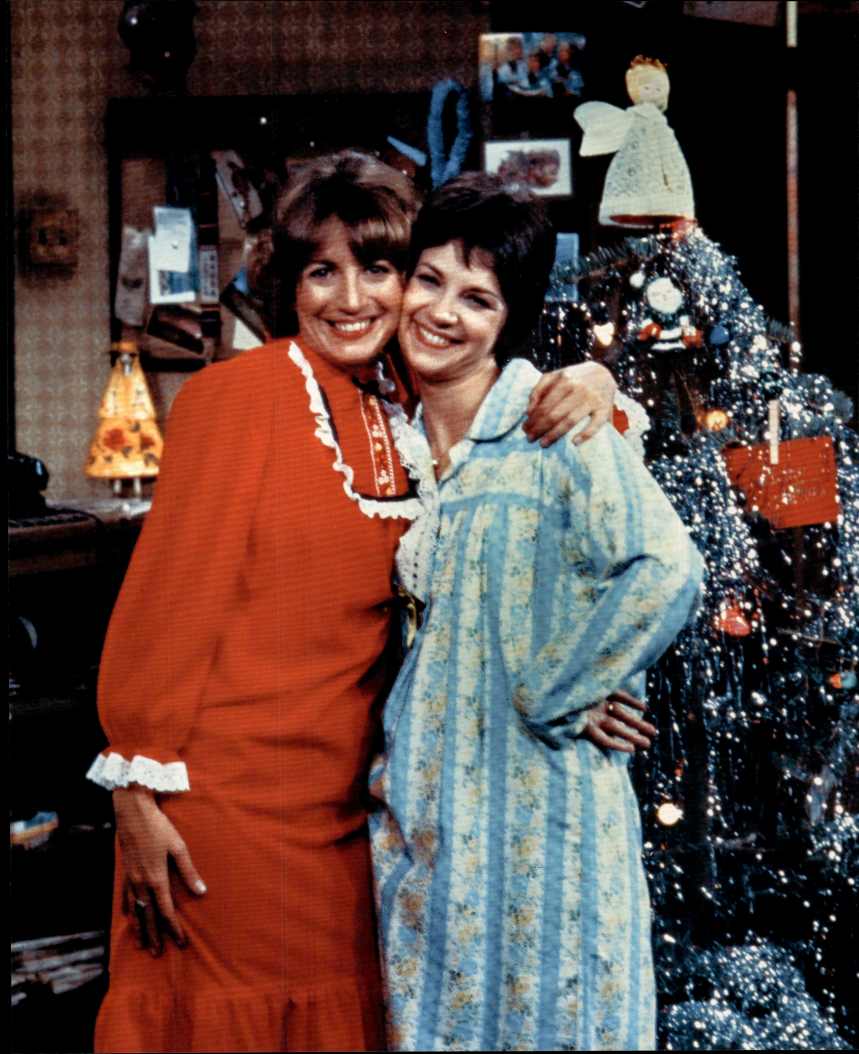

TOP (L): McKean and Lander adapted the dimwitted characters they created while in the improv group *The Credibility Gap*, Lenny and Anthony.

TOP (R): Laverne's dubious dream sequence has her flashing forward to imagine what her and Shirley's lives will be like in 2017 in Season Three's "2001: A Comedy Odyssey."

OPPOSITE: In 1977 the Mego Corporation released a line of *Laverne & Shirley* figures.

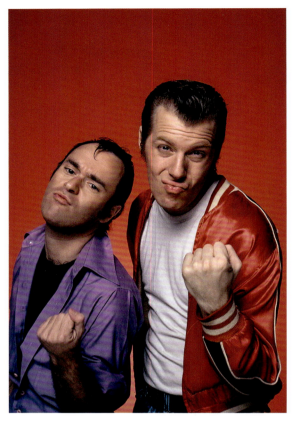

hasenpfeffer incorporated." The theme song told of how determined the pair were to "make all our dreams come true." And dreams do come true—*Laverne & Shirley* debuted as the number one show on television and the highest-rated series premiere in ABC's history.

What truly distinguished *Laverne & Shirley* from its competition was the duo's impressive physical comedy. Lowell Ganz once commented, "If Buster Keaton did half the shit those girls did, they would be showing them at the Museum of Modern Art." Initially Penny Marshall, a talented athlete, was assigned the physical bits, but Cindy Williams felt she was capable of such feats as well and lobbied Garry Marshall to give her the opportunity. Fortunately, he agreed, and soon America was treated to the girls' memorable attempts to wrestle a Murphy bed, battle a hurricane, change a hospital bed's sheets without disturbing the patient, and Williams's hysterical head-banging when serenaded by their idol, Fabian.

Beginning in the series' sixth season, after the characters lose their jobs at Shotz Brewery, the series moved from Milwaukee to Burbank, California, and the show jumps ahead several years. Lenny and Squiggy become talent agents, Laverne's father, Frank (Phil Foster), and his new wife, Edna (Betty Garrett), open a barbecue restaurant. Carmine delivers singing telegrams, and the girls find work in Bardwell's Department Store. It should be noted that the series' stars strongly opposed the show's location change, though the move to California did inject the series with some new blood and cast members, including Heisman Trophy–winner, Ed Marinaro, Los Angeles

Spin-offs: Laverne & Shirley **95**

ABOVE: In Season Five's episode "The Diner" the customers were played by the show's writing staff.

OPPOSITE: The girls unwittingly joined an acrobatic troupe and performed on TV's *The Hollywood Palace* in Season Eight's "The Most Important Day Ever."

provided opportunities for Laverne and Shirley to swing on a trapeze, hit the slopes for a ski weekend, and survive being stuntwomen. In one memorable episode, Lenny and Squiggy somehow become contestants on *The Dating Game*.

Laverne & Shirley's eighth and final season could have just been called *Laverne*. When the executive team declined to arrange the schedule to accommodate Cindy Williams's pregnancy with her first child, she walked away from the show. On top of that, Michael McKean appeared in only four episodes as Lenny Kosnowski. He left the show to play rocker David St. Hubbins in *This Is Spinal Tap* (1984), directed by Penny Marshall's ex-husband, Rob Reiner. The series aired its 178th, and final, episode on May 10, 1983. "Here Today, Hair Tomorrow" was hardly a "grand finale," but it bid goodbye to Eddie Mekka's Carmine Ragusa character. The story follows him to New York, where he scores an audition for the original cast of the Broadway musical *Hair*. *Laverne & Shirley* remained popular to the end, finishing the year still as a top twenty-five show for the year in the Nielsen ratings.

After the series ended, Eddie Mekka returned to the theater and embarked on national tours with revivals of *Grease* and *It Had to Be You* alongside Cindy Williams. Lander and McKean ended the partnership they'd begun at Carnegie Mellon University. McKean found success in features and television and was nominated for an Emmy for his work on the 2019 season of *Better Call Saul*. Lander followed his passion for baseball, becoming part owner of a Pittsburgh Pirates minor league team and working as a scout for the Seattle Mariners and Anaheim Angels. Lander, who detailed

his health battles in his 2000 autobiography, *Fall Down Laughing: How Squiggy Caught Multiple Sclerosis and Didn't Tell Nobody* (Tarcher), died in December 2020. Nearly a year later, Eddie Mekka suffered a fatal heart attack.

While channel surfing early one morning, Cindy Williams found herself enchanted by the 1950 Spencer Tracy/Elizabeth Taylor film *Father of the Bride*, and thought it would be terrific to remake. Her instinct resulted in Williams producing the 1991 hit film starring Steve Martin and Diane Keaton. Like the original, it spawned a sequel, *Father of the Bride Part II* (1995).

Cindy Williams returned to television in 1993 for two seasons of the series *Getting By*, co-starring Telma Hopkins from *Family Matters*. Produced by six *Happy Days* alumni, the show focused on two single mothers and best friends sharing a home and mortgage in Oak Park, Illinois.

In 1986, three years after *Laverne & Shirley* ended, Penny Marshall made her feature directing debut with *Jumpin' Jack Flash*, a spy comedy starring Whoopi Goldberg. She would helm six more films, including *Big* (1988), starring Tom Hanks, *Awakenings* (1990), based on Dr.

LONG AFTER *LAVERNE & SHIRLEY* ENDED, ITS STARS MENDED FENCES AND HAPPILY MADE APPEARANCES TOGETHER SEVERAL TIMES.

Spin-offs: Laverne & Shirley

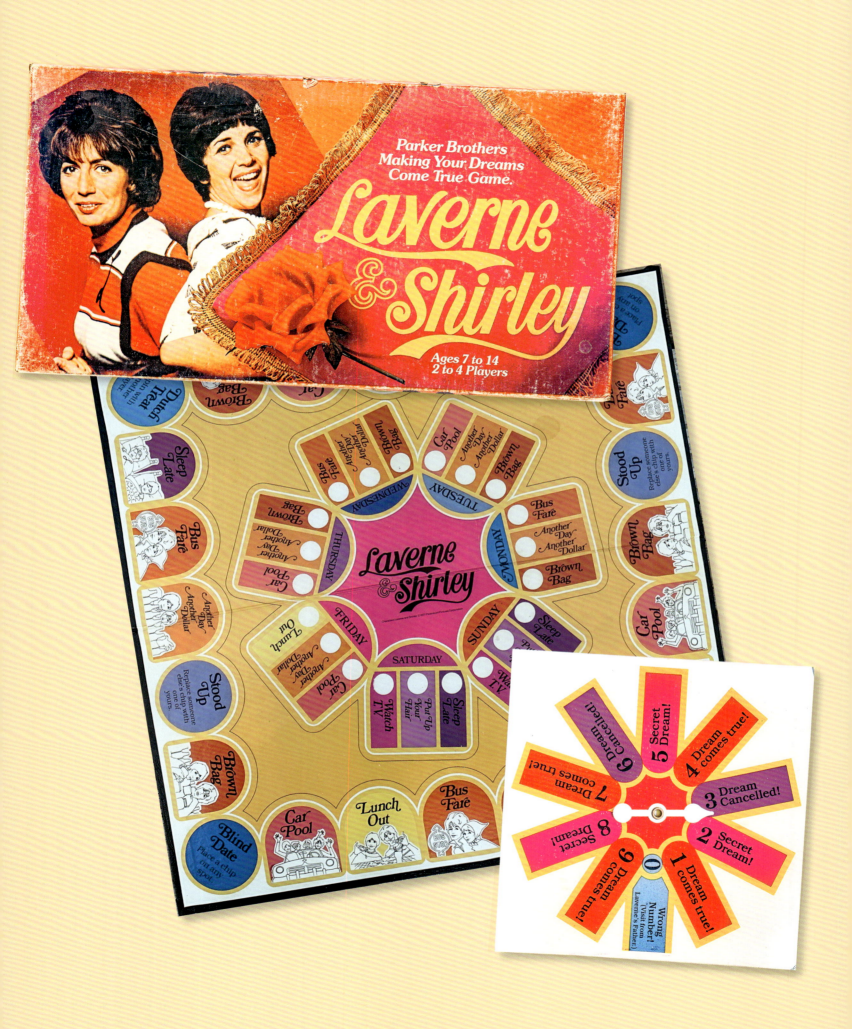

Oliver Sacks's true-life story and featured Robert De Niro and Robin Williams. Her film *A League of Their Own* (1992), about the World War II era of women's professional baseball, was recently named to the National Film Registry, which honors America's film heritage.

Long after *Laverne & Shirley* ended, its stars mended fences and happily made appearances together several times, including a 2013 spot on the Nickelodeon female buddy comedy *Sam & Cat*. Williams and Marshall returned to "Milwaukee" in 1995 for *The Laverne & Shirley Reunion*, an hourlong special which, like the series' first episode, featured a guest shot by Henry Winkler.

In 2018, Penny Marshall lost her battle with heart disease, and Cindy Williams passed away suddenly in January 2023. Though their relationship, like that of many comedy teams, was difficult, Penny Marshall and Cindy Williams joined Lucille Ball as the most successful female comedians in television history.

Happy Days and *Laverne & Shirley* provided the biggest one-two programming punch ever, and ABC would turn to the shows' producers again and again in the hope that they could continue their winning streak. But possibly the most consequential spin-off from *Happy Days* is one that never came to fruition, as Fonzie's ascension would trigger an event that threatened to upend the entire series.

OPPOSITE:
In 1977, Parker Brothers, the makers of Monopoly, released a *Laverne & Shirley* board game.

ABOVE:
Long after the series ended, the pair made several professional and personal appearances together. Including the *Happy Days: 30th Anniversary Reunion*.

SEASON FOUR

At the Season Three wrap party, writer and producer Lowell Ganz got big laughs with the line "Ron Howard can send an audience into a frenzy with just three words: 'Here comes Fonzie.'" He was making light of the sensitivity everyone felt. ABC's new boss, Fred Silverman, had decreed that the show's future was resting on the shoulders of Fonzie's leather jacket . . . which led to ABC's desire to retitle the series *Fonzie's Happy Days*.

After Season Three, Leonard Goldenson, the founder and chairman of ABC, had come to Winkler offering to give The Fonz his own show. Winkler demurred, pointing out that the success of *Happy Days* relied on Fonzie's affectionate relationship with the Cunninghams. Goldenson then pitched the name change, which Winkler thought "was crazy" and felt would be a slap in the face to everyone else on the show. He added, "The show's a hit. How much more successful can you be by changing the name?"

And what did series star Ron Howard think of the idea? "Tom Miller and Eddie

> **"I THINK GARRY AND RON WOULD'VE LEFT HAD THEY MADE IT THE 'FONZIE SHOW'."**
>
> —BARBARA MARSHALL

OPPOSITE: Although "Fonzie Loves Pinky Parts I–III" scored with the home audience, the experience on set was far less memorable.

LEFT: Though Fonzie's character came to dominate the series, Winkler and Howard's relationship was more than harmonious.

Milkis had been designated as the ones to try to talk me into it. Garry was not there. They pitched it as, 'Hey, we'll let you direct episodes. They'll tear up your contract and give you a raise. Your billing won't change. Nothing will change that way. They just want to change the title of the show, and the creative direction is set.' I said, of course, I understand the characters evolve and you need to write toward the strengths of the show. I wouldn't ever want to suggest anything other than that, but it just makes it seem like I'm [a] supporting [player] on the show, then, and it's not what I bargained for. I would choose to go back to film school."

"I could tell they weren't happy with the answer," Howard continues. "But

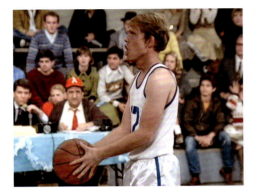

ABOVE: Richie Cunningham goes from hero to goat, when he misses a free throw with the game on the line in "A Shot in the Dark."

OPPOSITE: Fonzie's screen-worn coveralls.

PAGES 104–105: Richie and The Fonz talk "shop" in Fonzie's Garage by Mego.

when I left the room there was a little tension. I left, and Garry was waiting outside the door. He said, 'How did that go?' I told him how it had gone and what I had said, with all love and respect for Tom and Eddie and the show. 'Well,' he said, 'if this is not something you accept, the title won't change. I'll just promise you.' I said, 'Well, I appreciate that.'"

Barbara Marshall later confirmed her husband's position. "I think Garry and Ron would've left had they made it the 'Fonzie show'." Though ABC's name-change never went through, the incident festered in Howard's mind.

Bill Bickley returned to the series in the beginning of Season Four as a consultant along with his new writing partner, the show's former associate producer Michael Warren. Of the upheaval and its effects on Howard, Bickley shares a story about Howard showing up at his house one night. "I think he was upset about how upset he was." The issue and how it affected his standing in the industry haunted the young actor to the point where he developed a painful case of stress-related eczema on his eyelids. Bickley speculates, "I think at some point in the third season Ron really said, 'I'm going to use this to get what I really want,

> "I WAS DEFERRING MY DREAM . . . BUT I ALSO RECOGNIZED IT WAS A FANTASTIC GIG AND ONLY GETTING BETTER. BECAUSE OF HENRY, THE SHOW WAS TAKING OFF."
>
> —RON HOWARD

Season Four 103

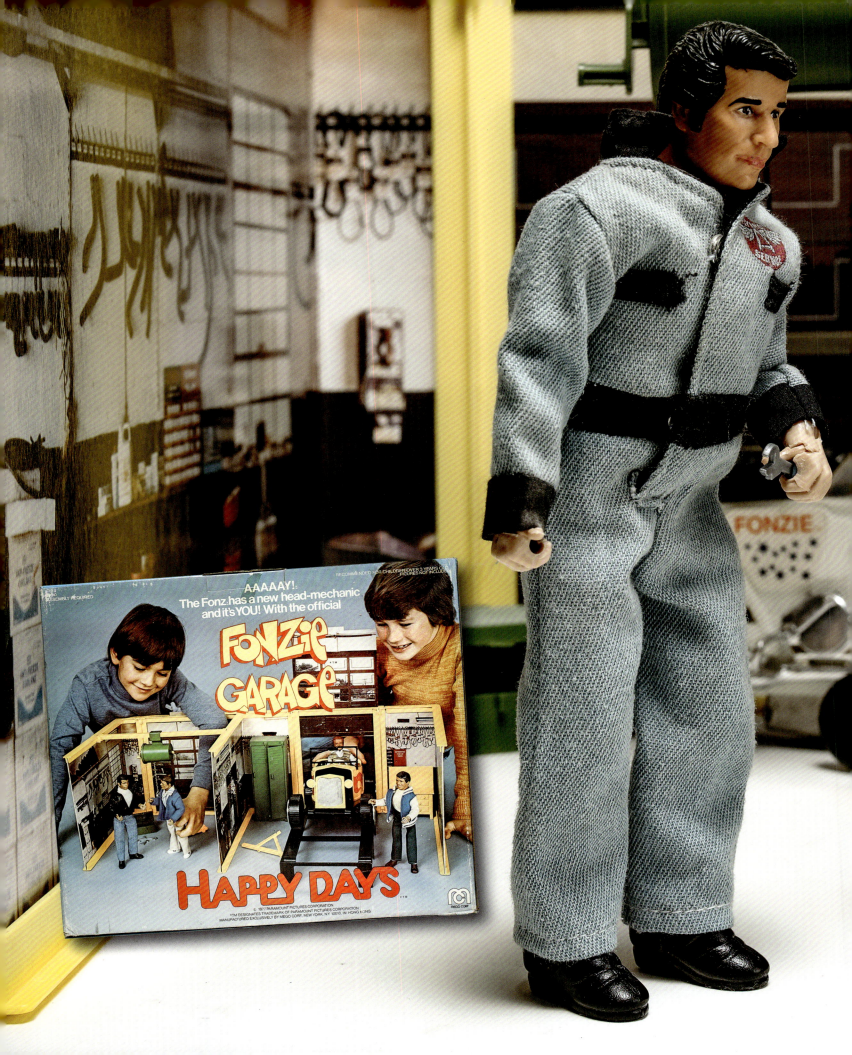

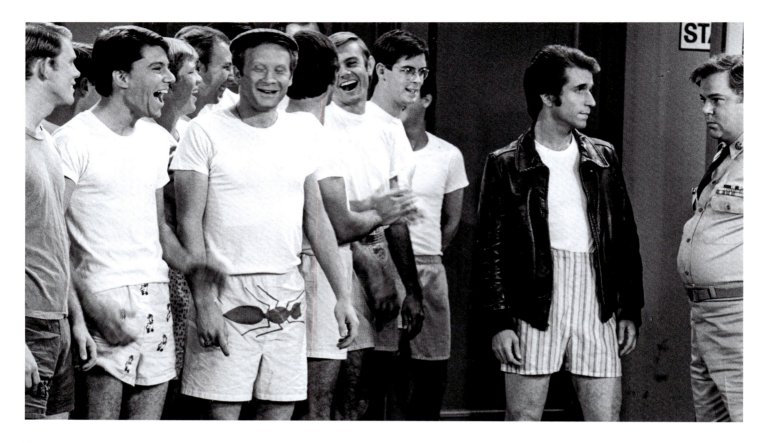

ABOVE: Fonzie and boys have their fitness assessed by the military in "The Physical."

OPPOSITE: Diana Hyland dated younger men onscreen in "Fonzie's Old Lady" and offscreen with John Travolta.

which is to be a director.' I think from that point, he had in mind that when the contract was up, he was going to leave and do everything he could in the meantime to be ready to make that transition."

Despite the barrage of questions from the media about how it felt to play second banana to The Fonz, Howard says, "No one made me feel that way creatively within the *Happy Days* family. Everything was great, but this was the perception, and I was feeling it from the networks and the studio. The combination of that pressure was a full-on paradox for me at a pretty young age, because I honestly really loved everybody on the show. I didn't love doing the show because I was deferring my dream to my mind, but I also recognized it was a fantastic gig and only getting better. Because of Henry, the show was taking off."

Indeed, *Happy Days* was on fire! The series climbed to the zenith of its ratings, finishing its fourth season as the nation's top show for the first time. Over thirty million viewers were tuning in every Tuesday night. To piggyback on the series' huge popularity, ABC began airing reruns of the show nationally on weekday mornings, under the title *Happy Days Again*. As the show thrived onscreen, there were several personnel changes behind the camera.

Lowell Ganz and Mark Rothman, who had guided the ship through Season Three's successful voyage, remained with their creation *Laverne & Shirley*, but continued to contribute by giving notes after run-throughs. Director Jerry Paris was named *Happy Days*' sole producer, solidifying his creative control of the set and guaranteeing that he'd have

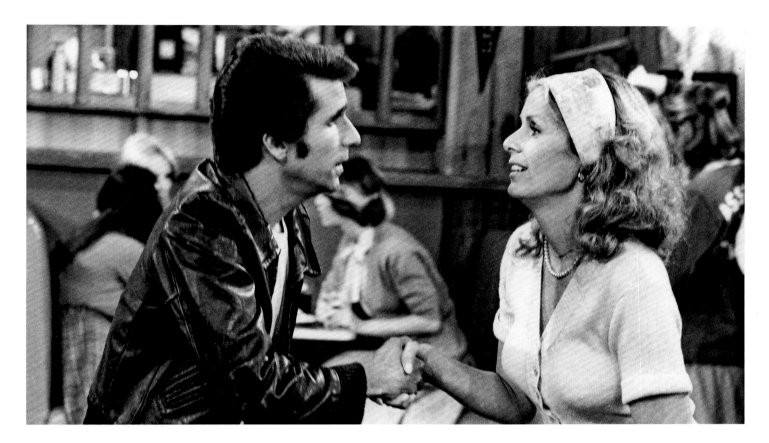

more input on story. With his multi-series empire continuing to grow, Garry Marshall brought on his father, industrial filmmaker Tony Marshall, to help supervise his productions. He also brought in his younger sister, Ronny Hallin, to oversee postproduction. Marshall's former writing partner, Jerry Belson, once quipped that "Garry's turned nepotism into an art form." And, finally, executive story editor Bob Brunner was teamed with Arthur Silver to supervise Season Four's twenty-five scripts. Today, Silver admits that he was ill-prepared for the task. "Six months before, I was getting coffee for these people . . . What a wreck."

The fourth season kicked off with three of the series' most fondly remembered episodes (except for those involved): "Fonzie Loves Pinky," Parts I through III. The storyline features The Fonz and motorcycle daredevil Pinky Tuscadero competing in (get this) a demolition derby sponsored by Howard's Leopard Lodge. There, they face off against the caped and plume-hatted Malachi brothers, played by Michael Pataki and Ken Lerner. Lerner would later appear in numerous episodes as Fonzie's former gang pal Rocco Baruffi. After winning the demolition derby, a triumphant Fonzie plans to marry Pinky, but their relationship ends when Pinky chooses her career over him, and Fonzie turns down the opportunity to join her on the road as her husband/manager. Fonzie explains that he can't see himself as "Mr. Pinky Tuscadero." He may have been head over heels about Pinky, but the entire cast wasn't as much of a fan of Roz Kelly, the celebrity photographer turned actress who portrayed a female version of Fonzie. Winkler took umbrage

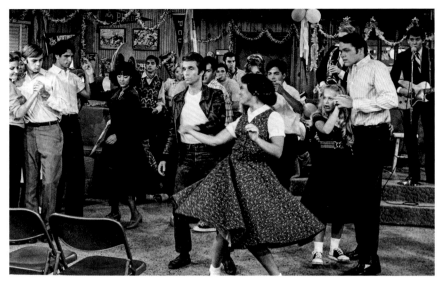

at her plagiarizing his "thumbs-up" signature, which still irks him.

Kelly had hardly been a unanimous choice for the role. Recently named Season Four showrunners Bob Brunner and Arthur Silver attended the final casting session, where the pair threw their support behind a young performer who'd already had a guest role on the show—future *Charlie's Angels* star Cheryl Ladd. Garry Marshall was vacationing with his family, so the decision fell to executive producers Eddie Milkis and Tom Miller.

Miller wanted Kelly to play the role of Pinky. But Silver and Brunner didn't agree, arguing vociferously that Fonzie would never sleep with someone with her looks, much less want to marry her. At that point, Milkis left the room. Moments later, Brunner and Silver received a long-distance call from Garry Marshall. They were told that Tom Miller "had a great eye and loved Kelly," and, furthermore, they were told they were now banned from casting.

Regardless of how the group felt about Kelly, when he saw the ratings, Tom Miller pushed Marshall, ABC, and Paramount to give Pinky her own series. Brunner and Silver wrote the pilot, and Silver cringes at the memory: "It's like a nightmare to me." Nevertheless, the pilot was shot, with Garry Marshall directing. Pinky never set foot in Milwaukee again, though her little sister, Leather (rock star Suzi Quatro), would appear the following season in a much more harmonious pairing.

Other Season Four standout episodes included "A Mind of his Own," where Fonzie seeks professional help dealing with his anger issues but struggles with eliminating them, and "AKA The Fonz,"

where Fonzie's nemesis Sgt. Kirk (Ed Peck) becomes sheriff—and vows to run all hoods out of town, including Fonzie. In other episodes, Fonzie shows his endurance in a dance marathon, finishing off his weary competition with a spirited high-kicking Hava Nagila. And he falls for an older, married woman played by Diana Hyland. At the time, Hyland was in a real-life relationship with John Travolta, who happened to be playing Fonzie's rival TV heartthrob Vinnie Barbarino on *Welcome Back, Kotter*.

Richie takes the spotlight in several episodes, including "A Shot in the Dark," where Richie leads Jefferson High's basketball team to glory, sinking a last-second shot for a win—only to be kidnapped by a rival school to keep him out of the next game . . . until Fonzie rescues him. Sadly, the hero turns to goat when he clanks a free throw that would've given Jefferson the win. Richie's dating woes continue despite Fonzie's efforts to bolster his

> "I SAID, 'RON, WE'VE GOT TO TALK ABOUT THIS. HOW DO YOU FEEL? YOU'RE THE STAR OF THE SHOW. THE FONZ IS TAKING OVER. HOW DO YOU FEEL? WE'VE NEVER TALKED ABOUT THIS.'"
>
> —HENRY WINKLER

ABOVE: When Officer Kirk is promoted, his campaign to rid Milwaukee of its hoodlum population is thwarted when Fonzie's many friends teach Kirk a lesson about discrimination on the basis of appearance.

OPPOSITE (TOP): Fonzie cuts a rug with Joanie and eventually outlasts the competition in a grueling dance marathon in Season Four's "They Shoot Fonzie's, Don't They?"

OPPOSITE (MIDDLE): Mrs. C takes a job in Arnold's in "Marion Rebels."

OPPOSITE (BOTTOM): A shrink advises The Fonz to sublimate his aggressions into building birdhouses in the episode "A Mind of His Own"...the treatment wasn't successful.

Season Four 109

ABOVE (L): Fonzie managed to pass his final Night School exams and join Richie, Potsie, and Ralph at their high school graduation.

ABOVE (R): A close call in a stock car race leads The Fonz to be baptized by Father Delvecchio in "Fonzie's Baptism."

OPPOSITE: The Mego Fonzie figure, with articulated "thumbs up" action, fit perfectly on his Harley.

friend's confidence, even setting Richie up with Wisconsin's pinup "Cola Girl." But, like most of Richie's dating escapades, these attempts crash and burn.

Richie wasn't the only one not getting much love. Ron Howard—the glue that held the show together in front of and behind the camera—wasn't either. Arthur Silver recounts seeing at a rehearsal how network and studio reps were all hanging out with Howard until they spotted Winkler, and the pack left in a cloud of dust to fawn over their "golden boy." Silver sighs, "They just deserted Ron . . . It was horrible." The coup de grâce was what Henry Winkler characterizes as "the wallet incident."

As a Christmas present from ABC, the cast members of their top-rated series were gifted Gucci wallets—all except Henry Winkler, who received an expensive ¾-inch videotape player. Ron Howard calls the slight "sickening." On behalf of the cast, Howard placed an angry call to ABC talent coordinator Bob Boyett (who in 1981 would become an executive producer on *Happy Days*, along with his partner in business and in life, Tom Miller). Howard chastised Boyett for "creating imbalance and disturbing the equilibrium that was our show." Howard recalls, "I explained that whatever's happening with the audience and the media is great for the show, [but] we still feel that we're an ensemble . . . and you're disrupting it when you do something like this." Howard punctuated his response by sending his wallet back. Laughing, he adds, "I thought everyone would send their wallet back, but no one else did."

Howard struggled with his feelings about the perceived change in his status and often sought the counsel of his family and others, but he had never broached

the subject with Henry Winkler—until Howard gave his co-star a ride home in his 1970 VW Bug from a location shoot for the Season Four opener. According to Winkler, "I said, 'Ron, we've got to talk about this. How do you feel? You're the star of the show. The Fonz is taking over. How do you feel? We've never talked about this.' He was very honest with me. He said, 'Here's the thing, you never did anything to make yourself great. You never did anything to make other people feel bad. You were just being you. You were funny, you were good. It's good for the show, but it bothered me.'" Winkler understood, and the pair ended the conversation by declaring how much they loved one another.

Winkler and Howard's relationship, forged on day one, remains as warm and close today as it was during the series' heyday. Henry Winkler is the godparent to Ron Howard's four children, and they maintain a busy text chain with Anson Williams and Don Most. Today the Academy Award–winning director says, "When I look at it with any perspective, I'm really grateful to Henry and grateful for the entire experience, but when I was in the middle of it, it was complicated. But over the course of making this show and then my leaving the show, and Henry agreeing to star in *Night Shift*, that journey definitely changed my life on a lot of levels. I grew from it, I benefited from it, it fueled me. Then, at the end of the day, that movie would prove to be a turning point in my adult life, my career . . . The movie was green-lit because Henry said, 'Yes, I'll do a movie directed by Ron Howard.'"

Today, Winkler still owns the tape deck and Howard still owns his VW Bug.

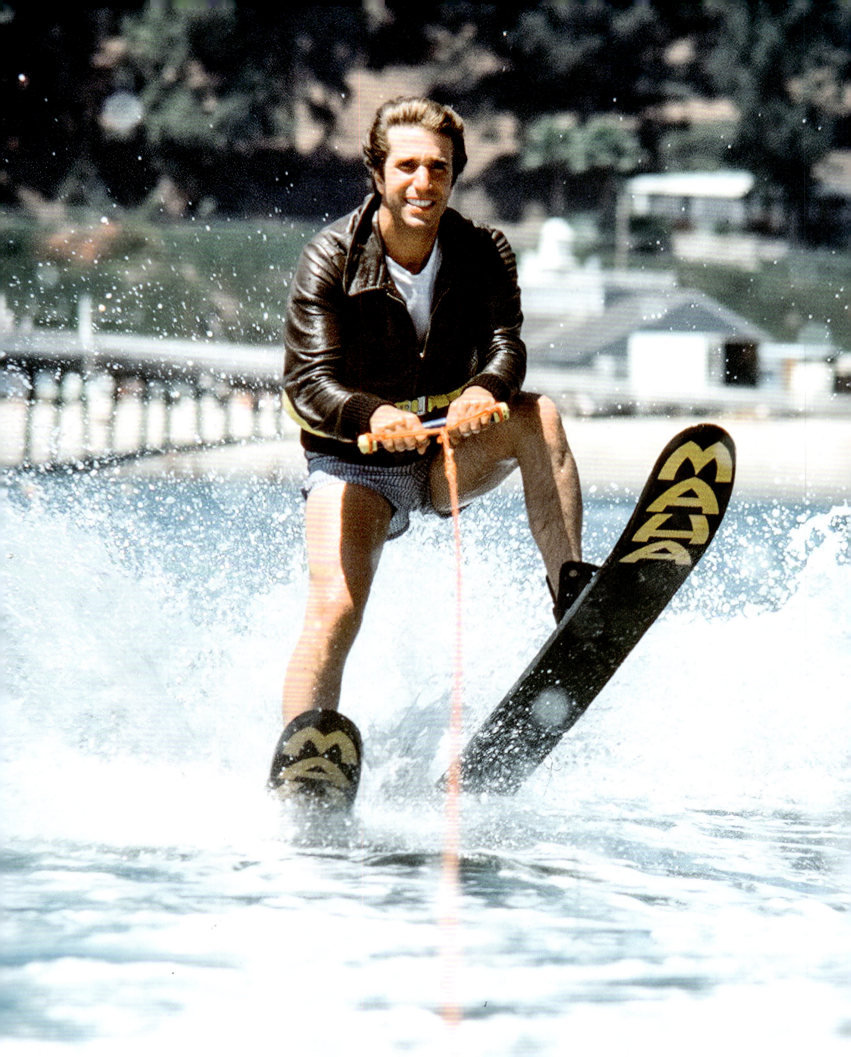

SEASON FIVE

Happy Days' pivotal fifth season featured its highest-rated episode of all time, which would also become its most controversial: where Fonzie jumps the shark! There were changes happening behind the scenes as well. Executive producer Garry Marshall began a strategic withdrawal from the day-to-day production of the show, turning it over to his lieutenants, writer-producer Bob Brunner and director-producer Jerry Paris. Onstage, soon-to-be heartthrob Scott Baio joined the cast as Fonzie's nephew, Chachi Arcola.

Baio remembers his first day on the set. He and his father walked in during a rehearsal in the Cunningham living room. "My father and I stood there like two bumps on a log, not really knowing what to do." Henry Winkler was the first to notice them. He welcomed Scott Baio onto the show with a big hug, shook Mario Baio's hand, and told them if they needed anything to just let him know. The warmth with which he was greeted, says Baio, "really took a lot of stress off me."

Winkler was quick to take Baio under his wing. "In the very beginning he would invite my parents and I over to his house—make us dinner and hang out. His stepson Jed became like my little brother . . . I owe a tremendous amount to Henry." Despite Winkler's warm welcome, Baio dreaded his first appearance in front of the studio audience. "There was a red light there. The cue light. I was standing backstage, hoping that the set would burn down before the cue light would go off. The light came on and all I remember is walking out of the scene. My lines were about selling cashmere ties made of

OPPOSITE: Fonzie would never have jumped the shark unless Winkler's father hadn't badgered him to tell Garry Marshall about his prowess on skis.

LEFT: Richie and the guys finally graduated from Jefferson High and headed directly for the University of Wisconsin–Milwaukee . . . but continued to live with their parents.

> **"I WAS STANDING BACKSTAGE, HOPING THAT THE SET WOULD BURN DOWN BEFORE THE CUE LIGHT WOULD GO OFF."**
>
> —SCOTT BAIO

ABOVE (L): When Richie and Fonzie get stuck in the girl's dorm after curfew, they slip into women's nightgowns to avoid detection... until Ralph and Potsie's "panty raid" spoils their escape.

ABOVE (R): Richie and college girlfriend, Lori Beth (Lynda Goodfriend), shine in a highly charged Apache dance in musical episode, "Be My Valentine."

OPPOSITE (R): In "Hollywood Part III," Warren Berlinger directs Fonzie's unsuccessful screen test for Paramount Pictures.

OPPOSITE (L): But it was Richie Cunningham who was offered a contract after playing opposite The Fonz in his screen test.

PAGES 116–117: When Don Most read the script, he shook his head and asked, "He's jumping sharks now?" Fonzie did... with over 30 million viewers holding their breath.

genuine Orlon ... but I don't remember saying anything."

Another big change in Season Five: Richie, Ralph, and Potsie finally graduated from Jefferson High, then headed to the University of Wisconsin, Milwaukee, where Richie's dating life continues to stall. Luckily, Fonzie takes his pal to one of his top pickup spots—the university's library. There Richie meets Lori Beth Allen (Lynda Goodfriend). The couple would go on to date and ultimately marry. During the episode, The Fonz proudly trumpets his acquisition of a "li-bary caad," which led to a huge, real-life surge of kids acquiring their own.

Pat Morita had left the series to star in ABC's ill-fated *Mr. T and Tina*, so the producers arranged for Arnold's Drive-In to be sold to Al Delvecchio, played by *The Odd Couple*'s Al Molinaro. Season Five also introduced the manic energy of Robin Williams as the alien Mork from Ork and produced what has become the series' most infamous episode.

The fifth season fall opener was a heavily promoted, three-part episode spread over two weeks: "Hollywood Parts I–III." In these episodes, a talent scout from Paramount Studios witnesses Fonzie's effect on women and offers him a screen test. With the rest of the cast in tow, Fonzie flies to Hollywood where, in the end, he is not offered a studio contract but, inexplicably, Richie Cunningham is. In an ode to the 1960s beach movies starring Frankie Avalon and Annette Funicello, Fonzie forms a rivalry with the "California Kid," a cocky, tanned Malibu blond played by *Animal House*'s James Daughton. Their competition escalates until finally, you guessed it, on water skis but still clad in his leather jacket, Fonzie jumps the shark.

Five decades later, according to the *Oxford English Dictionary*, "'Jumping the shark' is when a TV series passes its peak and the viewer senses a noticeable decline in quality or feels the show has undergone too many changes to retain its original charm."

Today, Winkler vehemently dismisses the concept. But any debate could have been avoided had Winkler not succumbed to the constant badgering by his father, Harry, to "tell Garry Marshall you water-ski. Tell him you were a water-skiing instructor at camp." Winkler finally gave in. "The next thing I know, I'm on water skis." So, was this truly the moment when *Happy Days* lost its mojo? Perhaps the answer is both yes and no.

Yes, admittedly there was no other place for *Happy Days* to go but down from the pinnacle that it had attained. By the fifth season, *Happy Days* had left the 1950s and entered the tumultuous '60s. The "boys" were no longer teenagers and Winkler was turning thirty-three. The series' writing has never been considered as ambitious as that of fellow ABC shows like *Barney Miller* and *Soap*. But by the fifth season, there was a tendency for the series to rely on "runners," expressions and catchphrases the show popularized like "nerd" and "sit on it." And too many episodes relied on the seemingly endless stream of Fonzie's abilities.

Still, *Happy Days* and *Laverne & Shirley* were the top two shows in all of television and both would continue to be in the top-twenty for another four seasons. Going forward, there weren't as many outstanding episodes, but every season had its share of memorable ones. As the show aged, the raw energy that powered its rise to the top became more difficult to sustain. But *Happy Days* also became much more capable of packing a genuine emotional punch. Advertisers still coveted the series' demographics and audiences continued to clamor for The Fonz. "Hollywood: Part III" was only the ninety-first episode, and there would be another 164 before the Smithsonian took custody of Fonzie's leather jacket. But "jumping the shark" might have been the moment when *Happy Days* discovered its first gray hairs.

The fifth season produced many other memorable episodes. Music was

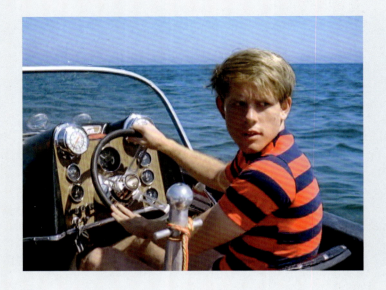

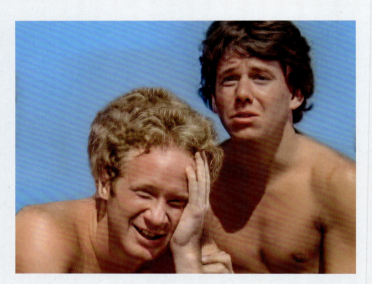

116 50 Years of Happy Days

Season Five

RIGHT: In 2004, Figures Toy Company offered an entire *Happy Days* line (see page 119) including this limited edition figure of The Fonz in leather jacket and bathing suit. Shark not included.

OPPOSITE: The Figures Toy Company *Happy Days* series turned virtually the entire cast into larger-than-life miniatures.

PAGE 120: Figures Toy Company's *Happy Days* series also included a limited edition Fonzie in his Falcons Jacket, as seen in "Our Gang," which flashed back to how Richie first met Fonzie, an event that would dramatically change both of their lives.

PAGE 120 (LOWER-L): AAAY! Be the coolest cat in your nursery school on the "Fonz-cycle" trike.

PAGE 121: Does this look like a man who thinks he's "jumped the shark"?

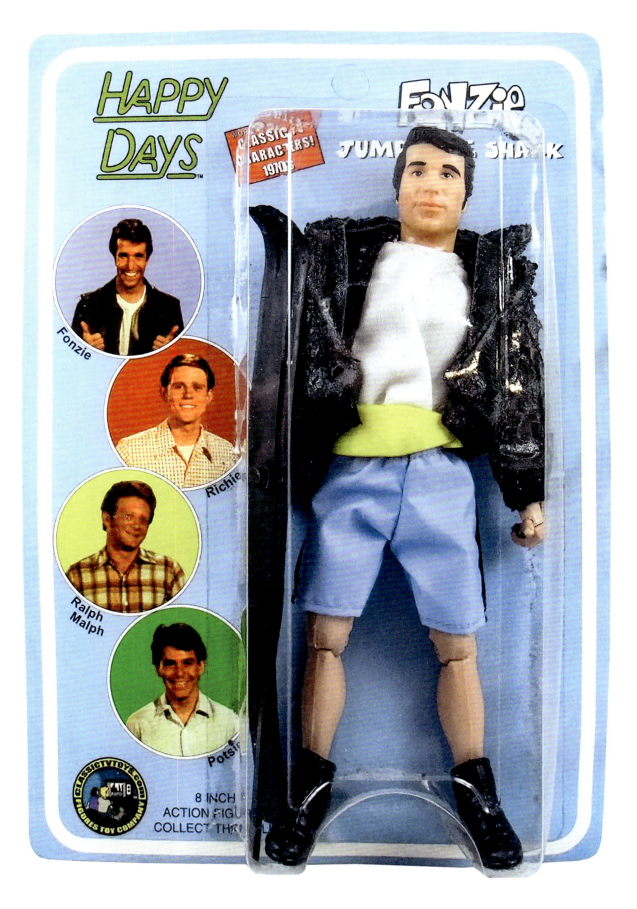

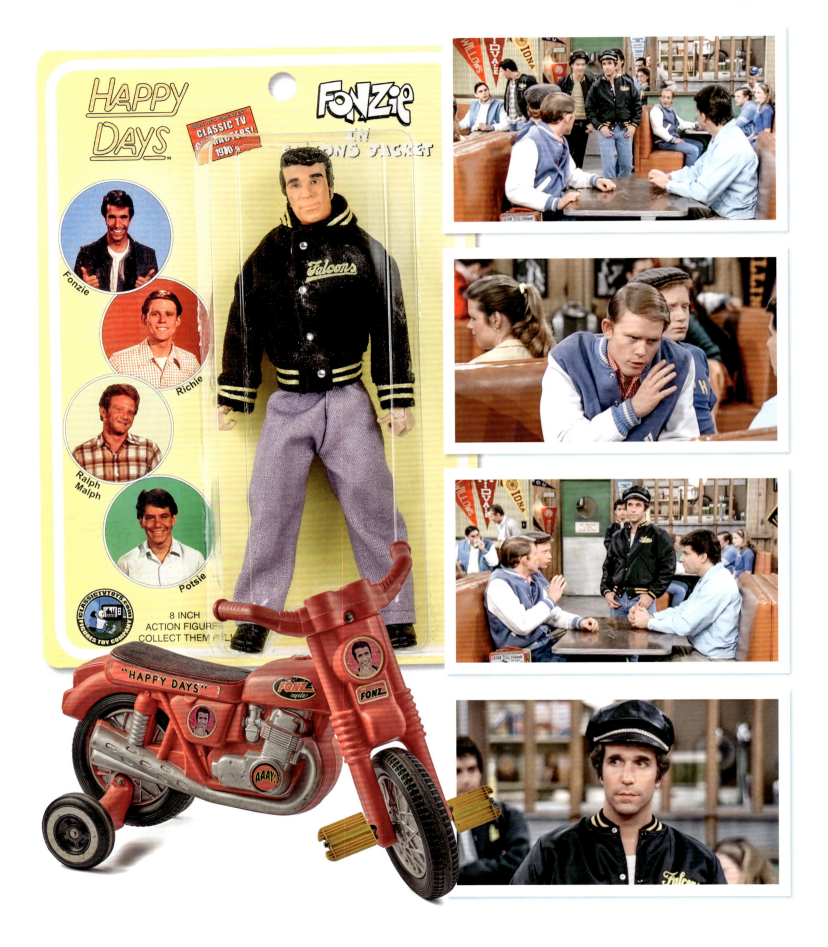

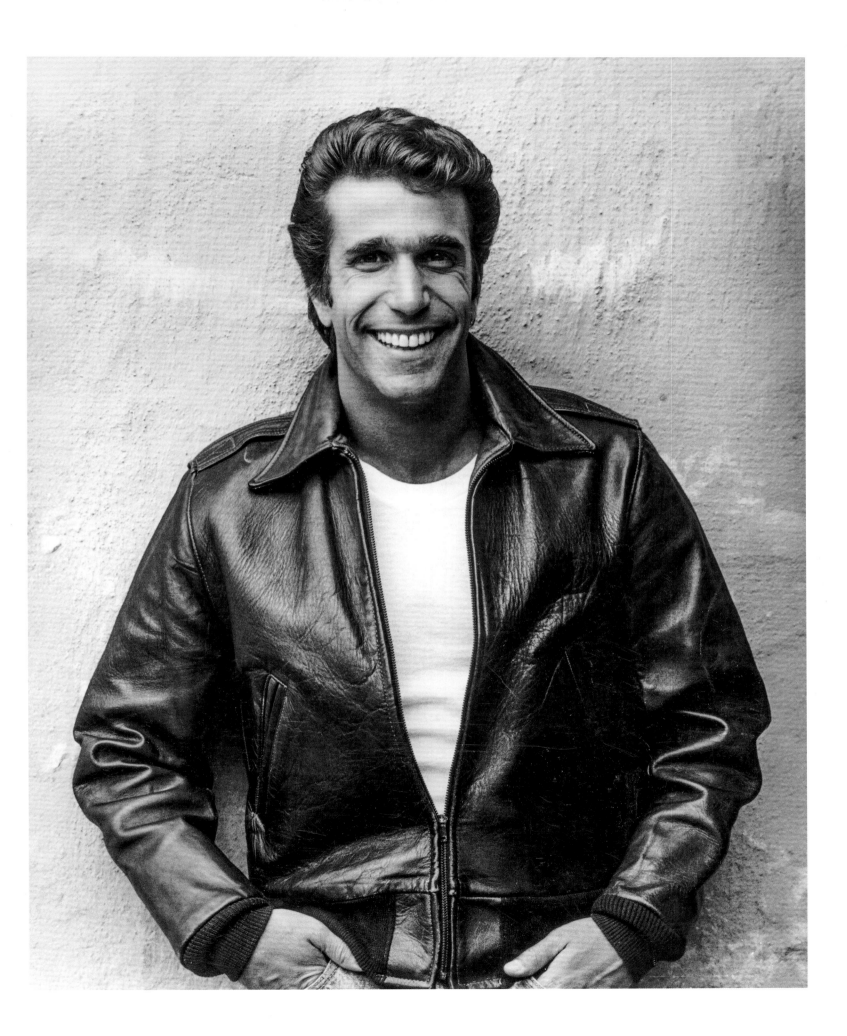

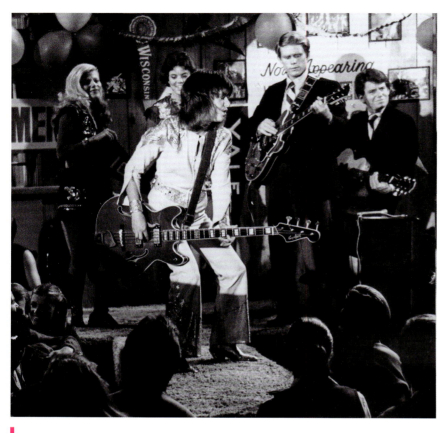 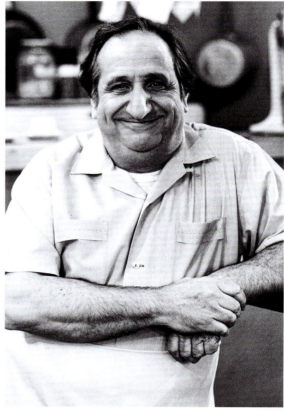

ABOVE: Season Five newcomers included real-life rocker Suzi Quatro, as reform school rad Leather Tuscadero, who was a much bigger hit with the cast and crew than her fictional sister Pinky had been, and Arnold's new owner Al Molinaro as Al Delvecchio.

OPPOSITE: Scott Baio's Chachi Arcola went "waa waa waa" for Joanie Cunningham, but it would take two seasons for her to agree to go out with him.

PAGES 124–125: Baio and Moran's characters' relationship had numerous ups and downs . . . as well as in real life.

at the forefront of several stories, too. Rocker Suzi Quatro made her debut as Leather Tuscadero, the younger sister of Pinky—fresh from reform school and trying to launch her performing career with a boost from the Cunninghams and Fonzie. For a Valentine's Day episode, *Happy Days* transformed into a full-fledged musical featuring everything from Richie and Lori Beth's Apache dance to Howard and Marion's recitation of *Gigi*'s "I Remember It Well." The episode's grand finale featured the entire tuxedo-clad cast singing a rousing rendition of Rodgers and Hart's "Isn't It Romantic?"

Anson Williams, whose 1977 single, "Deeply," cracked the Billboard Hot 100, was performing on weekends and let his '50s-style hair grow out. Ron Howard took notice of the change. "Anson, you look like you should be on *The Partridge Family*" and Anson replied, "They're not paying me enough to cut my hair." "Period look" be damned, soon all the guys let their hair grow out. Williams seized the spotlight several times to display his vocal prowess, including in the Season Five episode "Potsie Gets Pinned," which concluded with a duet between Williams and actress Lorrie Mahaffey. The pair's onscreen romance led to an offscreen marriage.

Scott Baio's Chachi was slowly integrated into the show, and his immediate (unrequited) attraction to Joanie Cunningham set the table for the couple to step into the center of the series down the road. Richie's early college days provided fresh storylines, kicking off with Richie and Fonzie masquerading as co-eds when they find themselves trapped in a female dormitory after

hours. Richie also pledges a fraternity and turns investigative reporter for the college's paper.

One of the season's funniest offerings was "Requiem for a Malph" by occasional *Happy Days* writer Steve Zacharias. Fonzie arranges for the spineless Ralph to be pummeled in a boxing ring by muscle-bound actor Reb Brown, who would go on to star as the title character in the 1979 TV movie *Captain America*. Most displayed a deft physicality in Jerry Paris's choreographed battle. Don Most reveals, "I was very different in real life from my character. I was not the jokester that Ralph was." Most was very contemplative and worried constantly about his performances. Speaking affectionately of Most, Lowell Ganz expresses feelings that almost everyone on the show shared: "Even though he was scared, he loved being in front of the audience. He had good jokes and he delivered them well. I thought he was happy . . . or as happy as Donny is capable of being." And Anson Williams says of his friend, "Donny is way underrated. He just was a genius on the show, so entertaining, so funny."

Producer Bob Brunner was a large man with a gravelly voice and sad eyes, his go-to weapon was sarcasm, and he fired it constantly. By nature, he was a brawler, and he and Jerry Paris often butted heads over the execution of material. It would sometimes reach a point where Garry Marshall had to step in and referee. Brunner felt that Richie Cunningham was the glue that held *Happy Days* together and was a huge fan of Ron Howard. Even though he helped to create Fonzie's character, Brunner never clicked the same way with Henry Winkler.

ABOVE (L): Potsie "pinned" Jennifer Jerome, and Anson Williams wed Lorrie Mahaffey.

ABOVE (R): Ralph Malph hangs on for dear life in "Requiem for a Malph", the series' 100th episode.

OPPOSITE (L): Marion Cunningham does everything in her power to heat up their marriage in "Marion's Misgivings."

OPPOSITE (R): The Happy Days cast graciously ceded the spotlight to guest star Robin Williams, an appearance that would launch the young comedian's career into the stratosphere. He would return for another visit in Season Six.

PAGES 128–129: Another indication of Happy Days' rising popularity is represented in this assortment of magazines from around the world.

PAGES 130–131: Jefferson High jacket worn by Anson Williams and a reminder of Fonzie's past as a member of a gang called the Falcons.

INSIDE GATEFOLD: A wide assortment of Happy Days memorabilia.

PAGES 132–133: In 1978, Nehi Beverages (the makers of Royal Crown Soda) issued two sets of Happy Days branded cans of various flavors.

Under Brunner's stewardship, Richie Cunningham became more independent and less reliant on Fonzie, which equalized their relationship dynamic. This was demonstrated in an episode called "Our Gang," which flashed back to how Richie and Fonzie first met—a confrontation that led to a "rumble," with Richie convincing The Fonz to leave his gang and follow his own path.

That same year, the show turned what certainly looked like it would be the series' worst episode of all time into one of its finest. When Garry Marshall acquiesced

> **WILLIAMS READ AGAIN. INCREDIBLY, HE STAYED ON SCRIPT. PARIS WAS SO BLOWN AWAY, HE RUSHED WILLIAMS TO THE SET BEFORE A CONTRACT HAD EVEN BEEN OFFERED.**

to his eight-year-old son Scotty's desire to see a "spaceman" on Happy Days, it eventually led to Robin Williams's breakout performance as Mork from the planet Ork. Months earlier, executive story editor Joe Glauberg had warily taken the assignment, groaning, "I'll do it, but it'll be painful." Presented with the script, the cast gave their most dispirited reading to date. Both John Byner and Dom DeLuise passed on playing Mork from Ork. And actor Henry Polic II made it through a single rehearsal before he quit.

With only three days before the audience arrived for the next episode, Happy Days casting director Bobby Hoffman and associate producers Ronny Hallin and Gary Menteer furiously worked the phones, begging agents to bail them out. Alan Iezman represented a young comic who did a bit as a Martian as part of his act. Hallin replied, "Send him over, now!" By 11 a.m., Williams had auditioned for the group, who immediately summoned Jerry Paris from the set. Williams read again. Incredibly, he stayed on script. Paris was so blown away, he rushed Williams to the set before a contract had even been offered.

Given the opportunity, Williams

 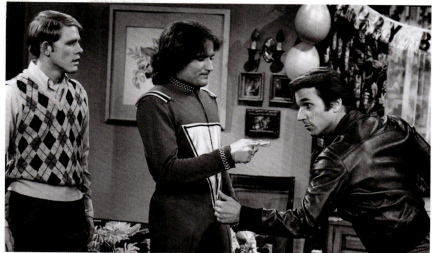 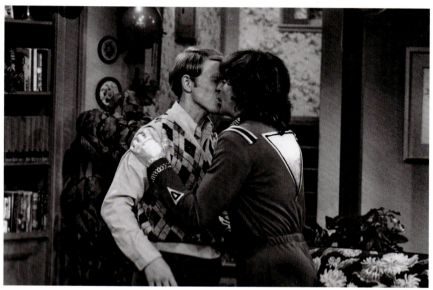 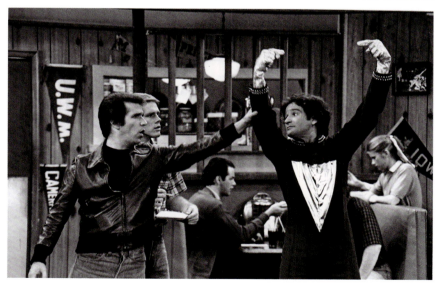

continued to dazzle. Most show's casts would have tossed this wild, improvising dynamo off the lot—but, recognizing a unique and original talent, the *Happy Days* group graciously ceded the spotlight to him. Winkler remembers the day well: "My only job was not to laugh and get out of the way, because you knew you were in the presence of greatness." Four hours later, the Wednesday run-through was a breathtaking, unforgettable experience, with Jerry Paris and the entire cast rising to meet the challenge posed by this soon-to-be comedy great.

The writers and producers left the run-through excitedly calling for a spin-off series, and indeed, in the fall of that year, *Mork & Mindy* would beam into America's living rooms.

At the end of its fifth season, *Happy Days* was again nominated for multiple Emmy Awards. For the third year in a row, Henry Winkler was up for Lead Actor in a Comedy Series, and was joined by nominees Tom Bosley for supporting actor and Jerry Paris for directing. But the sole Emmy awarded in the series' history would go to editor Ed Cotter for the emotional episode "Richie Almost Dies."

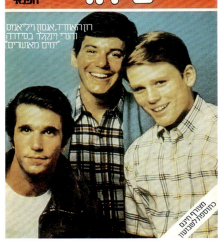
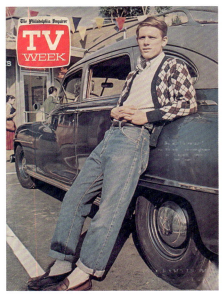

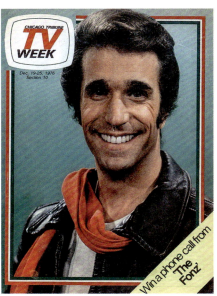

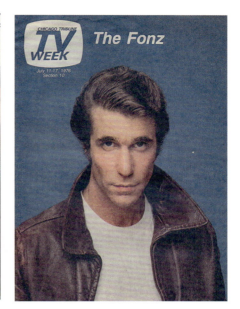
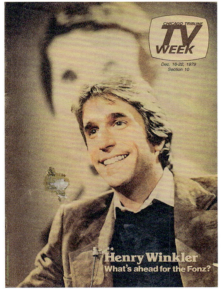
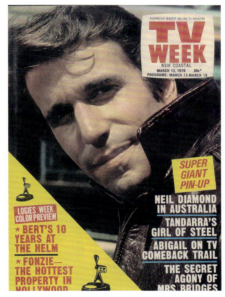

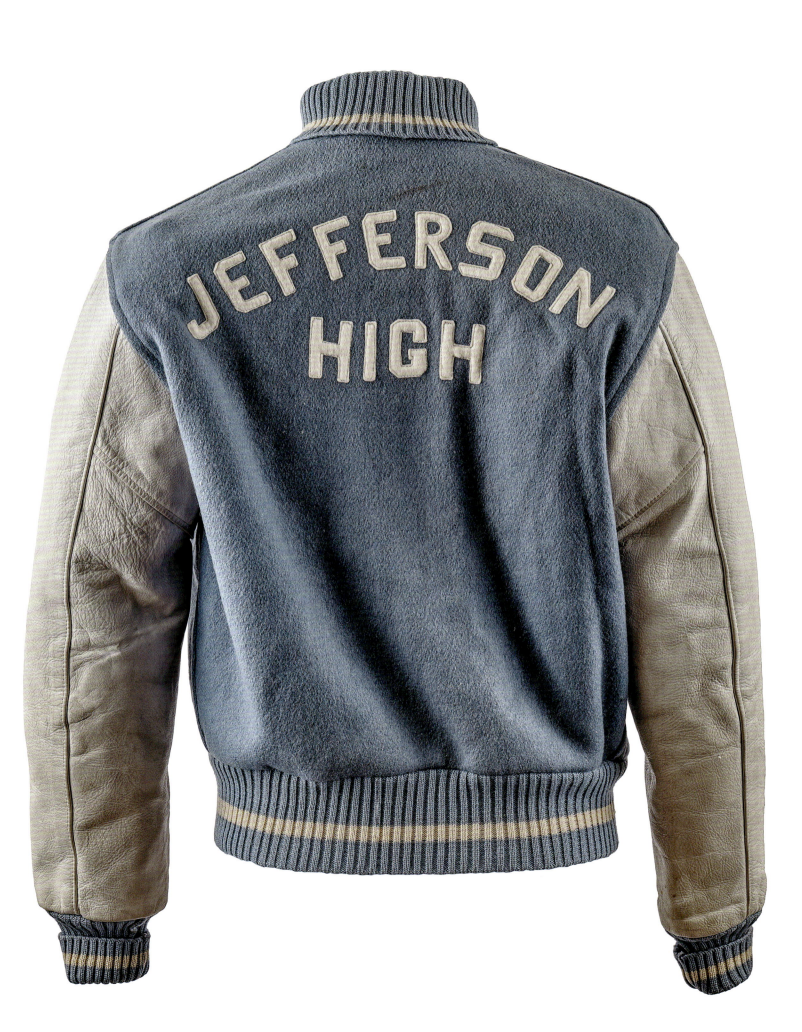

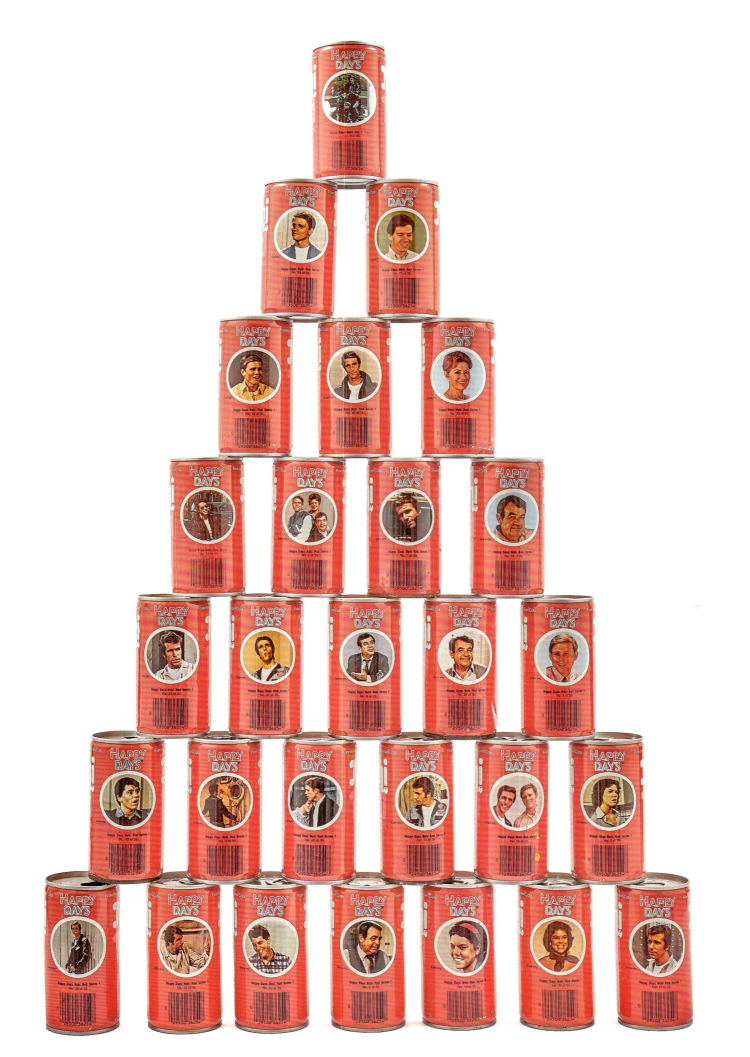

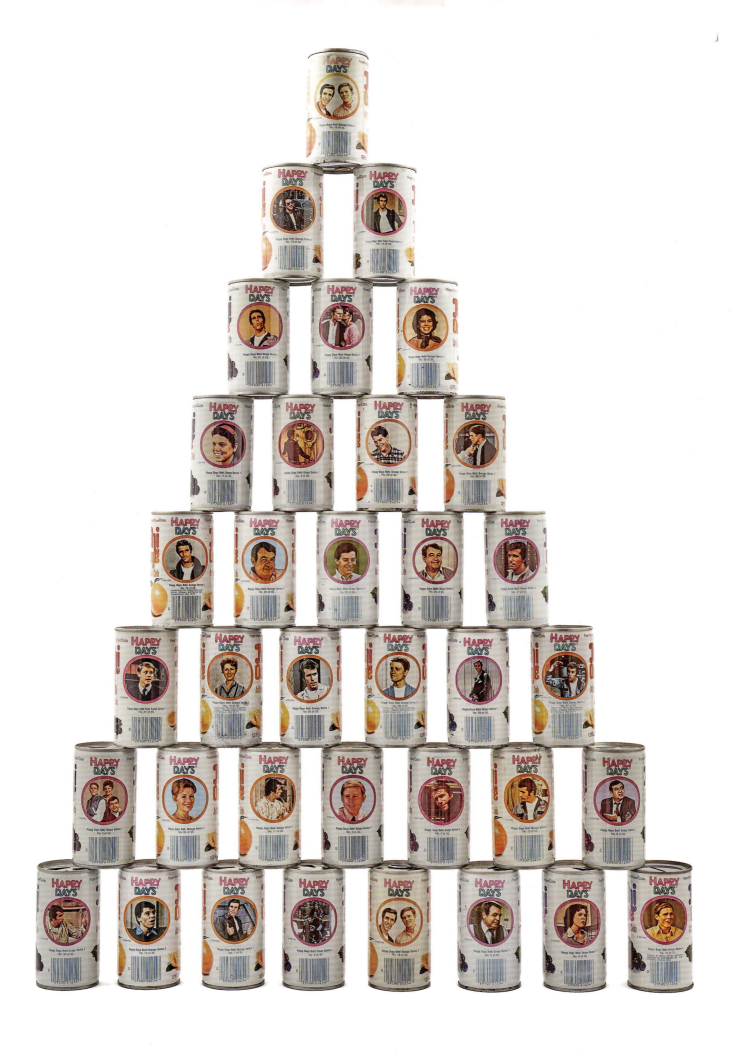

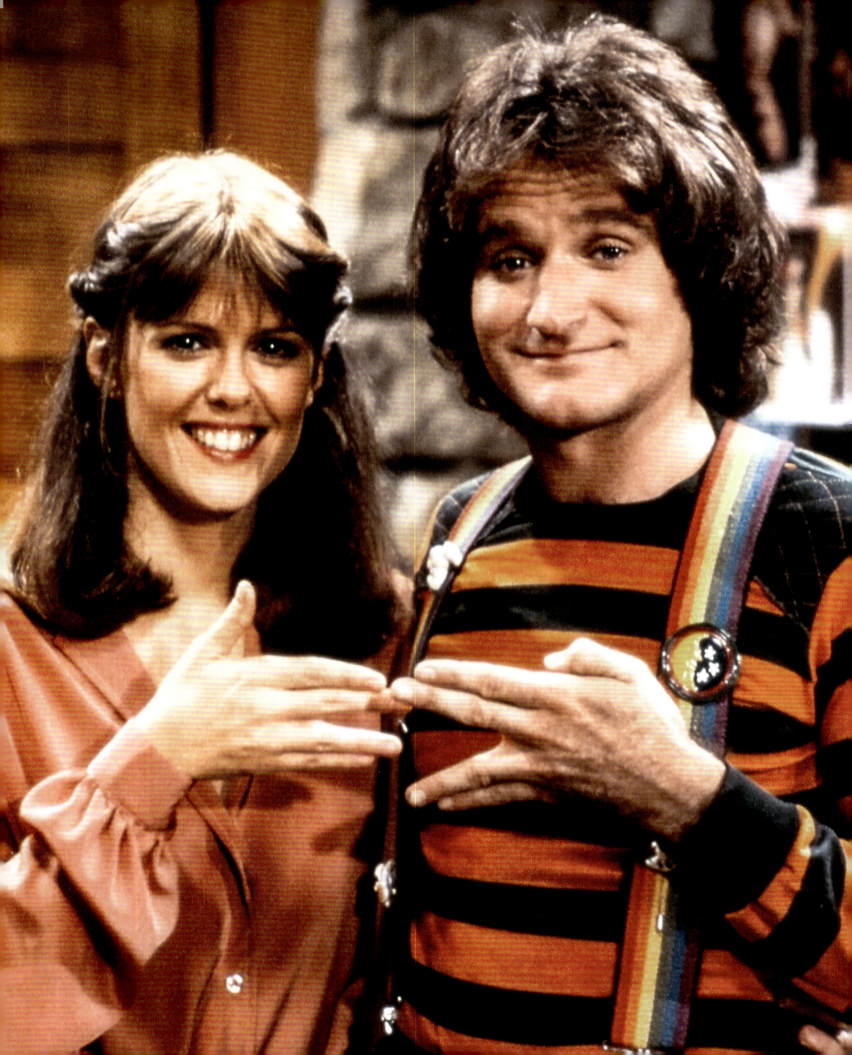

SPIN-OFFS
PART TWO
MORK & MINDY

Robin Williams's appearance during the fifth season of *Happy Days* was the guest shot heard around the world. Williams's last-second casting as Mork in the episode titled "My Favorite Orkan" gave Williams free rein to display his improvisational, rapid-fire wit, free association, impressions, wordplay, and graceful physicality.

Paramount and ABC felt the gust of comedy wind at their backs and clamored for more of the character, who seemed to be a combination of Groucho Marx and the Flash. No pilot was shot for the series. Instead, Garry Marshall sold *Mork & Mindy* with a presentation where he combined Williams's footage from *Happy Days* with clips from an unsold Paramount pilot, *Sister Terri*,

PAM DAWBER DIDN'T EVEN KNOW *MORK & MINDY* EXISTED UNTIL SHE WAS SHOCKED TO READ ABOUT IT IN THE *DAILY VARIETY*.

OPPOSITE: Mork's signature greeting "Na-Nu, Na-Nu" was appropriated from fellow Paramount alien, *Star Trek*'s Mr. Spock's "Live long and prosper" hand gesture.

LEFT: (clockwise from top left) Mork's 1981–82 cast featured Elizabeth Kerr (Grandma Cora Hudson), Robert Donner (the "prophet" Exidor), Conrad Janis (Mindy's father, conductor Fred McConnell), Dawber, Jonathan Winters (the couples' infant son), and Williams.

about a contemporary plain-clothed nun. It starred model-turned-actress Pam Dawber. A voiceover announcer asked what happens when "an adorable, down-to-earth earthling takes in a wacky, superior being from another world." Based on the brief presentation, ABC ordered thirteen episodes for the 1978 fall season. Pam Dawber didn't even know *Mork & Mindy* existed until she was shocked to read about it in the *Daily Variety* that it had been sold to ABC. She

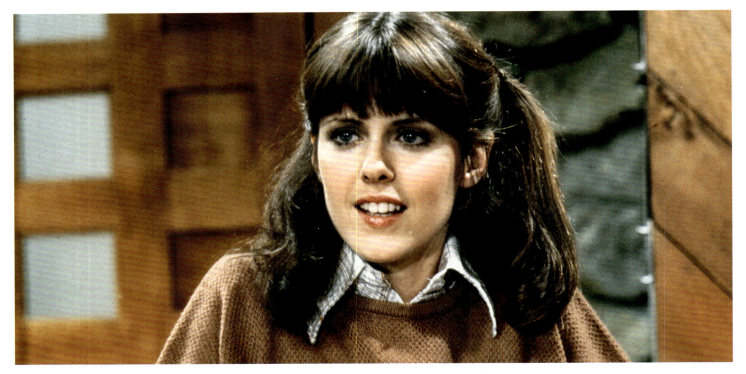

ABOVE: Before *Mork & Mindy*, Pam Dawber's acting resume included the *Sister Terri* pilot, Robert Altman's film *A Wedding*, and numerous shampoo commercials.

OPPOSITE: (clockwise from top left) Every episode concluded with Mork reporting to Orson, his unseen superior, about what he'd learned that week.

Mork's fourth season musical proposal became the series' title card.

When the pair were married, Mork had to learn how to sleep in a bed rather than hang upside down.

A national contest was held to name Mork and Mindy's son; the winner…"Mearth."

Mork and Mindy's nuptials provided the series with a much needed ratings boost.

and Robin Williams never even met until they were flown to Boulder, Colorado, to shoot the series' main title sequence. *Mork & Mindy* debuted Thursday, September 14, 1978, featuring crossovers by two of their sitcom "cousins," The Fonz and Laverne DeFazio.

And the show's premiere ratings were out of this world. *Mork & Mindy* became the second *Happy Days* spin-off to debut as television's top-rated series. It was a critical success as well. Wrote the *Los Angeles Times*' Lee Margulies, "*Mork & Mindy* is a prime contender for best new comedy of the season. Tonight's episode is nothing less than uproarious. The reason can be summed up in two words, Robin Williams. He's fantastic—wild, inventive, and unpredictable. He's a major comedic talent."

Mork's sartorial style was copied from Williams's personal wardrobe—colorful long-sleeve T-shirts with multicolored suspenders holding up baggy thrift-store pants. This look was quickly duplicated on dolls, action figures, trading cards, lunchboxes, radios, T-shirts, and officially licensed suspenders, which flew off shelves. *Mork & Mindy* finished its first season tied for third place with its parent, *Happy Days*, and a weekly audience of over twenty-one million viewers. Joe Glauberg, who'd reluctantly penned Mork's initial *Happy Days* episode, retired shortly thereafter.

In 1976, after breaking up with a girlfriend, Williams had begun doing stand-up comedy as an outlet for his heartbreak. When the twenty-six-year-old became a last-second hire on *Happy Days*, it provided the resourceful Williams with a character, opportunity, and freedom to display every facet of his talents. Williams's freewheeling associations and the broad range of characters he had developed in comedy clubs found a welcome forum on the Paramount lot.

Pam Dawber's flight to the planet

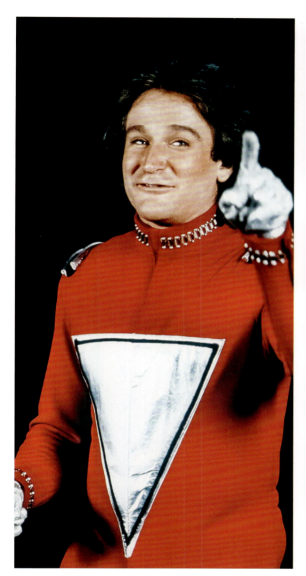
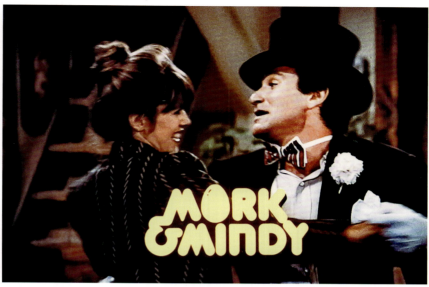
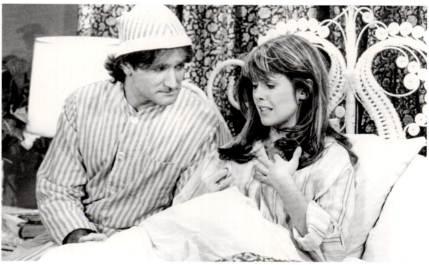
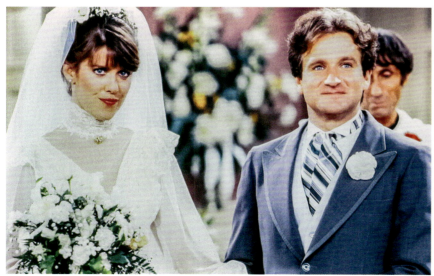

Spin-offs: Mork & Mindy

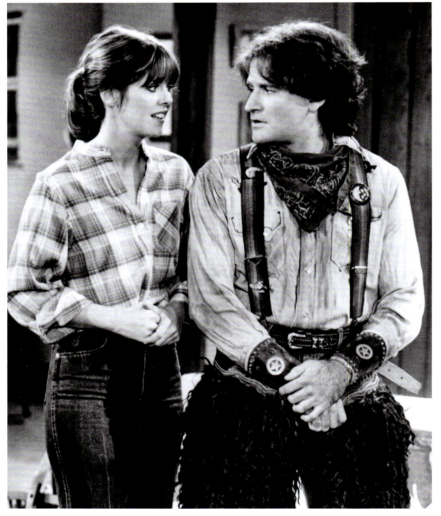

Ork took an unconventional course. She began modeling in car shows before she was signed by the Wilhelmina modeling agency. After appearing in dozens of ads, Dawber was signed by ABC to its talent development program. From there, she appeared as the bride in Robert Altman's *A Wedding* before landing *Sister Terri*.

Shortly before production began, onetime stand-up comedian Howard Storm was signed to direct the series' initial episodes. Storm and Williams spoke the same comedy "language," making Storm the perfect choice to help shape Williams's wild improvisations. Garry Marshall supervised every aspect of the show's first eight programs before handing the wheel to his former *Dick Van Dyke Show* cohort writer Dale McRaven.

Many of *Mork & Mindy*'s early episodes were some of its boldest, including: as Mork falls in love for the first time—with a mannequin. After being moved by the emotions displayed at a funeral, Mork brings the deceased back to life. To cure Mindy's grandmother (Elizabeth Kerr) of her loneliness, Mork transforms into an elderly man, and they date. And when a hooded group of hate-mongers who call themselves "Pure Power" try to recruit the naive Mork, he teaches them a lesson, when, upon removing their hoods, they discover that they've all become racial minorities.

Every episode of the series ended with Mork reporting his often insightful observations to his unseen, intimidating superior, Orson. Paramount had hoped to lure Orson Welles to voice Orson but eventually gave up and turned to Ralph James's basso profundo.

Tuesday nights' studio audiences on

Paramount's Stage 26 were treated to Robin Williams's mind-blowing, high-wire performances. Williams would improvise wildly, interact with the crowd, flash Dawber, and pummel ABC's censors to tears. Williams's antics led filming nights to drag on for hours, but every shoot night was a unique experience.

Networks generally avoid tangling with their uber-producers, so when Garry Marshall removed himself from the series' day-to-day operations to focus on launching his film career, *Mork & Mindy* lost its formidable protector, and ABC began tinkering with the show. They jettisoned Mindy's father (Conrad Janis) and grandmother (Elizabeth Kerr) and replaced them with more demographically appealing co-stars and, regrettably, moved the show from its popular Thursday night 8 p.m. perch to air instead on Sunday nights, opposite CBS's still-powerful *All in the Family*. The second season suffered from storylines pushed by the network whose infatuation with "Jiggle TV" led to episodes where Raquel Welch played a scantily clad alien and the highly promoted episode where Mork joined the equally scantily clad Denver Broncos cheerleaders.

For *Mork*'s third season, after losing a considerable slice of its audience on Sundays, the show was returned to Thursday nights . . . along with Mindy's father. The ratings rebounded only slightly, and ABC was losing confidence in *Mork & Mindy*. A fourth season was secured only by promising more involvement from Garry Marshall and a tantalizing storyline. In Season Four, Mindy and Mork's relationship would advance to include a six-episode arc following their engagement, wedding, and honeymoon on Mork's home planet—all resulting in Mork laying an egg, which would grow and hatch Jonathan Winters

OPPOSITE (TOP): Before playing Mrs. Doubtfire, Williams had experience wearing prosthetic makeup in the first season episode "Old Fears" where he befriends Mindy's grandmother Cora. And in Season Four's "The Wedding" where Mork temporarily turned into a sheepdog.

OPPOSITE (BOTTOM): Pam Dawber's patience and professionalism proved invaluable as Williams's improvisations and antics could push shoot nights into the following morning.

ABOVE: Mattel's 1979 Mork and Mindy figures included a Mork's talking backpack that recited some of Mork's more memorable expressions like "Shazbot!"

as their newborn son, Mearth. On Ork, as you may remember, you age backward.

Jonathan Winters had been Robin Williams's lifelong comedy idol. Winters emergence in the late 1950s was fueled by his wild stream-of-consciousness improvisations. Winters drew the creative map that guided Williams's acting and comedic techniques. On *Mork & Mindy*, the pair were a comedic tsunami, sorely testing Pam Dawber's good nature with their constant repartee and outlandish hijinks.

The marriage storyline between Dawber and Williams's characters garnered huge audiences, but as *Mork & Mindy* settled into parenthood, the excitement wore off and ratings dipped again. The producers tried to revive interest one more time by finishing the season with a three-part episode titled "Gotta Run." In it, Mork and Mindy are thrilled to meet Kalnik, an Observer from Neptune, and his human wife—until they discover Kalnik's wife is an android and Kalnik (*Murphy Brown*'s Joe Regalbuto) is an assassin targeting Mork. To evade Kalnik, Mork, Mindy, and Mearth go public, with Mork revealing he is a very illegal alien. But eventually they must escape from Kalnik by traveling through time. Part III was set in the Stone Age and shot in 3D, but it never aired in that format because of the difficulties of distributing fifteen million pairs of 3D glasses.

Garry Marshall then attempted to wring another season out of the series by pitching the network a storyline where the time-traveling trio would meet up with historical figures. But ABC chose not to renew the show. *Mork & Mindy* ended its run after ninety-four episodes in 1982.

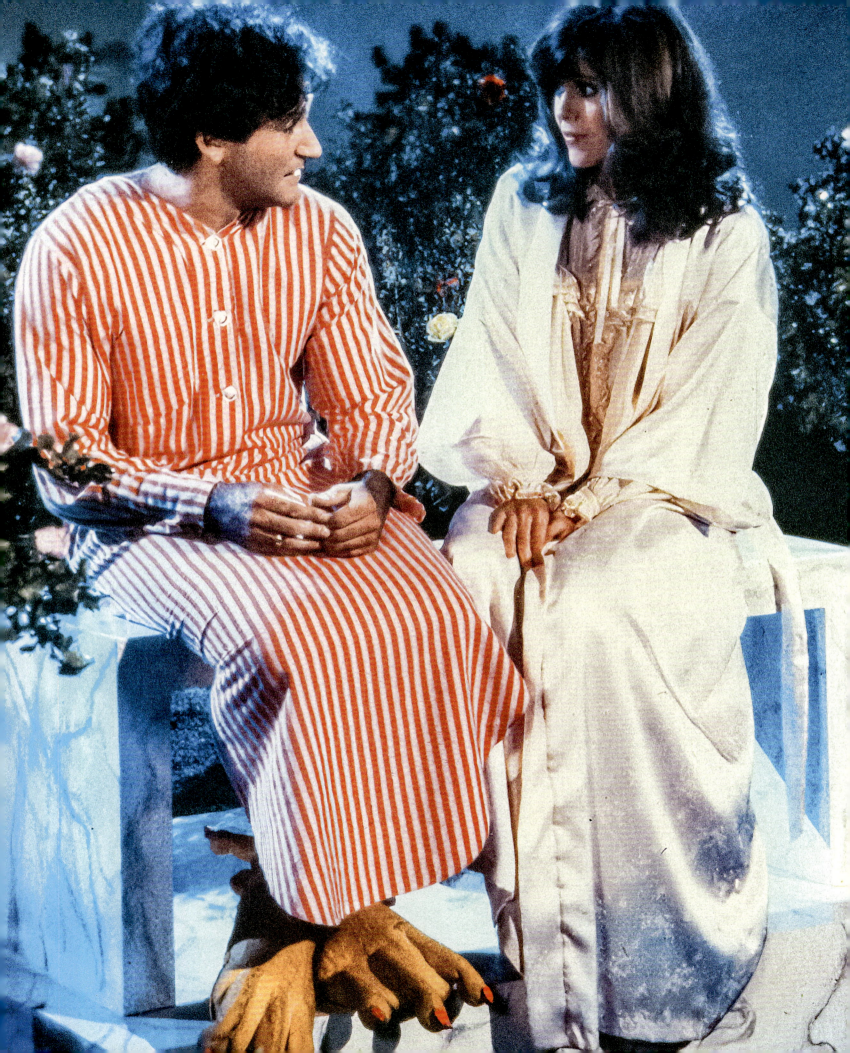

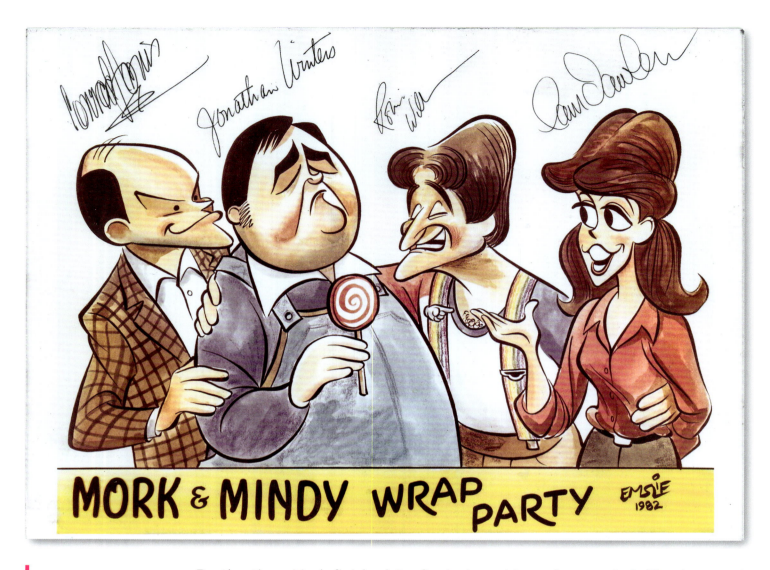

PAGES 140–141: Pull the string and Mattel's talking Mork Rag Doll said "Na-Nu, Na-Nu" and "6 other crazy things."

During Mork and Mindy's honeymoon on Ork, Mindy was surprised to find a rose garden, to which Mork replied, "How do you think they got to Earth?"

ABOVE: The invitation to Mork & Mindy's final wrap party. Williams bugged out early along with his party guest, Mick Jagger.

OPPOSITE: A sampling of Topps Inc.'s 1979 Mork & Mindy trading cards.

By the time *Mork* finished its final season, Robin Williams had already filmed starring roles in *Popeye* (1980) and *The World According to Garp* (1982). He would appear in over seventy more projects, including his Academy Award–winning role in *Good Will Hunting* (1997). Sadly, Williams would end his own life in 2014.

After *Mork & Mindy*, Pam Dawber did a few TV movies, then became the star and producer of *My Sister Sam*, which shot forty-four episodes before ending production when, tragically, co-star Rebecca Schaeffer was murdered by a stalker who had hired a private eye to get her address. As a result, California passed information privacy laws that have since been adopted across all fifty states.

Pam Dawber and Robin Williams would appear onscreen one more time, in a 2014 episode of Williams's short-lived series *The Crazy Ones* (the sole comedy by creator David E. Kelley), which featured Williams as the imaginative head of an advertising agency, working with his daughter, played by *Buffy the Vampire Slayer*'s Sarah Michelle Gellar. Dawber and Williams shared the screen as a short-lived couple in the episode, which was appropriately titled "Love Sucks."

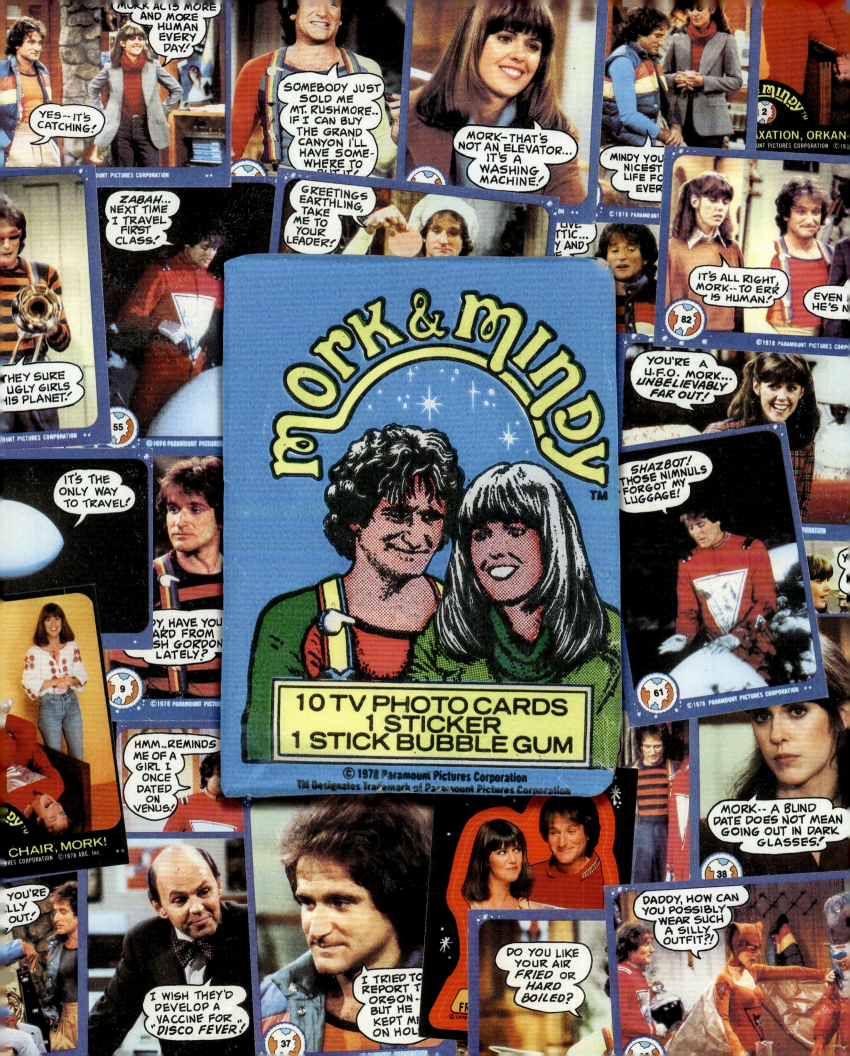

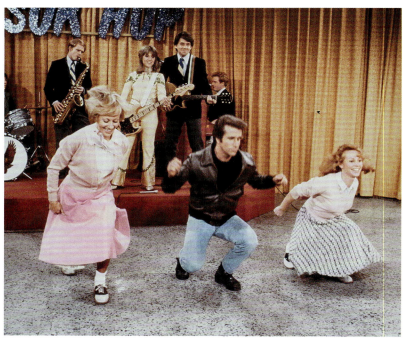
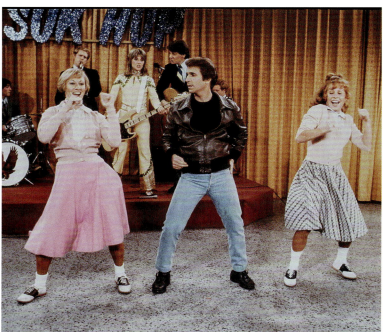
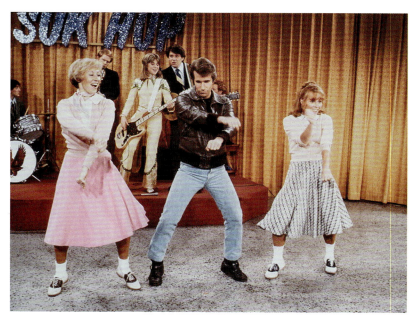
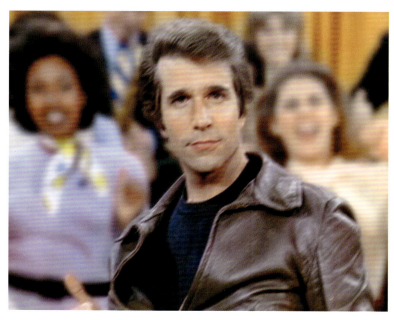

SEASON SIX

Much like Superman's post–World War II problems finding a worthy opponent, in *Happy Days*' sixth season, it became harder and harder to find Fonzie's kryptonite. This resulted in a string of episodes that drifted substantially from the series' iconic coming-of-age stories, as well as from the heartfelt episodes in which Fonzie is challenged to overcome his surprising array of threats to his "cool." Stories featuring an exorcism, facing down a gangster, a Houdini-like escape from a milk can, and an episode titled "Fonzie's Funeral" helped make this, in many fans' minds, the series' least memorable season.

Earlier in the year, Fred Silverman, known as the programmer with the Midas touch, left ABC to try to turn around NBC. Focusing on new projects, Garry Marshall was no longer regularly giving notes on drafts of *Happy Days* scripts or attending cast and crew readings or run-throughs. He was sorely missed.

Marshall's ability to create on the fly was legendary. For example, Arthur Silver points to the third season episode "Richie Fights Back," which was ranked by *TV Guide* as one of the one hundred greatest episodes of all time. It concluded with a showdown against a bully who'd humiliated Richie in front of his date. After a midweek rehearsal, it was obvious that the story lacked a plausible and comedic conclusion to the conflict. Garry Marshall returned the group to the set to try to

> **GARRY MARSHALL RETURNED THE GROUP TO THE SET TO TRY TO SOLVE THE PROBLEM. NOTHING SEEMED TO CLICK... UNTIL MARSHALL WHISPERED SOMETHING INTO RON HOWARD'S EAR.**

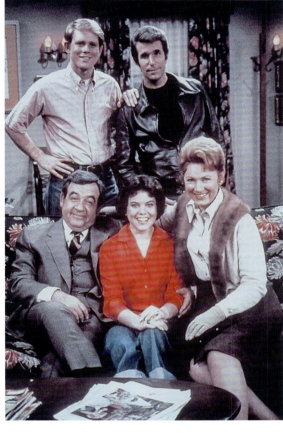

OPPOSITE: Leather Tuscadero helped America learn how to "Do the Fonzie" on National Sock Hop.

LEFT: The Cunninghams and their tenant, circa 1977.

ABOVE (L): The ill-fated "Fonz-How, Inc." storyline came directly from Garry Marshall.

ABOVE (R): Garry Marshall and Jerry Paris collaborated for a quarter of a century on numerous series, pilots, and two feature films.

OPPOSITE: Hi-Ho! Richie, Ralph, Potsie, and The Fonz are riding tall in the saddle during the filming of *Westward Ho Parts I & II*. The episode featured exciting moments like The Fonz and Richie running down a runaway stagecoach and Fonzie wearing a bandana.

solve the problem. Nothing seemed to click . . . until Marshall whispered something into Ron Howard's ear. Then, when Richie's opponent began to remove his leather jacket for the brawl, Howard grabbed it, slammed it to the floor, and proceeded to pummel the jacket. Richie follows this with a torrent of threats aimed everywhere and at everyone in his vicinity. Richie's erratic outburst drives away his opponent, who declares him to be "nutso." And just like that, the story problem transformed into a memorable moment. Ron Howard shares his respect for Marshall's talents: "It was remarkable to see Garry at the Friday dress rehearsal and sit and give notes. It was amazing to see how a brilliant comedy mind could see a scene and understand how to hone it or just reword it or add a reaction, and suddenly a thing that was flat—by the time the audience came in, we did it and it just worked. I was learning so much. It was fun."

Henry Winkler enthuses, "This is my story about Garry. I'm having trouble, I can't figure out a joke. I say, 'Call Garry.' Garry comes down to the set, 'What's the problem?' He tilts his head, and fifty-five solutions fall off the effin' dock. Garry Marshall, Jerry [Paris] . . . I miss them every day. There will never be another Garry."

But even Marshall could be fallible. During the fourth season, he insisted that Brunner and Silver write an episode centered on Fonzie and Howard creating

> **"GARRY MARSHALL, JERRY [PARIS] . . . I MISS THEM EVERY DAY. THERE WILL NEVER BE ANOTHER GARRY."**
>
> —HENRY WINKLER

an invention together. The writing staff hated the idea and kept pushing it further back in the schedule, and Marshall kept pressing for it. Finally, they gave in, and the twenty-second episode of the year was "Fonz-How, Inc.," in which Howard and Fonzie develop a trash compactor. When apprised of the episode's disappointing result, Marshall shook his head and said, "Huh, it didn't work on *Odd Couple* either."

Anson Williams notes that there was so much more to Marshall than his comedic skills. "He was a leader. He found the best in us, inspired us to give before taking. Inspired in us to use this so-called celebrity for the greater good for everybody. That's being a giver, not a taker. The man gave and gave and gave. What a fortunate position we were all in to be in that man's campground."

The sixth season would say goodbye to producer Bob Brunner, the last of the series' original writing staff. He had reteamed with *Laverne & Shirley*'s Arthur Silver to develop new projects. They would depart both shows three-quarters of the way through the season, when they sold two series: *Brothers & Sisters* to Silverman and NBC, and a television adaptation of *The Bad News Bears*, starring Jack Warden, to CBS. Walter Kempley was named showrunner of *Happy Days* after Brunner's departure.

Kempley had been a writer in New York for *The Tonight Show* in both the Jack Paar and early Johnny Carson eras. He created several of Carson's signature characters, including Aunt Blabby. After a major falling-out with Carson, Kempley walked. He endured several lean years before reconnecting with Garry Marshall, who had briefly and unhappily written for Paar. Kempley had joined the *Happy Days* writing staff only the season before he became showrunner. And though raised in rural Iowa, Kempley considered himself an urban cosmopolitan. His wardrobe was

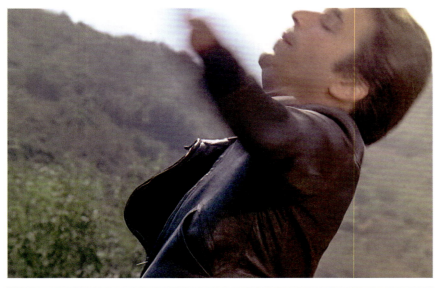
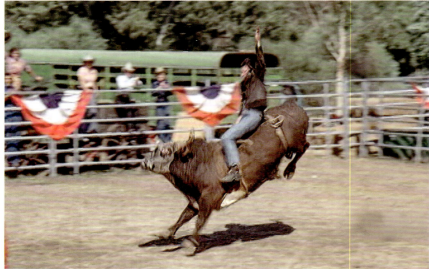
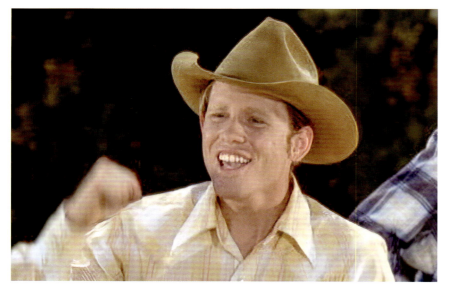

a far cry from the sneakers and blue jeans favored by most comedy writers, and he was rarely without a Dunhill dangling from his cigarette holder. He found the series a bit lowbrow and never developed the passion for *Happy Days* that so many others on the show shared.

There were further changes in the writers' offices, including the hiring of the series' first female staff writer, story editor Beverly Bloomberg. She would provide a viewpoint that had been lacking for half a decade. Unlike many series, Garry Marshall's shows always gave opportunities to freelance writers. As the seasons passed, these assignments and staff positions were too often filled by a network of family and friends—or the ability to bolster the show's softball team.

Another factor that contributed to the script issues was the shooting schedule. For decades, series have typically taken a weeklong hiatus after shooting two or three episodes. But by 1978, the *Happy Days* cast and producers had many irons in the fire and wanted a shorter work year. To accomplish this, production began by shooting eight or nine consecutive shows without a break, and then in groups of four and five. This put tremendous pressure on the writing and postproduction teams to meet airdates.

The biggest change onstage was that Fonzie started wearing a black T-shirt. Explains Henry Winkler, "I thought I had to change it up. It was stupid." There were changes in Winkler's personal life as well. Two months before production resumed, he wed Stacey Weitzman. The year before, Winkler had narrated the Academy Award–winning documentary *Who Are the DeBolts? And Where*

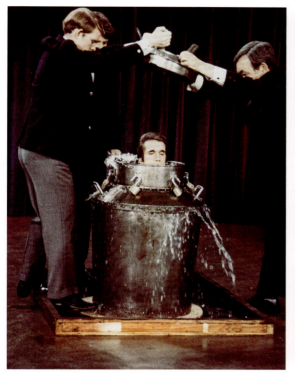
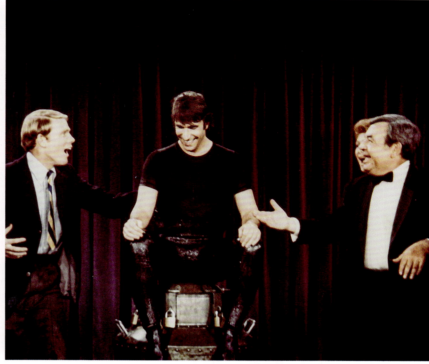

OPPOSITE: Will The Fonz ride the bull and save Marion's uncle's ranch? You bet!

ABOVE: Under the supervision of professional magician The Amazing Randi, Henry Winkler performed Houdini's, handcuffed, milk can escape in front of a live studio audience.

Did They Get Nineteen Kids? and then recruited everyone from John Ritter, Clint Eastwood, and Paul Newman to promote a hugely successful holiday airing on ABC. He would soon launch his own company, Fair Dinkum Productions, which would produce the hit series *MacGyver*, as well as feature films *The Sure Thing* (1985), directed by Rob Reiner, and *Young Sherlock Holmes* (1985), directed by Barry Levinson.

Winkler and his management agreed they needed more time to focus on these endeavors, and, following the lead of other successful television performers like Jackie Gleason, Dean Martin, and Fred MacMurray, Winkler made himself available to *Happy Days* only three days a week. After two weeks, it was obvious he missed being part of the group and began returning to readings and rehearsals, and soon the entire plan was forgotten.

Winkler wasn't the only cast member whose portfolio was expanding. During the hiatus, Ron Howard directed his first made-for-TV film, *Cotton Candy* (1978). The script, about competing high school bands, was written by Howard and his

> **"I GOT A BIG HEAD AND WASN'T DOING WHAT I WAS SUPPOSED TO BE DOING . . . I WOULD JUST BLOW THROUGH REHEARSALS AND DIDN'T REALLY CARE BECAUSE I THOUGHT I WAS PRETTY HOT SHIT."**
>
> —SCOTT BAIO

ABOVE: Both Anson Williams and Don Most got radio play and enjoyed long performing careers.

OPPOSITE: Both Gold Key and Whitman published *Happy Days* comic books.

PAGE 152: Al Molinaro helped young Scott Baio make a course correction that paved the way to the actor's future.

PAGE 153: "Fonzie's Blindness" gave Henry Winkler a chance to test his character's resiliency.

brother, Clint. Ron Howard has always proclaimed his affection for his early directing work, including films he made in junior high. And while *Cotton Candy* wasn't all he and his brother hoped it would be, filmmaking continued to be his focus.

Tom Bosley had just wrapped three seasons on Hanna-Barbera's animated sitcom *Wait Till Your Father Gets Home*, and was the national spokesperson for several brands including Glad Bags— plus, he was narrating the syndicated *That's Hollywood!* series. Anson Williams and Don Most maintained busy recording and performing schedules on weekends and during hiatus weeks. Scott Baio was moonlighting as well, but not just guest spots on shows like *Hollywood Squares* and *The Bay City Rollers Meet the Saturday Superstars*. He was a regular on another Garry Marshall series, *Who's Watching the Kids?* Baio was riding his bike between stages on the lot and, in his own words, "I got a big head and wasn't doing what I was supposed to be doing. I wasn't performing. I wasn't working. I would just blow through rehearsals and didn't really care because I thought I was pretty hot shit."

But not everyone shared Baio's self-evaluation. Executive producer Eddie Milkis didn't like what he was seeing and campaigned to have Baio taken off *Happy Days*. Garry Marshall countered, "Just let him get through it" and told Mario Baio, "Your kid's blowing it, you might want to have a talk with him." Baio asked his son if he wanted to return to Brooklyn. He did not, and his father told him to "go to

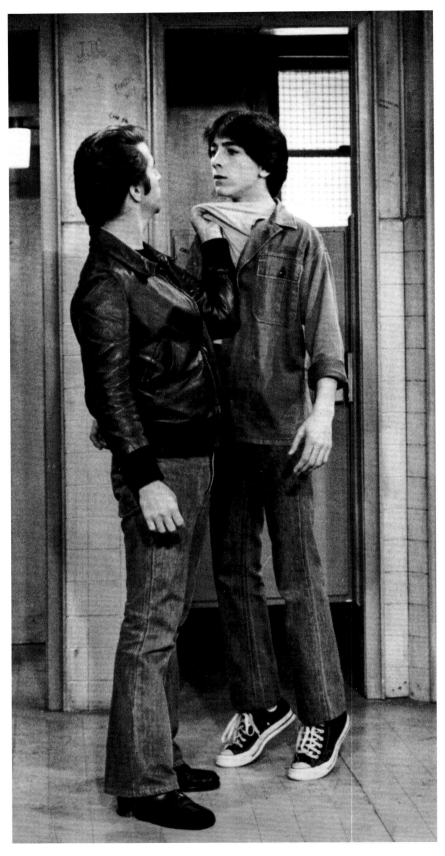

work." The incident troubled the young star. "I didn't know what to do. I didn't know what it meant, 'going to work.'" Baio's malaise lasted several days, until a fellow cast member read the expression on the youngster's face. "Al Molinaro, the sweetest guy in the world, sits down next to me and asks, 'What's the matter?' and I didn't know." Molinaro then counseled Baio to "just listen. When you're onstage, listen to the other actor, because you're not listening . . . you're just waiting for their last word to say your line. Acting is reacting. Just take your time and listen."

Soon after, things really began to click for Baio. "I stopped screwing around . . . My dad would read lines with me at night. I never did that." Soon afterward, Baio improvised a line that got a big laugh, and in that moment, "I got it. I had the ability to see what could be funny, to almost step out of myself and say, 'Well, that should be this and this is the way it could be fun.'" *Who's Watching the Kids?* wrapped after shooting only eleven episodes, and Baio returned to *Happy Days* full-time. And soon his role began to grow.

But no matter what happened behind the cameras, onscreen *Happy Days* continued to plow forward. Season Six began by answering the question, How do you top jumping the shark? The answer: by having Fonzie ride a bull in order to win enough prize money to save Marion's uncle's ranch. "Westward Ho!" kicked off the season as an hourlong episode that included romance, chasing down a runaway stagecoach, and Howard Cunningham riding a mechanical bull. In addition to owning Bronko's Garage and half of Arnold's, Fonzie starts a dance craze by teaching America to "Do the

Fonzie" when Leather Tuscadero's band appears on *National Sock Hop*.

Season Six was most successful when it focused on family matters. Tears are shed watching Joanie waltz with her father at her sweet sixteen. Howard and Marion celebrate their twenty-third anniversary. In "Fonzie's Blindness," Richie Cunningham turns the tables and gives Fonzie guidance when The Fonz (temporarily) loses his sight. In a special holiday episode, Fonzie struggles with his feelings when he receives a Christmas gift from his estranged father.

And there were stories that generated big laughs, like Richie testing the boundaries of a long-term relationship, or when best friends Ralph and Potsie become battling roommates. Leather Tuscadero makes the last of her seven appearances, when Marion helps transform the leather jumpsuit–clad rocker into a "proper lady" so she can attend a military ball with Ralph Malph. In "The Fourth Anniversary Show," Robin Williams beamed in from his Thursday night *Mork & Mindy* slot to Milwaukee to "pay off for my spin-off." Reuniting with Richie and Fonzie, they help Mork learn about the human concept of friendship, through flashbacks from previous episodes.

Happy Days would finish the season ranked in fourth place, with its spin-offs *Laverne & Shirley* and *Mork & Mindy* placing first and third.

Still, even though the cast had so many outside endeavors, the fuel that propelled the series remained the group's esprit de corps. Jerry Paris and the cast loved working together, and they had eased into a comfortable, simple routine. On Monday mornings the cast, writers,

ABOVE (L): The cast breaks the mood while filming "Fonzie's Funeral Part II."

ABOVE (R): The Fonz leads a different kind of gang in "The Claw Meets The Fonz."

OPPOSITE: Fonzie helps his latest flame, Oscar-nominated actress and ballerina Leslie Browne (*The Turning Point*), perform an arabesque allongé in "Do You Want to Dance?"

producers, department heads, and representatives from the studio, network, and, of course, standards and practices (the dreaded censors) packed into a conference room, filled with anticipation to hear the week's episode begin to come to life. After bagels, doughnuts, coffee, chitchat, gentle ribbing, and announcements, two scripts were presented. First, the "pink script" was read, debuting the following week's show, and then the revised "blue script" for the show that was to be filmed that week. It was often easy to discern how the cast responded to the stories by the effort they gave.

A script immediately recognized as top-notch would elicit an enthusiastic response, where every line earned gales of laughter. If the energy level dipped considerably, the writers knew they wouldn't be getting home until very late for the rest of the week. After the reading, the principal actors would give feedback on the nuts and bolts, but Garry Marshall always focused on what new things could be learned about the characters. Next, Jerry Paris would take the cast back to Stage 19 for a brief rehearsal to pencil in the staging. The writers would return to K Building, where they'd pat themselves on the back for the things that worked and blame what didn't on the cast's readings. As much time was spent fixing the script as trying to decide where to order lunch.

On Tuesdays, the cast would report to Stage 19, read the revised script, run each scene a couple of times, and call it a day. Wednesdays were very important, as the cast would perform a run-through in the afternoon for the producers, writers, and assorted network and studio reps. Wednesday's performances ran the gamut from rough to energetic to razor sharp. Notes would follow, then the writers would adjourn to the K Building conference room, where they would spend the next four to six hours dividing their time between punching up the script and deciding where to have dinner from. On Thursdays, Paris spent the day positioning the three cameras to record all the action. In the late afternoon (creeping earlier and earlier over the years), another run-through was performed. More notes, more rewriting, and still more anguish over what to have for dinner. And on Fridays, *Happy Days* fans began lining up on Melrose Avenue early in the day in hopes of landing one of the three hundred audience seats. At 4:30 p.m. sharp, a full

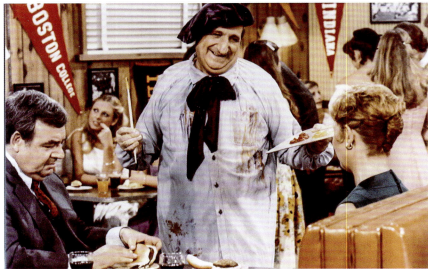

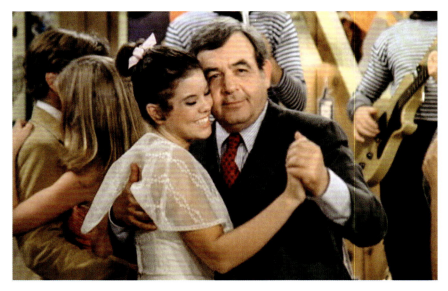

run-through was performed. Kids were allowed at the early show but not the 7:30 p.m. show. Both audiences showered the cast with applause and screams when each actor entered a scene, and their laughter would shake the bleachers. Like a football coach, Jerry Paris aimed for his team to peak on game day. And they did, though on occasion the run-through performance eclipsed the evening show, when the cameras were actually rolling.

After the run-through, Garry Marshall or his lieutenants would translate scribbles on a steno pad into ideas to smooth out the episode's remaining rough edges. After dining in the Paramount commissary (alongside colleagues on shows like *Taxi*, *Angie*, and *Family Ties*), the cast would go through final makeup and hair. For most of the show's run, Garry Marshall would do the "warm-up"—welcoming the audience, teaching them to laugh "up" at the microphones, and introducing the cast, accompanied by drumrolls and the show's theme song. During costume changes, mini candy bars were tossed to the crowd to keep their energy up. In later seasons, these warm-up duties were performed by writer Fred Fox Jr. with an often unfortunate assist from Director Paris. After a series of barbs directed at a pair of Japanese tourists in the audience, Paris found himself inches from being tossed off the lot and was subsequently banned from ever using the microphone again.

By now, *Happy Days* was a well-oiled machine and, nearly always, Friday night's performances would end in triumph. After the curtain call, the audience was urged to drive home safely . . . and on Monday the entire process would begin again.

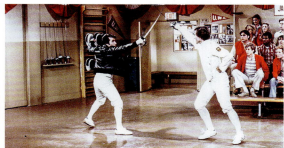
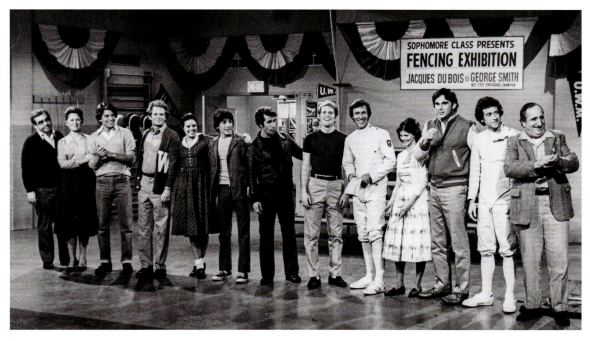

OPPOSITE (TOP): "Gay Paree" was the theme of Joanie's "Sweet Sixteen" party.

OPPOSITE (MIDDLE): Al gives condiments an artistic touch.

OPPOSITE (BOTTOM): When asked to pick her "best guy" for her first dance, Joanie chooses her Dad.

LEFT: Touché! In "The Duel" The Fonz battles Patrick Gorman as Jacques Du Bois in rehearsal, during filming, and the entire cast joins in the curtain call which concluded each week's filming.

Season Six 157

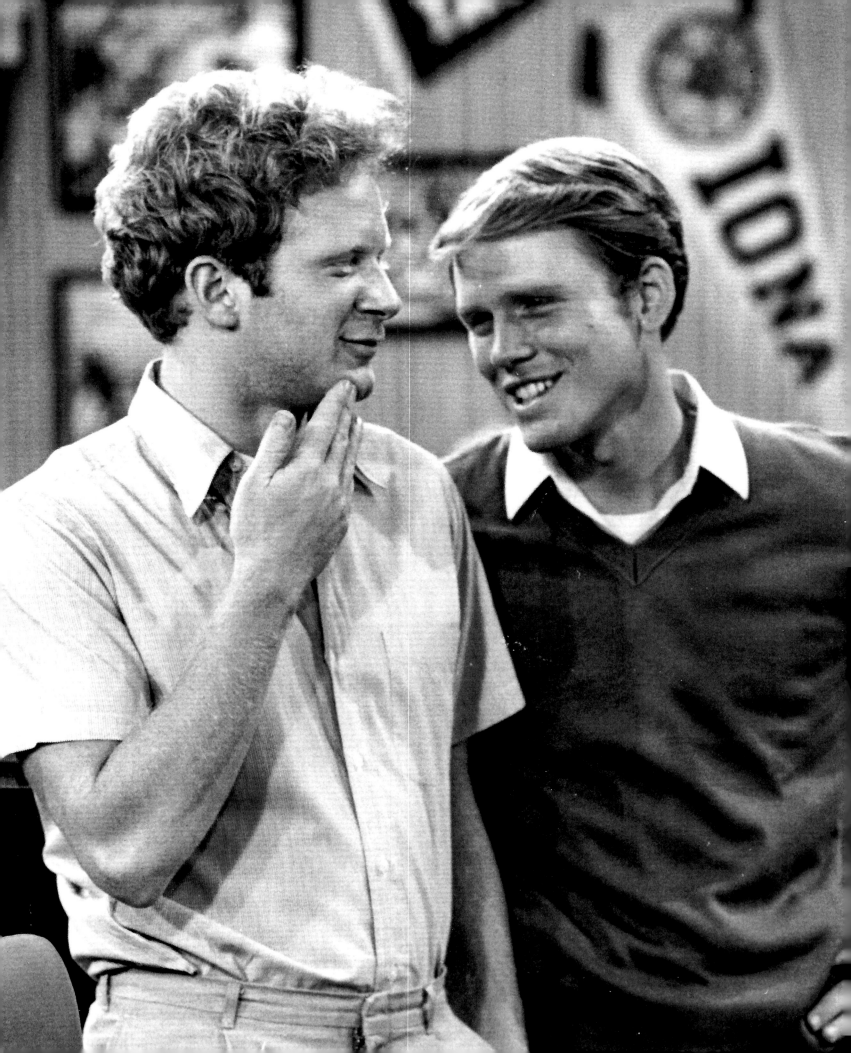

SEASON SEVEN

After a dismal start, the seventh season of *Happy Days* rebounded to right the ship and improved on the season before. The show premiered with a clumsy two-part crossover episode, "Shotgun Wedding Parts I & II" where Richie and Fonzie get involved with the wrong farmer's daughters. The story began on *Happy Days* and then concluded at 8:30 p.m. on *Laverne & Shirley*. In the episode, the girls rescued Richie and Fonzie by claiming they were married to the two philanderers.

The next week's episode was built around helping launch *Out of the Blue*, a new ABC sitcom from *Happy Days*' producers Tom Miller, Eddie Milkis, and Bob Boyett. Guest star Jimmy Brogan plays an angel who's trying to earn his wings and helps release Chachi from a deal with the devil. Evidently, Marshall and Miller's thinking was that if you could get away with an alien on *Happy Days*, you could get away with anything. Garry Marshall put this to the test in the fourth episode of the season. He used it as a launchpad for Deborah Pratt in the role of a mysterious warrior named Kat Mandu. After the most unenthusiastic reading of the entire series, the cast drew a line in the sand, and a closed-door session was held with the producers. They were fed up with promoting others to the detriment of their series. The following week, after an ABC-influenced episode in which Chachi is captured by a revealingly dressed motorcycle gang, Walter Kempley's term as showrunner came to an end; he'd overseen only fourteen episodes in all—a period Henry Winkler referred to as "the lost years."

Lowell Ganz, the man who had successfully warded off cancellation four years earlier, took charge of the series again. After leaving *Laverne & Shirley*, he and Mark Rothman sold their series *Busting Loose* (1977) to CBS. In the spring

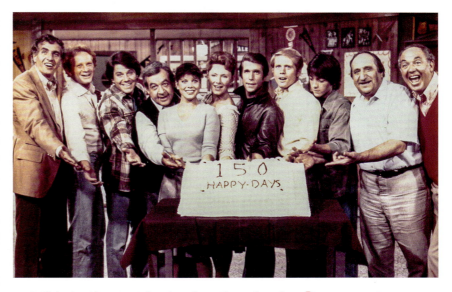

OPPOSITE: Season Seven would be the end of the line for both Don Most and Ron Howard.

ABOVE: *Happy Days*' cast and Director Jerry Paris and Garry Marshall celebrate yet another watershed achievement, filming their 150th episode!

> "THERE WASN'T A CHANCE FOR [MY CHARACTER] TO GROW AS MUCH, MY CONTRACT WAS UP . . . I JUST FELT IT WAS TIME TO MOVE ON."
>
> —DON MOST

BELOW (L): In "The Mechanic," The Fonz faces a different kind of challenge when he hires a bitter, handicapped grease monkey (Jim Knaub).

BELOW (R): Producer Lowell Ganz, here with Jerry Paris, returned to *Happy Days* and helped to put the show back on course, and build for the future.

OPPOSITE: Chachi accidentally started a kitchen fire at Arnold's with devastating results. The cast didn't see the extent of the damage until the cameras were rolling, to capture their emotional responses.

of 1978, they rolled out another series for the network, *The Ted Knight Show*. Both efforts had failed to catch on. Ganz was happy to return to his TV family.

"I was a little dizzy from my career being spun around so fast. I was really happy to be back. And the cast couldn't have been more appreciative. It was a glory job at that point. There was a certain amount of dissatisfaction [on set], and when I came back, I could do no wrong. They said, 'Lowell will make it better,' so that everything I did, they felt it was better . . . and to be honest, a lot of it probably was." But the series Ganz had returned to had changed. "I felt the show didn't have the same youthful energy that the third season had . . . But the cast was doing the work. The work was getting done, in some sense it was probably getting done better. They probably were more adept—their timing, their everything. But it just didn't have the same glow on it."

The seventh season brought other changes. Following *American Graffiti*'s example, faux '50s diner chains began popping up nationally, making Arnold's less than distinctive. It was decided to give Arnold's Drive-In a new look—so Chachi accidentally burns the place down to explain away the desired remodel. The aftereffects were hidden from the cast until the cameras rolled, to capture their genuinely saddened reactions. The following week, Arnold's had a grand reopening, showcasing the new, more upscale look and improvements like installing a desk in Fonzie's "office" in the men's room.

In other episodes, Ralph Malph's optometrist father stops seeing eye to eye with his wife and they divorce. And Joanie and Chachi's relationship advances from Chachi being "waa waa waa" about Joanie, to wearing her down to where they finally begin dating.

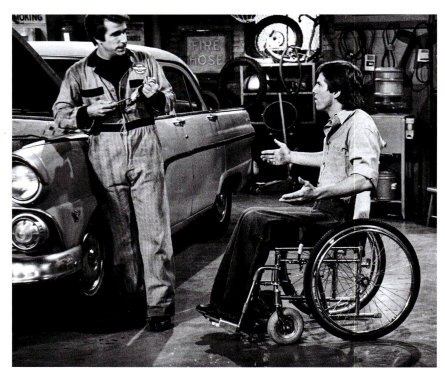

160 50 Years of Happy Days

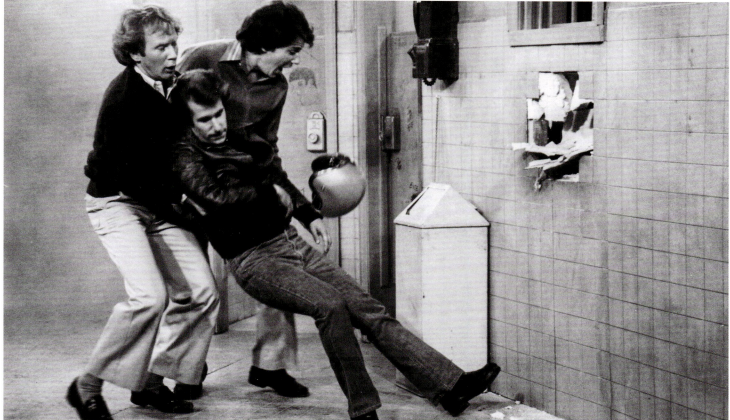

RIGHT: The season opener, "Shotgun Wedding" began on *Happy Days* and ended on *Laverne & Shirley* where the girls help Richie and Fonzie escape captivity.

OPPOSITE: In Season Three's "Dance Contest," The Fonz and Mrs C went cheek to cheek to win the top prize.

Several storylines grew out of Bosley, Anson Williams, and writer Fred Fox Jr.'s involvement with PATH (Performing Arts Theater of the Handicapped). This inspired episodes where Fonzie falls head over heels for a woman who is hearing-impaired (Linda Bove), and a story where Fonzie makes a new hire over the phone and is surprised to learn his new employee is paraplegic. In "The Mechanic," Fonzie must learn to conquer his preconceived notions of what Don Konig (onetime world-class pole-vaulter Jim Knaub) is capable of. After the episode aired, it received tremendous thanks and the support of organizations for people with disabilities, several of which, including the Human Resources Center, asked for copies of the show to use in their training programs, calling the episode "unparalleled as a teaching tool."

Throughout the series, the producers always made an effort to share the spotlight and give everyone an opportunity to shine, but none brighter than Marion Ross. In her autobiography's foreword, Ron Howard wrote about how Ross was the show's head cheerleader, an upbeat force who never lost her "wiseass streak." In "Marion Goes to Jail," Howard Cunningham makes his wife pay the price for crashing his '49 DeSoto through the wall of Arnold's. Marion takes responsibility—a five-day sentence—for not setting the emergency brake while parked on a hill . . . until Fonzie points out that he'd warned Howard months earlier that the emergency brake was shot. It was one of the few times in the series that the couple had a blowout fight. The Cunninghams enjoyed a successful marriage, and Mrs. C's sparkling personality and optimism

provided a delightful counterweight to her occasionally grouchy husband. But no matter their disagreements, the couple still liked to head upstairs to "get frisky."

Marion Ross's playful side often surfaced when she was working with Henry Winkler. The pair had a warm, fun-filled relationship, and it was always a pleasure when they got to perform together. The story for Season Three's "Dance Contest" found Marion Cunningham bored with the monotony of being a housewife and enlisting Fonzie to be her partner on a televised dance competition (after Howard declines) in which they perform a sizzling tango. In Season Seven he saves the day as a last-minute replacement for the lead actor in Marion's theater group's production of *The Rainmaker*, and the pair play a dramatic scene together. But the real evidence of their chemistry could be seen in the show's gag reels. Ross and Winkler could go wildly off script. They would begin making out when someone else was talking or chase each other around the set squirting whipped cream. One time, during filming, Marion Cunningham even came down the stairs from Fonzie's apartment buttoning her blouse and rearranging her hair.

Fortunately for Marion Ross, the days after her 1968 divorce, when she worried over how to support her children, were behind her. She was on a hit show and was able to return to the theater when it suited her. Her effervescent laughter was a constant both on Stage 19 and in her new, large, welcoming home—which she proudly named "The Happy Days Farm."

In a show about growing up, for Richie Cunningham, it was mission accomplished. He'd advanced from a fifteen-year-old

Season Seven 163

RIGHT (TOP): Fonzie gives Milwaukee Braves Home Run King Hank Aaron the thumbs-up, after the baseball legend filmed a commercial for Cunningham Hardware.

BELOW (L): Chachi and Joanie's first "real" date was a success.

BELOW (MIDDLE): "Marion Goes to Jail"…but it was Howard's fault that his Studebaker crashed through the wall of Arnold's.

BELOW (R): Howard reluctantly renewed his vows with Marion in "Here Comes the Bride Again."

OPPOSITE: In 1997, Exclusive Premiere *Happy Days* figures were available only at Target stores.

PAGE 166: Richie Cunningham would be stationed in Greenland, but Lori Beth would remain in Milwaukee and move in with the Cunningham's after she and Richie were married and had Richie Jr.

PAGE 167: The Exclusive Premiere Richie Cunningham figure. Potsie would also be immortalized in the collection.

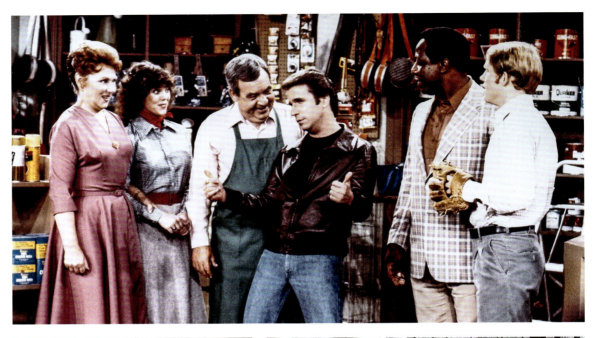
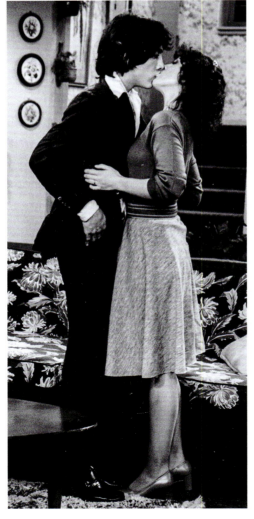

to a college sophomore who no longer was dependent on Fonzie. At the same time, the limited opportunities to grow his character would steer Howard toward pursuing his own productions.

Season Seven would be Ron Howard and Don Most's final year, both choosing not to renew their seven-year contracts. When performers are hired to be series regulars in pilots, the production entity has an option to tie them up exclusively for a period of up to seven years. Though the entire cast's contracts had been improved over the years, with Howard and Winkler even given slices of the series' spin-offs and merchandising, a new contract would mean substantially increasing the entire group's paychecks. Still, Most felt that for him, the experience had run its course. After playing a character very different from himself for seven years, he felt, "I was very interested in doing drama in addition to comedy. There wasn't a chance for it to grow as much, my contract was up . . . I just felt it was time to move on." Howard, who had already qualified for his Screen Actors Guild pension before his twenty-fifth birthday, was focused on a career behind the camera. So, when Fred Silverman offered Ron Howard and his Major H Productions a lucrative four-year deal at NBC to direct, produce, and act in films and series for the network, Howard leapt at the opportunity.

The first production Howard directed under the deal would be 1980's *Skyward*, the story of a young girl in a wheelchair who yearns for the freedom of flight. The film would be executive produced by Anson Williams, with Marion Ross co-starring. Williams had been pushing Howard to do something more serious . . . and then, struck with an idea,

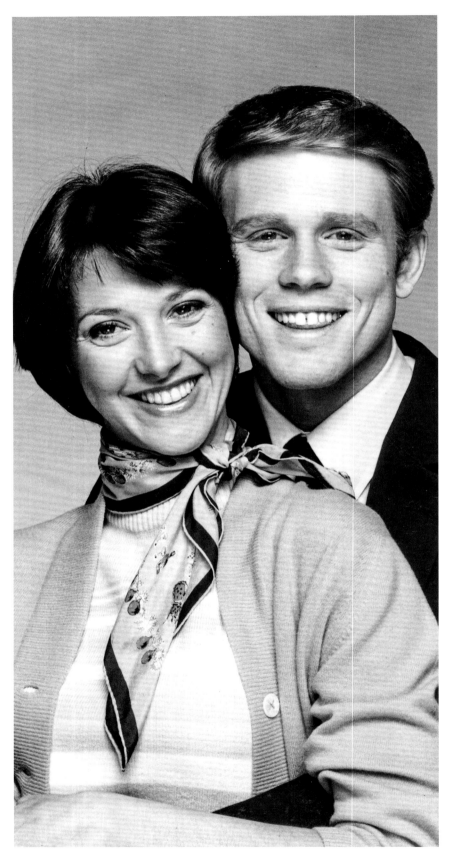

wrote a treatment in a single night, saying, "It just hit me . . . and Ron loved it."

Mindful of representation in a film about a wheelchair-bound young woman learning to fly, Howard and Williams were determined to cast a paraplegic actress to play the lead role. They were convinced they found their star when they shot an audition with fourteen-year-old Suzy Gilstrap. However, NBC programmer Brandon Tartikoff preferred to use *Little House on the Prairie*'s Melissa Sue Anderson. In the end, Tartikoff agreed to use the rookie actress—if they could land multiple Oscar-winning legend Bette Davis to play opposite Gilstrap. Davis, now in her seventies, had a reputation for being "difficult," and she even labeled herself "uncompromising, peppery, intractable, monomaniacal, tactless, volatile, and oft times disagreeable." Howard and Williams submitted the script to Davis, thinking she'd never read it. But

> "ANSON WAS SO DOGGED, HE WAS A REALLY GOOD PRODUCER—HE GOT BETTE DAVIS, WHO SOLD IT TO THE NETWORK, HE GOT US A GREAT WRITER. I WAS PARTICIPATING, BUT ANSON WAS THE ENGINE."
>
> —RON HOWARD

surprisingly, according to Williams, Davis was tired of playing what she called "old lady" roles, so she happily signed on to play a crusty veteran flight instructor.

Howard compliments his producing partner: "Anson was so dogged, he was a really good producer—he got Bette Davis, who sold it to the network, he got us a great writer [Nancy Sackett]. I was participating, but Anson was the engine. Anson was a go-getter, he's just the greatest, a great guy and a great friend."

Clu Gulager (*The Virginian*), WKRP's Howard Hesseman, and a young Lisa Whelchel (*The Facts of Life*) rounded out the cast. Filming took place in Rockwall, Texas, under scorching temperatures. Howard did butt heads with Davis on occasion, but he impressed her as well. She told him he could become the next William Wyler. After they screened the final cut, General Electric signed on to be the film's sole sponsor and showcased the movie as a *GE Theater* event. *Skyward* was well received by audiences and critics. Says Howard, "That movie was really the calling-card movie that helped convince the studio that I could actually direct a feature."

Late in the season, Ron Howard declared to Lowell Ganz, "I'm gonna direct movies. You wanna write movies?" Howard would produce and direct the hit film *Night Shift* (1982), starring Michael Keaton and Henry Winkler and written by Lowell Ganz and Babaloo Mandel. The pair would team with the director on five more films, including *Splash* and *Parenthood*.

Losing Don Most and Ron Howard necessitated a new game plan to ensure *Happy Days*' survival. And, once again, the series rose to meet the challenge.

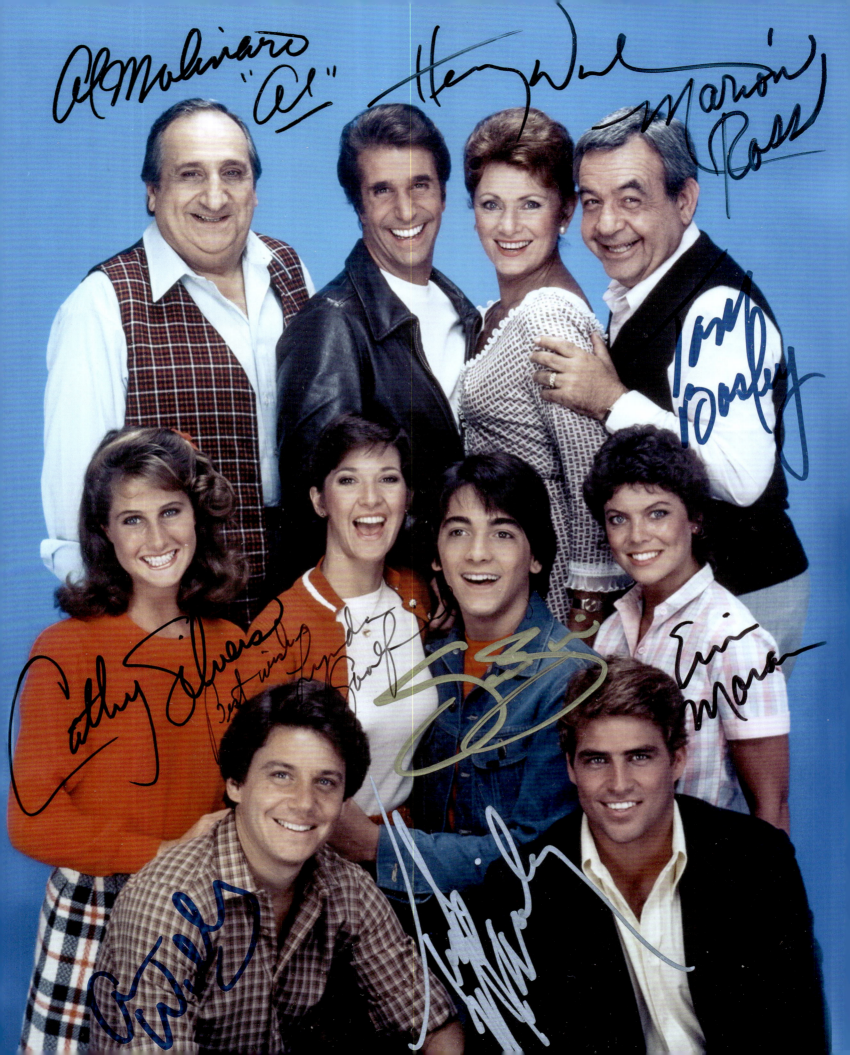

SEASON EIGHT

The 1980 to 1981 season of *Happy Days* began with a preseason bombshell. On Stage 19, there was only one telephone, and when craft service/bookie Lou Demarco told Henry Winkler he had a phone call, Winkler never expected the stunning news he was about to receive. Ron Howard was on the line, and he told his friend, "In a few minutes, it's going to hit the press—I'm not coming back." An astonished Winkler replied, "You're what?! You're what?!" "I'm not coming back." "You're not coming back?" "I'm dead."

For four years, Howard's discontent had grown over what he perceived as lack of respect in the media, as well as his employers' indifference to nurturing his directing career. When Howard's contract expired, the twenty-six-year-old made a bold choice. Howard turned thumbs down on a new contract with the

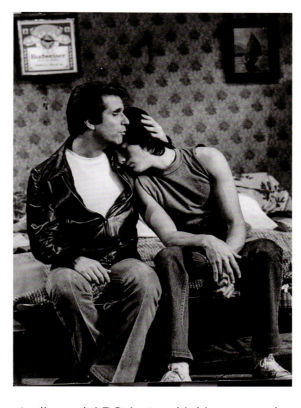

OPPOSITE: An autographed photo of *Happy Days'* realigned cast from the amazing collection of Giuseppe Ganelli.

LEFT: Scott Baio's growing maturity and strong relationship with Henry Winkler helped to smooth the transition to the post–Ron Howard era.

studio and ABC, instead inking an exclusive four-year contract to direct, produce, and act in projects for NBC. Says Howard today: "I needed to follow my dream and take responsibility for it . . . As much as I love television and even the people on the show, that wasn't really my dream. My dream was to get out there and prove I could do the job."

According to Lowell Ganz, his youngest son began watching *Happy Days* in the late 1980s, when it was airing reruns on Nick at Nite, and he once asked, "Did you guys do a few years without Ron Howard?" Ganz replied in the affirmative, and the boy responded, "Why did you do that?" Longtime writer Michael

> **"I NEEDED TO FOLLOW MY DREAM AND TAKE RESPONSIBILITY FOR IT . . . AS MUCH AS I LOVE TELEVISION AND EVEN THE PEOPLE ON THE SHOW, THAT WASN'T REALLY MY DREAM."**
>
> **—RON HOWARD**

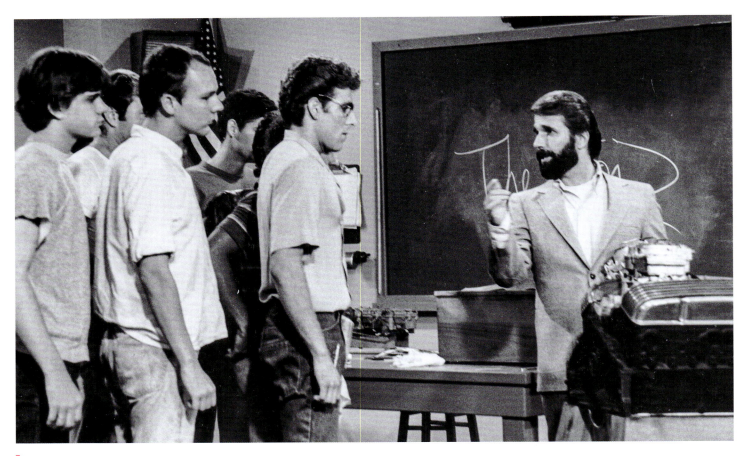

ABOVE: The Fonz dressed up for his first day teaching auto shop. Winkler had grown a beard over hiatus and wanted Fonzie to keep it...and he did, but for just one episode.

OPPOSITE: Ted McGinley applauds his fellow *Happy Days* rookie, Cathy Silvers, during a curtain call.

Warren concurs: "The show was about Richie growing up. When Ron left, the show should've ended."

However, Ganz and Garry Marshall never discussed pulling the plug while the show was still at the top of its game, like *The Dick Van Dyke Show* and *The Mary Tyler Moore Show* had. Today, Ganz admits that "*Happy Days* no longer existed in a natural condition anymore; it was a thing that was put together in a laboratory rather than something that was of woman born. I thought the show was fun when Ron was there. When Ron left, it was work . . . it was work I liked. I liked the work." That work revolved around recalibrating the show, shifting the spotlight more toward Joanie and Chachi's burgeoning romance as well as Fonzie and his cousin's relationship. According to Winkler, "I didn't know what was going to happen . . . Then Scott Baio happened. Scott Baio stood at the plate and hit a home run. He was just so talented, and he became my sparring partner."

Fonzie was given a new group of high schoolers to counsel when he became Jefferson High's auto shop teacher. There were several other significant additions made to the cast. Joanie's friend, the previously unseen, "boy-crazy" Jenny Piccalo, finally appeared on camera. She was played by Cathy Silvers, the daughter of comedy legend Phil Silvers.

Eighteen-year-old Silvers was a champion orator who radiated confidence at her audition. Silvers won the role over some tough competition, which included Demi Moore, Heather Thomas, and Heather Locklear. Silvers will never forget

her first day on the job. "One of the most amazing moments in the history of my life was walking onto that set... When the stage doors roll open and you turn around and bam, there's the Hollywood sign!" Silvers's arrival was good news for Erin Moran, too. "I just became best friends with Erin... When I got there, she needed me very badly." Silvers recalls: "She and I were meant to be Jenny and Joanie, like Lucy and Ethel."

Richie's room wasn't empty for long before Marion's nephew, Roger Phillips, moved to Milwaukee in the person of Ted McGinley. He first drew attention modeling in a fundraising calendar for the USC water polo team, where he'd been a star player. After graduation, McGinley moved to New York to model, where he caught the eye of casting director Joyce Selznick. She'd first found fame for discovering a truck driver named Bernard Schwartz—soon to be known as Tony Curtis. Selznick ushered McGinley into the same ABC talent training program pipeline that guided Pam Dawber and Tom Hanks to ABC/Paramount series.

Even though he had begun taking acting lessons only months earlier, the affable McGinley impressed *Happy Days* producer Ronny Hallin (who McGinley initially mistook for her sister, Penny Marshall). Hallin then sent him to meet with Garry Marshall. The producer saw a diamond in the rough and handed off McGinley to work with the show's casting director and former dialogue coach, Bobby Hoffman. McGinley shakes his head, continuing, "I worked for two weeks with Bobby and Garry. I didn't know what

ABOVE: Marion Cunningham went on the TV show *Dreams Can Come True* (hosted by *The Carol Burnett Show*'s Lyle Waggoner), to send Lori Beth to Greenland to marry Richie.

OPPOSITE: AAAY, a free game was hard to come by on Coleco's The Fonz home pinball game.

comedy was. I didn't know the rhythm and the timing." Comedy might have been new to McGinley, but he was no stranger to *Happy Days*. "We loved that show at my house. I remember trying to get home to see it . . . and then, literally, like a week later, I'm on it—and with no training." McGinley proved to be a quick study. Of auditioning for the powers that be with Henry Winkler, McGinley says, "Everything was so out-of-body, because I was just so worried about fainting all the time . . . I was so out of my element." But Henry Winkler was sold on the rookie thespian. "Ted was the handsomest man I ever met . . . I saw it, for sure." According to Jerry Paris's assistant Carmen Herrera, "Henry was instrumental in Ted getting the part."

McGinley lavishes praise on his co-star as well. "I always appreciated his ability to handle large groups of people, and he made everybody feel like they counted,

> **"I ALWAYS APPRECIATED HIS ABILITY TO HANDLE LARGE GROUPS OF PEOPLE, AND HE MADE EVERYBODY FEEL LIKE THEY COUNTED . . . I WOULD SAY THAT'S HENRY'S GREATEST ATTRIBUTE."**
>
> —TED McGINLEY

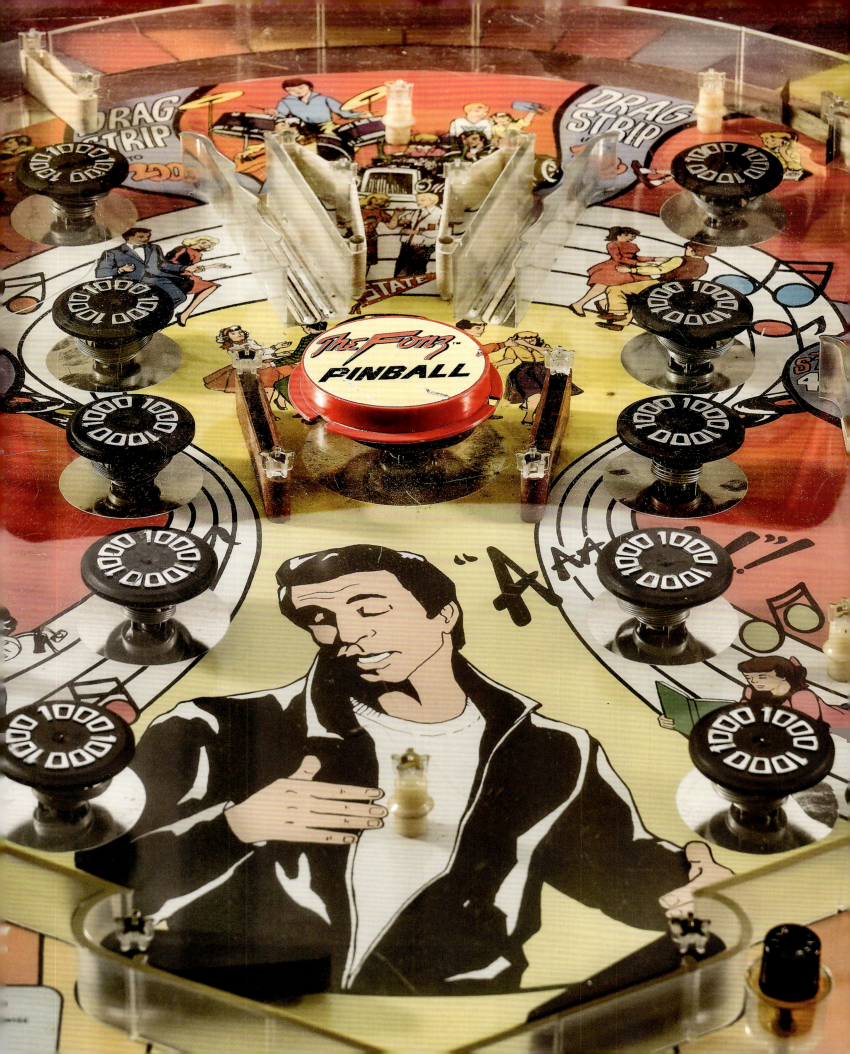

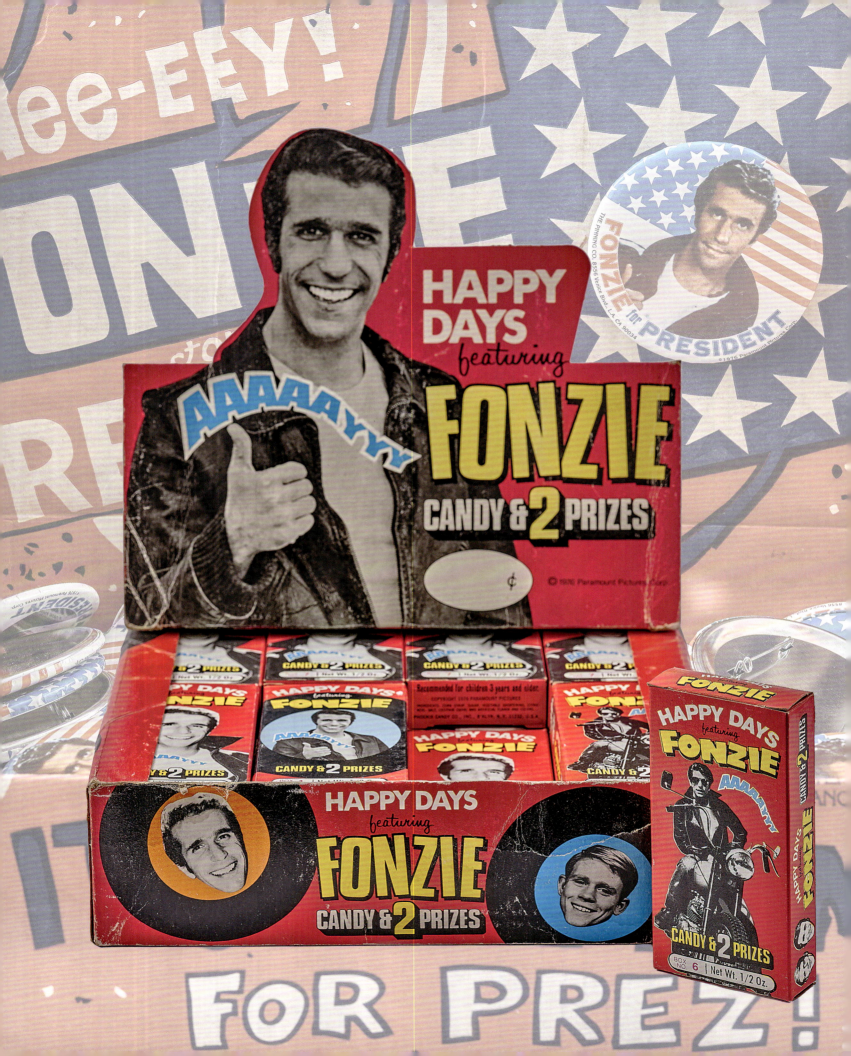

he saw them, and that he loved meeting them. I would say that's Henry's greatest attribute." On McGinley's very first day on the show, rehearsal was interrupted by an emergency call that was patched through to the stage: A young man was threatening to commit suicide unless he could talk to Fonzie. Winkler took the phone immediately and was successful in averting a tragedy.

McGinley, whose success in athletics had been built on hard work and perseverance, knew that he would need to make the same commitment to succeed on the show. "I was the lowest man on the totem pole . . . I knew I wasn't up to par with everybody else there. Jerry [Paris] would be so helpful to me in that time period, and I felt bad for Henry—because he had to work opposite me . . . and he used to work opposite Ron Howard. I considered that duo to be one of the most special in the history of television."

Fortunately, McGinley was playing a character that fit him like a favorite pair of jeans. "I love Roger! He was perfect for me, because I was stiff and Roger was a little stiff. Again, I think it was kind of Garry's genius . . . He found the types of people he could mold into something. He saw that 'all-American' part of me that worked for Roger." Though it took a while for McGinley to gain a degree of confidence, he was instantly welcomed by the cast and crew—and especially the softball team.

Despite his absence, Richie Cunningham was kept alive on the show. Richie and Ralph's absence was explained by the fact that the duo had been drafted

OPPOSITE: Counter displays for *Happy Days* candy and "Fonzie for President" buttons...despite the fact that he was too young to hold the office.

ABOVE: The Fonz falls prey to the rickety bed Joanie and Chachi did their best to avoid when they were forced to share the honeymoon suite of a roadside motel.

Season Eight 175

ABOVE: Marion Cunningham failed to win the grand prize on *Dreams Can Come True* to send Lori Beth to Greenland…so she was married to Richie over the phone, with The Fonz standing in for his pal.

OPPOSITE: In "Potsie On His Own" the gang wonders where Potsie is getting the money to buy lavish gifts for his girlfriend—who wouldn't hide the fact they were entertaining at kid's birthday parties.

and shipped off to Greenland. Richie would "phone in" for key episodes in Season Eight, like when he proposed to Lori Beth, and, later in the season, married her long distance, with Fonzie standing in for him.

Happy Days' eighth season opened by featuring Erin Moran and Scott Baio's characters in an episode called "No Tell Motel." The story had ABC's censors biting their nails. Joanie and Chachi's car breaks down while they're on their way to see the Beach Boys in Chicago, and they're forced to share a motel's honeymoon suite.

The episode was written by Cindy Begel and Lesa Kite. The pair were staff writers on numerous Paramount comedies over the years, including *Laverne & Shirley* and *Mork & Mindy*, and wrote two episodes of *Happy Days*. Begel and Kite had an idea, recounts Begel: "I always like to do the opposite. Instead of kids sneaking off to be in a motel room, what happens is the car breaks down and they're stuck in a motel . . . and of course Joanie's told her parents she's at Jenny Piccalo's house."

They verbally presented their idea to Ganz and his new writing partner, Marc "Babaloo" Mandel. "We pitched the story and right away he liked it," Begel recalls. "Lowell started pitching immediately, and he took everything that we had and made it better. Off the top of his head, jokes, story. He added stuff and really made it funny . . . It was amazing."

The episode's centerpiece was Joanie and Chachi's discomfort in sharing a motel room. The pair search for creative

176 50 Years of Happy Days

ways to avoid sleeping in the same bed. Chachi tries sleeping on the desk and in the bathtub. Finally, like in movies from the 1930s, he ends up on the same bed, but keeping one foot on the floor at all times. This somehow causes the bed to collapse. Of course, Fonzie comes to their rescue in the nick of time and squares things with Mr. and Mrs. C.

Begel adds, "It was a really good show. Scott Baio was actually quite charming and funny . . . On show night, it was really great being in the audience. They would introduce you, and everyone would clap. You felt this pride in having done it . . . Sitting there was so exciting. That thrill. How many jobs do people have where they can have an actual thrill? We were all very lucky. It was very magical, and we knew it at the time."

"No Tell Motel" earned positive reviews and strong ratings which continued as Joanie and Chachi's relationship yo-yoed over the season. Meanwhile, Baio and Moran began seeing each other offscreen as well.

As the season unfolds, Fonzie and Roger's friendship develops while they're both teaching at Jefferson High. Of course Fonzie believes his new job teaching auto shop will be a breeze—but it turns out to be far more challenging than he expected. The gig does, however, provide an opportunity to pass along his sage advice to a new generation of teen-age boys. Kevin Rodney Sullivan, who played Tommy, would go on to become a prominent film director (*How Stella Got Her Groove Back* [1998]). Denis Mandel and Scott Bernstein scored as super-nerd

Season Eight 177

brothers Eugene and Melvin Belvin. Harris Kal would appear as Bobby in nineteen episodes; and, perhaps not so coincidentally, at the University of Illinois, Kal set the Big 10 record for stolen bases in a season and was welcomed onto the traveling softball team's roster. Fonzie further offered his guidance by joining the Big Brother program, mentoring a character played by Meeno Peluce (the older half-brother of *Punky Brewster*'s Soleil Moon Frye). The mentorship program would provide a surprising coda in Season Eleven.

Without Howard and Most, Anson Williams's role in the series was diminished, and he appeared in only sixteen of the season's twenty-two episodes, often briefly. An exception was "Potsie on His Own," an episode where, despite having to move back in with his parents, Potsie spends indulgently on his new girlfriend, raising concerns about the source of his finances. In the show's lighthearted reveal, it turns out he wasn't gambling, as everyone believed. Potsie was just embarrassed to admit he was earning money by performing at kids' birthday parties.

The season finale was a musical revue, centered on a theme of America as a

HAPPY DAYS' ROBUST EIGHTH SEASON WAS REWARDED WITH AN UNHEARD-OF RENEWAL ORDER FOR FORTY-FOUR ADDITIONAL EPISODES.

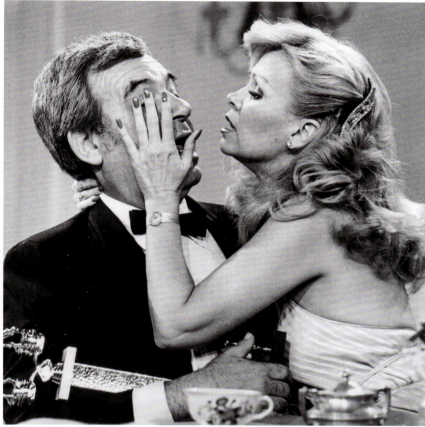

cultural melting pot. The cast enjoyed a challenge and the chance to show off their musical talents. The episode featured original songs by associate producer Jimmy Dunne and his collaborator J. Elizabeth Bradley. Numbers included a *West Side Story*–influenced song that celebrated Latino culture. The episode's grand finale, "Think Positive," defined the attitude of the Fonzarelli family arriving in America at the start of the twentieth century.

In the spring of 1981, there was an explosion of *Happy Days* births as Winkler, Howard, Ganz, Levant, and several others had children, which kicked off years of kids' birthday parties to add to the already crowded *Happy Days* social calendar. There were also sad occasions. In 1978, Tom Bosley lost his wife, Jean, to brain cancer. Two years later, Jerry Paris's wife, Ruth, would succumb to the same disease. The men leaned heavily on each other through both women's battles, and the show provided a welcome respite in dealing with their losses. Season Eight's twentieth episode, "Howard's Bowling Buddy," dealt with Marion's worries of being replaced by Fern Flagg, Howard's bowling partner, when a back injury forces Marion to spend most of the episode suspended on a door frame. Fern was played by Patricia Carr, an actress Tom Bosley had fallen in love with and married the previous year.

For a season that had begun with uncertainty and replacement parts, *Happy Days*' robust eighth season was rewarded with an unheard-of renewal order for forty-four additional episodes from ABC!

OPPOSITE: The "American Musical" finale, "Immigration Blues," where the entire male cast attempted to "think positive" and "spread your wings and fly."

ABOVE: Marion Ross earned big laughs without moving a muscle, while Fern Flagg put the moves on her husband in "Howard's Bowling Buddy."

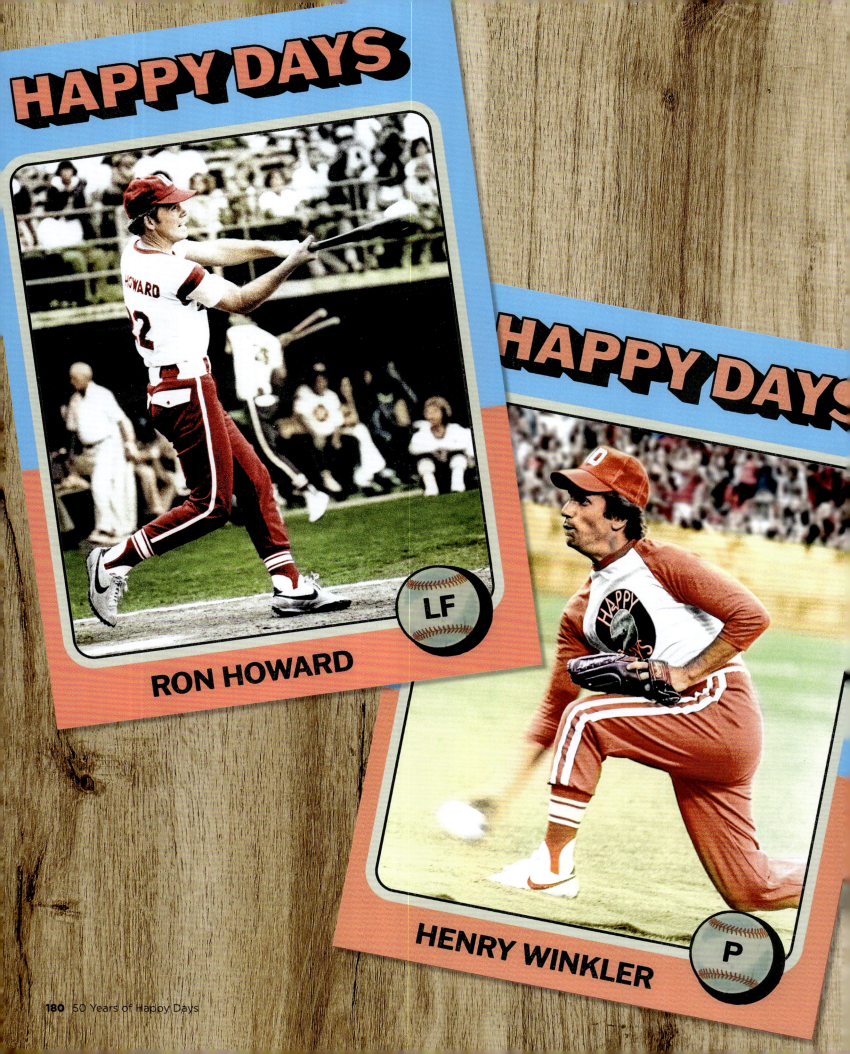

BARNSTORMING

For over a hundred years, youngsters have fantasized about making it to "the show," baseball's major leagues: the thrill of playing before thousands of screaming fans, coming up to bat with the game on the line. The cast and crew members of *Happy Days* were no different—except their dreams came true!

Happy Days' longest-running spin-off was the only one that never made a dime. For more than a decade, the *Happy Days* softball team traveled across three continents, serving as an "opening act" for major league teams from Seattle to Philadelphia. They headlined charity fundraisers everywhere from minor league stadiums to neighborhood baseball diamonds. They embarked on grueling USO tours stretching from West Germany's Zonengrenze to the shores of the China Sea. The squad faced off against all-star teams, media organizations, military teams, and scores of current and retired professional athletes—including Magic Johnson, Mark Fidrych, Jack Sikma, Kirk Gibson, Johnny "Red" Kerr, Pat Riley, "Fuzzy" Thurston, Matt Guokas, Bob Uecker, Doug Collins, Bobby Shantz, World Series hero Ron Swoboda, Hall of Famers Tommy McDonald, Richie Ashburn, and Lou Boudreau, Don Shula's Miami Dolphins and the San Diego Chicken. Yet the number of contests the multitalented squad lost over a decade could be counted on one hand.

By any metric, *Happy Days* was a great team onstage, offstage, and on the diamond. Series creator Garry Marshall was a writer-producer-director-actor-musician, but at heart he was an athlete. Marshall was a fierce competitor and a true leader who built his shows the way a great general manager puts together his team. For decades, Marshall hosted a Saturday morning basketball game in his backyard, where Hollywood stars traded elbows with pro athletes, writers, stockbrokers, and electricians. When Marshall renegotiated his deal with Paramount, the terms called for the studio to build

> ## "WHEN WE WERE ON THE ROAD, I WAS OUT FOR BLOOD."
> ### —HENRY WINKLER

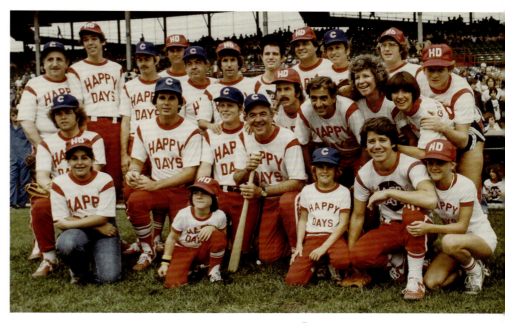

OPPOSITE: The baseball cards may be pretend but the *Happy Days* team played serious softball together for over a decade.

ABOVE: Tom Bosley received a heroes welcome at historic Wrigley Field, blocks from where he grew up. It was a special joy for team members to bring their children and significant others on the baseball trips.

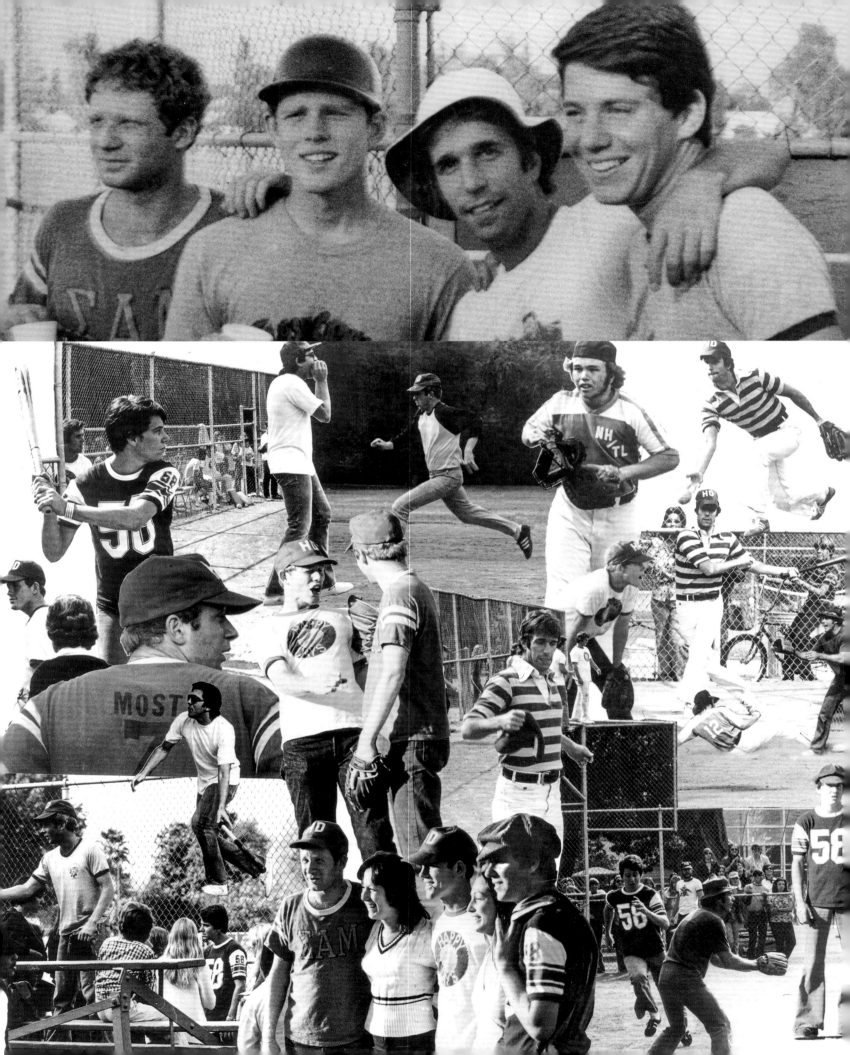

OPPOSITE (TOP): Most, Howard, Winkler, and Williams relax after an Entertainment League game.

OPPOSITE (BOTTOM): Ron Howard graciously shared the 1974 collage he made to chronicle the squad's first games.

LEFT: Erin Moran and Marion Ross loved playing with the team. Along with flowers, Executive Garry Marshall sent Marion Ross a note that read:

"Who could ever forget your red hair flying in the wind as you rounded 2nd base and headed for third on your stand-up triple in Seattle's Kingdome last week. You hit good—you field good and you run good. My congratulations to a complete athlete!

*Love,
Garry Marshall
1st baseman"*

him a soda fountain in his office and a basketball court behind it. But his first love was baseball.

Marshall began playing stickball as a kid in the Bronx and never stopped. He played softball in a fifty-five-and-over league into his eighties.

With *Happy Days*, Marshall was surrounded by a group of people whose desire to succeed burned as deeply as his own. By and large they were also true baseball fanatics who followed the sport intensely. Ron Howard and Don Most were top-notch players. Tom Bosley grew up in the shadow of Wrigley Field and was a student of the game. Though Bosley never played organized ball, his fundamentals were textbook. Anson Williams's audition included having to vouch for his softball skills. Williams recalls with a chuckle, "Obviously that was more important [to Garry Marshall] than acting was." In their first season, Marshall entered a *Happy Days* team in the Entertainment League, playing other television series crews, to spur a sense of cohesion—and that's when the team's nucleus began a decadelong run together.

There was only one small issue. One of the show's stars—the one whose mere

> **"I'M A FIFTY-THREE-YEAR-OLD WOMAN TELLING MY FRIENDS I CAN'T GO SHOPPING BECAUSE I HAVE BASEBALL PRACTICE."**
>
> —MARION ROSS

OPPOSITE:
ROW 1:
(L) Marion Ross, Scott Baio, and Lynda Goodfriend relax before the game.

(R) Garry Marshall played baseball his entire life, while Henry Winkler was given his first mitt at 28 from Ron Howard.

ROW 2:
(L) On their 1980 visit to the California Angel's Stadium, the *Happy Days* squad poses with Hall of Fame infielder Rod Carew.

(R) The *Happy Days* squad looks determined in their third visit to Dodger Stadium...but would go on to suffer a rare defeat.

ROW 3:
(L) Winkler's number always reflected his age at the time.

(R) Howard and Winkler pose for an off-season photo.

ROW 4:
(L) Ted McGinley steps into the batters box on the team's USO tour West Germany. The co-ed team of actors, writers and producers went 4–1 against young, athletic service teams.

(R) With a game in hand Ron Howard, his younger brother (and the team's catcher) Clint Howard, and dialogue coach (third baseman) Walter von Huene relax on the sidelines.

presence would soon pack stadiums—had never played baseball in his life. Growing up on New York's Upper West Side, Henry Winkler had never even owned a baseball glove. Ron Howard bought him one for his twenty-eighth birthday and included with it a pitching lesson. Under the patient tutelage of Don Most and dialogue coach (and former Loyola Marymount pitcher) Walter von Huene, Winkler learned to bat and field. By the time L.A. Dodgers executive Steve Brener invited the team to Chavez Ravine as a warm-up act for the club in 1976, Winkler's consistent low and inside tosses were forcing batters into meek pop-ups and nerdy ground balls.

Flush with the newfound excitement, camaraderie, and achievement the competition brought, Winkler became the squad's emotional and passionate leader. His newfound enthusiasm for the sport was the thirty-year-old's equivalent to a Little Leaguer who sleeps in his uniform the night before a big game. Winkler capsulizes his game-time demeanor: "When we traveled, I showed no mercy. I was out for blood."

> **"WOW, [YANKEES MANAGER] BILLY MARTIN TOLD ME THAT HE LIKED THE WAY I HANDLED THE BALL IN CENTER—THOSE ARE THE THINGS YOU DREAM ABOUT."**
>
> **—DON MOST**

Series matriarch Marion Ross was equally smitten with the game. She once remarked, "I'm a fifty-three-year-old woman telling my friends I can't go shopping because I have baseball practice." Ross became a dependable short fielder. She learned to milk walks off opposing pitchers, once hit a triple, and received flowers from Garry Marshall every time she got a hit or caught a ball in the outfield. Erin Moran and Arnold's "owners," Al Molinaro and Pat Morita, all took their swings, too. Ron Howard's brother, Clint, was the starting catcher. The lineup was later bolstered when the cast added All-Brooklyn Little League shortstop Scott Baio, and USC water polo team standout, Ted McGinley.

In addition to the show's stars, the team was frequently joined by former professional boxer and *Taxi* star Tony Danza and *Laverne & Shirley* castmates Penny Marshall and Eddie Mekka. Rob Reiner, who co-wrote the series' first episode and who'd had a brief stint in the minors, added his big bat to the lineup on occasion. *Leave It to Beaver*'s Tony Dow, as well as *Bosom Buddies*' Peter Scolari and Tom Hanks (who both guest starred in *Happy Days* episodes), all hopped on the bus for a few trips.

People couldn't get enough of *Happy Days*. The Fonz spawned a merchandising bonanza, he was on the cover of every national magazine, and when Major League Baseball front offices saw the squad's ability to pack stadiums with fans, families, and first-time visitors, teams rushed to invite the show's team to play ball, which they did thirteen times in MLB parks. In return, the team asked only for eighteen plane tickets and hotel rooms

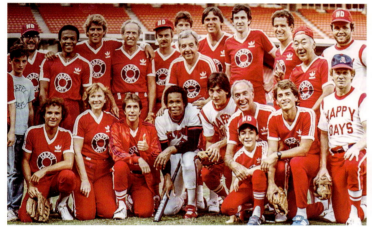
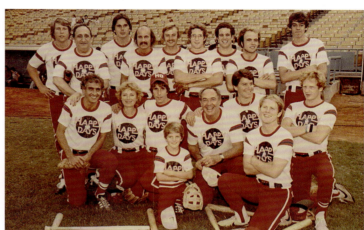

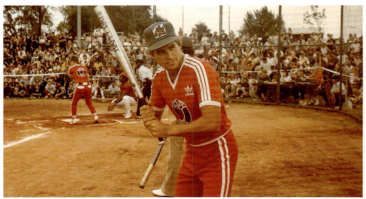

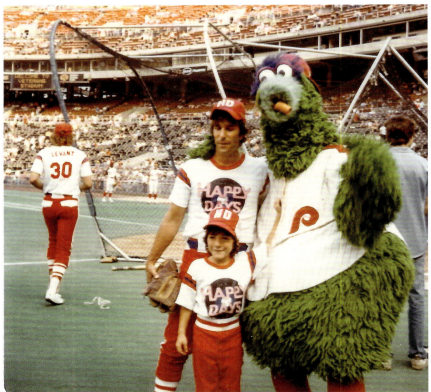

and the use of a bus. It was a labor of love.

Clad in red and white, the team made appearances in San Diego, Anaheim, Seattle, San Francisco, Los Angeles, and Chicago, and even a "home" game before 49,160 raucous fans in Milwaukee County Stadium. There, the *Happy Days* nine battled an all-star team of Wisconsin sports legends, ending in a 2–2 tie, as the squads were unable to go into extra innings because the Brewers and Rangers needed the field. One of the group's most memorable trips was a set of back-to-back games in Philadelphia's Veterans Stadium and New York's Shea Stadium.

At the time, sixteen-year-old Scott Baio was already doing a series of autograph shows around the country on weekends and, when asked if he would make the trip with the team, Baio, looking

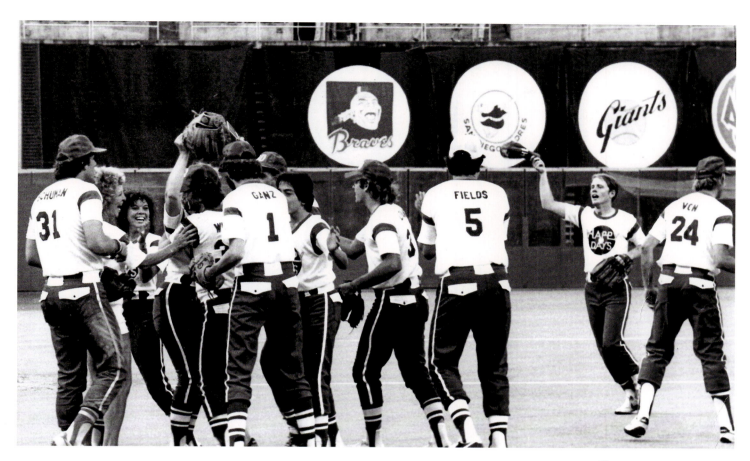

for some free time, begged off. Soon his father appeared on set and, in Baio's words, "He's got the 'mad face' on." The pair had been summoned urgently to Garry Marshall's office. "And I'm thinking, 'Oh crap, what did I do?'" Marshall ordered the pair to sit down, Baio then quotes Marshall word for word: "One of the reasons I like to do television is that I get to play ball. Your son, Mario, won't play with me. Why not?" Baio's puzzled father asked what he wanted, and Marshall answered, "I want your son to play with me."

Baio indeed made the trip, which was a special one. In order to travel on Friday for the weekend games, that week's episode of *Happy Days* was filmed on a Thursday night. Arriving in New York the next day, Tom Bosley treated the group to dinner at the iconic Broadway eatery Sardi's (where Bosley was seated below his caricature from *Fiorello!*). On the walk over from the hotel, the cast began to encounter fans on the street and continued to gather attention, until they were literally being followed by hundreds of incredulous New Yorkers.

On Saturday afternoon, spirits were high as the team traveled by bus to Philadelphia for their East Coast debut . . . until they saw who they were playing against. With the exception of the city's mayor, the opposing team was composed entirely of current and former professional athletes.

Fifty-six thousand fans packed into the old ballpark and witnessed a genuine nail-biter as both teams turned one sharp defensive play after another. As Scott

OPPOSITE (L-TOP): Garry Marshall signals Don Most that he needn't slide into home plate.

OPPOSITE (R-TOP): Anson Williams thanks Henry Winkler for advancing him to third base in a 1978 game.

OPPOSITE (BOTTOM): Two Icons meet. Henry Winkler and batboy Jed Weitzman greet rookie mascot, the Philly Phanatic, before game time.

ABOVE: After making the game ending catch in Philadelphia's packed Veteran Stadium, Ron Howard races in to join the celebration on the pitcher's mound after *Happy Days*' 2-1 victory over their fiercest opponent to date.

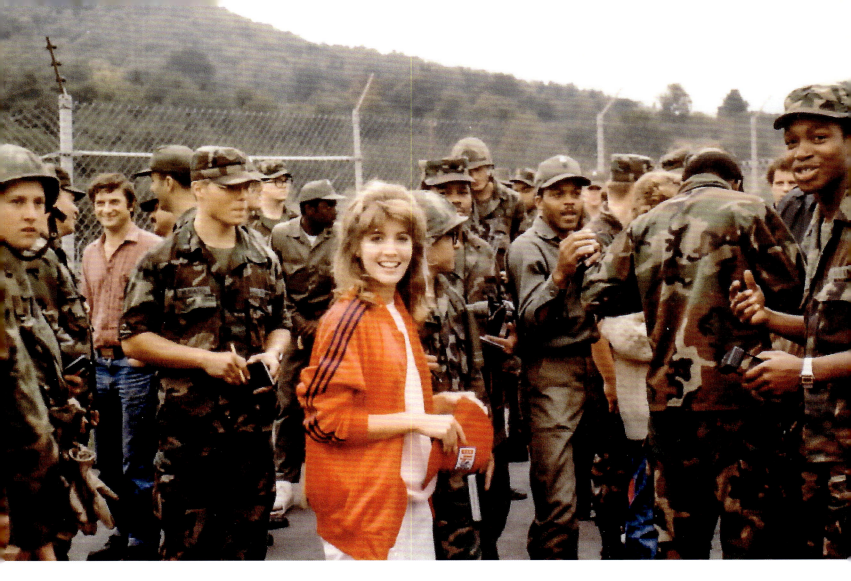

ABOVE: Crystal Bernard (K.C. Cunningham) greets the troops at the Giebelstadt Army Airfield.

OPPOSITE: The group paid an emotional visit to the dividing line between West and communist run East Germany. The sign marks the border.

Baio proudly remembers, "I was playing shortstop and I'd been making a couple of great diving catches, and the pros are, like, going, 'Whoa.'" Going into the seventh and final inning, the score was tied at one run apiece. With two outs, *Happy Days* managed to load the bases for Garry Marshall. With a keen eye, Marshall worked a full count . . . then watched ball four sail wide, walking in the lead run. But Philadelphia had last at-bats.

Fans went wild as Henry Winkler retired the first two batters, and, with the game on the line, up stepped to the plate recently retired Philadelphia 76ers point guard Hal Greer. Greer had faced many such moments in his fifteen-year career—but for Winkler, this was his first.

The pitcher took his time, then delivered a called strike inside. On the next pitch, Greer swung, and left fielder Ron Howard remembers the moment vividly. "He hit this towering fly ball and the crowd, 50,000 people, went utterly silent, like a movie. I didn't have to go far for it, but it hung up there forever and I thought about every possible way I could screw it up—drop it, a million different ways. But I caught it."

In the locker room, the *Happy Days* gang celebrated with cheesesteaks from the legendary Pat's King of Steaks. Bobby Murcer, then of the Chicago Cubs, gave Scott Baio his first taste of chewing tobacco. "I sat in the dugout and almost got sick," Baio recalls. "But he was a hero of mine when I was a boy."

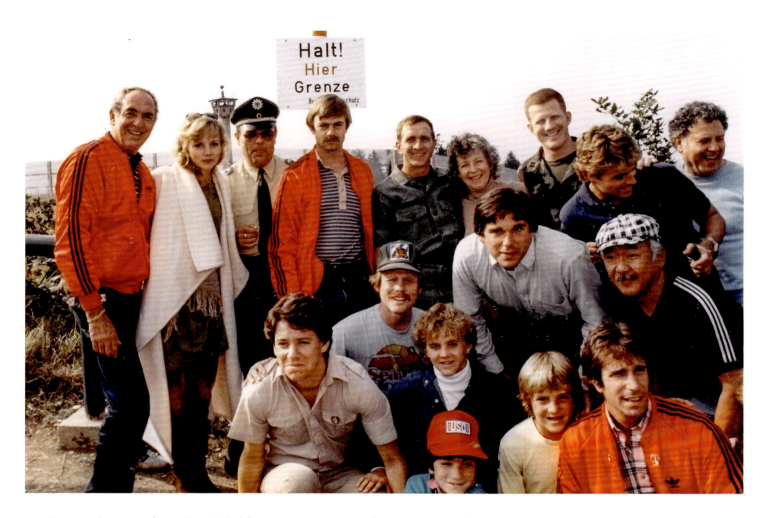

Returning to the city, Winkler convinced the staff at Rumpelmayer's ice cream parlor to stay open for a round of victory hot fudge sundaes.

Twelve hours later, New York baseball fans welcomed Henry Winkler and company to a packed Shea Stadium with the kind of monstrous ovation that the city normally reserved for ticker-tape parades. *Happy Days* cruised to a 10–0 victory, over a team of celebrities and Mets wives, then began their long trip home.

The crew arrived at Kennedy Airport to discover their flight would be delayed several hours. In order to keep the cast from being mobbed by fans, the airline moved everyone beneath the terminal to a run-down baggage handlers' break room. There, rather than sulk or whine, team announcer Jerry Paris led the group in an hours-long, laugh-filled charades marathon before heading back to L.A. and a week's hiatus for the actors.

The softball team's USO tours were first proposed by Four-Star General Fred Mahaffey, who happened to be Anson Williams's father-in-law at the time. In October 1982 the team, including Ron Howard who had left the series but not the team, flew to Germany. They played five games in seven days against Army and Marine squads. The team lost only one game in Germany against young, athletic players who were stunned to find themselves humiliated by a co-ed team of actors and writers. Henry Winkler was

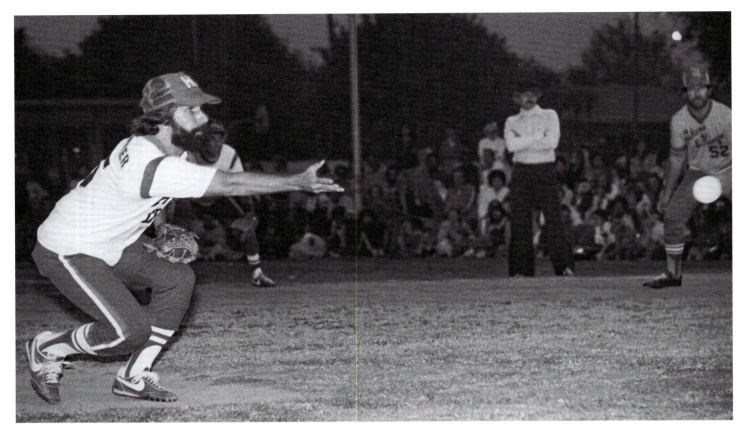

ABOVE: Twice *Happy Days* faced a team of Showtime era LA Lakers and Kings. Both times *Happy Days* led going into the final inning before the pros would notch comeback victories.

OPPOSITE: An official *Happy Days* team jacket and a selection of team jerseys circa 1976–2003.

named the tour's most valuable player for his superb pitching.

The cast dined with enlisted personnel, visited hospitals . . . and took joy rides in Black Hawk helicopters. The group paid an emotional visit to the border between East and West Germany. It would be another seven years before the Berlin Wall fell and the nation was reunited.

At 6 a.m. on November 12, 1983, the morning after filming their final episode ever, they flew to Okinawa and swept four games in four days against military teams across the island outpost. Anson Williams took home the trip's MVP trophy. Even for people who were used to the spotlight, on both trips, the entire group was overwhelmed by the incredibly warm response they received from the troops and their families.

The squad would gather two additional times. In 2003, a spirited intra-squad game was held, running innings longer than planned because no one wanted to stop. In 2005, they squared off again, this time as part of the Henry Winkler–produced *Happy Days 30th Anniversary Reunion*. The cast and crew split into two teams, with Arnold's Drive-In battling Cunningham Hardware at Malibu's Pepperdine University.

The team's rosters were expanded to include Penny Marshall, Cindy Williams, and many characters from the series' past. The game ended with Ted McGinley's game-saving, highlight-reel-worthy diving catch. He recalls modestly, "I lucked out, I got really lucky, and I was excited because my two boys were there to see it."

The touring team's experience mirrored that of professional athletes in

Barnstorming 191

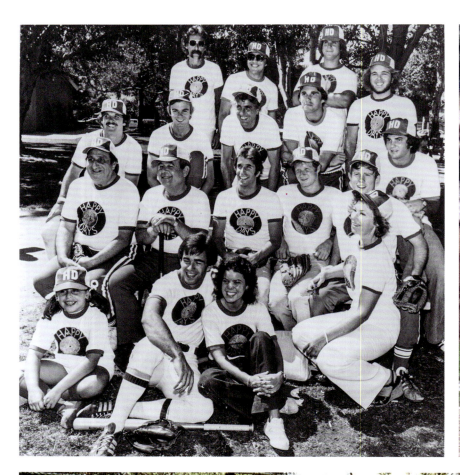

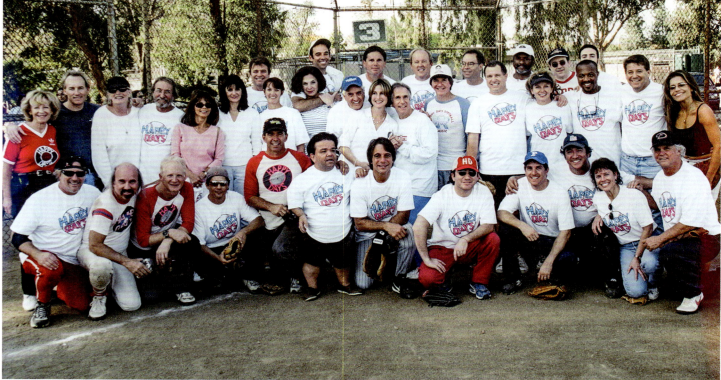

rigorous practices: playing poker on planes, singing on buses, calisthenics, batting practice, signing endless autographs, jersey swaps, arguing with umps, spitting sunflower seeds, and hearing the roar of the crowd after a dazzling play. The squad always sought to perform at the peak of their abilities and defeated many teams that they had no business even being on the same field with. Not to mention sharing dugouts and locker rooms with some of baseball's biggest names—Reggie Jackson, Tommy John, Rod Carew, Joe Torre, Tommy Lasorda, Ryne Sandberg, Don Sutton, Pete Rose—and earning their respect.

Don Most fondly shared a moment from the squad's game in Seattle's Kingdome. "There was a ball hit to deep center, I had to go back pretty far, but I made the catch. I come back to the dugout and [legendary New York Yankees manager] Billy Martin says to me, 'I like the way you went back for that ball out there.' Wow, Billy Martin told me that he liked the way I handled the ball in center—those are the things you dream about."

"People always ask me, what were my favorite moments of Happy Days?" muses Anson Williams. "It wasn't on the set—it was traveling with our team, the major league parks, and hangin' with all the players. Those are the best memories." Marion Ross reflects, "It kept the cast together. I don't know if we would have survived if we didn't have that softball team." The Happy Days squad was a once-in-a-lifetime experience, an extension of the teamwork developed onstage, a team whose play exemplified the true spirit of America's national pastime.

OPPOSITE (L-TOP): The first official team photo from the 1977 season.

OPPOSITE (R-TOP): Winkler crosses home plate.

OPPOSITE (BOTTOM): The 2003 intra-squad reunion game including *Taxi*'s Tony Danza (bottom row, middle) and travel coordinator Diane Frazen (top row, far left).

ABOVE: The group played their final game as part of the Henry Winkler produced 30th Anniversary Special. The intra-squad game included *Laverne & Shirley*'s Cindy Williams, Penny Marshall, and ump Eddie Mekka along with Danny Butch (Fonzie's nephew "Spike"), Ken Lerner (Rocco Baruffi), Linda Purl, Lynda Goodfriend, Pat Morita, authors Levant and Fox, and former batboy Scott Marshall. Tom Bosley fulfilled a boyhood dream by moving to the announcer's booth and calling the game.

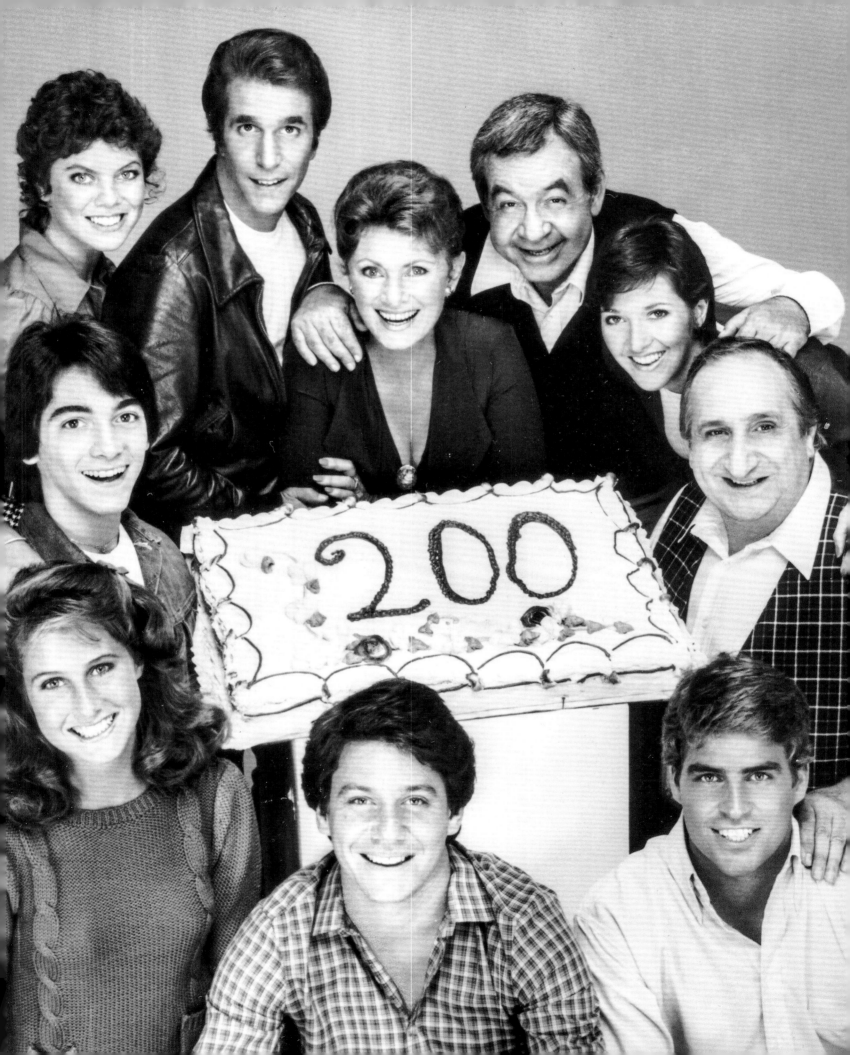

SEASON NINE

In its ninth season, *Happy Days* remained a top twenty show, coming in eighteenth with nearly twenty million viewers weekly. More than ever, the spotlight shone on Scott Baio and Erin Moran's Chachi and Joanie, while Fonzie stories drove fewer episodes. It's common practice for producers to signal to series stars that an episode features them by placing their character's name in the title. For instance, in Season Nine, only two titles mentioned Fonzie by name, as opposed to ten in Season Four.

Season Nine opened with an hourlong episode titled "Home Movies." It was an ambitious undertaking, tracking each character through their summer via the Cunninghams' home movies. The footage is narrated by Joanie and sent as a gift to Richie, still "stationed in Greenland."

Over the course of the episode's summer, Roger works as a lifeguard and finds love practicing "the buddy system" with Corrine (D.D. Howard), a champion swimmer. Meanwhile Fonzie, rather than

jumping or riding something, faces an even greater struggle—accepting his maturity. This pivotal moment for the character coincides with the reunion of his old gang, the Falcons, an event delayed until "everyone was out of jail." The gathering is interrupted by a challenge from one of their rival gangs, the Warmongers, to settle an old score. Fonzie accepts the dare, but instead of a rumble with car antennas, chains, and knives, Fonzie decrees that they settle their differences with baseball bats . . . and gloves, on the softball field. This gave Winkler a chance to display his pitching skills to a national audience.

> **AS THE SERIES MOVED FIRMLY INTO THE '60S, THE SHOW FELT IT WAS TIME TO ACKNOWLEDGE THE CIVIL RIGHTS MOVEMENT.**

OPPOSITE: The cast of *Happy Days* celebrates a rare television achievement.

LEFT: Scott Baio and Erin Moran's onscreen relationship would outlast their offscreen one.

PAGES 196–197: The cast and Jerry Paris pose for photos at the gala event Paramount and ABC threw in their honor at the Beverly Hills Hotel. Garry Marshall quipped that, "at the Beverly Hilton Hotel, they're having a party for every realtor who sold someone here a house." Party crashers included *Blues Brothers* Dan Aykroyd and John Belushi.

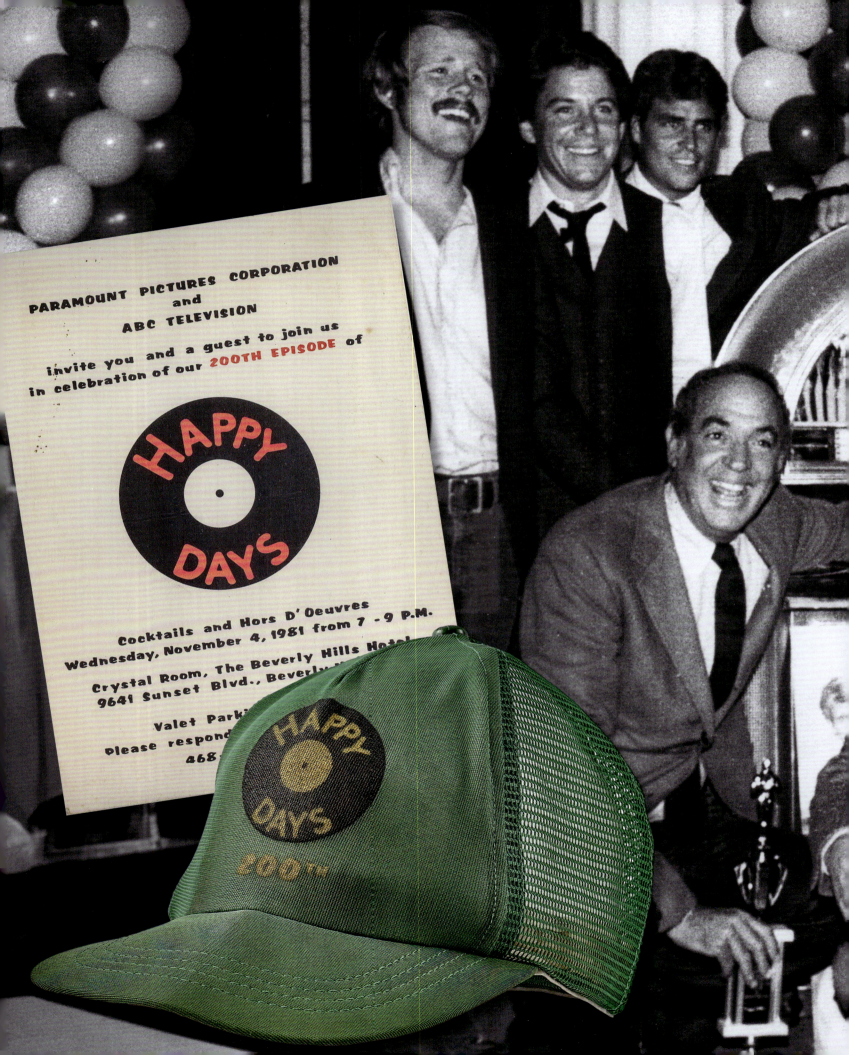

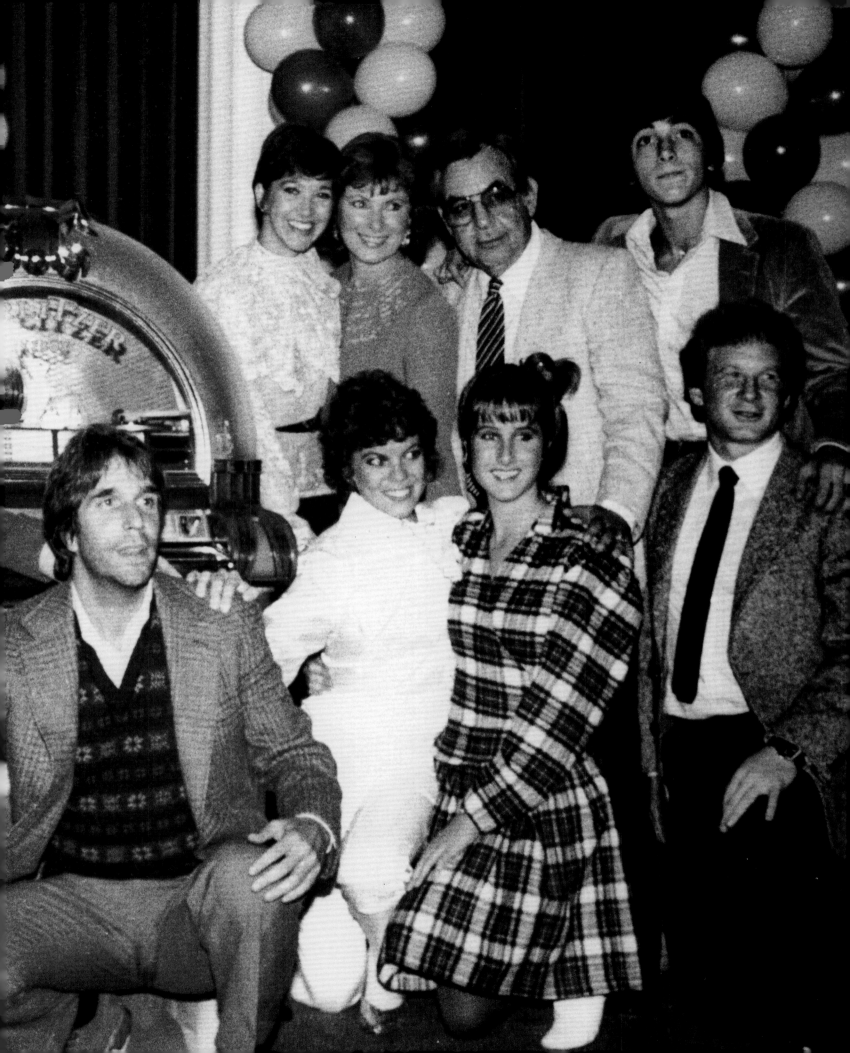

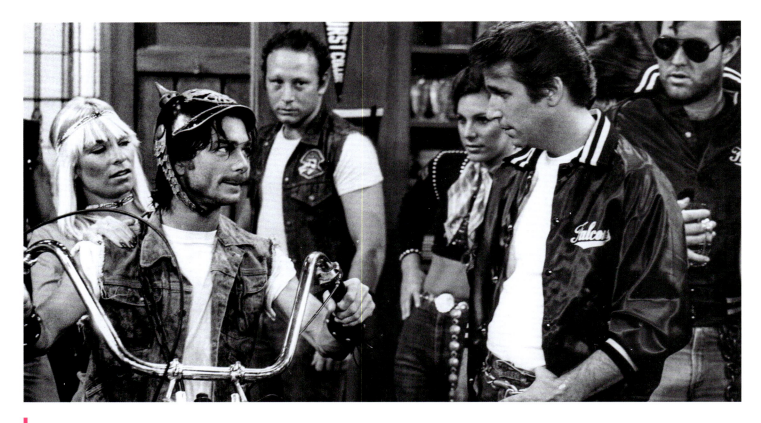

ABOVE: The leader of the Warmongers (Derrel Maury) challenges the Falcons to a rumble at their reunion in "Home Movies Part I."

OPPOSITE (L): Sgt. Kirk (Ed Peck) puts the collar on Jenny and Joanie in "Just a Piccalo."

OPPOSITE (R): Like nearly every member of the crew, Henry Winkler grabbed a photo with Cathy Silvers and her dad, legendary comedian Phil Silvers.

But a disputed call turns the game into a full-scale rumble after all. Afterward, icing their bruises, Fonzie and his old pal Rocco Baruffi (Ken Lerner) finally accept that they're no longer who they were a decade ago. Now Rocco has a child, Fonzie owns two businesses and is teaching summer school—rather than having to repeat classes.

Meanwhile, Joanie and Jenny Piccalo work at a lakeside snack bar that summer, while Joanie and Chachi continue their seesaw romance. At one point, Chachi asks for his letterman's jacket back, only to discover that Joanie has burned it. Naturally, by Labor Day they were back together.

During the summer, Anson Williams found a new niche in the series as Potsie Weber goes to work for Mr. C at the hardware store. He also replaced Richie as Howard's seatmate at Milwaukee Braves games. Howard Cunningham faced problems of his own when Lori Beth's pregnancy triggers Howard's fears of mortality. Fortunately, he has Marion by his side to comfort him and share all the years to come.

When the hourlong script for "Home Movies" was read for the first time, it earned applause from the cast and crew, but not everyone was thrilled. The producers got an earful from Al Molinaro, who was very upset that his character was the only one without a storyline. Lowell Ganz quickly addressed this by adding a visit from Al Delvecchio's overbearing, critical mother, played by Alice Nunn. By the episode's end, Al finally learns to stand up to his nagging mother. The writers tried to make further amends by setting up the romantically challenged Al with Chachi's mother, Louisa Arcola, played by Ellen Travolta (the sister of movie and

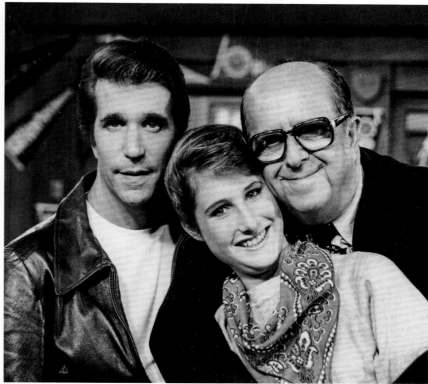

television star John Travolta). Later in the season, the pair would marry, and the following year they would be spun off with Joanie and Chachi.

Al Molinaro was genuinely a sweet man, but the lack of a storyline in the opener remained a burr in his saddle. After the series ended, he appeared in only one Happy Days public or private event.

After the "Home Movies" episode, and throughout Season Nine, the role of Jenny Piccalo grew, along with the writers' confidence in Cathy Silvers. She could crush a line, and Jenny's antics propelled several stories. In "Just a Piccalo," Joanie and Jenny try to join a snooty girls club, the Rondells. To be accepted, they're tasked with stealing a statue from Pfister Park, only to be apprehended and arrested by Officer Kirk. Silvers's real-life dad played her TV dad when comedy king Phil Silvers appeared at the end of the episode. As he exited his scene, Silvers surveyed the Cunninghams' living room and declared, "What a dump."

Cathy Silvers's fraternal twin sister, Candace, appears in "Home Movies" and two other episodes. However, Candace Silvers was not the only Happy Days

> **NOT SINCE THE BATTLES OVER FONZIE WEARING A LEATHER JACKET EIGHT YEARS EARLIER HAD THERE BEEN A SIGNIFICANT DUSTUP BETWEEN THE PRODUCERS, ABC, AND PARAMOUNT.**

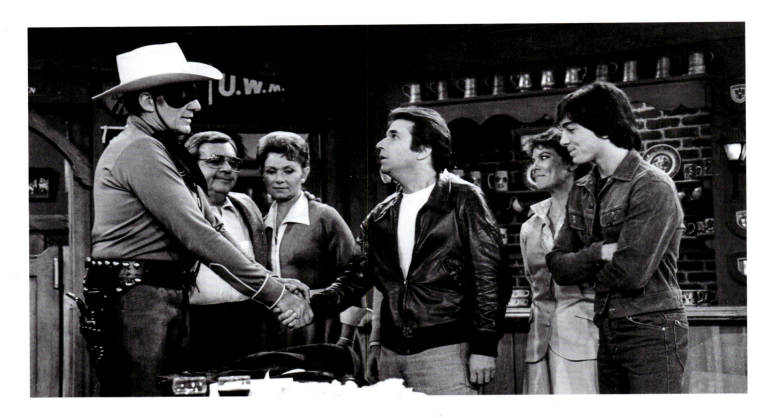

ABOVE: The Fonz is at a loss for words when he meets his hero the Lone Ranger played by John Hart. Though Clayton Moore is better known for the role, Hart donned the mask for a season when Moore unsuccessfully held-out for a raise.

OPPOSITE: The Fonz stands-in for Richie in Lamaze class and in the delivery room in one of the season's standout moments.

family member to log screen time. Ron Howard's father, Rance, and brother, Clint, had roles, as did Tom Bosley's daughter, Amy, Erin Moran's brother, John, Jerry Paris's daughter, Julie, and son Andy. Scott Baio's brother, Steven, dropped by for three episodes. Plus, Garry Marshall, his kids (Lori, Kathleen, Scott), and even his mother, Marjorie, got screen time.

Even the characters brought family members into the mix. Since Fonzie had a handsome relative on the show, why shouldn't Roger Phillips? So, the ninth season introduced Roger's rebellious little brother, Flip, played by future *Baywatch* and soap opera star Billy Warlock.

Employment was not only provided to immediate family. Over the years, *Happy Days* would provide opportunities for dozens of young performers, many as dates for Fonzie and the boys. That list includes Amy Irving (*Carrie*), Charlene Tilton (*Dallas*), Dinah Manoff (*Soap*), Cassandra Peterson (*Elvira*), Morgan Fairchild (*Falcon Crest*), Talia Balsam (*Mad Men*), Shawn Weatherly (*Baywatch*), Janine Turner (*Northern Exposure*), Wendy Schaal (*The 'Burbs*), sisters Audrey (*Dallas*) and Judy (*L.A. Law*) Landers, Rita Wilson (twice) and Morgan Hart, whose one-week gig blossomed into a five-decade marriage to Don Most.

The emotional highlight of the ninth season, besides Fonzie turning into mush upon meeting his childhood hero, the Lone Ranger (John Hart), was "Little Baby Cunningham," in which Lori Beth gives birth to Richard Cunningham Jr. At a time when it was becoming more and more difficult to find new challenges for The Fonz, he valiantly accompanies Lori Beth to Lamaze classes and the delivery room, standing in for his best

friend in Greenland. As always, Fonzie is under complete control . . . until he faints—which was the same reaction ABC and Paramount executives had when they read the script for Episode 202, "Southern Crossing."

Garry Marshall was fond of saying, "If television was the education of the American public, then my shows were recess." But as the series moved firmly into the '60s, the show felt it was time to acknowledge the Civil Rights Movement. In "Southern Crossing," Al Delvecchio announces that he is going to Selma, Alabama, as a Freedom Rider. The Cunninghams express concerns for Al's safety, but he can't tolerate the idea of a restaurant turning away people because of the color of their skin. In a heartbeat, Fonzie joins Al on his journey, where they help to integrate a diner by leading a sit-in protest.

Not since the battles over Fonzie wearing a leather jacket eight years earlier had there been a significant dustup between the producers, ABC, and Paramount. Both companies were frightened by the possibility that stations in the deep South would refuse to air the episode and risked

MIDWEEK, AN ULTIMATUM CAME DOWN TO REPLACE THE ACTOR PORTRAYING THE LOCAL SHERIFF OR ABC WOULD WITHHOLD FUNDING FOR THE EPISODE.

Season Nine 201

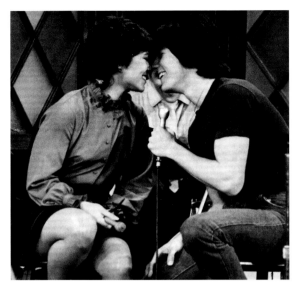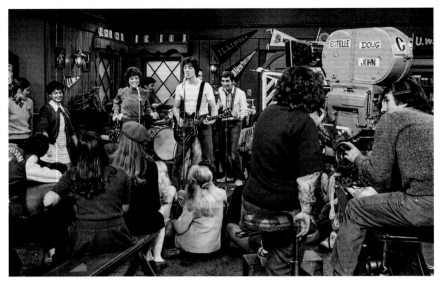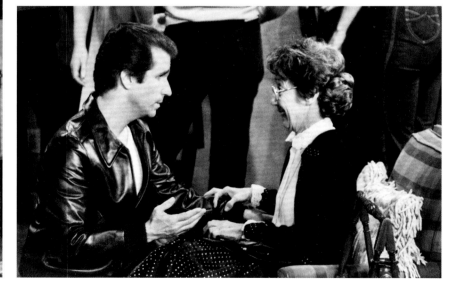

OPPOSITE (TOP): Music propelled more episodes and would launch Moran and Baio into their own series, which began production immediately following the end of Season Nine.

OPPOSITE (L-MIDDLE): Marion Cunningham finds a new way to polish her coffee table.

OPPOSITE (R-MIDDLE): Newlyweds Al Delvecchio and Louisa Arcola (Ellen Travolta) were spun-off with Joanie and Chachi.

OPPOSITE (R-BOTTOM): After their controversies over "Southern Crossing," putting Fonzie and Chachi's Grandma Nussbaum (Frances Bay) in a rest home was met with relief.

LEFT: In the much debated episode "Southern Crossing," The Fonz triumphantly puts a coda on his helping to integrate a southern diner.

eroding *Happy Days*' audience. With showrunner Lowell Ganz battling the flu at home for most of that week, it fell to producer Ronny Hallin to mediate the firestorm. Even though the writers gamely tried to soften the material to appease the network's demands, nothing could satisfy ABC. Midweek, an ultimatum came down to replace the actor portraying the local sheriff or ABC would withhold funding for the episode. It was difficult to discern exactly what the network wanted from the role as their notes ran the gamut, wanting the white sheriff to be "a lawman who's much more sophisticated than Sheriff Lobo, but not as savvy as Rod Steiger's portrayal in the film *In the Heat of the Night*." And as for the family that Fonzie and Al bunked with, the network wanted them "higher up the economic scale than the family in *Good Times*, but not as well off as *The Jeffersons*." The sheriff was recast. Finally, Garry Marshall was forced to make a pilgrimage to ABC to defend the integrity of the episode. Marshall felt "Southern Crossing" contained a "very poignant and moralistic message" that was right for the series.

After the filming of the show, Jerry Paris stated, "It worked well, didn't it?" And it had. The studio audience cheered wildly; no stations banned the show. "Southern Crossing" was highlighted in *TV Guide* as the pick of the day, and millions of school kids learned about the Civil Rights Movement for the first time.

The following week, everyone's blood pressure dropped considerably, with a show about putting Fonzie's Grandma Nussbaum in a retirement home.

SPIN-OFFS
PART THREE
FROM PRIMETIME TO SATURDAY MORNING

Happy Days' producers had built what was often referred to as a comedy empire . . . but empires do tend to crumble. After the success of *Laverne & Shirley*, Marshall and Tom Miller thought they had another breakout star in *Happy Days* character Pinky Tuscadero, played by the brash Roz Kelly. In the Season Four opener, "Fonzie Loves Pinky, Parts I–III," The Fonz joined his old flame in a battle against the Malachi brothers in a wild, fender-bending demolition derby. "Fonzie Loves Pinky" garnered huge numbers, and the producers pushed ABC to spin off the female version of Fonzie into her own show. Despite some apprehension on ABC's part, Marshall, Miller, and Milkis wrangled a commitment to film a *Pinky* pilot. Garry Marshall directed the project, but when it was completed, test audiences gave the show a "thumbs down." ABC passed on *Pinky*, but Pinky wasn't done yet.

A strategy of ABC chief Fred Silverman's was to weaken opposing networks by stealing talent from their hit shows. In 1976, he lured Nancy Walker from CBS and the series *Rhoda*. This led

> **"FONZIE LOVES PINKY" GARNERED HUGE NUMBERS, AND THE PRODUCERS PUSHED ABC TO SPIN OFF THE FEMALE VERSION OF FONZIE INTO HER OWN SHOW.**

OPPOSITE: Scott Baio says "I loved Erin...She was my first girlfriend" but by the time *Joanie Loves Chachi* debuted, they were no longer a couple offscreen.

LEFT: Nancy Blansky (Nancy Walker) and her "Beauties." On either side of Walker are Caren Kaye and Lynda Goodfriend, who would remain in Las Vegas for *Legs* and *Who's Watching the Kids?*

to Garry Marshall launching 1977's short-lived *Blansky's Beauties*, starring Walker as the choreographer and den mother to the chorus line at Las Vegas's Oasis hotel. To launch the series, Walker paid a visit to *Happy Days*' "The Third Anniversary Show" as Howard Cunningham's "cousin" Nancy Blansky. Though *Blansky's* was not a direct spin-off, the series' regulars included future *Happy Days* cast members Scott Baio (who made his TV debut in the *Pinky* pilot) and Lynda Goodfriend. Additional regulars included Pat Morita, reprising his Arnold role, writer Fred Fox, *Laverne & Shirley*'s Eddie Mekka, playing Carmine Ragusa's cousin and Nancy Walker's nephew Joey DeLuca, Garry Marshall himself as Oasis casino owner Mr. Smith . . . and, you guessed it, Roz Kelly as Pinky Tuscadero. Though the character was heavily promoted in the first episode, she clashed with Nancy Walker, as she had with the *Happy Days* cast, and was dropped from the series.

For a show about dancers, the entire endeavor seemed out of step. Lynda Goodfriend relates that the entire experience was "such a nightmare. Nobody knows what they're doing. They kept trying to change it to make it work." ABC finally threw in the towel after only thirteen episodes, and Walker returned to *Rhoda* the following fall.

Despite the setback, Marshall was convinced his showgirl concept had legs, and to prove it, he sold *Legs* to NBC. The 1978 hourlong pilot featured *Blansky* stars Caren Kaye and Goodfriend. Along the way, it was whittled down to a half-hour and retitled *Who's Watching the Kids?* They added Baio and Tammy Lauren as the titular kids for family appeal, along

with Jim Belushi and Larry Breeding to play a local TV news team and occasional babysitters. Lynda Goodfriend recalls her frustration: "Every week the show was changed. I remember filming and Garry comes up to me, puts his arm around me, and he says, 'Look, don't feel bad. The show's not going to be about you and Caren any longer.' We were the leads of it originally. They wanted it to be about the two guys now." The cornucopia of mismatched pieces had aired only nine episodes when the curtain came down.

Another show that got its start with a boost from *Happy Days* was ABC's short-lived 1979 series *Out of the Blue*, which featured comedian—and future head writer of *The Tonight Show with Jay Leno*—Jimmy Brogan. Brogan, as an angel named Random, who is trying to earn his wings by performing good deeds as a high school teacher. The series was created by Tom Miller and Bob Boyett, who arranged an appearance by Brogan's character on *Happy Days* to promote the show. Later that week, they chiseled Robin Williams, as Mork, into *Out of the Blue*'s premiere episode.

A pilot was actually made for *Lenny and Squiggy in the Army* written and starring Lander and McKean with their partner from The Credibility Gap, Harry Shearer. During *Happy Days*' sixth season, a half-dozen scripts were prepared for a Ralph & Potsie series, where the boys would move to Los Angeles. And the *Happy Days* episode "Ralph vs. Potsie" focused on the pair as roommates in a "back-door" pilot for their own show. However, all involved were apprehensive about the impact of breaking up the cast of *Happy Days*.

OPPOSITE (TOP): The cover of the unsuccessful *Pinky Tuscadero* pilot. Co-writer Arthur Silver recalls, "We kept rewriting stuff we hated and the network kept saying things like, 'Has Garry seen this?'"

OPPOSITE (BOTTOM): Ethel "Sunshine" Akalino (Lynda Goodfriend) comforts her nephew Anthony DeLuca (Scott Baio), in the short lived *Who's Watching the Kids?*

LEFT (TOP): At first ABC didn't even want Lenny and Squiggy on *Laverne & Shirley*, but by the end of their first season, they attempted to spin them off.

LEFT (MIDDLE): In its sixth season, *Happy Days* episode "Ralph vs. Potsie" served as a back-door pilot for yet another spin-off.

LEFT (BOTTOM): As he had for *Mork & Mindy* and *Laverne & Shirley*, The Fonz blessed *Joanie Loves Chachi* with a visit for their second-season premiere.

Spin-offs: Primetime

RIGHT: Joanie and Chachi jam with their back-up band. On bass: Annette (Winifred Freedman); drums: Bingo (Robert Pierce); and keyboards: Mario (Derrel Maury).

OPPOSITE (TOP): In their second season, the show's ratings declined substantially when the show moved to Thursday nights opposite *Magnum, P.I.*—who had knocked *Mork & Mindy* off the air the previous season.

OPPOSITE (BOTTOM): Howard and Marion Cunningham paid a visit to check-up on their daughter in Season One's "Joanie's Roommate."

Three years later, with *Happy Days*' end looming, they changed their minds. So, on March 23, 1982, *Joanie Loves Chachi* premiered on ABC. The spin-off took Erin Moran and Scott Baio's *Happy Days*' romantic duo ninety miles South to Chicago to pursue their music career. They were chaperoned by Al Molinaro, whose *Happy Days* character had married Chachi's mother, Louisa Arcola (played by Ellen Travolta).

Happy Days was able to flex its ratings magic one last time, and *Joanie Loves Chachi* debuted to huge numbers. The audience remained loyal throughout *Joanie Loves Chachi*'s initial four-episode run, airing in *Laverne & Shirley*'s time slot as *Happy Days*' companion piece.

The series was ambitious in that it featured a new musical number in every episode. Of the duo's romantic ballads, Baio confesses, "I was never comfortable with music because it's not what I do. It's

> **"EVEN THOUGH I DID TWO RECORDS FOR RCA. I'M NOT A SINGER. I JUST FELT UNCOMFORTABLE. ERIN [MORAN], BEAUTIFUL SINGER. ME, NOT SO MUCH."**
>
> —SCOTT BAIO

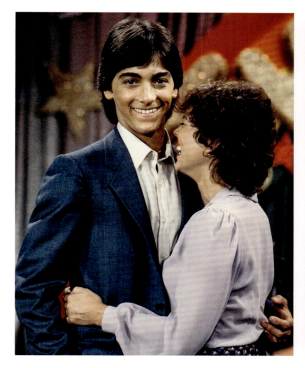
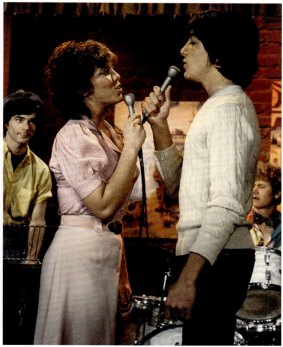
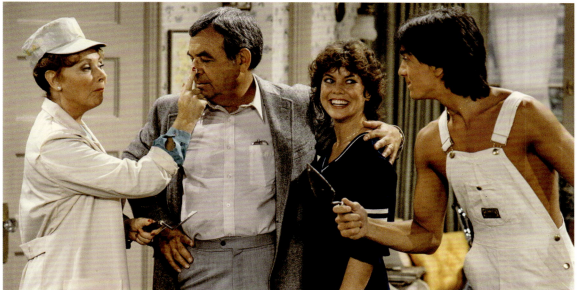

not me. Even though I did two records for RCA. I'm not a singer. I just felt uncomfortable. Erin [Moran], beautiful singer. Me, not so much."

Joanie Loves Chachi was renewed for a second season, but without Lowell Ganz, who wrote the pilot and supervised the production, as he returned to *Happy Days* along with the entire writing staff. That team was replaced by new writers, who, Baio would later complain, "Didn't know the characters." ABC moved the show into *Mork & Mindy*'s old Thursday night slot . . . and got clobbered by CBS's powerful *Magnum, P.I.* Baio and Moran's series was canceled after seventeen episodes, and the pair gladly returned to *Happy Days* for its final season.

RIGHT (TOP): Robin Williams, Pam Dawber, and Conrad Janis voiced younger versions of their TV characters along with Frank Welker as Mork's pet alien, "Doyng."

RIGHT (BOTTOM): The Fonz took over the motor pool on the girls' base in the second season of *Laverne & Shirley in the Army*.

OPPOSITE: A screen-used animation cell is surrounded by character style guides for the cast of *The Fonz and the Happy Days Gang*, from Hanna-Barbera Productions.

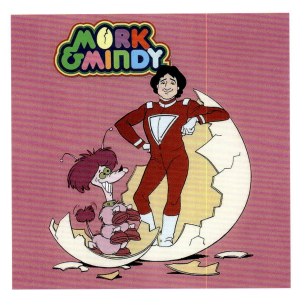

There were better results when *Happy Days* and its heirs set their sights on Saturday mornings. In the fall of 1980, Henry Winkler, Ron Howard, and Don Most supplied the voices for the ABC cartoon series *The Fonz and the Happy Days Gang*. The show was produced by Paramount and Hanna-Barbera, the animation powerhouse behind *The Flintstones* and *Scooby-Doo*. Pajama-clad kids followed the crew from Milwaukee on their time-traveling adventure, in a storyline suspiciously like BBC's *Doctor Who*. Richie, Ralph, and The Fonz were accompanied by Cupcake, a girl from the future (*Grease*'s Didi Conn). Also tagging along was Fonzie's dog, Mr. Cool, voiced by original *Scooby-Doo* cast member Frank Welker. The show ran for twenty-four episodes over two seasons.

The following fall, Lenny and Squiggy finally made it into the military, though in animated form, when they joined their downstairs neighbors in *Laverne & Shirley in the Army*. All four principals supplied their characters' voices. Playing their porcine nemesis, Sgt. Squealy, was *Welcome Back, Kotter*'s Ron Palillo. The series was inspired by a two-part primetime episode where the girls enlisted "to meet guys." The first episode of the animated series conspired to send the girls into space, where they were captured by aliens.

The animation juggernaut continued to roll into 1982 with the *Mork & Mindy/Laverne & Shirley/Fonz Hour*. Both Robin Williams and Pam Dawber added their voices to high school versions of their characters. Meanwhile, The Fonz and Mr. Cool were wedged into the second season of the *Laverne & Shirley* cartoon, when The Fonz took over the base's motor pool. Like she had in primetime, Cindy Williams departed the show for its final season, leaving Penny Marshall to carry on with Williams's close friend Lynne Marie Stewart voicing Pvt. Shirley Feeney.

In addition to *Happy Days*' 255 episodes, its spin-offs generated another 357 episodes of television. But with the medium's current obsession for reboots and revivals, who knows, there may be more to come.

SEASON TEN

On September 28, 1982, *Happy Days* began its tenth season on the air. The show had already outlived *Mork & Mindy* and passed *Laverne & Shirley*'s final episode tally. After the success of *Night Shift*, Lowell Ganz and Babaloo Mandel stepped back to being consultants and passed the showrunner torch to long-time writers Brian Levant and Fred Fox Jr. The focus of Season Ten was on The Fonz entering his first serious and long-term relationship . . . meaning longer than a three-part storyline. The season's opener featured Fonzie performing yet another stunt—falling head over heels for a sophisticated divorcee, Ashley Pfister, played by Linda Purl. Fonzie's first "steady" relationship was an heiress who was estranged from her family and raising a young daughter, Heather, on her own.

For Linda Purl, her road to Stage 19 took a circuitous path. Purl first met Don Most doing a shampoo commercial in New York. Purl arrived in Los Angeles shortly after Most was cast as Ralph. A few weeks into production, Most called and said, "There's a role on *Happy Days* and maybe I can get you in to read." The audition would lead to her being cast as Gloria, who became a frequent, and problematic, date for Richie. Producer Bill Bickley confesses he wrote the character "as a composite of every girl who ever hurt me. It was like this cathartic thing." Besides constantly playing with Richie's

OPPOSITE: Henry Winkler poses for a family portrait with Linda Purl (Ashley Pfister) and Heather O'Rourke as her daughter, Heather.

LEFT: Bosley and Ross gather with recent cast additions Cathy Silvers (Jenny Piccalo) and Ted McGinley (Roger Phillips) both Season 8. Billy Warlock ("Flip" Phillips) Season 9 and Crystal Bernard (niece K.C. Cunningham) who debuted in Season 10.

> **HAPPY DAYS WAS "LOOKING FOR SOMEONE TO PLAY FONZIE'S FIANCÉE AND THEY WANTED A 'LINDA PURL TYPE,' LITERALLY." HER REPRESENTATIVES ASKED IF THE SHOW WOULD BE INTERESTED IN THE REAL THING.**

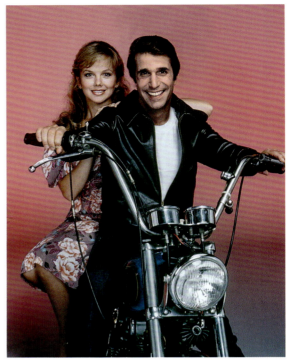

ABOVE (L): Purl and Winkler on the *Happy Days* team bus during the squad's USO tour of West Germany.

ABOVE (R): Purl sits sidesaddle on The Fonz's Harley.

OPPOSITE: Heather O'Rourke would win a Young Artist Award for her work on *Happy Days*. The actress died February 1, 1988, while being treated for problems related to Crohn's disease. O'Rourke was only 12 years old.

emotions, Gloria was also constantly playing with her chewing gum, removing it only before granting Richie a kiss. "That was absolutely Jerry Paris," Purl says. "Jerry talked about how you have to have a gimmick. Just these simple things that would set someone's character, set them apart."

Purl and Most, who had dated for a time in the 1970s, were recruited for Ron Howard's attempt at a microbudgeted, improvised, contemporary romantic comedy, *Leo and Loree* (1980). They shot on weekends over *Happy Days*' production hiatus, working from a story outline by Howard and occasional *Happy Days* scribe James Ritz. Purl continues, "everyone was pitching in. Ron's parents were doing craft service, we wore our own wardrobe. We shot in my apartment . . . various parks—no permit or anything, very much on the fly. We got through almost all of it, then their hiatus was over . . . and now their hair is cut short, and nothing matches." Howard assembled what he'd shot and took that to United Artists, who agreed to finance and reshoot the film. By the time the next hiatus rolled around, Ron Howard had booked his *Grand Theft Auto* feature and Jerry Paris would direct *Leo and Loree*. Ron Howard served as the film's executive producer and today laughs at the memory. "UA told us it was the lowest-grossing film in their history."

Nearly a decade after Purl was first sent to Western Costume to be fitted for a poodle skirt and saddle shoes, she saw a casting notice that *Happy Days* was "looking for someone to play Fonzie's fiancée and they wanted a 'Linda Purl type,' literally." Her representatives asked if the show would be interested in the real thing. They were. Winkler gushes of his co-star, "She was like elegance personified . . . the dearest, the loveliest, and so beautiful."

"It was a great kindness of Garry to

allow me to come back as a totally different character, totally different person," says Purl, who would discover that much had changed on the *Happy Days* set since the single-camera era. "For one thing, they had been through so much life together. People had gotten married, divorced, and had babies, and had illnesses, and people died. They'd also been to the outer space of fandom together. They'd been through so many fires. That resulted in a beautiful tempering and patina."

After an extensive search, Heather O'Rourke, who had appeared memorably as Carole Anne in *Poltergeist* ("They're here!"), was cast as Ashley's daughter. The decision was made after what was essentially a playdate: Henry Winkler and the youngster enjoyed an imaginary tea party; Winkler wanted to determine whether she was, like many other young performers, a windup doll—or a promising young actress.

Purl has fond memories of her stage daughter. "She was a smart little girl . . . so on the ball, self-aware, but not precocious." Because the O'Rourkes lived an hour from Paramount, Heather would sometimes stay overnight with Purl. "We'd come home, we'd have dinner, we'd have bath time, and read stories . . . and run our lines. It was very special for me to have that trust from [O'Rourke's mother] Kathy."

With the new additions on board, *Happy Days* began its second decade with what would be a major event in the series. In the episode "A Woman Not Under the Influence," Fonzie manages to track down the lady he was instantly smitten with after passing her going in the opposite direction on an escalator.

ABOVE: Joanie and Chachi turned folk duo for the chance to grab some national exposure on *Hootenanny*.

OPPOSITE: Joanie and Chachi got the Funko Pop treatment in 2021. That same year Mego released their first *Happy Days* figures in forty-five years.

To The Fonz's amazement, Ashley Pfister is immune to his charms. This forces Fonzie into new, unsettling territory: having to work to gain a woman's trust and affection.

This new pairing challenged The Fonz to live a more mature life for the first time, seriously considering the possibility of becoming a husband and father (by choice). Their romance created a wealth of comic situations, like trying to broker a truce with Ashley's snooty family, attempting to get in good with her daughter by bribing her with a trip to the circus, and integrating Ashley with his friends.

When Fonzie throws a mixer for his buddies to pass judgment on his official, first-ever potential "steady," inviting a group so diverse, ranging from faculty members to gang members, that Roger can only compare the gathering to the time his "Yale glee club performed at Attica." So, with everyone's blessing, Fonzie takes the big step—only to endanger his relationship when he gives temporary shelter to an old flame. The incident forces Fonzie to come to grips with the boundaries of monogamy, but he's so committed to Ashley that he's willing to try.

Though *Joanie Loves Chachi* had been picked up for a second season, the pair would still be featured in six episodes of *Happy Days*. Thinking Baio and Moran would never return full-time, the producers moved Mr. C's seventeen-year-old niece, K.C. Cunningham (Crystal Bernard), into Chuck's old room. Bernard, the Texas-born daughter of a televangelist, would go on to star on NBC's long-running *Wings*.

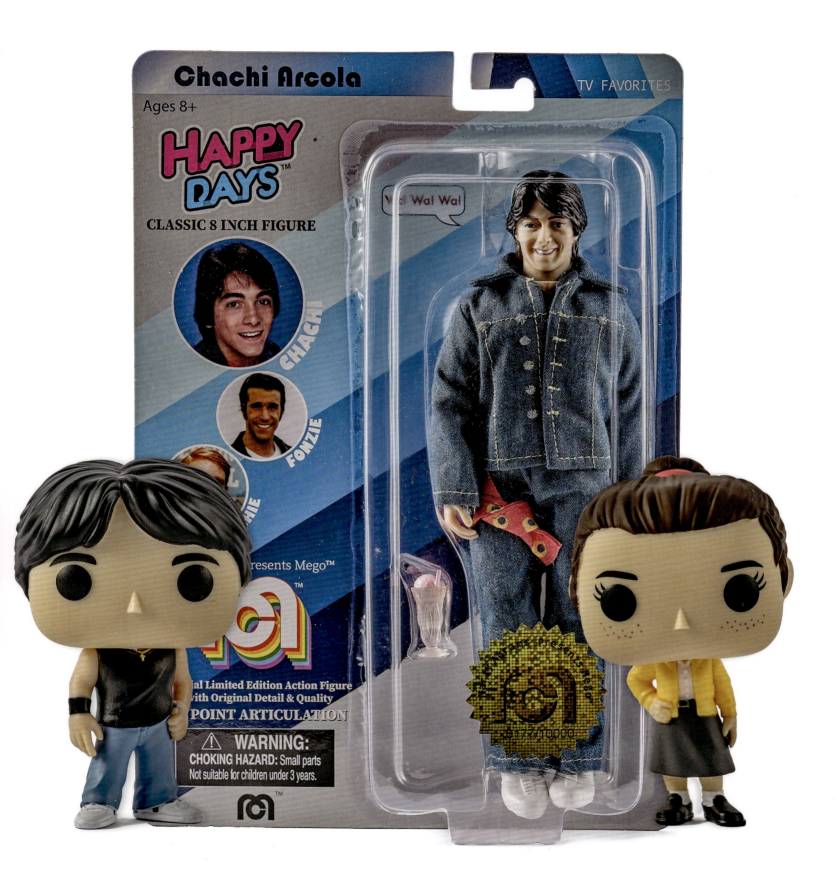

218 50 Years of Happy Days

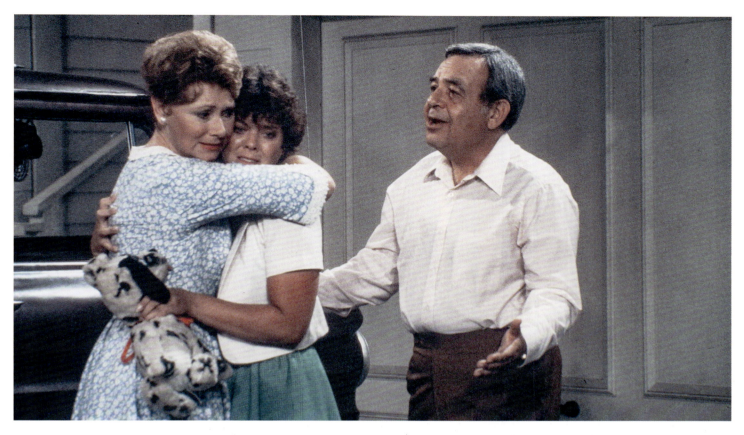

The second episode of Season Ten featured Erin Moran and Scott Baio's season debut and was an emotional exercise for all involved. In "Letting Go," Joanie asserts her independence by going to war with her father, after Howard forbids her from returning to work in Chicago and demands she instead attend Northwestern University there. Joanie locks herself into the bathroom until her dad finally relents in a sweet and heartfelt scene, much like the ones played out backstage. Bosley, Ross, and Moran constantly had to have their makeup retouched because so many real tears were flowing. As the episode's emotional montage of Joanie growing up on the show demonstrates, twenty-two-year-old Erin Moran had spent almost half her life on Stage 19, and though she'd be on *Joanie Loves Chachi* right around the corner on Stage 23, it truly felt like she was "leaving home."

But across the lot, in its second season the musical series wasn't as harmonious as it seemed. Though Moran and Baio had developed a wonderful chemistry over five years of working together, by the time the spin-off debuted, their offscreen romantic relationship had unraveled. "Erin was as cute as a bug . . . and it was only

> **BOSLEY, ROSS, AND MORAN CONSTANTLY HAD TO HAVE THEIR MAKEUP RETOUCHED BECAUSE SO MANY REAL TEARS WERE FLOWING.**

OPPOSITE: Fonzie got the paper doll treatment in 1978.

ABOVE: In "Letting Go" the tears shed when Joanie moved away were very real.

Season Ten 219

ABOVE: With Richie and Joanie out of the house, Marion is counseled on coming to terms with the "Empty Nest" syndrome, by fellow TV moms Harriet Nelson (*The Adventures of Ozzie and Harriet*) and Jane Wyatt (*Father Knows Best*). Here they compare their "spoon bracelet" craft projects.

OPPOSITE: As the years wore on, Bosley and Ross grew much closer, loved working together … and it showed.

natural. We worked together, we went to school together—it had to happen, it happened, and it didn't end well."

Marion Ross told of receiving tearful calls from her TV daughter about her relationship with her co-star. Ross offered advice, but, "With Erin, sometimes I felt she didn't understand some things, because at home she had never been taught how to cope with the realities of life." In a recent interview with the *Sun* newspaper, Moran's brother Tony mused that "we were raised by a mum and father who were unfit to be parents." He recalled that the *Happy Days* years were "[t]he most content I ever saw Erin. Her castmates were the stable family she never had growing up."

With both kids out of the house, Howard and Marion suffered from an "Empty Nest" syndrome. This led to a memorable scene where Marion Cunningham bursts into tears at the beauty parlor and is then consoled and guided by two other classic TV moms who'd suffered the same fate: *Father Knows Best*'s Jane Wyatt and *The Adventures of Ozzie and Harriet*'s own Harriet Nelson. The scene was shot midweek instead of in front of a studio audience to accommodate the seventy-two-year-old Wyatt's hiking trip with her granddaughters in the Sierra Nevada mountains.

A highlight of Season Ten was a visit from occasional *Happy Days* softball team member Tom Hanks, guest starring in the episode "A Little Case of Revenge." The episode was written by Fred Fox Jr. and associate producer Rich Correll. In 1926,

ABOVE: In "All I want for Christmas" Fonzie fails to bring Ashley and her parents together, but Howard Cunningham and his brother Dick (Richard Paul, later of *Full House*) buried the hatchet. Here the group including Pat Morita and Dick's wife Belle (Sue Ane Langdon) are caroling for Richie, still stationed in Greenland along with Lori Beth and their infant son.

RIGHT: Roger Phillips finally makes a clean break with the woman (Wendy Schaal) who for years was both the love of his life and the bane of his existence in "Since I Don't Have You."

OPPOSITE: Dwayne Twitchell (Tom Hanks) has spent years of his life training to get back at Fonzie for pushing him off a swing in the third grade. He gives Twitchell the first shot and he kicks The Fonz through a glass window. Twitchell gloats until Fonzie reenters and says "I believe it is my turn." Twitchell's knees buckle in fear.

Correll's father, Charles Correll, with his partner, Freeman Gosden, invented the first situation comedy with radio's *Sam 'n' Henry*, soon to be retitled *Amos 'n' Andy*. Correll acted as a child and appeared on several seasons of *Leave It to Beaver*. After *Happy Days*, Correll would go on to direct more than seven hundred episodes of various television episodes and co-create the Disney Channel's smash hit *Hannah Montana*.

In the episode, Tom Hanks portrays Dwayne Twitchell, a kid Fonzie pushed off a swing in elementary school who has spent the rest of his life planning and training for his revenge. Unfortunately for Fonzie, Dwayne's reappearance coincides with The Fonz's promise to Ashley to avoid any more physical altercations. Twitchell, clad in a karate *gi*, is relentless in trying to get deep enough under Fonzie's skin to provoke a physical response. Fonzie remains stoic, but when Dwayne pushes Ashley to dump him

"for a real man," Ashley happily releases Fonzie from his vow. Always a gentleman, Fonzie offers Twitchell the first shot. He delivers a monster spinning kick—sending Fonzie crashing through a window. Twitchell, gloats over his triumph . . . until an unscathed Fonzie returns and turns the brash Twitchell into a quivering mass of jelly just by saying, "Now it's my turn." Shortly thereafter, Ron Howard would view a rough cut of the episode, and cast Hanks as the male lead in *Splash*, which established Hanks as a bona fide movie star.

"A Little Case of Revenge" was such a hit that another episode was written for The Fonz and Hanks's character, but he declined to return. The role was then revised for a different character and played by Hanks's "bosom buddy," Peter Scolari.

While providing a broader canvas for the character to explore, the Fonzie-and-Ashley romance never truly "sizzled," and it smoothed out many of The Fonz's rougher edges that initially propelled the character's fame. In some respects, having a serious relationship cost The Fonz some of his cool. The next season, after the *Joanie Loves Chachi* cancellation, the band broke up, Joanie moved back home, K.C., Flip, Ashley, and Heather joined Chuck Cunningham in TV heaven, and Fonzie got his groove back.

When asked how she felt about leaving the series, Linda Purl answers, "It's a gypsy life and you just take the bonds when they come and deal with the rest. Of course it was disappointing, but to be expected. If there was a sadness or something, it's long since been outweighed by the fact that I got to do it at all."

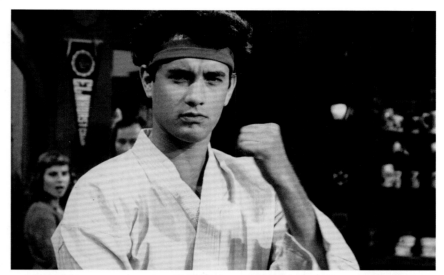

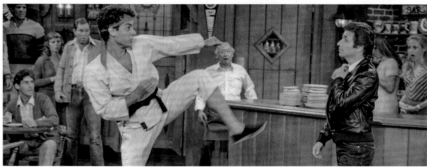

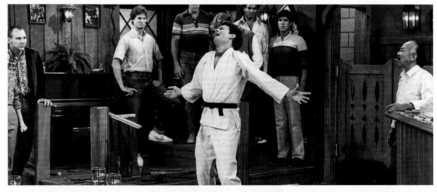

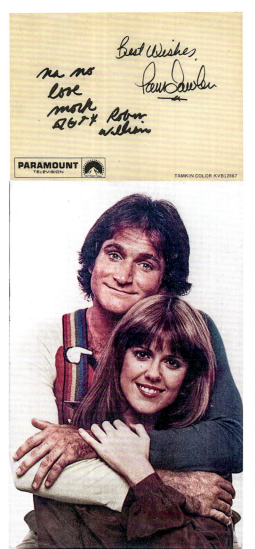
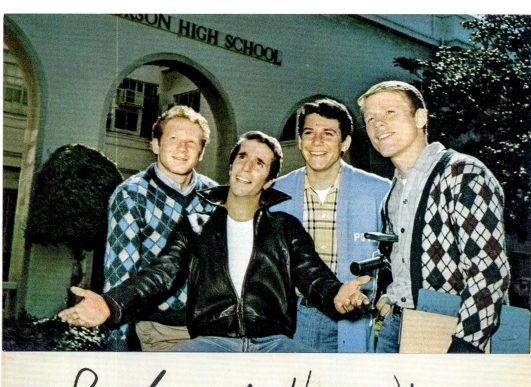

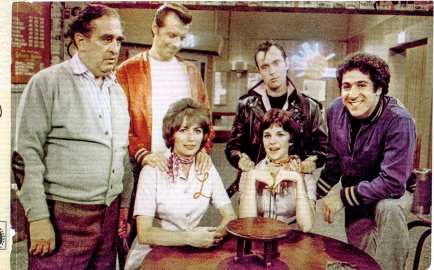

CAMP MARSHALL MOUNT

In July of 1980, with four series on the air—*Angie*, *Laverne & Shirley*, *Mork & Mindy*, and *Happy Days*—rather than going to each of the writers and production staff to welcome them to the new season, Garry Marshall gathered his (roughly) hundred-member production staff to Stage 19 for the inaugural Camp Marshall Mount.

Even though some of the productions shared the same buildings, there was little opportunity for contact between the series. Marshall felt that introducing everyone to one another would foster a sense of community.

Marshall, in shorts, with a whistle around his neck, welcomed groups from the four series, as well as studio and ABC executives. Marshall stressed his philosophy that "life is more important than show business," even emblazoning it on the Camp Marshall Mount pin-back buttons that were handed out at the entrance. The refreshments consisted of some of Marshall's favorites: cheese sticks and Jello molds.

After awkward attempts at humor by various studio and network representatives, a spokesperson for each show (usually one of the writer-producers) would step up to the mic and open with a flurry of roast-style jokes about their series, stars, and even Marshall himself—all before introducing their staffs. A week before, Lowell Ganz had been in a bad accident and his head was bandaged. He opened by saying, "They said I could go

> **"WHY DOES A MAN WHO CLAIMS THAT LIFE IS MORE IMPORTANT THAN SHOW BUSINESS MAKE HIS WRITERS WORK A HUNDRED HOURS A WEEK?"**
>
> —JERRY BELSON

OPPOSITE: If you wrote a fan letter to a Paramount TV series, you received one of these "personally autographed" postcards.

LEFT: The "Life Is More Important than Show Business" pinbacks were handed out at the door at each camp session, which was as much a roast as a team building exercise.

back to *Laverne & Shirley*, or I could go back to *Happy Days* and get hit by a car."

The first two camp sessions featured a guest appearance by Marshall's former writing partner Jerry Belson. Belson began by asking, "Why does a man who claims that life is more important than show business make his writers work a hundred hours a week?"

The third and final Camp Marshall Mount was a much bigger event, with musical numbers backed by a band formed from the various shows' music departments. Before the start of the 1982 fall season, Marshall had directed his first feature film, *Young Doctors in Love*. The movie spoofed the conventions of medical shows. It starred *Laverne & Shirley*'s Michael McKean, *Happy Days*' Ted McGinley, and Crystal Bernard. So, Camp Marshall Mount opened with scrubs-clad vocalist Michael Austin and a chorus of female staffers dressed as nurses, all holding pill trays and singing (with lyrics by *Happy Days* writer Larry Strawther) to the tune of "Wild About Harry":

> **Garry's gone into movies,**
> **he's deserting TV**
> **I'm just wild about Garry,**
> **I hope he doesn't forget about me,**
> **Cuz he's gonna win an Oscar for**
> **Young Doctors in Love Part 3.**

At this point, the nurses tossed their pill cups filled with glitter in the air and revealed that their trays were movie clapboards. They then used the trays to imitate a tap dance solo, and the song continued as the nurses formed a Rockettes-style kick line.

> **Garry's gone into movies,
> he's gonna make an E.T.,
> But if Garry's going to movies,
> then what will happen to,
> what will happen to meeeeeee?**

Then, Marshall was wheeled out on a gurney to rousing applause. His opening remarks were similar to those of past years—with the addition of introducing a staff member who would provide counseling for depression, drug, and alcohol issues.

Then a representative from each show introduced their staffs and ribbed their colleagues. The following are some of the most memorable lines:

Al Aidekman
(LAVERNE & SHIRLEY)

"Last year, Jerry Belson said the difference between a writer and a producer is that a producer has a personality. I understand why I'm not a producer . . . but that doesn't explain why Arthur Silver is."

OPPOSITE (L): Clad in shorts, baseball cap, and a whistle around his neck, Marshall greeted his campers.

OPPOSITE (R): Marshall with his former writing partner Jerry Belson, who was a guest speaker at the first gathering…for the second, he just sent a letter to be read.

ABOVE: The third Camp Marshall Mount opened with an elaborate musical number. (L-R) Pam Burton-Ventura (Garry Marshall's office), Judy Hickman (*The New Odd Couple*), Rosie Dean (*Happy Days*), and Judy Hallin (casting).

Camp Marshall Mount **227**

RIGHT: The logo from the lyric sheet to the official Camp Marshall Mount song.

OPPOSITE (TOP): The conclusion of the final Camp Marshall Mount found Garry Marshall leading the group in the camp song.

OPPOSITE (BOTTOM): If you ordered a large drink at Burger King in 1977, you received one of these cool *Happy Days* glasses!

Brian Levant
(HAPPY DAYS)

"I'd like to wish Scott Baio well. He's in the hospital recuperating from surgery to have his father removed."

Terry Hart
(JOANIE LOVES CHACHI)

"What an incredible waste of time this is."

Bruce Johnson
(THE NEW ODD COUPLE)

"And finally, I want to refute the rumor about Cindy Williams's baby. Preliminary X-rays sho0w that it does not have horns and a tail."

Garry Marshall
(FOLLOWING BRUCE JOHNSON)

"Thank you, Bruce. Once again, a blending of not funny and bad taste."

Lowell Ganz
(CONSULTANT)

"Garry Marshall is one of the most talented men I've worked with, but I have to question the judgment of a man who's decided to ride Ted McGinley to the top."

1982's words of wisdom were delivered by Harvey Miller, a former *Odd Couple* executive producer and a co-writer of the recent hit film *Private Benjamin*. Instead of going for the throat, he went for the heart.

Harvey Miller
(GUEST SPEAKER)

"Garry makes you feel like you're part of the family. Working here was the most fun I've ever had. There was a feeling of camaraderie and hard work . . . and warmth between people. Learning from people who learned from the masters. Things that stay with you: when you go out on your own, when things start coming out of your mouth instead of Garry's or someone else's. And it's the best training ground in the world. I kind of envy you, I wish I was starting over right now. Thank you."

For the finale, the entire group stood and sang the camp song, penned by associate producer Jimmy Dunne.

Camp Marshall Mount
Camp Marshall Mount
It feels like home to me
Camp Marshall Mount
Camp Marshall Mount
It's creativity
There's just one thing to recall
What Garry's taught us all,
"Life is more important than
show business"
Camp Marshall Mount,
Camp Marshall Mount,
It feels like home to me
It feels like home to me!

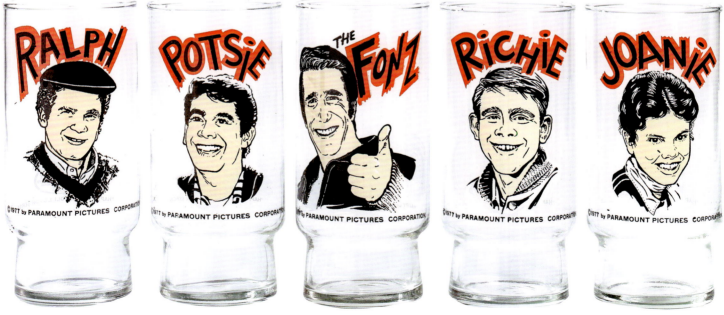

Camp Marshall Mount 229

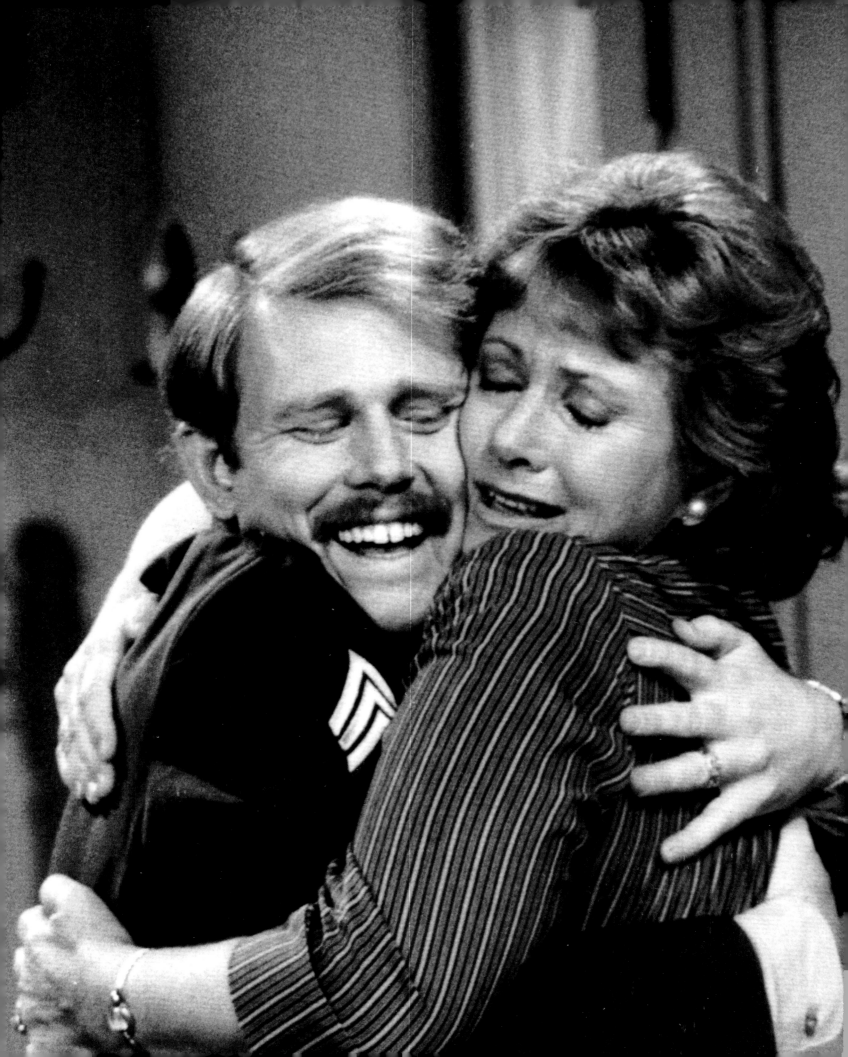

SEASON ELEVEN

During what would be *Happy Days*' final season, from 1983 to 1984, the show faced its first true competition in a decade. NBC's 1983 midseason hit *The A-Team*, starring the infamous Mr. T as B.A. "Bad Ass" Baracus. He became television's hottest character since . . . well, Fonzie. The series encountered further roadblocks, included losing its longtime companion piece when *Laverne & Shirley* was canceled and the series made its first time-slot move, sliding from 8 p.m. to 8:30 p.m. on Tuesday nights. *Happy Days*' very first lead-in was *Just Our Luck*, a weak sitcom whose producers would go on to make *Die Hard*. The show was built around the concept of a 300-year-old hip genie played by T.K. Carter. And, unfortunately, just their luck, the series bombed, failing to deliver an audience and pummeling *Happy Days*' already fading ratings. *Just Our Luck* was canceled after only eleven episodes, and ABC took *Happy Days* off the schedule with it. The shows were replaced by a rip-off of the NBC show *TV's Bloopers & Practical Jokes* hosted by Steve Lawrence and Don Rickles.

All around, it was a bad season for all comedy series. Just a few years before, nine of the top ten shows in the Nielsen ratings were situation comedies, and in the 1983–1984 season, there were none, with only three in the top twenty. Still, Paramount Television remained the king of comedies, with Garry Marshall, Sherwood Schwartz (*The Brady Bunch*), and Gary David Goldberg (*Family Ties*). The studio landed James L. Brooks in 1978, and, right off the bat, Brooks launched his

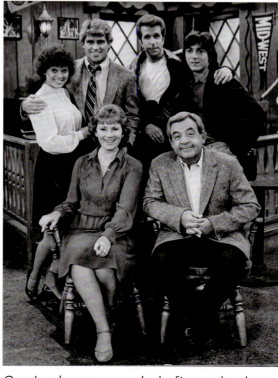

OPPOSITE: Ralph Malph, Richie, and Lori Beth Cunningham returned to Milwaukee in "Welcome Home Parts I & II," triggering tears and laughter.

LEFT: *Happy Days* final season featured a thinner roster of regulars who drove the series to a satisfying conclusion.

> "*HAPPY DAYS* WAS A WAY OF LIFE, A FAMILY, A BUNCH OF FRIENDS WHO WOULD NOW SPLIT UP. SAD BECAUSE I LOVED PLAYING FONZIE, AND IT WAS TIME TO TAKE THE JACKET OFF."
>
> —HENRY WINKLER

ABOVE: With cousin Chachi observing, The Fonz finally conquers "Suicide Hill" on his bike, in Season Eleven's opener, "Because It's There."

OPPOSITE: Lyle Waggoner returns as an old college flame of Marion Cunningham's and sets his sights on Joanie in "Like Mother, Like Daughter."

Emmy Award–winning series *Taxi*, which was produced by Glen and Les Charles. The Charles brothers would go on to create *Cheers* (1982), which spun off the bar's snooty psychiatrist, Frasier Crane, in *Frasier* in 1993. The two series would run a combined twenty-three years for the studio and collect nine Emmy Awards for Outstanding Comedy Series between the two.

Marshall's partners Tom Miller and Eddie Milkis, later adding producer Bob Boyett, also spawned several series, including *Bosom Buddies* and the much hyped and short-lived disco-themed series *Makin' It* (1979), which was inspired by the studio's *Saturday Night Fever*. Gary Nardino, the tough negotiator who ran the studio's TV division and drove Paramount Television to become an industry powerhouse, would leave the studio in 1984.

Happy Days was the sole survivor of Garry Marshall's creations, and he feared that ABC was ready to move on from the show. To make sure that the show's eleventh season would shoot all twenty-two episodes before the axe fell, production began in March of 1983 instead of July, to ensure that almost every episode was in the can before the start of the fall season. *Happy Days* would finish the season rated sixty-fourth but would produce some of the series' most beloved episodes and a triumphant finale.

After the demise of their spin-off, Joanie and Chachi returned to Milwaukee to pick up where they left off: Chachi wanted to marry Joanie, but she wanted to break up. There were other changes as well in the *Happy Days* universe.

Roger is named principal of George S. Patton Vocational High School, known primarily for its unruly student body. He soon discovers that the best way to control his rowdy pupils is to hire Fonzie as the dean of students. Joanie becomes a student teacher at the school as well. Anson Williams had accepted a smaller

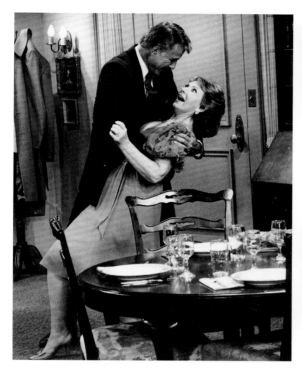

role in the series and appeared in only four episodes. With Arnold's Diner under new management, Al Molinaro was seen in only three shows, two of them as the character's brother, Father Delvecchio. In Molinaro's absence, Pat Morita donned an apron again for a couple of appearances as Arnold.

The highlight of the eleventh season came when Ron Howard's four-year exclusive NBC contract ended, and he decided to pay his TV family a visit. In "Welcome Home Parts I & II" Richie Cunningham and Ralph Malph, along with a pregnant Lori Beth and Richie Jr., come home after being discharged from the Army. *TV Guide* described the episode: "'Red' returns to Milwaukee (and TV's longest-running sitcom) and nothing seems to have changed, not even Richie's bedroom (the Howdy Doody lamp is still there). The future looks bright, too. Ralph is joining his fathers' optometry business. And Richie has a writing job all but assured at the *Milwaukee Journal*—something he has always wanted. Or at least 'it was something he always used to want.'"

Ron Howard's return energized the entire company. Even though both episodes would be shot in a single week, spirits were high, and the cast rehearsed with joy and vigor. On shoot night, the studio audience went wild when the trio walked through the door, and the ovation lasted for several minutes as Richie hugged his tearful family. But that joy would be short-lived. Richie (with a nod to Ron Howard's career) soon announces his plans to move to Hollywood rather than accept the job on the *Milwaukee Journal* that his father has arranged. After Howard hammers Richie over financial responsibilities, his son caves and takes the job. But, when Howard and Marion finally see how unhappy Richie has become, they give him their blessing to follow his heart.

The episode concludes as Richie and Fonzie exchanged a memorable farewell:

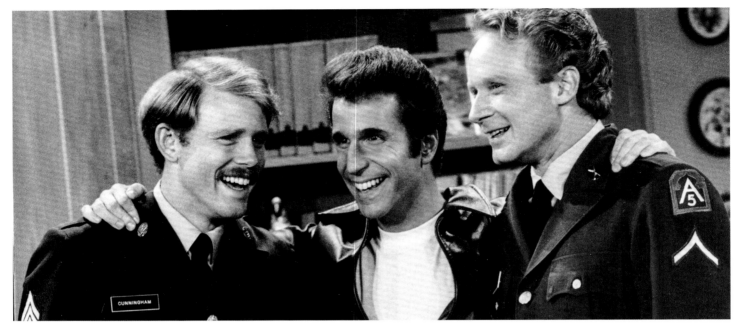
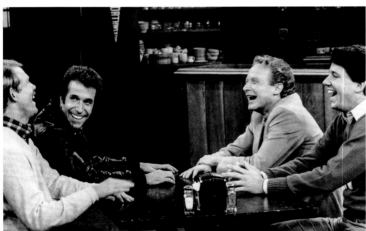

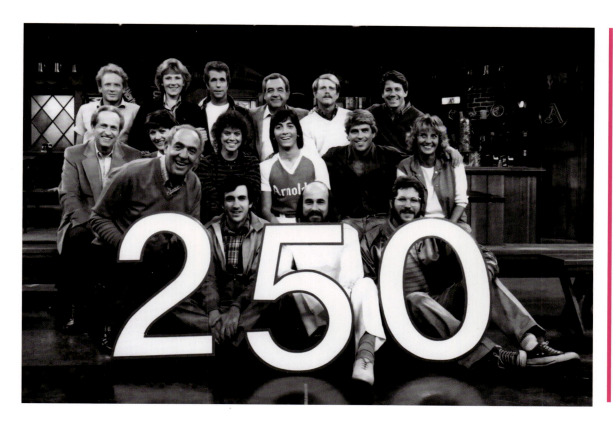

OPPOSITE: In *Happy Days*' 250th episode, "Welcome Home Parts I & II," Richie and Ralph return from service and reconnect with their pals. However, Richie's plans to become a screenwriter are short-circuited when the financial pressures of having a second child force him to take the job at the *Milwaukee Journal* his father arranged. Richie's unhappiness grows until a drunken confrontation with Fonzie helps Richie to leave home and follow his dream.

LEFT: The cast (minus Cathy Silvers) celebrates yet another landmark achievement along with (in the center row) Executive Producer Eddie Milkis, Producer Ronny Hallin and (front row L–R) Producer-Director Jerry Paris, Consultant Lowell Ganz, and Supervising Producers (and authors) Fred Fox Jr. and Brian Levant.

RICHIE

I'm a writer, at least I hope so . . . so sometimes it's easier for me to write to express myself on paper.

Richie reaches into his pocket and takes out an envelope.

RICHIE (CONT'D)

This morning I wrote this to you. I knew when we were face to face like this, I wouldn't have the words. How do you thank a man who has been everything to you . . . a brother, protector . . . a man who delivered my own child. I don't know how to say it.

FONZIE

I think you just did.

Richie holds on to the envelope and hesitates. Fonzie reaches out and takes it and puts it inside his jacket. Fonzie pats his heart.

FONZIE

You know what you did for me? You made me need someone. I love you.

Fonzie exits, Richie takes one last look around and walks out the front door for the very last time.

For virtually everyone, the "Welcome Home" episode seemed like it should have brought the curtain down on the series. But there were still five episodes left to shoot. According to Marion Ross, in the final weeks, the company knew the end was coming and "everyone took turns getting weepy." Despite all that, the

ABOVE: When Joanie and Chachi realize they're dating people who look like each other... They decide to get back together, for good.

OPPOSITE: Though Baio would state that their relationship at the time was "awkward," the pair looked very happy on their character's wedding day.

entire group rallied for *Happy Days*' true finale, "Passages Parts I & II." In "Part I," after Chachi and Joanie realize that since they broke up they've been dating exact replicas of one another, they rekindle their romance and finally decide to tie the knot. Offscreen, it was a very different story. Says Baio, "Look, Erin was my first girlfriend, I loved her, but we weren't getting along then, and it was very awkward." Meanwhile, Fonzie becomes so attached to Danny (Danny Ponce), a ten-year-old boy he's mentoring through the Big Brother program, that The Fonz decides to adopt him

As "Part II" begins, Chachi is a nervous wreck before his marriage vows, and Fonzie faces off against a "by the rules" social services administrator who won't allow him to adopt Danny because Fonzie isn't married. Fonzie is convinced that rules can be broken, but it's Howard and Marion Cunningham's passionate support of Fonzie's character that sways the final decision in The Fonz's favor.

The big day finally arrives, and the wedding takes place in the Cunninghams' backyard, officiated by Father Delvecchio, with Fonzie as Chachi's best man and Jenny Piccalo as Joanie's maid of honor. In attendance are Al Delvecchio, Roger, Chachi's mom, Grandma Nussbaum, and Chachi's buddies Bobby and Tommy. But not Anson Williams.

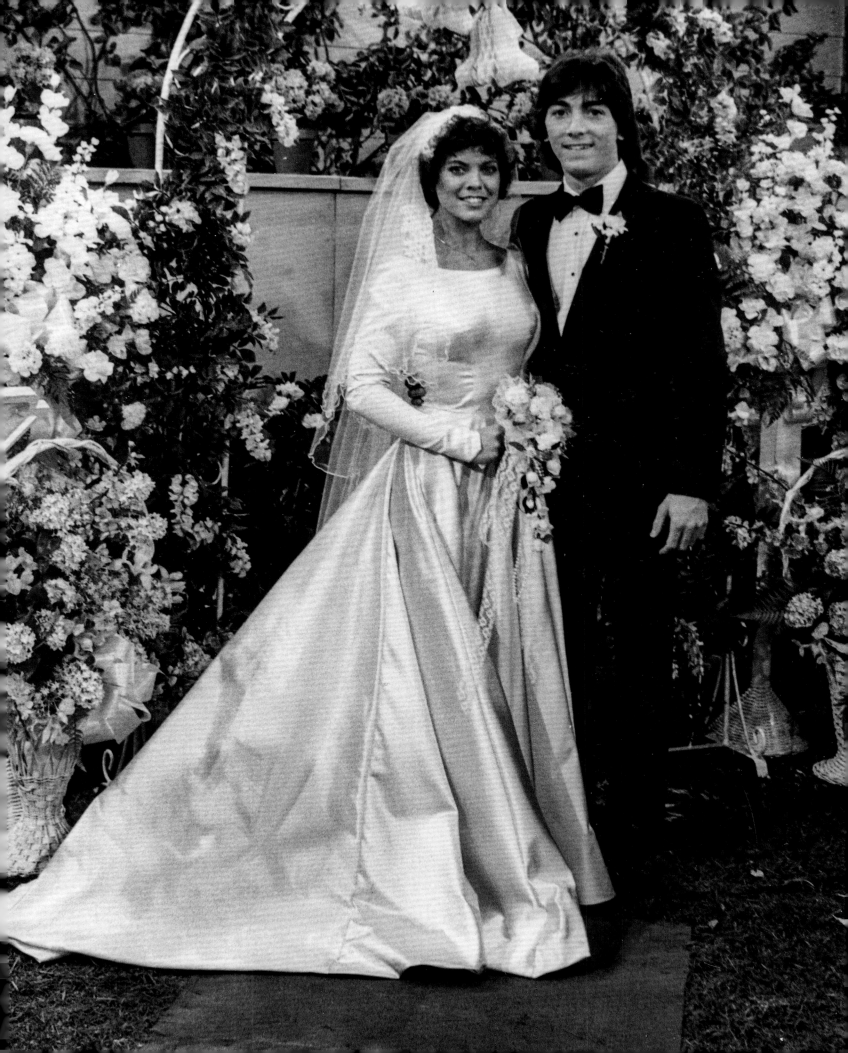

OPPOSITE (L): Joanie and Chachi exchange their vows.

OPPOSITE (R-TOP): Richie, Lori Beth, and Howard and Marion share in the emotion of the moment.

OPPOSITE (R-MIDDLE): With their friends and family looking on, Joanie and Chachi cut their wedding cake.

OPPOSITE (BOTTOM): Howard Cunningham handed off his toast to Tom Bosley, who thanked *Happy Days*' audience for being part of their family.

After Howard and Most exited the series, Anson Williams appeared in fewer episodes in each new season, and he declined a reduced payment simply to be a wedding guest. However, Ron Howard was true to his promise to appear in the final episode of *Happy Days*, and Richie and Lori Beth make a surprise entrance, just before the wedding march begins. Joanie Cunningham looks beautiful in her flowing wedding gown as she and Chachi exchange their vows. After the ceremony, everyone gathers together as Howard Cunningham proposes a toast:

HOWARD

Well, what can I say? Both of our children are married now and they're starting out to build lives of their own. And I guess when you reach a milestone like this, you have to reflect back on what you've done, on what you've accomplished. Marion and I have not climbed Mount Everest or written the great American novel, but we've had the joy of raising two wonderful kids and watching them and their friends grow up into loving adults. And now, we're going to have the pleasure of watching them pass that love on to their children, and I guess no man could ask for anything more.

Then, not as Howard Cunningham, Tom Bosley turned to the camera, lifted his glass and spoke directly to the home audience.

BOSLEY

So, thank you all for being part of our family . . . To Happy Days.

And as everyone joined the toast, Elvis Presley's emotional ballad "Memories" played over a montage of warm moments from the series' past eleven seasons, before the final fadeout.

When Jerry Paris yelled "cut," the cast embraced and wept. *Happy Days* had ended.

During the final week of production, Scott Baio observes, "I think everybody in that last episode was just trying to make believe it wasn't happening and just not really addressing it ever, and then I think when Tom made that speech in the end, I think people went, 'Oh wow, I guess we're done,' because that's how I felt."

For Henry Winkler, "I was torn. It was time. Ten years was a great run . . . We were all getting older in those stories

> **"THERE WAS A CERTAIN SHOW BUSINESS LOGIC THAT IT HAD TO END, BUT I STILL WANTED IT TO GO FOREVER. IT FELT LIKE A SHOW THAT WOULD NEVER STOP . . . LIKE EVERYBODY SHOULD GROW UP AND YOU FOLLOW THEM. I DIDN'T WANT IT TO END, I REALLY DIDN'T."**
>
> —LOWELL GANZ

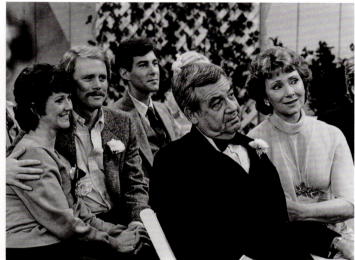
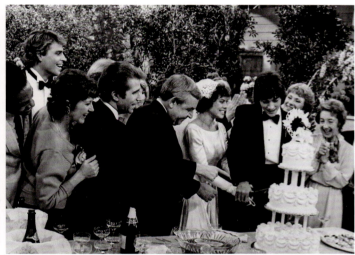
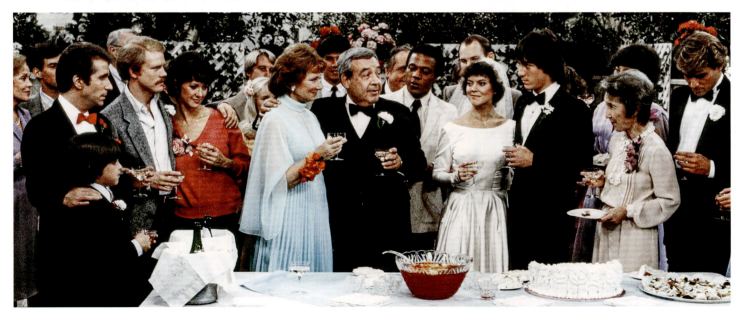

Season Eleven

BELOW: The 1983–1984 cast and crew photo was taken on the eleventh day of the eleventh month of the series' eleventh season.

OPPOSITE: The final photo of the *Happy Days* cast taken during the group's last wrap party.

and the characters were ready to move on, too. And sad. *Happy Days* was a way of life, a family, a bunch of friends who would now split up. Sad because I loved playing Fonzie, and it was time to take the jacket off."

For Bill Bickley, the end of the series was a life lesson: "It taught me something, that every job we ever have is temp work and is going to end. I thought it was remarkable that even an old pro like Tom was shocked that it was actually ending. I thought it was heartbreaking. It was nostalgic for all of us, it was our youth, literally our twenties and thirties . . . But it was time to 'put 'em down.'"

And for Lowell Ganz, "there was a certain show business logic that it had to end, but I still wanted it to go forever. It felt like a show that would never stop . . . like everybody should grow up and you follow them. I didn't want it to end, I really didn't—we were just *so close*. There were the baseball games and trips and everybody on the show having children at the same time . . . it was just being *so close* to people—Ron and Henry in particular, the two of them meant so much to me. It's not a cliché to say it was like a family . . . It was a family."

Drying their tears, the company moved from their home on Stage 19 to Stage 20 for the final wrap party. Unlike the past ten years' joyful events, where the cast and

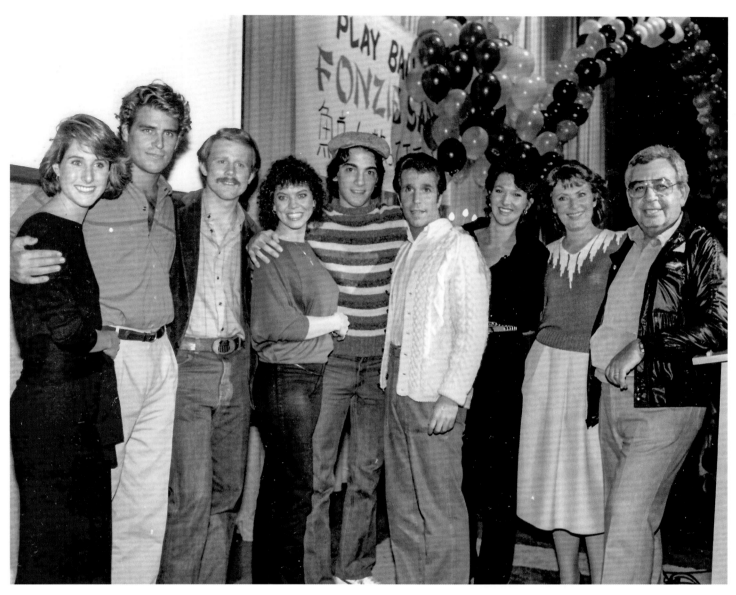

crew were roasted, the final gathering was a somber affair. It was hard to believe that the engine that had brought so many years of joy and security for so many had run out of gas. Eddie Milkis was the only executive producer present; Garry Marshall was on location shooting *The Flamingo Kid.* Milkis offered that the group shouldn't dwell on the end, but remember how amazing their journey had been.

With such an emotional finale, one would think that the last thing this group would want after spending so many years together would be to assemble the next day at 6 a.m. to fly sixty-five hundred miles to Okinawa, Japan, to play softball against U.S. troops for a week—but that's exactly what they did. And the day they returned, the entire group rushed directly from the airport, across town to celebrate Garry Marshall receiving a well-deserved star on the Hollywood Walk of Fame. *Happy Days* may have ended, but the relationships that were built there have endured far longer than the show itself.

AFTER HAPPY DAYS

When the series ended, its cast and key players would go on to achieve an unparalleled record of success across the entertainment spectrum.

After *Happy Days*, **Marion Ross** continued to be a staple on television. She was nominated for an Emmy for best actress in both 1992 and 1993 for her role as Sophie Berger on producer Gary David Goldberg's critically acclaimed autobiographical series *Brooklyn Bridge*. Ross garnered her fifth Emmy nomination for her appearances as a homeless woman on *Touched by an Angel*. The actress took on multiple guest spots, including playing the TV moms of Drew Carey (*The Drew Carey Show*), Sally Field (*Brothers & Sisters*), and grandma to Lauren Graham on *Gilmore Girls* and Topher Grace on *That '70s Show*. She has also done a considerable amount of animation work, lending her voice to everything from *King of the Hill* to *SpongeBob SquarePants*.

Ross earned a Golden Globe nomination for Best Supporting Actress in a

> **VIRTUALLY NO CAREER IN THE ENTERTAINMENT INDUSTRY HAS BEEN AS PROLIFIC AND DISTINGUISHED AS RON HOWARD'S.**

Motion Picture for one of her finest roles: as Shirley MacLaine's longtime housekeeper, Rosie Dunlap, in *The Evening Star*, the sequel to the Best Picture Oscar winner for 1983, *Terms of Endearment*.

Ross often returned to her first love, the theater, headlining a dozen productions at San Diego's Old Globe Theatre, where she first appeared as a college student in 1948. In 2018, Ross was named a Globe associate artist. Her West Coast theater credits include *The Glass Menagerie*, *Barefoot in the Park*, *Long Day's Journey into Night*, *Judgment at Nuremberg*, *Twelfth Night*, and *The Last Romance*, with her second husband, Paul Michael. In 1986, Ross made her Broadway debut in a sparkling revival of *Arsenic and Old Lace* with *All in the Family*'s Jean Stapleton.

In March of 2018, Marion published a warm and revealing autobiography, *My*

OPPOSITE: More than fifty years after *Happy Days* began, in March of 2024, the two friends found themselves working in Queensland, Australia, where they met up and Winkler took this selfie.

ABOVE (L): Marion Ross earned back-to-back Emmy nominations for playing family Matriarch Sophie Berger in *Brooklyn Bridge*. Seen here with her third TV family, the Silvers. (L–R) Louis Zorich, Matthew Louis Siegel, Annie Aquino, and Danny Gerard.

ABOVE (R): Marion Ross poses beside the statue of herself, in front of the newly renamed Marion Theater for the Performing Arts, in Albert Lea, Minnesota.

ABOVE: Ron Howard served as narrator for all 84 episodes of Imagine Entertainment's acclaimed series *Arrested Development*. In a fifth season episode titled "Emotional Baggage," Howard's entire family appeared as themselves.

OPPOSITE (L): Henry Winkler poses with a bronze version of his alter ego in Milwaukee on "Bronze the Fonz Day" to celebrate its unveiling.

OPPOSITE (R): Winkler proudly displays two of his 40-plus books, the majority for young readers.

Days: Happy and Otherwise (Kensington), with a foreword by Ron Howard. In 2021, in Ross's hometown in Minnesota, the Albert Lea Community Theatre was renamed the Marion Ross Performing Arts Center, and a statue of the actress was unveiled at the theater's entrance. In 2021, she retired from performing, but the always effervescent Ross remains active on social media.

Virtually no career in the entertainment industry has been as prolific and distinguished as **Ron Howard**'s. His 1982 feature *Night Shift*—written by *Happy Days* veterans Lowell Ganz and Babaloo Mandel and starring Henry Winkler and Michael Keaton—sparked a flurry of hit comedies, including *Splash* (1984) and *Parenthood* (1989). Then, as his talent continued to mature, Howard's mastery of storytelling and filmmaking were on full display in *Cocoon* (1985) and *Apollo 13* (1995) and *A Beautiful Mind* (2001), which won four Academy Awards, including Best Picture and Best Director.

With his producing partner Brian Grazer, Ron Howard founded Imagine Entertainment in 1985. Since then, Imagine Entertainment has been nominated for forty-seven Academy Awards and garnered 228 Emmy Award nominations. And as his boyhood dream flourished, Howard's films ran the gamut of genres. He collaborated with Lucasfilm on epics *Willow* (1988) and *Solo: A Star Wars Story* (2018). He made Westerns: *Far and Away* (1992) with Tom Cruise and *The Missing* (2003) with Cate Blanchett. He directed true-life stories: *Rush* (2013), *Frost/Nixon* (2008), *Cinderella Man* (2005), and 2022's rescue drama *Thirteen Lives*. Howard scored with the taut thrillers *Ransom* (1996) and *Backdraft* (1991), plus adaptations of literary works including *Hillbilly Elegy* (2020)

and Dan Brown's best-selling series *The Da Vinci Code* (2006), *Angels & Demons* (2009), and *Inferno* (2016), all starring Tom Hanks, plus *Dr. Seuss's How the Grinch Stole Christmas* (2000).

Beginning in 2013, Howard developed an appetite for documentary filmmaking, resulting in a chronicle of the Beatles' early days, *Eight Days a Week: The Touring Years* and a portrait of an iconic opera singer *Pavarotti* (2019). He highlighted the disaster aid work of chef José Andrés in *We Feed People* (2022) and the effect of devastating wildfires on a community in *Rebuilding Paradise* (2020). Howard and his brother, Clint, authored *The Boys* (William Morrow). The 2021 memoir was a well-received retelling of their parents' love affair and the brothers' diverging paths as young performers.

Long ago, Howard stated his goal was to "direct as many films as I can until I'm sixty-five . . . then just become a character actor." Obviously, that plan has evolved, and he continues to seek filmmaking challenges as he enters his seventies.

Since his emergence in the mid-1970s, **Henry Winkler** found success across the entertainment landscape. After hanging up his leather jacket and donating it to the Smithsonian, Winkler has excelled as a producer, director, author, public speaker, fly fisherman, and, most prominently, as an actor.

Winkler's production company, Fair Dinkum Productions, has been responsible for dozens of feature films, made-for-TV movies, lasting prime-time fare like *MacGyver* and cable series including the long-running *Sightings*, and even spearheaded a 1998 revival of the popular *Hollywood Squares* game show.

After starting his directing career on a first-season episode of *Joanie Loves*

ABOVE: Winkler, Ross, and Tom Bosley pose in front of the Cunningham home during the filming of the Winkler produced *Happy Days: 30th Anniversary Reunion*.

Chachi, Winkler made his feature directorial debut with *Memories of Me* (1988), starring Billy Crystal and Alan King. Next, Winkler headed to Florida to direct Burt Reynolds in the family film *Cop and a Half* (1993) for Ron Howard's Imagine Entertainment. Winkler also directed the memorable TV movie *A Smoky Mountain Christmas*, starring Dolly Parton. Winkler's great friend John Ritter also appeared in that film, as did Ron Howard's parents, Rance and Jean Howard.

Winkler takes particular pride in the thirty-eight children's books he's authored with Lin Oliver. Throughout his life, Winkler has dealt with dyslexia. Hank Zipzer (named after Winkler's childhood upstairs neighbor) battles the same affliction, as well as everyday struggles, through nineteen volumes plus its prequel series, *Here's Hank*. The Hank Zipzer books were turned into a BBC television series. Other titles in Winkler's canon include his *Ghost Buddy* and *Alien Superstar* book series, as well as *Detective Duck*.

Winkler's reflections on family, photography, and fly-fishing were chronicled in his book *I've Never Met an Idiot on the River* (Insight Editions, 2011). His best-selling memoir, *Being Henry* (Celadon Books), was released in October 2023.

Though he's worn many hats in his career, Henry Winkler's passion continues to be performing. Winkler's acting credits over the past forty years are too voluminous to list. Highlights include thirty-two episodes of *Arrested Development* as the Bluth family's attorney, Barry Zuckerkorn. He popped up occasionally as Dr. Lu Saperstein on Amy Poehler's series *Parks and Recreation*. And Winkler's three-part guest shot on David E. Kelley's series *The Practice* led to an Emmy nomination for Outstanding Guest Actor in a Drama Series. Films for television include the medical drama *Absolute Strangers* and *One Christmas* (the latter alongside Katharine Hepburn, in her final film role). Feature work runs the gamut from the original *Scream* (1996) to independent films, and collaborations ranging from Pixar to Wes Anderson.

Winkler would return to primetime in two series: In 1994's *Monty*, he played a conservative talk show host. The show never developed a following and lasted only thirteen episodes. In *Out of Practice*, Winkler portrayed the patriarch of a New York family of doctors, with co-stars Stockard Channing and Ty Burrell. Though the 2005 show, created by *Cheers* and *Frasier* alumni, was a critical success, CBS canceled it after only a single season.

It's no surprise that some of the kids who had Fonzie posters on their walls would grow up to be performers who longed to work with their hero. Adam Sandler and Winkler formed a bond that resulted in Winkler appearing in

five of Sandler's films, most prominently as Coach Klein in *The Waterboy* and as Sandler's father in *Click*. Another *Saturday Night Live* alum, Bill Hader, along with Alec Berg created and produced the HBO series *Barry* (2018), the story of a Gulf War vet turned hitman, turned actor. Hader's first call for the key role of Gene Cousineau was to Henry Winkler. Hader told the actor, "I can't get you out of my mind" and begged Winkler to test for the part of Barry's pompous acting teacher. The series provided a new vehicle for Winkler to display his talents, and he—excuse the expression—absolutely killed in the role.

In *Barry*'s four seasons on the air, the offbeat show's sometimes brutal, and always unexpected, plot turns delighted audiences and critics. *Barry* was nominated for an incredible 198 Emmy Awards, with fifty-one wins, including Best Comedy Series. Bill Hader captured Emmys for Best Lead Actor in a Comedy, Directing in a Comedy Series, and Outstanding Writing in a Comedy series. And five decades after his first nominations for *Happy Days*, Henry Winkler won the Emmy for Best Supporting Actor in a Comedy Series. *Barry* would also be feted with Golden Globes, Critics Choice Awards, and awards from the Writers Guild, Directors Guild, Screen Actors Guild, Producers Guild of America, and more!

At the 2018 Emmy Awards ceremony, when Henry Winkler's name was called, he received a sustained standing ovation, reflecting the admiration the industry had long held for him. Leading the crowd's cheers was Ron Howard. A turbocharged Winkler accepted his award, saying, "I only have thirty-seven seconds and I wrote this forty-three years ago. Can I just say, [entertainment attorney] Skip Brittenham said to me a long time ago, 'If you stay at the table long enough, the chips come to you,' and tonight I got to clear the table." He then praised *Barry*'s creators, thanked his wife, Stacey, the show's cast, crew, and writers, and then addressed his adult children: "Jed, Zoe, and Max, go to bed now, Daddy won!"

After *Happy Days*, **Tom Bosley** moved from Milwaukee to Cabot Cove as Sheriff Amos Tupper opposite Angela Lansbury on *Murder, She Wrote*. In 1987, Bosley donned a clerical collar to star in *Fatal Confession: A Father Dowling Mystery*. The film was so successful, it launched the NBC series *Father Dowling Mysteries*, which ran from 1989 to 1991. He was assisted by a streetwise young nun, played by third-generation TV star Tracy Nelson, Ozzie and Harriet Nelson's granddaughter.

Thirty-five years after his Tony Award–winning performance in *Fiorello!*, Bosley

> **AT THE 2018 EMMY AWARDS CEREMONY, WHEN HENRY WINKLER'S NAME WAS CALLED, HE RECEIVED A SUSTAINED STANDING OVATION, REFLECTING THE ADMIRATION THE INDUSTRY HAD LONG HELD FOR HIM.**

returned to Broadway in the original cast of the acclaimed stage presentation of Disney's musical *Beauty and the Beast*, playing Belle's father, Maurice. Tom Bosley continued to make guest appearances and perform a considerable amount of voice-over work until passing away October 19, 2010, at the age of eighty-three. Garry Marshall, Ron Howard, and Marion Ross all spoke at his memorial. His daughter, studio executive Amy Baer, related just how significant *Happy Days* had been in her life, as her father's schedule allowed the two of them to share time together, when he drove her to school every single morning. This ritual began when she was in kindergarten . . . and when the show ended, his daughter was a sophomore in high school.

Early on in his career, Garry Marshall had been counseled by *Here's Lucy* writer Fred Fox Sr. to "do more than one thing in the business." The multitalented Marshall took his advice and urged those he mentored to do the same. No one followed his example more than actor-singer-writer-producer-director-entrepreneur-politician **Anson Williams**.

After creating and producing *Skyward* and its holiday sequel, Williams made his directorial debut with *No Greater Gift*, a 1985 installment of *ABC Afterschool Specials*. Williams has directed more than 150 projects, ranging from television dramas like *Melrose Place* and *L.A. Law* to fantasy shows such as *Xena: Warrior Princess*, *Hercules*, and multiple *Star Trek* series. He also directed movies of the week and family fare ranging from *7th Heaven* and *The Secret Life of the American Teenager* to *Lizzie McGuire* and *Sabrina the Teenage Witch*.

Williams longed to prove himself in the business world, first with his chain of Arnold's-style diners with Al Molinaro, and then with his successful cosmetics

OPPOSITE (L): Tom Bosley assisted by Tracy Nelson solved crimes for two seasons on *Father Dowling Mysteries*.

OPPOSITE (R): Anson Williams and Marion Ross visited *The Today Show* with their friend Don Most to support Most's album: "D Most: Mostly Swinging" in 2017.

LEFT: Following Erin Moran's passing, Marion Ross hosted an event to honor their beloved colleague in 2017. (L –R) Scott Baio, Cathy Silvers, Ross, Anson Williams, Ron Howard, and Don Most.

line, Starmaker Products. In November 2022, Williams ran for mayor of Ojai, California, where he'd relocated two years before. He campaigned promising to end division in city government and promote measures to help the community thrive. Initially declared the winner, Williams lost the race after a recount, by forty-one votes. Anson Williams's autobiography, *Singing to a Bulldog: From Happy Days to Hollywood Director, and the Unlikely Mentor Who Got Me There*, was published in 2014 by *Reader's Digest*.

Like many of his castmates, **Don Most** moved behind the camera after leaving *Happy Days*. Most has helmed three independent films, which he calls "some of the most rewarding work of my career." His 2007 film, *Moola*, stars Treat Williams and Shailene Woodley and won the Outstanding Achievement in Directing Award at the Newport Beach Film Festival. *The Last Best Sunday* (1999) was a feature film winner at the Telluride IndieFest. He also directed the 2011 family film *Harley's Hill*, which features Rance Howard.

Most has continued to act—notably in his recurring role on *Glee* as Rusty Pillsbury and as a network executive in the Ron Howard directed film *EDtv*. However, Most's passion today is his love for singing. In the tradition of Sinatra and Bobby Darin, Most records and swings nationwide in jazz clubs and other venues with his big band. His latest release, 2023's *New York High*, is climbing the Heritage charts. Most occasionally performs with his old friend and castmate Linda Purl.

Unfortunately for **Erin Moran**, life post–*Happy Days* was complicated. Although she made appearances on *The Love Boat*, *Murder, She Wrote*, and *Diagnosis Murder*, she would receive more attention for her financial issues and her troubled marriage to actor Rocky Ferguson.

Although at times Moran had been critical of her *Happy Days* experience, she joined her castmates for autograph shows and the *Happy Days 30th Anniversary Reunion* special. Moran was living with her second husband, Steven Fleischmann, in Corydon, Indiana, when she was diagnosed with metastatic throat cancer. She died in 2017 at the age of only fifty-six. Cathy Silvers says she had "sent her roses the day before she died. I begged to go see her, but she didn't want me to see her like that. She was my best friend." After his friend's passing, Ron Howard tweeted, "Such sad, sad news. I'll always choose to remember her on our show, making scenes better, getting laughs and lighting up TV screens." Marion Ross held a memorial with nearly the entire *Happy Days* cast at her home. Before she passed on, Moran reportedly was planning to write an autobiography, titled *Happy Days, Depressing Nights*.

As soon as *Happy Days* ended, **Scott Baio** went directly to the pilot of CBS's *Charles in Charge*. Baio starred as the male nanny to the Pembroke family. The pilot sold, but after one season of middling ratings, the series was canceled, then moved to syndication. *Charles in Charge* would go on to make 126 episodes, of which Baio directed thirty-six. He would also helm episodes of multiple series, ranging from *Out of This World*, starring Donna Pescow (*Angie*) and Burt Reynolds, to *The Wayans Bros.* and *The Jamie Foxx Show*. Baio starred in *Baby Talk*, the TV adaptation of the hit film *Look Who's Talking*. When that series ended after only a season and a half, the one-time teen idol put on scrubs and solved murders alongside Dick Van Dyke on the last two seasons of *Diagnosis Murder*. Baio made dozens of appearances on several series, including replacing Henry Winkler as the Bluth family's lawyer on *Arrested Development*.

In 2007, Baio produced and starred on the hit VH1 reality show *Scott Baio Is 45 . . . and Single*, which focused on working with a life coach to sort out his challenges in committing to a relationship. Evidentially the treatment was a success, and the following season *Scott Baio Is 46 . . . and Pregnant* was born. Baio was back on Paramount's Stage 19,

producing and starring in the domestic comedy *See Dad Run on Nick at Nite*. The series ran from 2012 to 2015, and its directors included some familiar names: Rich Correll and Scott Marshall, Garry Marshall's son. Baio's interest in politics led to his becoming a featured speaker at the 2016 Republican Convention.

Of *Happy Days*' end, **Ted McGinley** comments, "I was just starting to get comfortable . . . and I would've been happy to stay . . . but I was ready to try something else." In the subsequent years, McGinley has remained a fixture on television. After *Happy Days*, McGinley immediately booked passage for a three-season cruise on *The Love Boat*, before heading to shore on another number one series, *Dynasty*. McGinley then segued to Aaron Sorkin's Emmy Award–winning *Sports Night* and appeared as the Bundy's neighbor Jefferson D'Arcy for a whopping seven seasons on *Married . . . with Children*. McGinley starred opposite Kelly Ripa for three seasons on *Hope & Faith* and played Nathan Lane's neighbor on *Charlie Lawrence*. He's headlined dozens of TV movies and starred in feature films such as *Revenge of the Nerds* and *Major League: Back to the Minors*. With over five hundred acting credits, McGinley has again grabbed the brass ring playing Derek (the husband of Christa Miller's character) on Apple TV+'s hit comedy *Shrinking*, alongside Jason Segel and Harrison Ford.

Pat Morita would find massive success on the big screen, playing the stoic, inscrutable martial arts master Mr. Miyagi in *The Karate Kid*, and its three sequels. As the apartment building handyman and teacher of Daniel-san (Ralph Macchio),

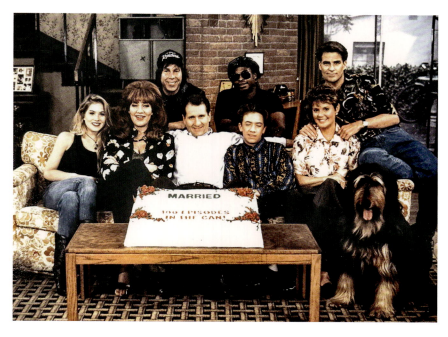

Morita snagged both Academy Award and Golden Globe nominations for supporting actor. Helmed by *Rocky* director John Avildsen, the $8 million film grossed nearly $100 million at the box office. On television, Morita played a variation of the Mr. Miyagi character as the star and co-creator of the ABC detective series *Ohara*. The series' format drifted over its season and a half, from Ohara being employed with the LAPD and then by the Feds before turning in his badge and becoming a private eye. Morita's only other series role was as Grandpa Woo on the Nickelodeon series *The Mystery Files of Shelby Woo*.

Morita would go on to star in *The Karate Kid Part II*, *The Karate Kid Part III*, and 1994's *The Next Karate Kid*, with a new protégé played by Hilary Swank. Pat Morita did guest shots and voiceover work on everything from his Emmy-nominated role opposite Kirk Douglas in *Amos* to voicing the Emperor in Disney's animated *Mulan*. In 2021, an honest and compelling documentary portrait, *More*

OPPOSITE (L): Scott Baio was back on Stage 19 for *See Dad Run* for three seasons. Here with his TV family (L-R) Bailey Michelle, Alanna Ubach, Baio, Ryan Whitney, and Jackson Brundage.

OPPOSITE (R): Baio launched a successful reality series on VH1, with *Scott Baio Is 45...and Single*.

ABOVE: Ted McGinley was a regular on a different kind of family show, *Married...with Children* for seven seasons. Alongside executive producers Ron Leavitt and Michael G. Moye, Christina Applegate, Katey Sagal, Ed O'Neill, David Faustino, and Amanda Bearse celebrate the show's 100th episode.

ABOVE: At the 2023 Hollywood autograph show, *Happy Days* fans were thrilled to find Ted McGinley, Cathy Silvers, Anson Williams, Marion Ross, and Don Most.

OPPOSITE: Pat Morita found box office gold as Mr. Miyagi in *The Karate Kid* and its three sequels.

Than Miyagi: The Pat Morita Story, traveled the festival circuit.

When *Happy Days* ended, **Al Molinaro** tended to his business interests and rarely appeared onscreen for the next thirty years. An exception was his work as a pitchman for On-Cor Frozen Foods from 1987 to 2003. He also reprised his character Al Delvecchio in *Happy Days*–themed video for Weezer's 1994 single "Buddy Holly." And, finally, he played Grandpa Joe Alberghetti on CBS's *The Family Man*. The series starred Gregory Harrison and was created and produced by *Happy Days* alumni Bill Bickley and Michael Warren. The show lasted only a single season.

In 1987, Molinaro partnered with Anson Williams to open a chain of diners called Big Al's, featuring a caricature of the establishment's namesake plastered all over the chain's restaurants and merchandise. Complications from a gallbladder surgery ended Umberto Francesco "Al" Molinaro's life in October 2015. He was ninety-six years old.

A year after *Happy Days* went off the air, **Cathy Silvers** returned to television in producer Diane English's (*Designing Women*) legal comedy *Foley Square*. Interestingly, Silvers's father, Phil, and Harvey Lembeck, the father of her castmate Michael Lembeck, had starred together on *The Phil Silvers Show* thirty years earlier. *Foley Square* left the air after only fourteen episodes. Since then, Cathy Silvers has devoted herself to social activism and advocating for mental health and nutrition. In 1981, she founded Homeless Helpers, which is now part of the Arlington Women's Civic Alliance in Virginia. This organization isn't just focused on feeding the unhoused, but also aims to end their cycle of poverty and despair. In 2007, Cathy Silvers authored the book *Happy Days Healthy Living: From Sit-Com Teen to the Health-Food Scene* (North Atlantic Books). The book was part autobiography as well as the story of her journey to a healthy lifestyle. Since then, Silvers has authored six other books focusing on positivity, individual achievement, and personal satisfaction.

After appearing in seventy-eight episodes of *Happy Days*, actress and dancer **Lynda Goodfriend** played small roles in five of Garry Marshall's movies, including *Pretty Woman* and *Beaches*. Besides acting, Goodfriend poured her energy into building her Actors Workout Theater and School. In 2007, Goodfriend began teaching at the New York Film Academy's

Burbank, California, location alongside *Happy Days* alumnus Ken Lerner. Since 2011, she has served as chair of the school's Acting Department.

Having achieved such monumental success in television, anyone else might've been comfortable to just rest on their laurels . . . but not **Garry Marshall**. After *Happy Days* ended, he directed eighteen movies with a cumulative box office of nearly $2 billion. Marshall was known for his keen eye and for nurturing new talent. He provided opportunities for young performers such as Julia Roberts, Chris Pine, and Anne Hathaway to become stars. Marshall also directed films featuring some of the biggest names in entertainment: Jane Fonda, Bette Midler, Tom Hanks, Michelle Pfeiffer, Richard Gere, Jennifer Aniston, Jackie Gleason, Julie Andrews, Matt Dillon, Diane Keaton, Kurt Russell, Al Pacino, Goldie Hawn—and her daughter, Kate Hudson.

Adept at comedy and drama, Marshall fed moviegoers a steady stream of successful, optimistic films, from *Pretty Woman* and *Beaches* to his later star-studded projects, *New Year's Eve* and *Mother's Day*. Marshall also worked in front of the camera as an actor, playing variations of authoritarian figures like the casino owner in Albert Brooks's *Lost in America*, and appeared as a network boss in the feature *Soapdish* as well as on twenty-four episodes of *Murphy Brown*. Marshall lent his distinctive Bronx accent to voice-over work on everything from shows like *The Simpsons* and *BoJack Horseman* to Disney's animated *Chicken Little*. In addition, along with his daughter Lori, Marshall penned two biographical works, 1995's *Wake Me When It's Funny* (Newmarket

Press) and *My Happy Days in Hollywood: A Memoir* (Crown Archetype) in 2012.

Despite his overwhelming success in television and film, Garry Marshall had always longed for success in the theater as well. He had penned several plays over the years, including 1980's production of *The Roast* (with his former partner Jerry Belson), starring Rob Reiner and Peter Boyle. He made a successful return to Broadway in 1992 when he co-wrote *Wrong Turn at Lungfish* with *Happy Days* veteran Lowell Ganz. Marshall also directed the play, which starred Tony Danza, Laurie Metcalf, and George C. Scott. In one of his final projects, Marshall co-wrote the book for the *Pretty Woman* musical, with songs by Bryan Adams.

In 1997, Marshall fulfilled a lifelong dream of having his own performance venue when he built his Falcon Theater

ABOVE AND OPPOSITE: A selection of autobiographies from *Happy Days* cast members and creator Garry Marshall.

(now called the Garry Marshall Theatre) only blocks from his home. The theater offered an array of plays, concerts, and experiences for all ages. It was there Marshall developed a *Happy Days* musical, collaborating with noted composer Paul Williams.

> **IN 1997, MARSHALL FULFILLED A LIFELONG DREAM OF HAVING HIS OWN PERFORMANCE VENUE WHEN HE BUILT HIS FALCON THEATER (NOW CALLED THE GARRY MARSHALL THEATRE) ONLY BLOCKS FROM HIS HOME.**

In 2016, the beloved Garry Marshall passed away after suffering a stroke. He was eighty-one years old. Marshall's memorial was attended by over a thousand people and included film clips and remarks and humorous recollections from colleagues including Michael Eisner, DreamWorks co-founder Jeffrey Katzenberg, Henry Winkler, Julia Roberts, Lowell Ganz, and Tom Hanks. Bette Midler sang "The Wind Beneath My Wings" and the event concluded with the marching band from Marshall's alma mater, Northwestern University, appearing onstage and parading through the aisles playing the *Happy Days* theme song.

Sadly, **Jerry Paris** passed away just as his feature-film directing career began to soar. After wrapping *Happy Days*, Paris replaced the director of the second *Police Academy* film early in production. Paris guided *Police Academy 2: Their First Assignment* to a $115 million gross and

what was then the largest March opening of all time. Paris reunited with *Odd Couple* star Jack Klugman and a young John Stamos to help launch the 1986 NBC series *You Again?*, then returned to Warner Bros. to film the third installment of *Police Academy*—this time adding Paris's son, Andy, to the Steve Guttenberg–led cast.

Two weeks before the movie debuted, Paris developed a pain in his leg. The cause was discovered to be a brain tumor. Two surgeries were attempted, but neither was successful. Jerry Paris died on March 31, 1986, at sixty years old—ten days after *Police Academy 3: Back in Training* opened as the number one movie in America and would again top a hundred million dollars worldwide.

The only *Happy Days* executive producer who maintained his duties to the end was **Eddie Milkis**. After the show ended, he severed ties with his producing partners Tom Miller and Bob Boyett and devoted most of his time to charity work. Milkis supported an organization called The Guardians for the Jewish Home for the Aging and the Weizmann Institute of Science, where he served as the organization's president. Behind the scenes, Milkis helped relaunch the Enterprise for *Star Trek: The Next Generation* and produced a made-for-TV movie called *The World According to Straw*. His final credit was as executive producer of Garry Marshall's 1994 sex comedy, *Exit to Eden*. Unfortunately, Edward K. Milkis lost his fight against a rare blood disease on December 14, 1996. He was sixty-five years old.

Thomas L. Miller would continue his winning streak in television when *Happy Days* ended. He and his business and life partner, **Bob Boyett**, teamed with Paramount alumni to produce over a thousand episodes of sitcoms over the years. The duo produced *Full House* and its Netflix sequel *Fuller House*, which was

ABOVE: The Marshall family and friends gathered for the renaming of the Falcon Theater after its founder, Garry Marshall.

OPPOSITE: In 2019, Don Most, Ron Howard, Henry Winkler, Marion Ross, and Anson Williams joined Barbara Marshall to pay tribute to their former boss, Garry Marshall, at a fundraiser for his eponymous theater.

created and run by Jeff Franklin (who began his career as a writer on *Laverne & Shirley*). Partnering with former *Happy Days* showrunner, **William S. Bickley** and his longtime writing partner, Michael Warren, the group filled their résumés with *Perfect Strangers* (created by *Mork & Mindy*'s Dale McRaven), *Step by Step*, *The Family Man*, *On Our Own*, *The Hogan Family*, and nine seasons of *Family Matters*.

Tom Miller died in 2020 at the age of seventy-nine. Bob Boyett would then turn to producing for Broadway, winning multiple Tony Awards for revivals of *South Pacific* and *Boeing Boeing*, and staging original works such as *The Curious Incident of the Dog in the Night-Time*.

Lowell Ganz, with his writing partner and longtime *Happy Days* contributor, Marc "Babaloo" Mandel, are regarded among the top screenwriters in Hollywood history. Beginning with the film *Night Shift*, the pair wrote five films for Ron Howard, including monster hits *Splash* and *Parenthood*. For Penny Marshall, they penned *A League of Their Own*. Along with Billy Crystal, they created *Forget Paris*, *Mr. Saturday Night*, *City Slickers*, and its sequel. Ganz and Mandel are two-time Oscar nominees, and in 2019 the Writers Guild of America bestowed upon the pair the Laurel Award for Screenwriting Achievement, which honors their entire body of work. Lowell Ganz and Garry Marshall wrote the Broadway hit *Wrong Turn at Lungfish* and, in 2022, Ganz and Mandel's musical adaptation of *Mr. Saturday Night* debuted on Broadway—fifty years to the day from when Ganz began working on *The Odd Couple*.

Supervising Producers and authors of this book, **Brian Levant** and **Fred Fox Jr.** would continue to collaborate on numerous projects including creating the comedy/action series *My Secret Identity*. In 1989, the series won the International Emmy Award for Best Children and Young People's Program.

Fox would produce several series including an eight-year tenure as the co-executive producer of *Family Matters*.

Fred Fox continued to be involved with *Happy Days* long after production ended. He co-wrote the book for *Happy Days: The Musical*, playing in London and Australia. Fox also wrote and produced *The Happy Days 30th Anniversary Reunion Special* for executive producer Henry Winkler.

Brian Levant moved directly from Milwaukee to Mayfield with another beloved TV family, the Cleavers of *Leave it to Beaver* fame for five seasons. After winning the CableACE Award for Best Director in a Comedy Series for the show in 1989, he turned his attention to

directing feature films and churned out a series of hit family comedies. His movies include the original *Beethoven* (1992), *Are We There Yet?* (2005) starring Ice Cube, *Jingle All the Way* (1996) with Arnold Schwarzenegger, and the Steven Spielberg produced box office juggernaut *The Flintstones* (1994).

Rarely, if ever, has a group of individuals achieved success on such a massive scale in film, theater, television, advertising, music, and publishing as those nurtured by the chemistry and love *Happy Days* generated for those in front of and behind the camera. This group has passed along the lessons learned on Stage 19 to all those they've collaborated with and have attempted to repay their success through a wide range of social activism and charitable endeavors.

For half a century, *Happy Days* has been a lightning bolt of joy that struck into the hearts and homes of families around the world. In the end, *Happy Days* was everything it originally set out to be. A throwback, the kind of show people didn't make anymore: about a family and their friends you wanted to spend time with every week. The storylines dealt with the relatable trials and tribulations on the perilous road to maturity . . . and a loner who discovers that life is more fulfilling when shared with others. Though at times, *Happy Days* could challenge credulity, it was always energetic, fun, warm and crafted by loving hands. Few series from each decade continue to hold audiences' loyalties, but there is little doubt that *Happy Days* will continue to shine for the next fifty years.

50 Years of Happy Days

DESIGNED BY
Brian Levant

LAYOUT, TYPESETTING, AND ART DIRECTION BY
Dustin Ames

PHOTOGRAPHY BY
Matteo Imbriani
Joe Pellegrini

SPECIAL DESIGN PROJECTS
Leo Pellegrini

Page 23:	*TV Guide* cover	Mario Casilli / TV Guide / courtesy Everett Collection
Page 23:	Ron Howard	Peter Brooker / Shutterstock
Page 37:	*New Family In Town*	ABC Photo Archive / Disney General Entertainment Content / Via Getty Images
Page 62:	*TV Guide* cover	TV Guide / courtesy Everett Collection

The authors wish to thank their families, our friend Giuseppe Ganelli, Judy Linden, and Adrienne Procaccini, and extend our deepest gratitude to our *Happy Days* family for their incredible support for this project, graciously sharing memories and their personal photos.

We so appreciate the contributions of Ron Howard, Henry Winkler, Marion Ross, Don Most, Anson Williams, Scott Baio, Ted McGinley, Cathy Silvers, Lynda Goodfriend, Linda Purl, Barbara Marshall, Bill Bickley, Lowell Ganz, Arthur Silver, Ronny Hallin, Scott Marshall, Carmen Herrera, Michael Warren, Cindy Begel, Rich Correll, Pamela Ventura, Jimmy Dunne, Larry Strawther, Patty Bosley, Hillary Horan Krieger, Kari Zirkle, Dana Vines, Gwen Berohn, Tracy Re ner, Zak & Emily Hudson, Heather Hall, the Garry Marshall family, The Garry Marshall Theatre, Andy, Tony, and especially Julie Paris.

After half a century, we're still a great team!

INSIGHT
EDITIONS

PO Box 3088
San Rafael, CA 94912
www.insighteditions.com

Find us on Facebook: www.facebook.com/InsightEditions
Follow us on Instagram: @insighteditions

TM & © 2024 CBS Studios Inc. HAPPY DAYS and all related marks are trademarks of CBS Studios Inc. All Rights Reserved. Text copyright © 2024 Brian Levant, Fred Fox, Jr.

Published by Insight Editions, San Rafael, California, in 2024.
No part of this book may be reproduced in any form without written permission from the publisher.

ISBN: 979-8-88663-645-1

Publisher: Raoul Goff
Group Publisher & SVP: Vanessa Lopez
VP, Creative: Chrissy Kwasnik
VP, Manufacturing: Alix Nicholaeff
Editorial Director: Lia Brown
Art Director: Matt Girard
Senior Editor: Adrienne Procaccini
Editorial Assistant: Emma Merwin
Executive Project Editor: Maria Spano
Senior Production Manager: Greg Steffen
Senior Production Manager, Subsidiary Rights: Lina s Palma-Temena

Insight Editions, in association with Roots of Peace, will plant two trees for each tree used in the manufacturing of this book. Roots of Peace is an internationally renowned humanitarian organization dedicated to eradicating land mines worldwide and converting war-torn lands into productive farms and wildlife habitats. Roots of Peace will plant two million fruit and nut trees in Afghanistan and provide farmers there with the skills and support necessary for sustainable land use.

Manufactured in China by Insight Editions

10 9 8 7 6 5 4 3 2 1